CW01429296

CARTIER
The Tank Watch

To all the devoted, passionate people, past and present,
who have been part of Cartier during its long history. Without them,
the *Tank* and this book would never have seen the light of day.
F. C.

Acknowledgments

Franco Cologni and the publisher would like to express their profound
gratitude to all those have collaborated in the publication of this book, among
them: Bernard Fornas, CEO of Cartier, Pierre Rainero, Pascale Lepeu, and
Michel Aliaga. We are grateful to Éric Sauvage for his beautiful photographs.
We particularly thank Cartier's archivists and experts in Paris: Betty Jais and
Aude Barry, in London: Charlotte Batchelor and Jenny Rourke, in New York:
Gregory Bishop and Violette Petit. Édouard Mignon, Philippe Beguelin,
Patrizia Elia, Thierry Lamouroux and Justine Torres for their collaboration.
Special thanks for their help to: Véronique Sacuto, Monique Gay
and Caroline Kranz.

Note

Objects on pages 6, 12, 16, 17, 18, 21, 22, 23, 31, 35, 44, 48, 51–53, 55, 59, 60, 61, 62, 63, 64, 68–69,
73, 77–78, 82, 88–89, 91, 94, 107, 114, 116–117, 119, 130–131, 133, 134, 135, 136–137, 139, 142, 147, 153,
155, 156, 160, 162, 164–165, 174–175 are part of the Cartier Collection. Inventory numbers
in captions refer to the inventory numbers of the objects in the Collection.

EXECUTIVE DIRECTOR
Suzanne Tise-Isoré

EDITOR
Sarah Rozelle

EDITORIAL ASSISTANT
Lucie Lurton

LITERARY COLLABORATION
François Chaille

GRAPHIC DESIGN
Bernard Lagacé

TRANSLATED FROM THE FRENCH BY
Datawords

PRODUCTION
Élodie Conjat-Cuvelier

COLOR SEPARATION
Les artisans du Regard, Paris

PRINTED BY
Gruppo Editoriale Zanardi,
Maniago, Italy

Simultaneously published in French as
Cartier, La montre Tank, L'icône du temps
© Flammarion SA, 2012
© Cartier International, 2012
English-language edition
© Flammarion SA, 2012
© Cartier International, 2012

Flammarion SA
87, quai Panhard et Levassor
75647 Paris Cedex 13
editions.flammarion.com
12 13 14 3 2 1
ISBN: 978–2–08–020131–7
Dépôt légal: 09/2012

FSC
MIX
Paper from
responsible sources
FSC® C006866

Printed on FSC®-certified paper in Italy

CARTIER
The Tank Watch
Timeless Style

FRANCO COLOGNI

Flammarion

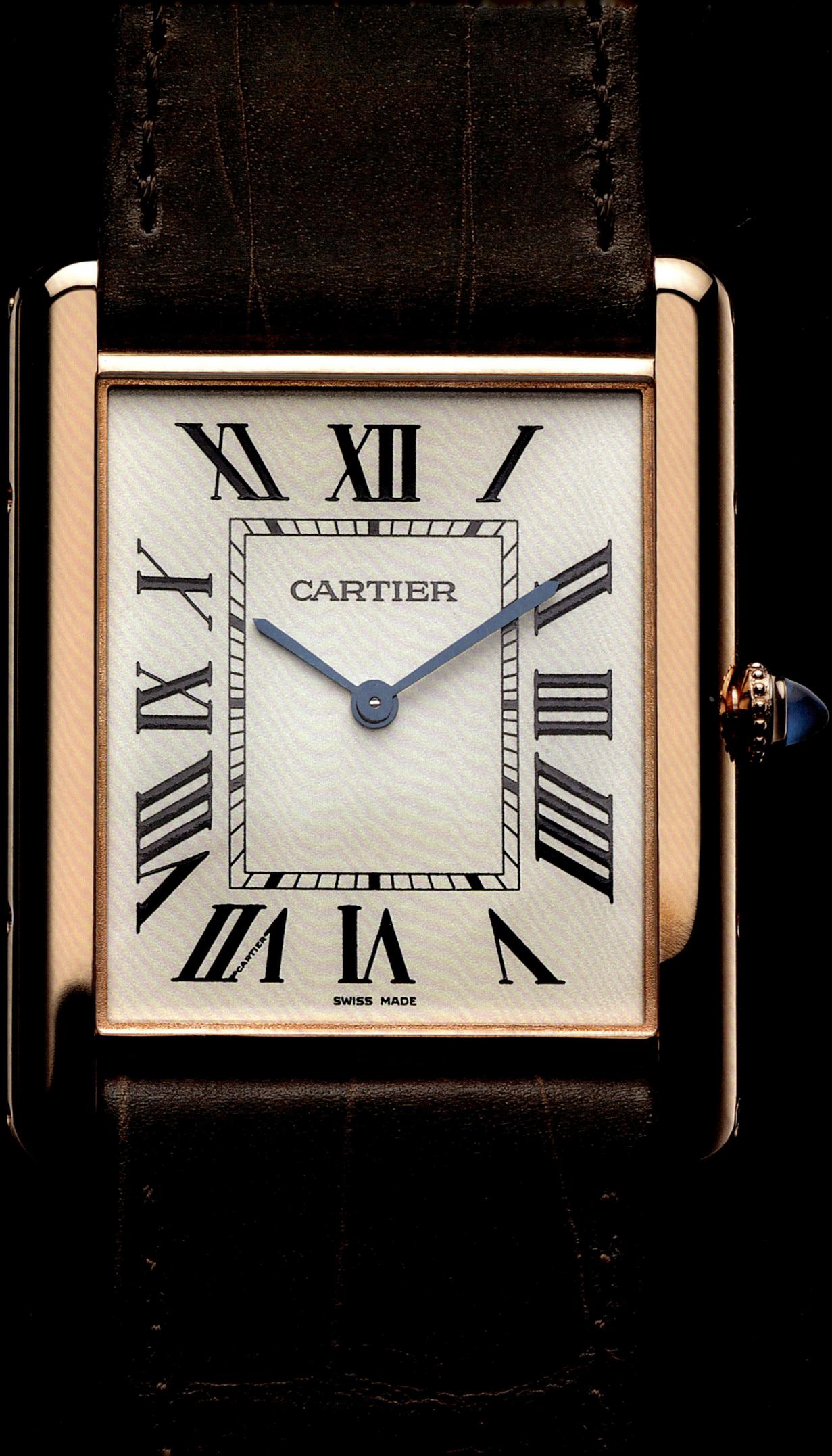

Contents

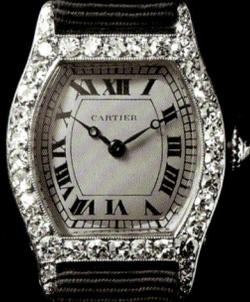

Timeless Style

Very often, the men and women who enter a Cartier boutique are more than customers who admire the jewelry, accessories, and extraordinary watches created by this jeweler: they are the *faithful*, who love to linger over the pieces, almost worshipping them as icons.

The chief characteristic of an icon is its "canonicity" or faithfulness to the original image. This allows each reproduction to be simultaneously new and "classic", immediately recognizable.

By this criterion, the *Tank* can be considered a truly iconic watch, one that has evolved to reflect—and often anticipate—major changes in the spirit of the times. Its launch introduced a new approach to watch design and its superb, entirely original styling soon became a landmark in fine watchmaking. Its shape has since been developed further by the art of the master craftsmen without ever losing its essential character.

As a perfect synthesis of beauty and time, the *Tank* rapidly became an indispensable icon. As such, it deserves as much attention from historians, connoisseurs and even people who simply admire its design, as from a master watchmaker at his bench examining its movement.

Throughout history, painting an icon has called for complex, essential preparation: fasting, awaiting inspiration and total dedication in order to capture the timelessness and sacred significance of the faces.

For this reason, before we talk about "icons" in connection with today's luxury products it is important to think deeply about what the word means. An icon is not only an object of contemplation, it is also a work that, even if it is continually mutating and produced by different people, manages to preserve its deep, essential uniqueness. This does not mean a refusal to change, but rather, being part of an identity that is stronger than any trend or fashion.

Before starting to write this new book on the *Tank*, a watchmaking "icon" admired since the early twentieth century for its contemporary character and the message of refined elegance that its design conveys, I could not avoid thinking about what it means to be a benchmark in a world that is constantly evolving.

The *Tank*'s own history provided me with a key to understanding: the *Tank* was not only an important reference within the world of Cartier but also the tangible manifestation of an ideal of purity and refinement that anticipated numerous æsthetic trends. It was able to remain true to itself while continuing to evolve.

Or rather, precisely because it was able to anticipate and adapt to the spirit of the times, the *Tank* was not only the expression of an expertise but, more importantly, a way of thinking.

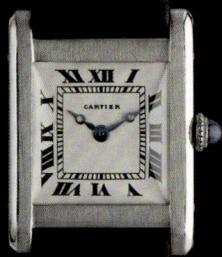

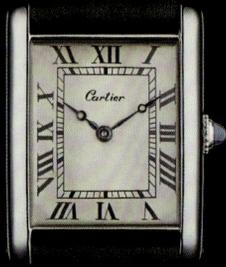

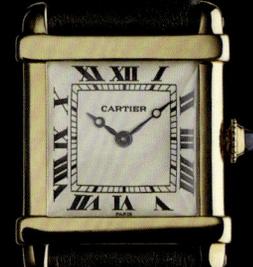

The *Tank* has remained true
to itself while evolving.

ABOVE, LEFT TO RIGHT
Tank Wristwatch,
Cartier, 1920 (*see page 31*).
Tank L.C. Wristwatch,
Cartier, 1925 (*see page 55*).
Tank Chinoise Wristwatch,
Cartier, 1930 (*see page 63*).
Tank Rectangle Wristwatch,
Cartier Paris, 1952 (*see page 116*).
Small Elongated Curved Tank
Wristwatch, Cartier London,
1967 (*see page 138*).
Tank Anglaise Wristwatch,
Cartier, 2012 (*see page 204*).

A way of thinking about time as a faithful companion, requiring measuring instruments that
are not only sophisticated (think of the important collaboration with Edmond Jaeger) but also also
æsthetically attractive.

A way of thinking about valuable, highly admired materials that never allows the container—if I can
call it that—to become more important than the contents and the overall design.

A way of thinking about the wider world and its rapidly changing elites that goes to the very heart
of their desires: the lasting beauty of an object that makes us feel elegant, refined, different and therefore
better (even if only partially).

The evolution in Louis Cartier's thinking led him—right from the start—to develop the *Tank*
as a watch that represented one and several things at the same time, exactly like real icons.

Like real icons... or like trees in a garden: an image that will also reappear in this book. As Voltaire
recalls: "We must tend our garden...."

In the *hortus conclusus* of Cartier watchmaking, just as in every garden, each pomegranate tree,
for example, will obviously produce pomegranates, but they will all be different because the trees are
different. The soil is different. The sun and the rain caress the leaves differently.

In the same way, when the *Tank* was introduced in the various places where Cartier has been active,
such as Paris, New York and London, it drew nourishment from whatever the sky provided, but never
diluted its identity by producing dry, dead branches.

This watch is an "icon" not because it has survived unchanged but because it represents the very
meaning of time, and its story is as fascinating as a historic fresco. I have attempted to sketch this story,
not with the knowledge of an expert or a scholar, and not with the precision of a collector or a technician,
but with the genuine affection of a passionate spectator.

Those who read this book also have to be spectators: the text is a light, but hopefully never invasive,
counterpoint to the images that do better than anything else at telling the history and evolution
of the *Tank*.

In producing this book we have reconsidered, reorganized and updated the 1998 edition (*Cartier,
the Tank Watch*, Flammarion). It provided a well-documented account of the extraordinary history
of the *Tank* with an excellent descriptive catalog (of which parts of the text by Dominique Fléchon,

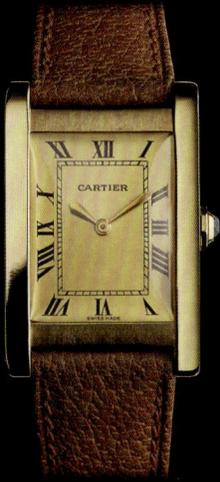

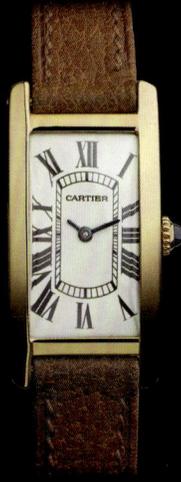

based on Cartier Archives, is reproduced here). We have had two objectives: first, to renew and augment the reference iconography of the *Tank* with new images of the design that has made history; second, to appeal to collectors, watch enthusiasts and those with a general interest in beautiful objects: people who may already know all about the *Tank* but would enjoy reliving its story.

We ask these reader-spectators to forgive the liberties we have taken in speeding through certain points in order to spend more time on others. We have tried to ensure that all the various collaborations, the faces and the stories blend together in a narrative that never overshadows the star—the *Tank*. *Excusatio non petita, accusatio manifesta.* Here the words never try to dominate the images but to complement them: this is not an illustrated text but rather a commentary to a beautiful book of illustrations.

There are many hands, faces, and personalities who have played a part in the *Tank*'s epic story: some may be anonymous such as the ancient icon painters, others may be famous names in the media, but they all have prepared the ground for the *Tank* to plant its roots by making an essential contribution to its timeless charm.

And if it seems strange to apply the word "timeless" to an instrument for measuring time, we only need to reflect on the definition of an icon to understand why, in the multifaceted evolution of Cartier fine watchmaking, the original instincts are the ones that last–*forever.*

Creating an Icon

Chapter *I*

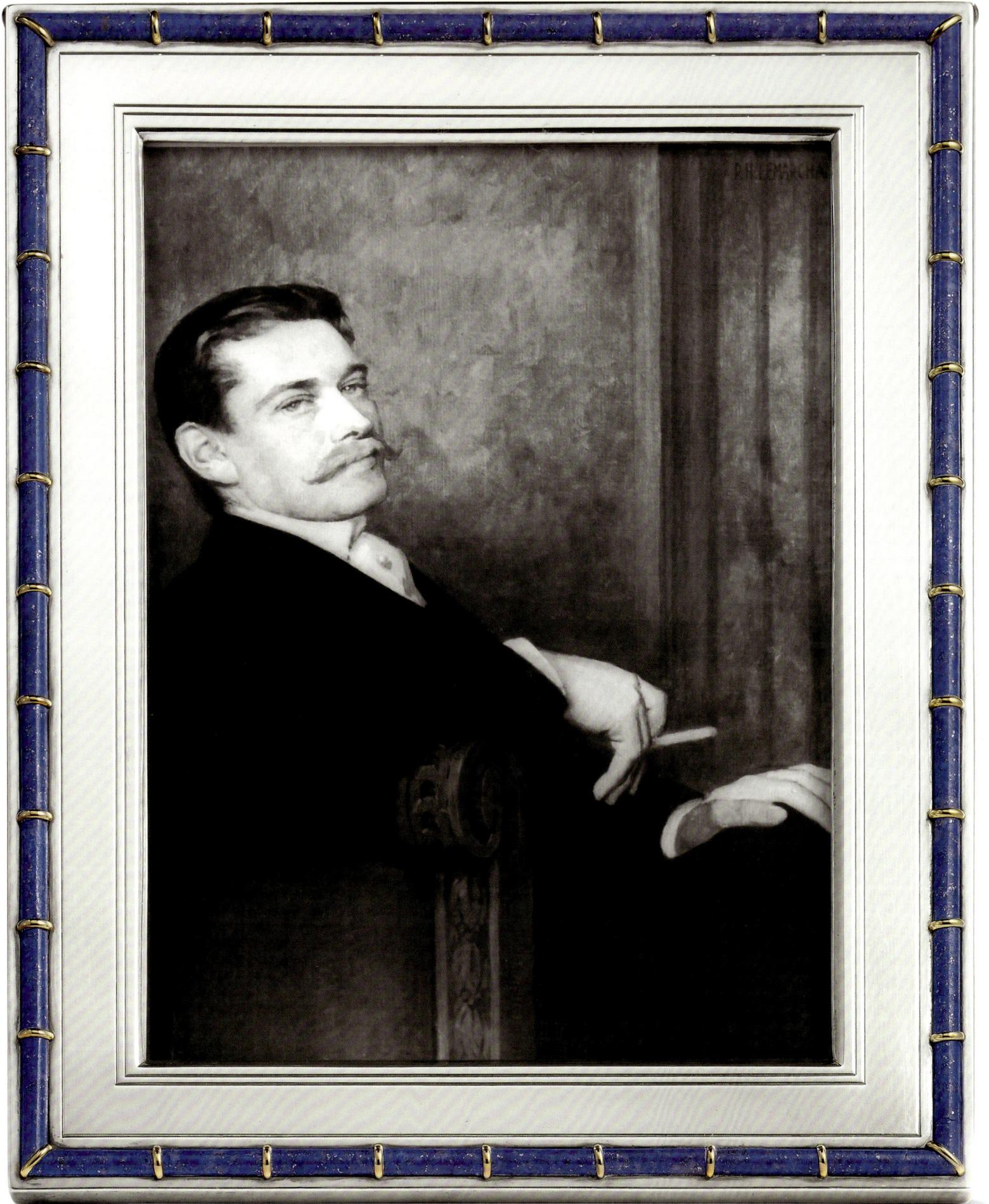

PAGE 11
Tank Wristwatch.
Cartier Paris, 1920 (*see page 30*).

FACING PAGE
Portrait of Louis Cartier by Émile
Friant from 1904, that is, five years after
"Monsieur Louis" took over at the helm
of the Paris store on Rue de la Paix. The
portrait is in a frame made in the Cartier
Paris workshops, S Department, 1928.
Polished silver, three engraved lines,
frame of lapis lazuli cylinders framed
in gold, silver stand. PF 03 A28

Decември 1916. France was at war and Paris was getting ready for Christmas, preparing the festivities that would cheer up the soldiers returning on leave. Louis Cartier was then aged 41. For 18 years he had been at the head of the famous jewelry company founded in 1847 by his grandfather Louis François and he had never changed his Parisian habits. Since divorcing Andrée Worth six years earlier, he was a bachelor living at the Ritz on the Place Vendôme and working at his office just a few steps away at 11 and 13 Rue de la Paix. While his younger brothers, Pierre and Jacques, were both in the armed forces, Louis had been rejected due to injuries sustained in a car accident. Like all Frenchmen at that time he was highly patriotic and to make himself useful he became a non-commissioned administrative officer in the Red Cross. This post enabled him to remain in his office, looking after the interests of the world-famous company with branches in New York and London. It also gave him time to design imaginative new pieces of jewelry, watches and accessories.

And on this day in December, what he designed was indeed a watch. Or more precisely, the idea of a watch. Without the dial, without the hands, without the crown. Just a sketch of a case: four lines forming a square with two of the sides extending above and below like the handles of a stretcher, with a strap fitted between them. Simplicity itself. The design was probably inspired by a report from the front that appeared in the December 2 edition of the magazine *L'Illustration*. But the images of the war in the famous weekly really only triggered something that was already in his mind: they suggested a shape that perfectly suited his taste for clean lines and marked the last stage of the search for new watchmaking æsthetics that he had been pursuing for over 10 years.

❖

In order to understand why the wristwatch that Louis Cartier had just sketched was important in so many ways, we have to go back to the start of Cartier watchmaking and, more generally, to certain events in watchmaking history. Louis Cartier loved watches, even more so than his father and grandfather. These practical accessories allowed him to apply concepts in jewelry and design to an object under strict limitations, something he found particularly stimulating. And, as the genuine pioneer that he became in all his areas of expertise, he had a special love for wristwatches: he was among the first to wear one in France although they would not become really popular until the 1930s. In 1898, when his father Alfred brought him into the company and gave him full control

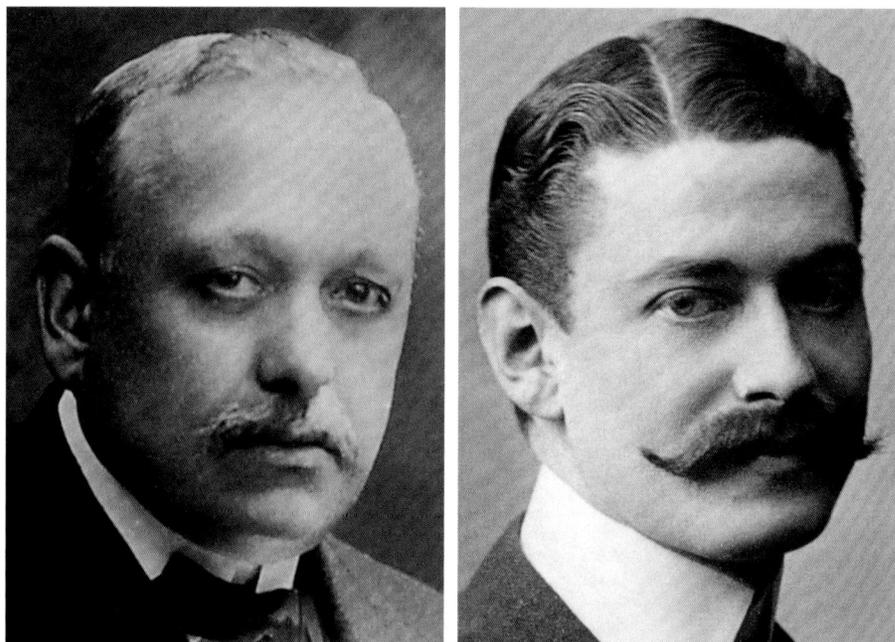

almost immediately, Louis made it clear that he wanted to develop its watches. His first wife, Andrée Worth later recalled that at that time Louis already had one major ambition among his two or three business and jewelry objectives: to "revolutionize the ideas of watchmaking."

From 1853, when it opened to clients, the company sold men's pocket watches as well as watches in the form of pendants, brooches and chatelaines for women. Some of these were very expensive, supplied by watchmakers with a reputation for their high-quality movements and the design of their external parts. Most were produced in gold or silver and often decorated in a classic style with onyx, pearls and enamel motifs. At that time, the company also offered old watches acquired from specialist antique dealers or at public auctions. But whatever their age or provenance, watches were still uncommon items in Cartier stock and rarely displayed in its windows. Later, in 1949, Louis Devaux, President of Cartier New York, explained the reason for this at a conference on "The Art of Modern Watchmaking" quoting the art historian Henri Clouzot: "In the world of diamonds, fine stones and pearls, it was very difficult to manufacture timepieces that had to be regulated, repaired, adjusted and guaranteed, and which, after all, were not considered jewelry of great value."

This was exactly the situation when Louis Cartier began working with his father and that he decided to change. He showed his father what he intended to do in this area, focusing on three objectives: the collection with a line of decorative clocks, the expansion of production of jewelry and objects within the company itself, and the development of a wristwatch. These objectives allow us to form a fairly complete picture of the young man. He was a businessman creating decorative clocks to display all his talents, but also offering the "great value" pieces that were missing in watchmaking. He was a creator and designer, conceiving models himself. And he was a man ahead of his time, developing the wristwatch—the watch of the future.

Louis Cartier loved watches but he was, above all, a jeweler. For him, form—style and design—was always more important than function. In his first months in the company, he started searching for suppliers of movements who were able to meet his design requirements. The first were Bredillard on Rue Jean-Jacques Rousseau, Dagonneau on Rue des Petits-Champs, and Prévost on the Boulevard de Sébastopol. At the dawn of the twentieth century, they were involved in the first expression of Louis Cartier watchmaking: a delicate adaptation of his classic style with garlands and Louis XVI motifs. These were already used in his jew-

The historic Cartier-Jaeger agreement, March 21, 1907. Reproduction of the contract between Louis and Pierre Cartier on the one hand and Edmond Jaeger on the other, by which Jaeger granted the Cartier brothers "exclusive rights to his production of chronometers, watches with flat calibers and all new inventions." In return, Cartier guaranteed commissions a minimum annual total of 250,000 old francs. Both parties remained bound by this contract for fourteen years after signature. The contract was followed a few days later by a hand-written letter from Louis Cartier authorizing Jaeger to patent in his name the inventions described in the contract. Cartier Archives, Paris.

elry and clearly linked to the birth of a truly French style of luxury. Many pocket watches, ladies' extra-thin watches, clocks and small clocks acquired a decoration that was inspired by Russian taste: garlands, laurel leaves, acanthus and scrolls, often framing a translucent colored enamel, on a base of fine *guilloché* metal.

The watchmaker most able to help Louis Cartier in this period, and for more than three decades in all, was Edmond Jaeger. Born in 1858, the son of a saddler, he left his native Alsace when it came under Prussian rule after the war of 1870, opted for French nationality, and joined his brother, a watchmaker, at Épernay. He served his apprenticeship there under the watchmaker Lebert then at Pierre Gabriel in Paris where he studied the art of the famous chronometer-maker, Joseph Thaddeus Winnerl. In 1880, he set up his own business in Paris at 75 Rue Saint-Saveur. As a specialist in extra-thin watches and marine chronometers, he soon won several gold medals in competitions organized by the Naval Ministry and various observatories. His reputation grew rapidly. A contract signed in 1899 shows that he already had an agreement with the Swiss company LeCoultre, a leading movement manufacturer in Sentier in the Vallée de Joux, one of the centres of Swiss watchmaking.

So he was a well-known watchmaker when Louis Cartier arrived in Paris and approached him. In 1903, the jewelry company became Edmond Jaeger's principal client. For Cartier he designed thin and ultra-thin movements which were manufactured by LeCoultre. In 1907, the company formalized the collaboration with Jaeger by signing a 14-year contract. Cartier agreed to place orders worth 250,000 francs a year with his partner, in exchange for the exclusive use of his thin lever-escapement movements in all diameters, ranging from the thinnest piece he could make, up to the five-millimeter movement for watches with complications. Jaeger also agreed to give Cartier exclusive use of all his new watchmaking designs and innovations including layouts, shapes, dials and case decorations. The contract stipulated that all models remained the property of Cartier. Before long, Jaeger set up a watch assembly unit within the Cartier manufacturing workshop in Paris at 17 Rue Bachaumont.

Their contract was unique in the history of watchmaking. It proved to be a bargain for all three partners, Cartier, Jaeger and LeCoultre, and was renewed for more than 25 years. It enabled them to revolutionize the watch by moving it from the pocket to the wrist. It freed Cartier from all technical problems allowing him to pursue his development of highly sophisticated design. Almost all forms and

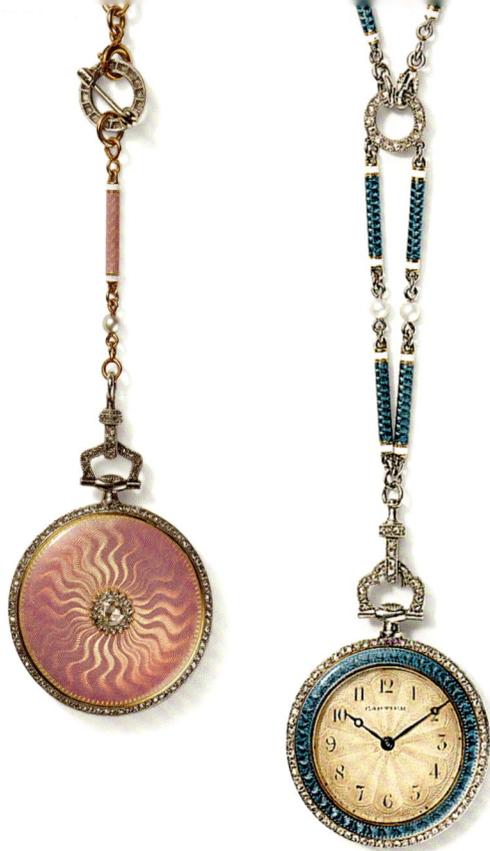

sizes of watch case were allowed because Jaeger could always produce a movement to fit, sometimes by reducing its size to the limit. It enabled Jaeger, an exceptional inventor, to develop his movements without being limited by manufacturing capacity. And it turned LeCoultre into a manufacturer of truly high-class watches, one of the very few at the time capable of producing a limited series of extra-thin movements in smaller and smaller diameters. Almost before the ink was dry on the contract, Jaeger had produced a 1.32 millimeters (¹/₁₆ inch) caliber, the thinnest that had ever been made, giving Cartier almost total freedom for innovative design.

The collaboration between Cartier and Jaeger soon produced exceptional results: pocket watches that were extra-thin or offered special functions, spherical watches, egg-shaped clocks with a turning disc, inspired by the tradition of imperial Russia. Their most notable results, however, concerned the wristwatch, still an avant-garde idea at that time. A watch that could easily be read by the person wearing it. In the early twentieth century, watches were attached to a chain or a brooch, or carried in a pocket. A rare exception was watches that formed part of a lady's jewelry bracelet, such as those Cartier had been selling since 1888. In fact, the only people at the time who appreciated the practicality of the wrist-

watch were armies and they placed a series of orders for their officers. One of them, a British officer, ended his report in 1904 with: "The wristwatch is an essential item of field equipment."

But before it could become widely accepted, the wristwatch required a series of inventions to solve a number of technical and æsthetic difficulties. The mechanical problems mostly concerned the position of the movement in space. While it generally remained vertical in a pocket watch, it now had to function in all positions, changing constantly and unpredictably with the motion of the wrist. It also had to adapt to being more exposed than in a pocket. This meant ensuring that both the watch case and the movement were sufficiently shock-resistant. Lastly, because the wearer might not have both hands free, it had to be possible to wind and reset the watch rapidly with one hand.

By the turn of the century, most of these problems had already been solved separately, during the long technical evolution of the pocket watch. The proper functioning of the gear train in all positions, despite the effect of gravity on the various components, had already been ensured in the mid-eighteenth century by the invention of the lever escapement, then improved by the tourbillon, patented in 1801 by Abraham-Louis Breguet. Five years later, Breguet drew on studies already carried out by Lépine to create a

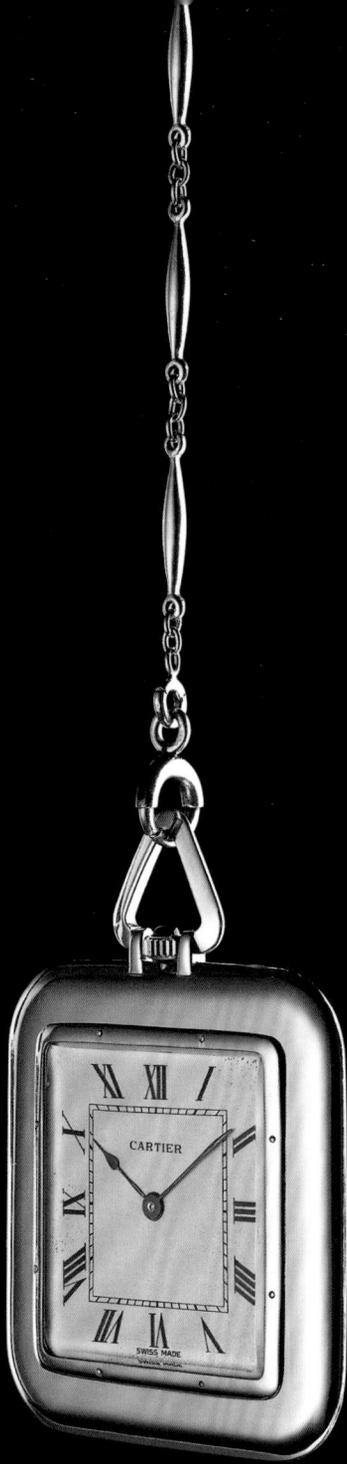

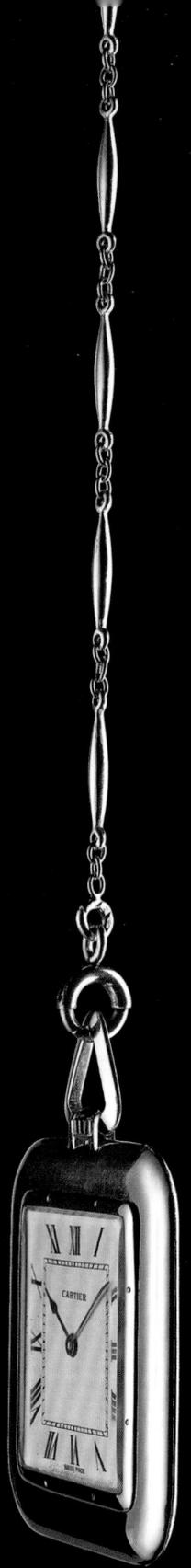

Fig. 1.

Pocket Watch

CARTIER PARIS, 1914
Marked on the dial: *Cartier*

Square, polished platinum case with rounded corners, raised bezel of polished platinum with 8 screws. Fluted winding crown on pendant capped with an onyx cabochon. Triangular pendant bow of polished platinum. Platinum chain with "oat-seed" motif (*grains d'avoine*), ring with spring clip. Square grained-silver dial with Roman numerals around a "railroad" minute track. Pear hands of blued steel.

❖ *Round LeCoultre caliber 139 movement, fausses Côtes de Genève decoration, rhodium-plated, 8 adjustments, 18 jewels, Swiss lever escapement, bimetallic balance, flat balance spring.*
WPO 28 A14

RIGHT
Drawing for patent number 421746, applied for by Edmond Jaeger in Paris on October 22, 1910. The watch is polygonal and the glass is attached by means of screws. Cartier Archives, Paris.

shock-absorber device that protected the balance staff if the watch was dropped or suffered a violent impact. Another problem concerned temperatures. Instead of enjoying a more or less steady temperature of 32°C (90°F) in the pocket, it was now exposed to much greater variations and, more importantly, a difference in the temperature of the watch face open to the air, and the case back in direct contact with the skin. The potential effect of these variations on the expansion and contraction of the metal would have made it impossible to produce reasonably accurate wristwatches without Charles-Édouard Guillaume's discovery, in 1897, of a special steel-nickel alloy, aptly called Invar® with a coefficient of thermal expansion fifteen times lower than steel.

The wristwatch also benefited from an earlier evolution of the winding system. Until the mid-nineteenth century, a key was required to wind and set a pocket watch. The biggest problem with this system was the risk of losing the key or turning it in the wrong direction. There was a constant search for a better method until 1842 when the French watchmaker, Adrien Philippe (who was later to join forces with Antoine Norbert de Patek to found the famous company with their two names) developed a system for winding a watch by turning its crown. The crown also had a push-piece set into it that was used for setting the time.

The traditional 12 o'clock position of the crown on a pocket watch also posed a difficult problem in a wristwatch. It meant that the lugs had to be placed on either side of the crown, which not only looked awkward but made winding and setting the watch quite difficult. Many manufacturers adopted a solution that may seem quite drastic: they turned the watch 90° to the right so that the lugs were positioned at 9 o'clock and 3 o'clock, while 12 o'clock was at the current 3 o'clock. This certainly did not make it easier to read the time and for a while it was customary to emphasize the 12 by showing it in red numerals. This episode shows just how insensitive many watchmakers could be to design and structure.

Getting rid of the key resolved another problem, almost accidentally, more than half a century before the arrival of the wristwatch: how to prevent dust from entering the movement through the keyhole. But the difficult issue of keeping out external elements such as dust (also water and humidity that could penetrate via the case back, or around the crystal and the crown) was not satisfactorily resolved until 1926 when the founder of Rolex, Hans Wilsdorf, patented his waterproof case.

Ironically, while the large majority of watchmakers were opposed to the concept of the wristwatch, they actually

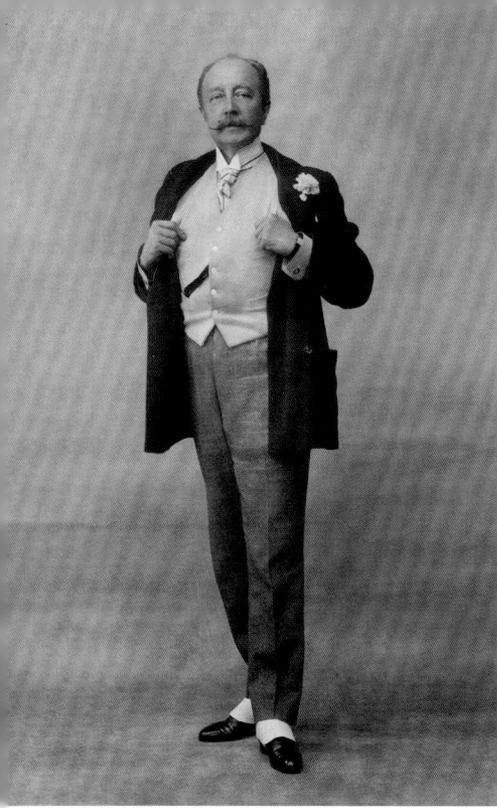

Wristwatch

CARTIER PARIS, 1910

Marked on the dial: *Cartier*
Engraved on back of case: N.F.T

Square case with rounded corners of polished and satin-finish platinum, raised bezel of polished platinum with 8 screws. Beaded winding crown capped with a sapphire cabochon. Wire (*fil*) lugs, leather strap, pin buckle. Square grained-silver dial, engine-turned decoration in center, Roman numerals around a railroad minute track. Apple-shaped hands of blued steel.

❖ *Round LeCoultre caliber 126 movement, fausses Côtes de Genève decoration, silver-plated, 8 adjustments, 18 jewels, Swiss lever escapement, bimetallic balance, flat balance spring.*
WWG 43 A10

helped it to succeed by anticipating and solving most of the problems it would have faced. All the technical solutions developed for the pocket watch over several centuries were applied to the wristwatch and adapted to its considerably lower thickness and volume. As we have seen, reducing the size of movements was a speciality of Edmond Jaeger. His technical solutions were especially effective when combined with æsthetic solutions.

For the most thoughtful designers and jewelers such as Cartier, style and design in watchmaking took precedence over technology, and they understood that the new way of wearing a watch would affect the nature of the watch itself. While the point of the wristwatch was to make it easier for the wearer to read the time, it also made it easier for other people to look at the watch itself. Worn in open view and in direct contact with the skin, it was no longer just a measuring instrument to be taken out when needed, but a fashion accessory and, potentially, a piece of jewelry.

This explains why the wristwatch was the subject of so much intense scrutiny during the first 15 years of the twentieth century. The main problem was to successfully integrate the lugs with the case. The æsthetic challenge of creating lugs that blended into the design of the case led many sophisticated watchmakers to search for a formal solution

and they soon produced a range of bold innovations. At that time, more than 90% of watches had a round case, but this tradition was challenged by what watchmakers call "shaped watches". At the start of the century, watches in an almost unlimited variety of forms started to appear. The case could be rectangular, square, octagonal, hexagonal, oval, barrel-shaped or even triangular. The corners of the polygonal cases could be sharp, rounded or cut at an angle. External shapes were combined in countless ways with various dials, such as a round case with a diamond-shaped dial, a polygonal case with a round dial, or a long rectangular case with an oval dial. And the number of possible combinations was doubled by an additional form: a case that was curved to fit comfortably on the wrist. This curved case, called "cintrée", or arched, is one of the features of the famous barrel-shaped watch introduced by Cartier in 1906, the *Tonneau*. It was followed six years later by the tortoise shape. The *Tortue* was a spectacular success, together with other oval watches.

The design problem posed by the lugs was solved in a watch invented by Cartier, probably in collaboration with Jaeger: the *Santos*. This watch is still produced today and has become one of the most famous Cartier models. Alberto Santos-Dumont was a famous flying pioneer. He and Louis Cartier were approximately the same age and had been

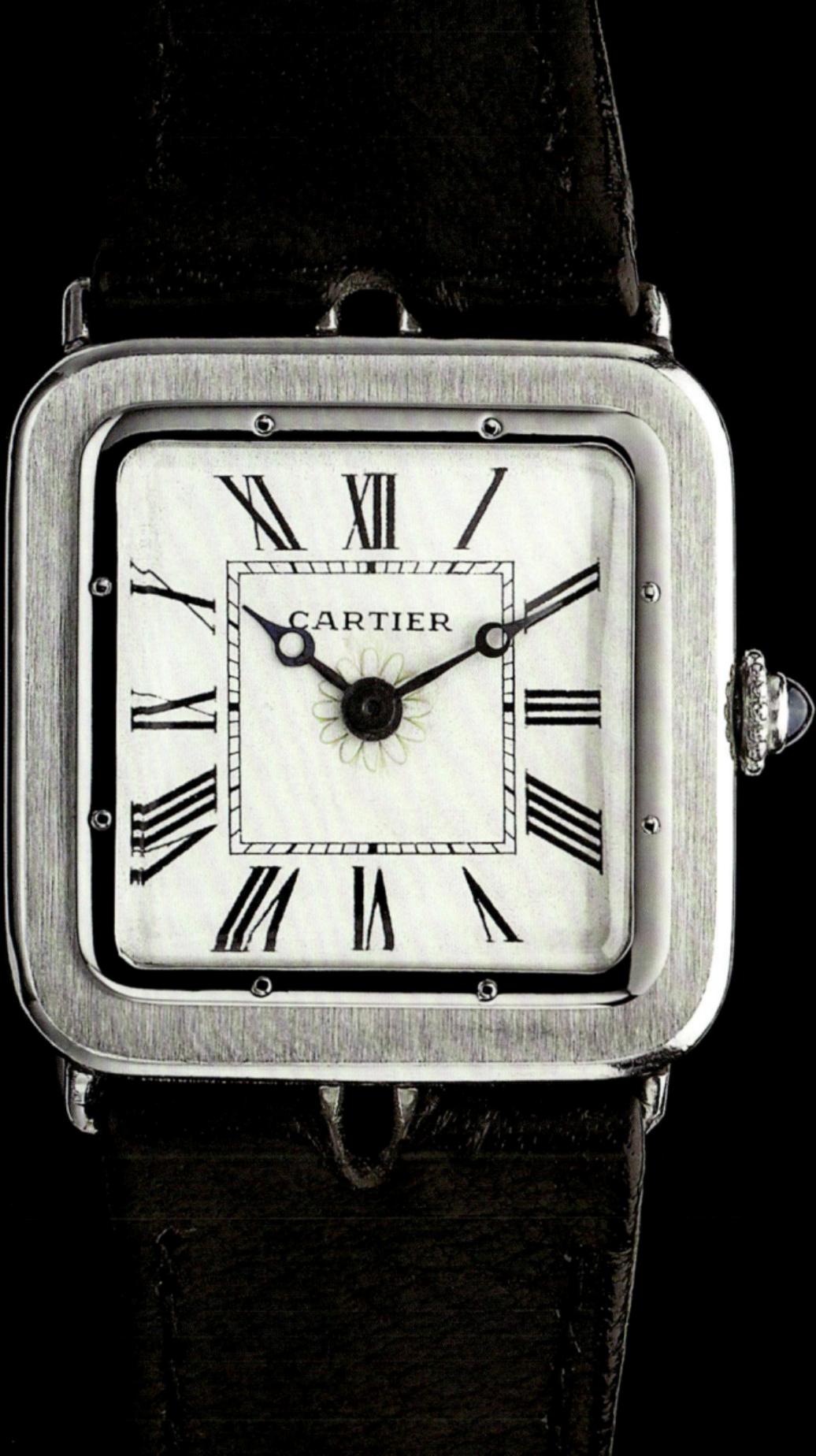

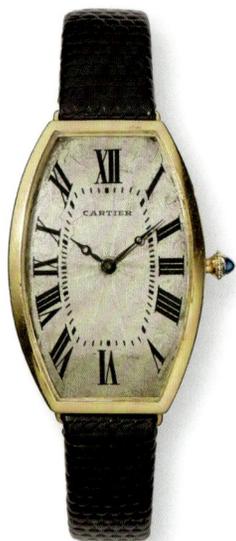

Tonneau Wristwatch

CARTIER PARIS, 1908.
Marked on the dial: *Cartier*
Sold to Countess von Hohenfelsen

Curved case; a monogram on the back. Beaded winding
crown capped with a sapphire cabochon. Leather strap,
pin buckle. Curved dial of silver with radial engine-turned
decoration and Roman numerals around a minute track.
Apple-shaped hands of blued steel.

❖ *Round LeCoultre caliber 10HPVM movement,
gold-plated, 18 jewels, Swiss lever escapement, bimetallic
balance, flat balance spring.* WCL 122 A08

friends since 1898. We can imagine what brought them together: a shared fascination with new technology and modernity, and a desire to create lightness and openness— two cardinal principles of Cartier jewelry at that time. The young Brazilian billionaire—he had inherited a huge fortune from a "coffee king"—was a flamboyant dandy and the following year he ordered a lady's extra-thin gold watch from Cartier as a gift for a friend. His achievements in the air had already made him famous when, in 1901, King Leopold of Belgium presented him with a pocket watch made by Cartier.

Three years later, Louis Cartier gave the pilot a watch with a dial that would always be visible while he was flying an aircraft. It was a wristwatch. He was no doubt stimulated by this project for a man who was always in search of new technical solutions and wanted to give him a type of watch that had never existed before. Although the original model has disappeared without trace, it was probably not very different from the *Santos II* model designed in 1908 that Cartier started selling three years later (subsequently called *Santos-Dumont*, then *Santos*). It was available in gold or platinum and fitted with a movement developed by Jaeger and produced by LeCoultre.

The *Santos* has its place in watchmaking history as the first model designed in every detail to be worn on a strap around the wrist. In other words it was the first modern watch. Cartier had designed a square watch with lugs that were an integral part of the case, not simply added on: a watch that was always intended to be worn on a strap. There was no structural break between the case and the lugs: the rounded edges of the square continued into the gentle curve of the attachments, forming a single piece ready to receive its strap. The company's records show that this new structure was no small matter for its designers: they insisted that the lugs were "an integral part of the watch" or were "incorporated into the case." His thoughts about the structure of the attachments illustrate the essence of Louis Cartier's contribution to watchmaking.

The *Santos* never appeared in a jewelry version because it was the product of a different mindset: it was designed as a beautiful instrument, not as a watch with beautiful decoration. The dynamic square shape, a flanged bezel that enhances the functions, visible screws and pins: Louis Cartier boldly focused his watch design on function or structure, an approach that was already under way in architecture and to a lesser extent in the decorative arts, but would not appear in jewelry until the triumph of modern art in the 1920s. The only counterbalance to this approach was the valuable sapphire set on the crown. One of the "signatures"

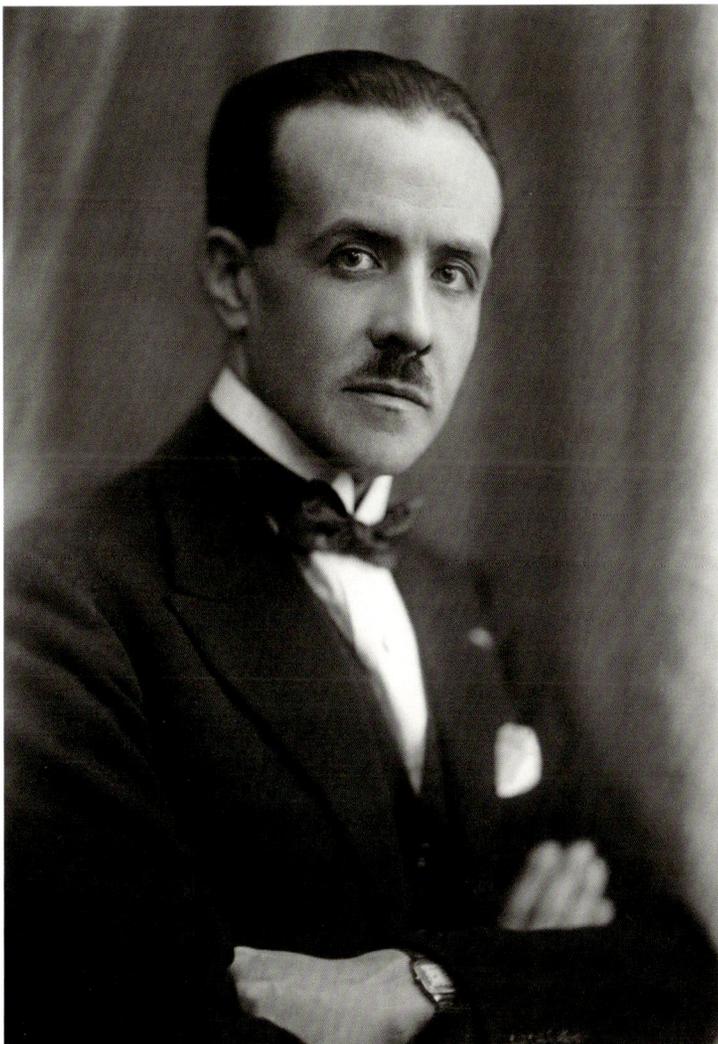

RIGHT

Santos Wristwatch

CARTIER PARIS, 1916

Marked on the dial: *Cartier*

Case of polished and satin-finish platinum, raised bezel of polished platinum with 8 screws, back of satin-finish gold. Beaded winding crown capped with a sapphire cabochon. Leather strap, pin buckle. Square grained-silver dial with Roman numerals around a railroad minute track. Apple-shaped hands of blued steel.

❖ *Round LeCoultre caliber 126 movement, fausses Côtes de Genève decoration, rhodium-plated, 8 adjustments, 18 jewels, Swiss lever escapement, bimetallic balance, Breguet balance spring.*

WCL 88 A16

BELOW

Jean-Charles Worth, circa 1920. Great-grandson of the famous fashion designer Charles Frédéric Worth, Jean-Charles ran the family business. He was the brother-in-law of Suzanne Cartier, the younger sister of Louis, Pierre and Jacques Cartier. On his wrist he is wearing a *Santos* watch.

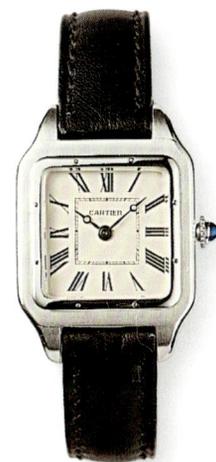

of Cartier watches, it added a discreet touch of luxury that was subtly attractive under the cuff of a dinner jacket.

The preeminence of Cartier in watchmaking was confirmed when the thinking that produced a new shape—the square—was applied to structures and techniques.

Leaving aside the hypothetical shape of the first watch made for Santos Dumont, the year 1908 when the *Santos II* was created, seems to mark the start of a trend at Cartier towards the square watch, a foretaste of modern style. In fact, that year saw the introduction of a square pendant watch in platinum with a ruby cabochon set in the crown. Two years later, Edmond Jaeger made a patent application for a "polygonal watch" in which the crystal was fixed in place by screws. The drawing in the patent file shows a square pocket watch with rounded corners and a screwed bezel, a design that would have great success at Cartier with the *Santos*. That same year, the first watch of this kind, in polished gold, extra-thin and with a sapphire cabochon on the crown, was sold to the Countess Hohenfelsen, the morganatic wife of Grand Duke Paul of Russia and one of Cartier's most important customers at that time. A jewelry version of this model is now part of the Cartier Collection (a large collection of pieces made by the company from its earliest days and patiently assembled since 1973). Also in 1910, the first square wristwatch for men finally

LEFT

Louis Cartier was essentially a classicist, a lover
of clarity, balance, and the harmony of simple lines.
This drawing, made in 1921 by the architect Louis Süe,
shows how the golden number is used to define
architectural proportions.

BELOW

Sketch of the South facade of the Villa Mirande
at Saint-Cloud. Taken from *Le Rythme de l'architecture*,
by Léandre Vaillat and Louis Süe, it shows how
a module is used to calculate proportions.

appeared. It retained several elements of the initial drawing including the flange and the visible screws.

It is impossible not to be struck by the avant-garde style of this watch. Yet in the following year, Cartier went even further with the *Santos*, a decisive step towards the modern watch. It now seems like a sort of final sketch from which an idea of genius would soon emerge, because despite its daringly visible screws, its size that was highly original for the time, and its platinum caseband, polished as if to pay tribute to the new metal, it was just a watch with a traditional structure to which lugs had been added to attach a strap. With the *Santos* one year later, there was no longer a distinction between the case and the lugs: Cartier had invented the modern watch.

Progress continued after the *Santos* in a series of watches forming a perfect square with right-angle corners called "coins vifs". For example, a jewelry wristwatch from around 1914 in polished platinum and a gold case back with a bezel set with a line of rose-cut diamonds and a beaded crown with a single diamond of the same type. Or a men's wristwatch, that appeared around 1915, in platinum with a gold case back, a *moiré* silver dial, a perfectly square case with right-angle corners, and no decoration whatsoever. In the spirit of the time, it was a firmly modern design.

Æsthetics and modernity. It is impossible to understand the early development of Cartier watchmaking without using these two terms. They are concepts that Louis constantly combined. He was certainly modern in his passion for new technology, sport, cars, and flying. But he was perhaps even more modern in his enthusiasm for new, innovative art forms. His taste for square surfaces, for example, showed in his jewelry from 1906 and in his watch designs by 1908. This was a time when important artistic movements were emerging: the rampant eclecticism of the Second Empire style and the convoluted scrolls of Art Nouveau were starting to be replaced by straight lines, perpendiculars and parallels. Cubism, among other theories of art, was born in 1907. Yet his precocious modernity almost seems paradoxical: Louis Cartier was primarily a classicist. He had a classic French love of clarity, balance and the harmony of simple, clean lines, encapsulated in the famous dictum of Nicolas Boileau: *Whatever is well conceived can be clearly explained.* At the same time as he was developing his square jewelry and watches he was also enjoying great success with his "garland-style" jewelry, a light, brilliant, neo-classical interpretation of the Louis XVI style with its graceful motifs of leaves, bows and flowers. He persevered with this style until the triumph of Art Deco in the 1920s, producing

RIGHT

Project for the façade of the Champs-Elysées theater
by Antoine Bourdelle (1861–1929). The theater,
built in 1913, was designed by Auguste Perret (1874–1954)
and is considered a masterpiece of "second neo-classicism"
and a forerunner of the Art Deco movement.
Pen and Indian ink, watercolor on woven paper,
circa 1911. Paris, musée Bourdelle.

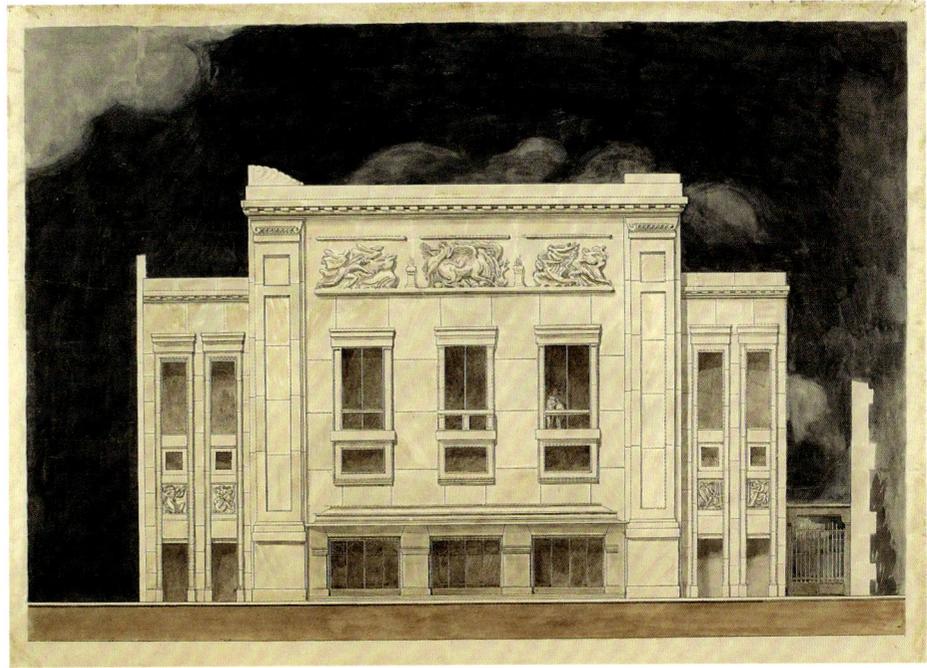

it in parallel with the "modern side" of his work. In both aspects of his art during the first two decades of the twentieth century he was surely searching for the same elegance, the same very French harmony that comes from a certain purity. The search for harmony in design, just as much as in architecture, can even be part of a pseudo-scientific process in which beauty has specific proportions represented by a mathematical ratio, the "golden number". The search soon inspired a number of architects, including Le Corbusier. One architect in particular seems to have inspired Louis Cartier in his pursuit of modernity and his love for the right angle: Auguste Perret, a fervent believer in a "style without decoration." Among his most important designs was the Théâtre des Champs Élysées in Paris, a masterpiece of "second neo-classicism" and a forerunner of the Art Deco style. It made a major impression when it opened in 1913. The facade of this theatre built in reinforced concrete, as well as the black marble facade of the Cartier boutique at 11 and 13 Rue de la Paix (enlarged and renovated in 1912) were similar in spirit to a watch that was sketched in December 1916.

Its design would certainly have been approved by a group of Dutch architects and painters who were working on a theory of æsthetics in Leyden. In October 1917, they produced the first edition of the magazine *De Stijl*

(Style). Their leader, the painter and architect Theo Van Doesburg, explained their purpose very simply: to meet the very strong need for "clarity, certainty and order." This new movement, sometimes labelled "Neoplasticism", went on to have a considerable impact on the world of contemporary art. Rejecting the dominance of the irrational element in art, they embraced a kind of absolute beauty that is found in mathematics: the beauty of geometry. They believed it had an æsthetic value that went beyond emotions and ideologies, creating a rigid, indisputable structure that confined the eruptions of disorder.

The most famous artist in this group was certainly the painter, Piet Mondrian. He used the simplicity of squares and rectangles, and the purity of basic colors, in an explicit attempt to make art a means of achieving perfect calm and stillness, and to restore the harmony that had been lost between man and nature. The contrast between formal theory and dynamic movement was a feature of all avant-garde work at the start of the century but Mondrian brought it into conscious awareness. His solution renounced all movement completely, serenely affirming the precedence of form.

Comparable results, even more fertile due to the practical nature of their work, were obtained by the architects in the group, particularly J.J.P. Oud and Gerrit Rietveld. Oud

designed some low-cost houses in Rotterdam and other Dutch cities. Even today these buildings are very striking with the simple beauty of their plain white surfaces, the clean lines of their square doors and windows, and the harmonious match of their internal and external volumes. The simplicity of their structure promises clean and dignified living. Gerrit Rietveld, who was chiefly interested in design, created furniture such as the famous red-blue chair in which Mondrian's formal color experiments abandoned the flat plane of a painting in order to acquire volume and became a highly intensive form of expression.

There is no doubt from some of his work, including the watch he had just sketched in four lines, that Louis Cartier was a natural part of this trend. He enthusiastically supported the second wave of French neoclassicism. The impact made by the De Stijl movement just after the war and by the Bauhaus school, founded in Weimar in 1919 by Walter Gropius, meant that when Cartier's radically simple design went on sale in 1918, it was recognized as *the* modern watch.

❖

When Cartier first saw the images of the war in *L'Illustration* in December 1916, it was only two weeks after the battle of the Somme. The attack launched by the French and British

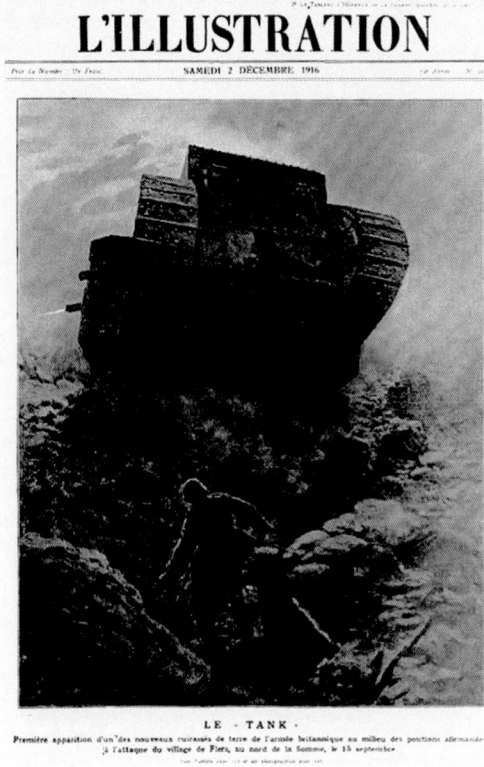

L'ILLUSTRATION

SAMEDI 2 DÉCEMBRE 1916

LE - TANK .

Première apparition d'un des nouveaux cuirassés de terre de l'armée britannique au milieu des positions allemandes, à l'attaque du village de Flers, au nord de la Somme, le 15 septembre.

on 1 July against the fortified German lines north of the Somme was an attempt to break their grip around Verdun. It continued until November 19. It was one of the bloodiest battles in history with more than a million victims: almost 500,000 dead on each side. Yet it only advanced the Allied forces by about a dozen kilometers. Its only positive result was to reduce the number of German troops at Verdun who finally lost their grip on the area. But it also damaged the morale of the German high command who then launched a relentless submarine offensive instead, and this provoked the United States into joining the war.

Throughout the entire battle, the French press gave daily reports of the efforts of the French and British troops, quoting official communiqués from headquarters and omitting—due to censorship—the details of the horrendous trench warfare, the suicide assaults under machine-gun fire from the German lines and the terrifying number of victims, all taking place in a sea of mud following the heavy rains in September. Every day for almost five months, the French people held their breath, reading stirring accounts of the heroic advances of the "Poilus" and the "Tommies".

On September 16, two and a half months after the start of the battle, most papers carried a sensational report that raised everyone's hopes: "We have brought into service a new model of heavily armored vehicle that has performed admirably," quoting an official British communiqué from the previous day. It was true. On September 15 at Flers, the first armored assault tanks in history, mounted on tracks, went into action—the British *Marks.* There were nine of them that first day (thirty others would soon arrive). When they showed that they could drive across trenches, mow down barbed wire, and withstand enemy fire, panic spread in the German lines. For several days the press did not know what to call these "armored cars." On 17 September, *Le Petit Journal* wrote about a highly ingenious combination of sledge and car and concluded: "On its debut, the English car-sledge has worked wonders." That same day, *L'Intransigeant*, which must have heard a rumor about the English name for the vehicle, described the new "'reservoirs' or mobile turrets that have done such important work." The following day, 18 September, *Le Figaro* still did not know their name, calling them "armored cars" and comparing them to the "false armed wagons" of the Greeks and Trojans, while *Le Petit Parisien* described the "terrible cars as a hurricane of iron and fire." Also on 18 September, *L'Intransigeant*, where an editor must have mis-read the English press, told its readers, with no explanation, that "the nickname for these saurian monsters is 'fank,'" and repeated

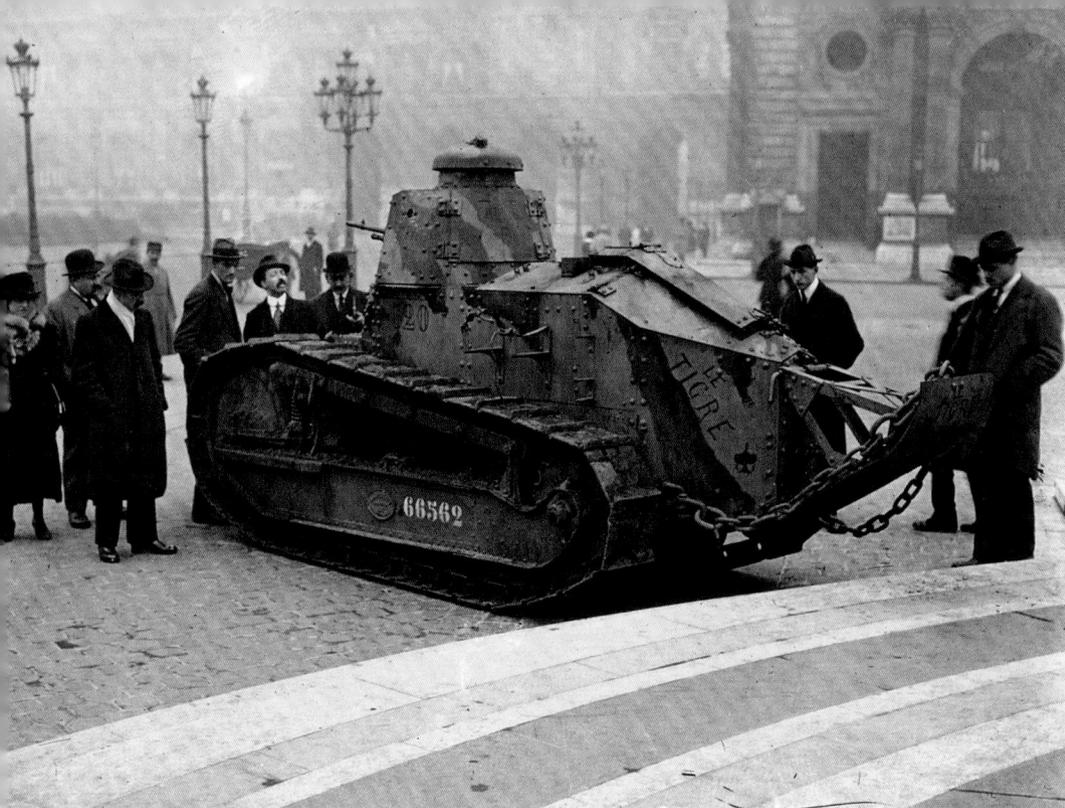

LEFT
"A monster with an impenetrable shell painted like the décor of a Russian ballet..." The Renault tank called "Le Tigre" astonished Parisians in 1918.

it on the 19 September: "On the far right, in the Bouleaux woods where fighting continues, one of our incomparable 'Fanks' capsized."

The next day, the readers of the *Gaulois* were the first French people to learn the real name that the British had given to the armored vehicle in an article translated from the *Daily Mail*: "One corner of the battlefield where the fighting is heaviest happened to be the wood to the North of Bazentin-le-Petit. Here the German troops, supported by fierce artillery fire, were holding their attackers at bay. But the 'Tanks' arrived and joined in the party." However, the name does not seem to have been entirely accepted even in England since Reuters, the London news agency, gave another term, a word used to describe a battleship. This was picked up by several French newspapers: the headline in *Le Petit Parisien* was "'Terrestrial dreadnoughts' terrify the Germans," and *Le Figaro* wrote: "To show you the effectiveness of the new armored cars called 'terrestrial dreadnoughts' we report an incident." On 23 September, the weekly *L'Illustration* again talked about "colossal armored cars, real terrestial 'dreadnoughts' mounted on caterpillar tracks."

However, the word *tank* spread rapidly in the press and therefore among the French public. It appeared, and never disappeared, on 22 September in *Le Figaro* and *Le*

Petit Journal, and on 29 September in *Le Petit Parisien* and *L'Intransigeant.* But why was it called a "tank", a word defined as "reservoir" or "cistern"? Two theories were debated in the press. *L'Illustration* explained it with a simple analogy: the "Tommies" had given the machine this name because it resembled "a huge metal reservoir designed for carrying liquids." *Le Figaro* meanwhile offered another theory on 22 September: "The terrestrial battleship, which has been given the bizarre name 'tank' assisted in the victory. Tank does not mean anything. The word was chosen deliberately because, if intercepted, it provides no information."

Le Figaro's theory was correct. The top-secret project had been developed by naval engineers on the orders of the First Lord of the Admiralty, none other than Winston Churchill, and right from the start was given a name that revealed nothing about it nor aroused too much curiosity. Even when it went into action on the Somme, censorship prevented the press from describing it in any detail and forbade the publication of any drawings or photographs: "the censors have said: 'Shhhh!' And we may not get even an approximate idea of these formidable, highly scientific machines," reported *Le Petit Parisien* on 29 September. The next day, *L'Illustration,* which, as its name suggests, specialized in publishing high-quality drawings and pho-

Le canon de 280 camouflé,
extrait du carnet 2 by André Mare, 1916.
Cubist painters paid homage in their turn
to the "infernal war machine." The links
between jewelry and watchmaking on the
one hand, and the figurative art of Cubism
and the decorative arts on the other are
here becoming more clearly established.

tographs in black-and-white as well as in color, apologized to its readers: "A page of text at the head of this edition must replace one of the engravings that our readers have been awaiting with the most impatient curiosity: it would have presented the mysterious and formidable tanks of the British Army (…) Photographs of the tanks may not be published for some time: at present it would be of even greater interest to German engineers than to the British and French public." It is easy to imagine the wave of curiosity this created about the mysterious tank, fueled by the vivid imagination of excited journalists: "a monster with an impenetrable shell painted in wild colors like the decor of a Russian ballet, a prehistoric monster, a variety of the Ichtyosaur, a gigantic motor carriage fully the equal of a saurian from the ice age." There were also dramatic accounts of what the tank achieved, so for several weeks it must have caused lively debates in cafes and salons. But what did it really look like?

The suspense continued for ten weeks—two weeks after the Battle of the Somme itself had ended. On 2 December, France finally saw what a tank looked like. On the front of *L'Illustration,* a full-page drawing showed an armored tank surging over a mound, revealing its underside between two crawler tracks, and about to mow down a stunned, terrified German soldier. Inside the magazine was a double-page illustration of several tanks attacking together and, most satisfying for its impatient readers, two black-and-white photographs of a tank. "Today", explained the editor, "we are permitted to publish official photographs of the tanks together with equally detailed drawings of their exterior which is already very familiar to the enemy."

The tank's major advantage was its crawler tracks framing the central body and extending in front and behind. They must have impressed Louis Cartier when he opened *L'Illustration* that day together with so many others. (The expensive, elitist magazine then had the largest circulation in its history, printing 400,000 copies). The tracks were like the handles of a stretcher—two extended sides of a square—and, graphically simplified, they would soon become the distinctive, easily recognizable feature of *the Tank,* a new watch. On that day in December 1916, the æsthetic problem posed by strap attachments was finally resolved. The separately designed lugs of the *Santos* disappeared: nothing now separated them, structurally or graphically, from the case. Both tanks, weapon and watch, were distinguished from birth by a similar special shape and by a shared name that had just been invented. Each, in their very different ways, became a symbol of a new era.

THE TRACKS WERE LIKE THE HANDLES OF A STRETCHER— TWO EXTENDED SIDES OF A SQUARE—AND, GRAPHICALLY SIMPLIFIED, THEY WOULD SOON BECOME THE DISTINCTIVE, EASILY RECOGNIZABLE FEATURE OF THE *TANK*, A NEW WATCH.

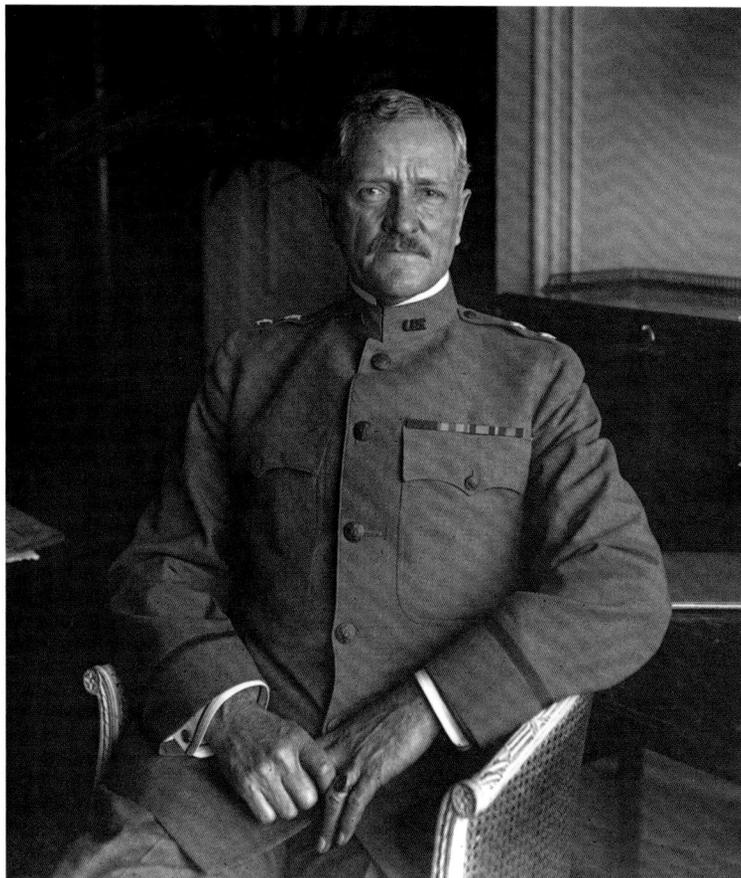

LEFT

According to the oral tradition within the House, General John Pershing, commanding officer of the American Expeditionary Force in Europe during the Great War, was presented with a Cartier *Tank* watch. Its form, probably designed in December 1916, was inspired by the armored tanks that had made their first appearance in the war.

FACING PAGE

Tank Wristwatch

CARTIER PARIS, 1920

Marked on the dial: *Cartier*

Case of polished and satin-finish gold, *brancards* of polished and satin-finish platinum. Beaded winding crown capped with a sapphire cabochon. Leather strap, pin buckle. Square grained-silver dial with Roman numerals around a railroad minute track. Apple-shaped hands of blued steel.

❖ *Round LeCoultre caliber 119 movement, Côtes de Genève decoration, rhodium-plated, 8 adjustments, 19 jewels, Swiss lever escapement, bimetallic balance, Breguet balance spring.*

WCL 115 A20

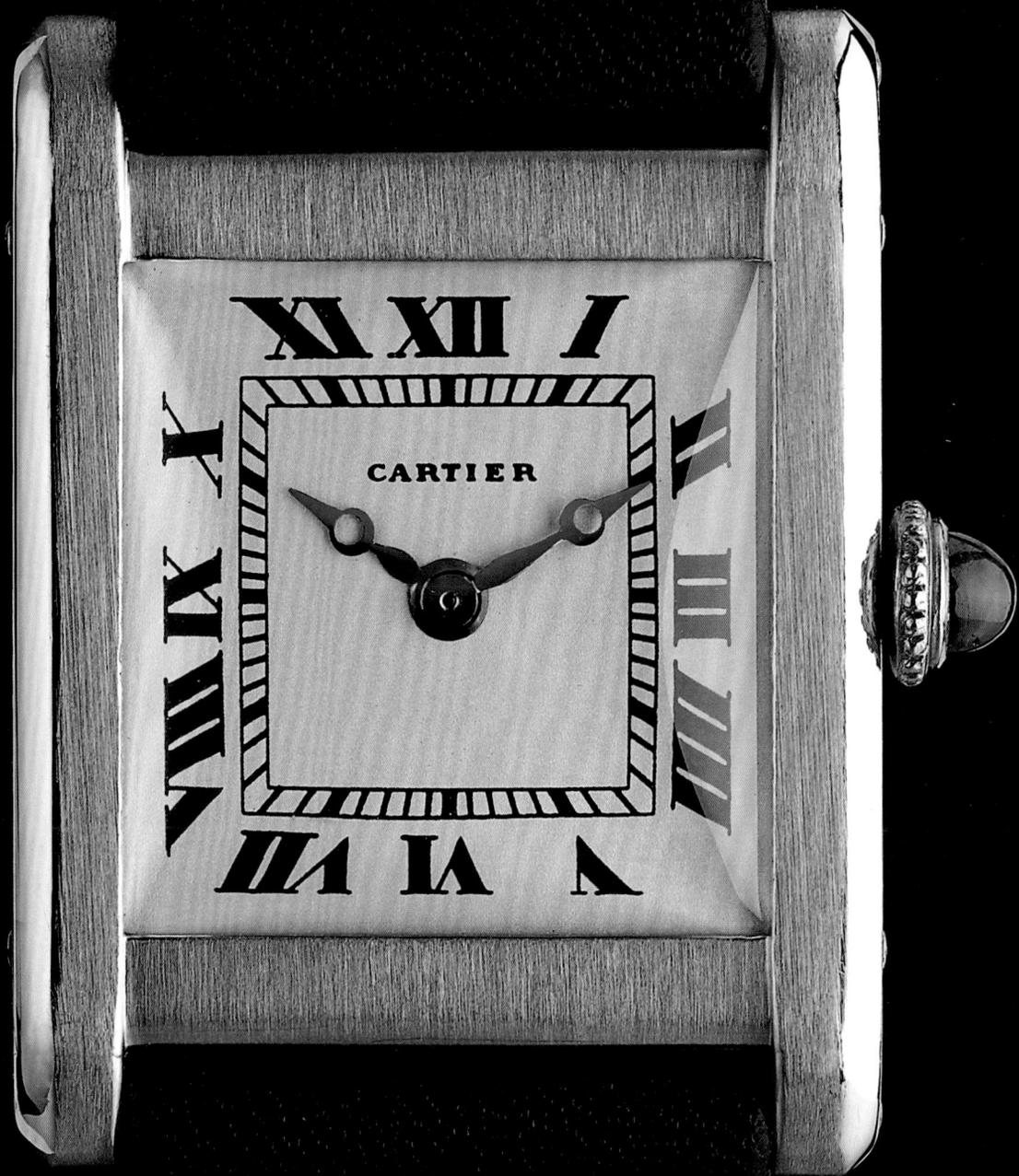

1915 Novembre 29	6907	Reprise W.B. Leeds Ex: 4363 - S.C 143847 Jaeger 8575	1 Montre médaillon cristal, deux entg en roses. Bélière 2 rangs de roses, fond platine, entg roses, 2 navelots roses s/ le four (voir détail au 4363) — ~~Jaeger 23 nov 14. Fait chaine corde finition culots~~ ~~platine av à refer~~ = 5 + Reportée aux colliers 3885 14/1/18	2285 50
Décembre 1ᵉʳ Rep. 6939	6908	J. 14897	1 Bracelet-montre tortue platine 9 lignes lunette 1 rang onyx calibré et 1 rang de roses attachés chatons brillᵗˢ et ligne roses, S/moire fermoir rectangle roses centre onyx plat, boucle déployante or 1200 Ecrin 10	1210
2	6909	Reprise Mᵐᵉ M. Mougeot c 1/2061 - Ex. 6827 Jaeger 16112	1 Bracelet-montre "santos" platine 10 lignes, remontoir saph. cal. bracelet cuir fermoir boucle rigide, boucle déployante or } IFE } Ecrin C5 }	559
	6910	J. 14279	1 Bracelet-montre "baignoire 8 lignes lunette roses, attaches roses en onyx rectangles, s/moire, fermoir rectangle roses, boucle déployante or, mre } platine = 1680 } Ecrin 10 }	1690
	6911	J. 14263	1 Montre-pendant rectangle, décor peau de tigre pavage brillᵗˢ et onyx a bᵗˢ lignes 1 anneau pavé même décor, attache forme T en brillants [3e rectificative à 3725] Grande moire, coulant et broche onyx et brillants = 3780 } Ecrin 20 }	3745 3860
	6912	J. 14924	1 Bracelet-montre carré, 9 lignes lunette 2 rangs de roses et 1 onyx, s/ moire, fermoir rectangle roses et onyx calibré, boucle déployante or = 1325 [2e rectificative à 1110] } Ecrin - 10 }	1110 1335

Just possibly, a few families in the United States today own a treasure without realising its importance: it could be one of the very first watches produced according to the sketch drawn by Louis Cartier, probably in December 1916. There is a story at Cartier that, just after the victory in November 1918, several examples of the first *Tank* were presented to General Pershing, who led the American Expeditionary Force in Europe, and to some of his officers. Legend or fact? Unfortunately, there is no trace of these pieces in the archives. If they did exist, they were probably made as prototypes with the decision to start real production taken some time later.

It was not until one year after the war that the watch was put on the market, naturally called a *Tank* because of its similarity to the plan view of the first British machines. On November 15, 1919, four men's watches called *Tank* were mentioned for the first time in the Cartier stock register. Two more appear shortly afterwards, on 23 and 26 December. According to the register, the six watches were all sold on January 17, 1920. The average time that the new model of Cartier wristwatch remained in the window was three weeks. What's more, on November 12, 1919, a few days before the real *Tank* appeared, a unique example of a lady's jewelry watch was put on sale. It was not described as a *Tank*,—Louis Cartier probably wanted to reserve that

name for men's watches—and it had a smaller caliber than the six others: 8 lines instead of 9 (the line was an old measurement unit equal to 2.255 millimeters [$^1/_{16}$ inch]). But it did have the style codes of the new Cartier watches and carried the stamp of his personality. The strict right angles of the vertical lugs prolonged to form the attachments, the continuous flow of the case, and the perfect integration of the strap all strongly implied that this watch was a member of the *Tank* family. This is confirmed by an entry in the stock register dated May 31, 1920, recording an almost identical model under the heading "*Tank*". It had an 8-line caliber and a platinum case, decorated on each of its vertical sides by a row of rose-cut diamonds. Interestingly, within six months Louis Cartier had changed his mind and decided that "Tank", despite its military connotation, could be the name of a woman's watch. Since the end of the war the status of women had changed radically and the notion of their "eternal femininity" was fading. Cartier was primarily a jeweler and, as a general rule, he never produced a man's watch without immediately following it with a version for women.

The jewelry model aside, the first six watches were fitted with a Jaeger 9-line caliber. This means they were small watches by today's standards. Their most striking features were the flat lugs, with sharp edges and the white silver dial.

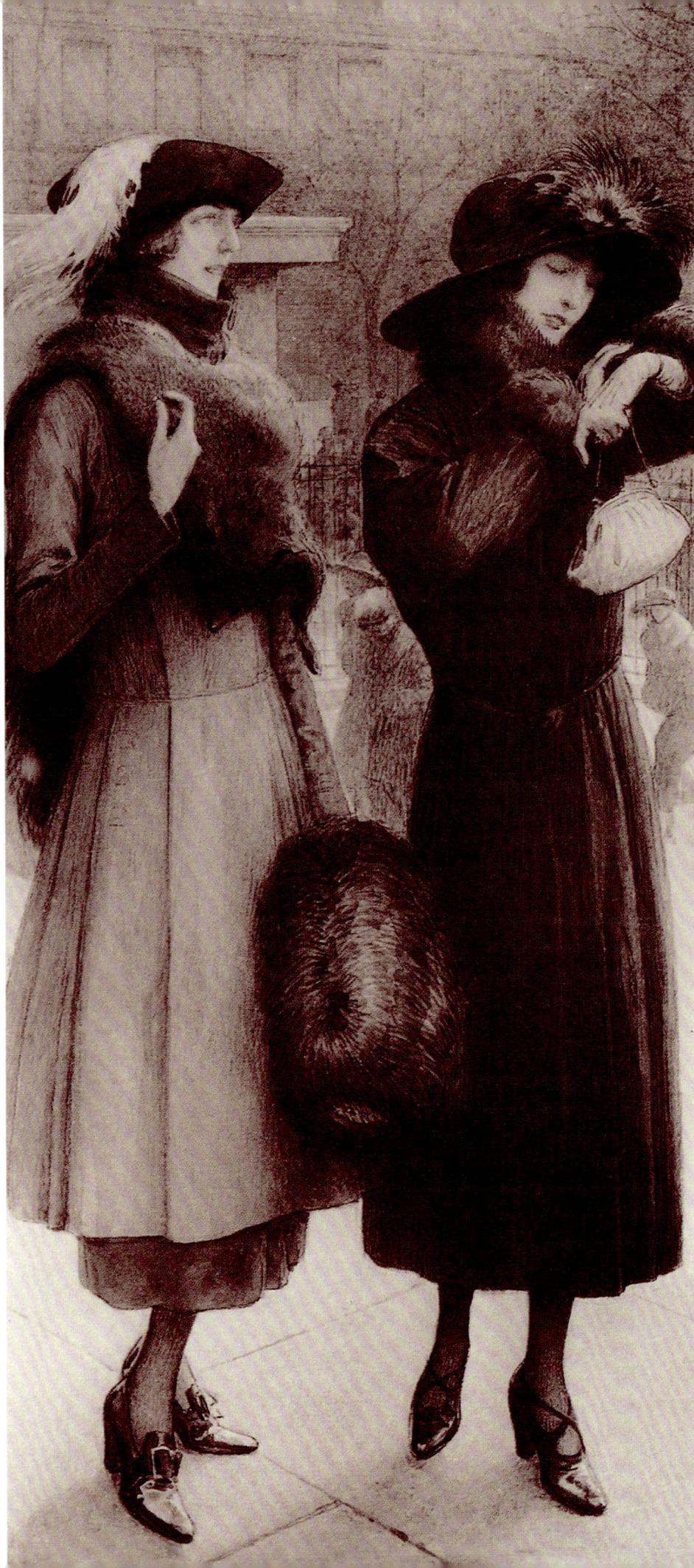

LEFT

"How today's Parisienne looks at her watch!"—a headline in the fashion column of *L'Illustration* of December 17, 1921. Watches, now increasingly worn on the wrist, have become desirable objects in their own right, adopted by women as well as men.

FACING PAGE

Tank Wristwatch

CARTIER PARIS, 1921

Marked on the dial: *Cartier*

Case of polished and satin-finish platinum, *brancards* a row of millegrain-set rose-cut diamonds. Beaded winding crown. Satin strap, pin buckle. Square cream dial with Roman numerals around a railroad minute track. Apple-shaped hands of blued steel.

❖ *Round LeCoultre caliber 8HPVMJ movement, Côtes de Genève decoration, rhodium-plated, 8 adjustments, 19 jewels, Swiss lever escapement, bimetallic balance, Breguet balance spring.*
WCL 11 A21

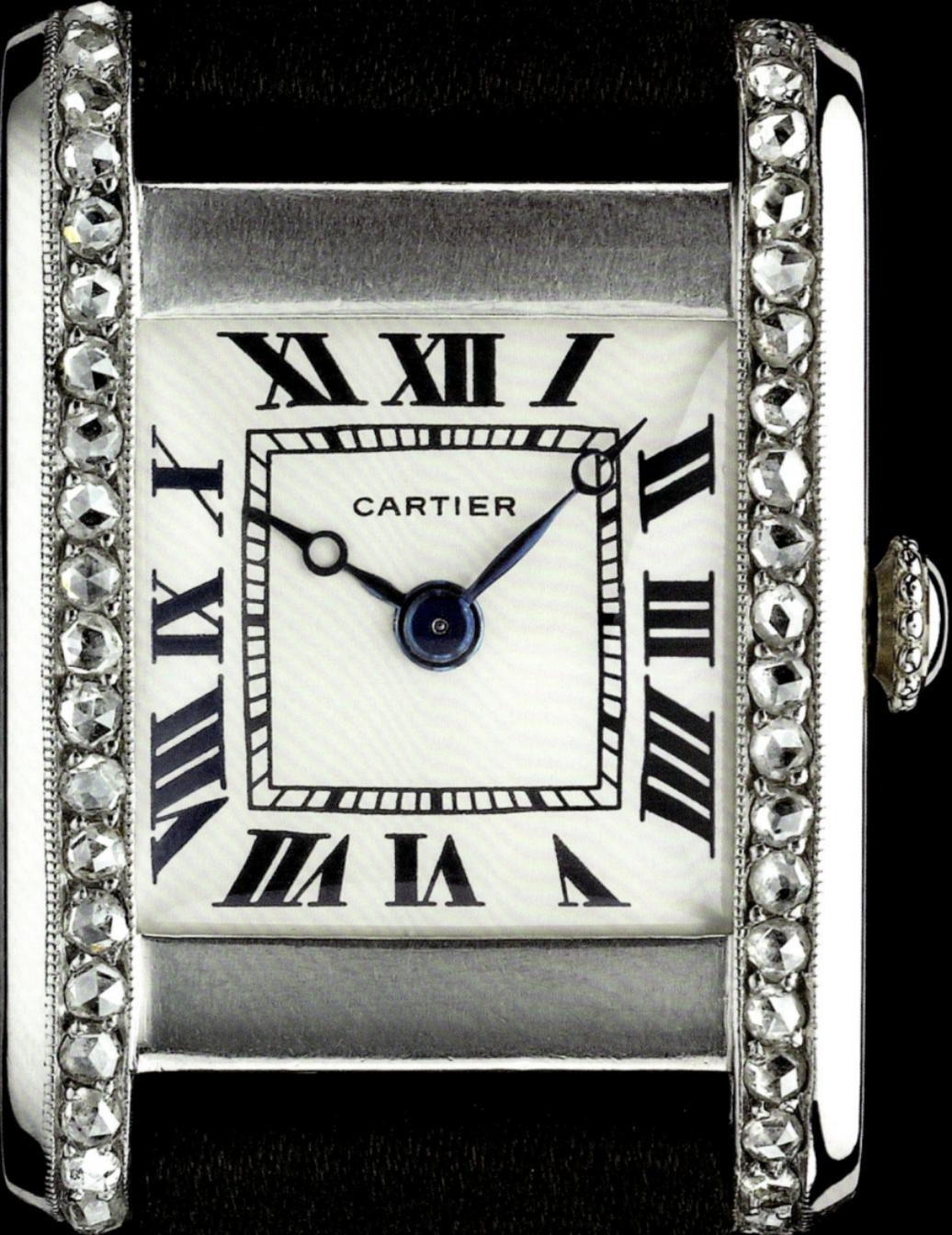

The *Tank* watch's design codes stem from
the world of Cartier jewelry and watchmaking
traditions: the radial Roman numerals, the railroad
minute track minute circle, the *brancards* (lugs)
and the beaded crown set with a sapphire cabochon.
These codes are beautifully illustrated on
the classic *Tank L.C.* of 1944 (*see p. 44*).

The sheer simplicity of the case design, highlighted by the lugs protruding beyond the square was enough to make the first *Tank* a completely new and revolutionary watch. But, as we have seen, it only arrived after much reflection on the integration of the lugs—a problem that it solved once and for all. It also adopted an entire style code that Cartier had gradually established and that had made his watches so successful, especially the highly prized pre-war wristwatches: the *Tonneau, Santos* and *Tortue*. There were several elements that Cartier used regularly: radial Roman numerals, apple-shaped hands in blued steel that first appeared in the company in the nineteenth century, and a "railroad" minute track minute circle. However, only four of the first seven models were given the traditional Roman numerals: the other three had Arabic numerals, two inclined and one straight.

Two other elements of the watch design code came from Cartier's jewelry world. In chronological order, the first was the use of platinum. In three of the first *Tank*s, including the jewelry version, the case was made in this precious metal. Two others combined a platinum case with a gold case back and the remaining two were entirely in gold. At the turn of the century, Louis Cartier was the first to create jewelry in platinum, although the metal had been used in the company since the 1860s. Diamond mounts in platinum can

be extremely fine and they added sparkle and lightness to his "garland-style" jewelry. In 1899, Cartier's first platinum watch, a pocket watch in the form of a heart paved with diamonds, was sold to the American banker and businessman, John Pierpont Morgan. The metal then became a permanent feature of Cartier watchmaking, used in pocket-watch cases and bracelets. The *Tonneau* watch, introduced in 1906, was the first wristwatch ever made in platinum. Its clearly metallic nature emphasized, more than gold could ever do, the essential modernity of the new watch. After the *Tonneau* and before the *Tank*, the *Santos* and the *Tortue* also announced their modernity with their platinum cases.

A second purely jewelry element in the design code of the first *Tank*s had appeared in 1906, again in a series of platinum wristwatches: a fine or precious stone, cut as a cabochon, set on the beaded crown. The cabochon had been decorating Cartier creations for several years, particularly writing instruments. One example was a mechanical pencil in matt gold, crowned by a sapphire cabochon, that was on sale from 1899 and was acquired by Santos Dumont. The cabochon would soon become a distinctive symbol of Cartier pens just as much as wristwatches.

But on the watches it became almost a manifesto. Cartier had to reinvent the traditionally decorated parts—the dial,

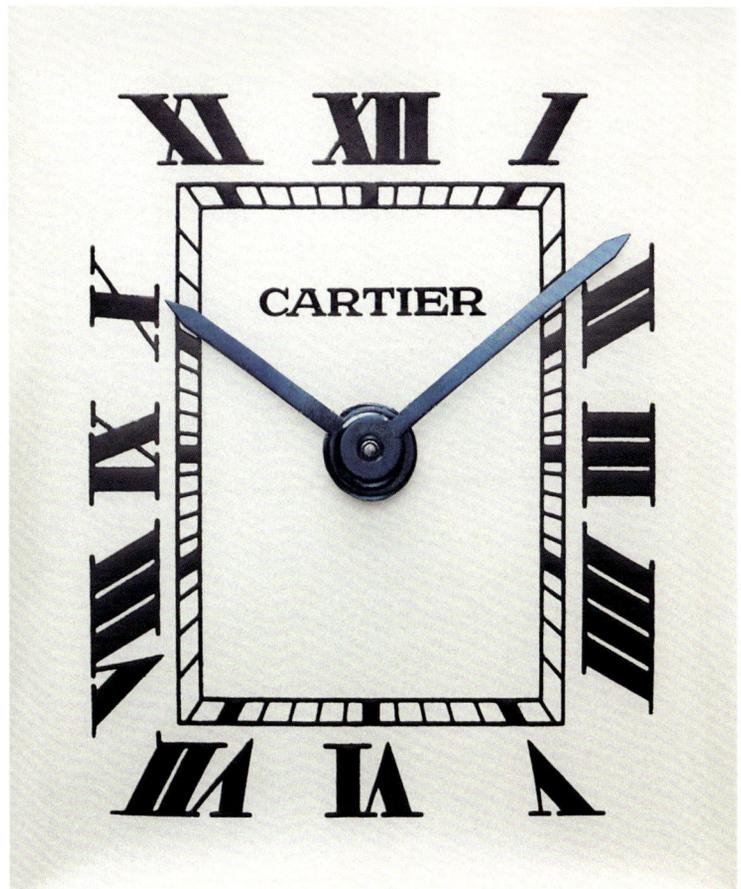

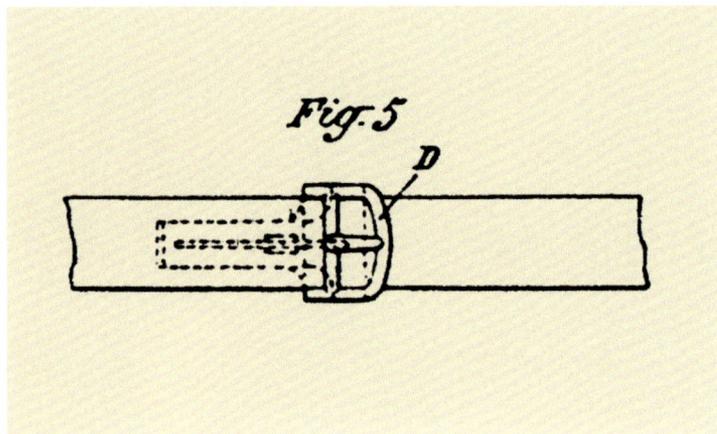

Fig. 5

the bezel and the case—as well as the purely technical parts that had often been neglected: the crown and, on wristwatches, the lugs. The year 1906 also saw the arrival of the first round wristwatches in which all four lugs and the crown were enhanced by a cabochon. By drawing attention to the only elements that were unique to a wristwatch, Cartier was showing again, two years after the *Tonneau*, the importance he gave to this new kind of watch and his faith in its future. As we have seen, he never stopped searching for æsthetic solutions to the problem of the lugs and, less than ten years later, his thinking had led, in several stages, to the radical design of the *Tank*. It is interesting that while he tried to achieve modern simplicity in the case, he also added a touch of jewelry as a personal signature: a rather ancient ornament, the cabochon, on the crown. But far from undermining the modernity of the watch, it acts as a reminder that a Cartier wristwatch, however it is worn and in whatever mood, is a very beautiful piece of jewelry that measures the passage of time. The cabochon on the crown would remain one of the distinguishing features of the various models (with a few exceptions) in the newborn *Tank* family.

The last jewelry element in the design code of the first *Tanks* concerned the strap, which was leather in those first models (black watered silk in the jewelry version.) The fold-ing buckle of the strap was a system invented by Edmond Jaeger. It appeared for the first time at Cartier in 1910 on a precious watch set with rose-cut diamonds and five cabochons (on the lugs and the crown). The system was used the following year on the *Santos*. In 1913 a member of Louis Cartier's watchmaking staff, Joseph Vergely, found its definitive form: a "D-shape". Replacing the classic ardillon buckle, the folding buckle was a truly revolutionary system. It radically improved the appearance of the strap by making the clasp invisible, and prevented the watch from falling from the wrist. The attention that Cartier and Jaeger paid to this detail, and the modernity of the eventual solution, show the clear-mindedness with which they developed the wristwatch, examining every element of what had originally been conceived as a new type of jewel.

Jaeger received the patent for the folding buckle in 1910, and signed a contract that reserved it exclusively for Cartier products. It is reasonable to assume that this invention, like so many others patented by Jaeger and reserved for Cartier, was the result of their joint research. A letter in the company archives, undated and unsigned but certainly in Louis Cartier's handwriting, supports this idea. It authorized Jaeger to register patents in his own name and at his expense. We do not know which patents were concerned but

The folding buckle was a truly revolutionary system. It radically improved the appearance of the strap by making the clasp invisible, and prevented the watch from falling from the wrist. It was used on, among others, the *Tank Cintrée* Wristwatch, Cartier Paris, 1936 (*see page 48*).

BELOW, RIGHT
Sheet of drawings for the patent concerning a type of fastening for straps, watch chains, etc. Cartier Archives, Paris.

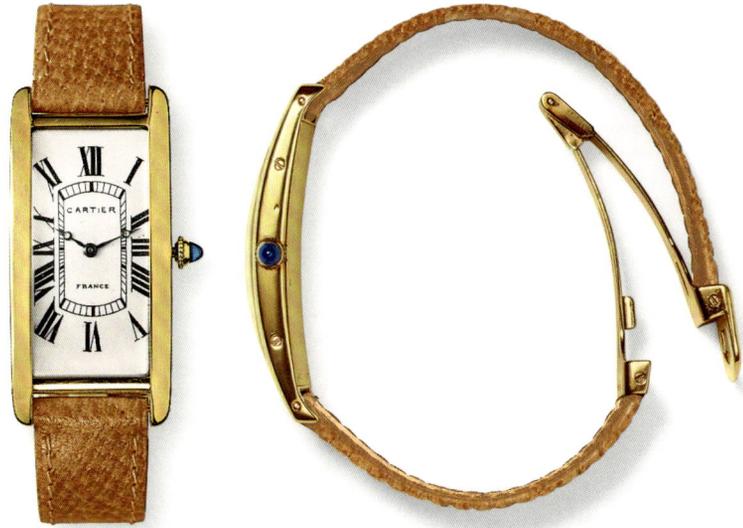

RÉPUBLIQUE FRANÇAISE.

OFFICE NATIONAL DE LA PROPRIÉTÉ INDUSTRIELLE.

BREVET D'INVENTION.

XVII. — Arts industriels.
5. — Bijouterie.

N° 409.891

Genre de fermeture pour bracelets, porte-montre ou autres.

M. Edmond JAEGER résidant en France (Seine).

Demandé le 2 décembre 1909.
Délivré le 28 février 1910. — Publié le 3 mai 1910.

La présente invention a pour objet un genre de fermeture se rapportant à cette catégorie de bracelets qui ne peuvent présenter aucune solution de continuité et dont le diamètre, assez grand pour permettre l'introduction de la main au travers, est ensuite réduit pour assurer la position du bracelet sur le poignet.

On conçoit tout l'avantage que présentent ces bracelets qui, ne présentant jamais de solution de continuité, ne peuvent tomber à la suite d'une ouverture accidentelle.

Ces bracelets, sont utilisés en particulier comme porte-montre et aussi comme bracelets ordinaires.

Le genre de fermeture qui fait l'objet de la présente invention, se caractérise par ce fait que le resserrement du bracelet sur le poignet a lieu par le simple renversement soit de deux pattes métalliques l'une sur l'autre, soit d'une patte sur le corps du bracelet lui-même, de telle sorte que la réduction de la longueur du bracelet est justement égale au double de la longueur de l'une des deux pattes dans le premier cas et de la patte unique dans le deuxième. On conçoit l'avantage de ce système qui assure une mise en place très rapide du bracelet.

Ce dispositif sera du reste bien compris par la description qui va suivre en regard du dessin annexé sur lequel :

La fig. 1 représente le bracelet déployé vu en élévation ;

La fig. 2, une vue en plan de la fig. 1;

La fig. 3, une vue en élévation du bracelet tel qu'il serait une fois assujetti sur le poignet ;

La fig. 4, une vue en plan de la fig. 3;

Les fig. 5 et 6, les vues en élévation et en plan d'une variante d'exécution de ce bracelet déployé, et

Les fig. 7 et 8, les vues en élévation et en plan de ce même bracelet lorsqu'il est assujetti sur le poignet.

Le système de fermeture représenté sur les fig. 1, 2, 3 et 4 comporte une patte en métal A de forme légèrement incurvée, articulée par une charnière B sur une deuxième patte métallique de courbure semblable C qui comporte elle-même une première partie pleine *a* puis une partie élargie et évidée *b*, en forme de cadre rectangulaire, dont les branches allongées sont réunies par une première barrette transversale *c* et par une deuxième barrette voisine de la première *d*, interrompue en son milieu sur un intervalle *e*. La pièce A porte d'autre part à son extrémité et sur le milieu de sa largeur une saillie *f* et trois trous *g*. Le bracelet proprement dit D, en étoffe rigide ou élastique, cuir, métal, etc., est relié d'une part à la pièce A, par exemple par des points d'attache passant dans les trous *g*, et à la patte C, par l'intermédiaire de la barrette *c*. Sur les fig. 1, 2, 3 et 4, le bracelet est supposé être un porte-montre, la

Prix du fascicule : 1 franc.

CARTIER

FACING PAGE
Positioning sketches for the railroad
minute track circle on a *Tank* watch, 1930.
Cartier Archives, London.

the simplicity of the letter suggests that this was a common arrangement at the time: two companies working together to develop new technical solutions. Although the patents were reserved for use with Cartier products, they were registered in Jaeger's name, perhaps to guarantee him larger profits than the modest amounts agreed in the 1907 contract.

So, just as the reliability of the wristwatch in general benefited from several decades of technical progress in pocket watches, the *Tank* that was launched in 1919 would not have existed without the watchmaking and jewelry ideas that Louis Cartier had been applying in his watches for 20 years, in collaboration with Edmond Jaeger. It marked a major milestone in Cartier watchmaking and in watchmaking as a whole—because the total integration of the lugs, called *brancards* in French, made it *the* quintessential wristwatch. It was also important because the concept that it introduced has allowed multiple versions to be developed—even today—without affecting its fundamental consistency or its unique identity—that of a watchmaking icon. ∎

The Golden Age

Chapter *II*

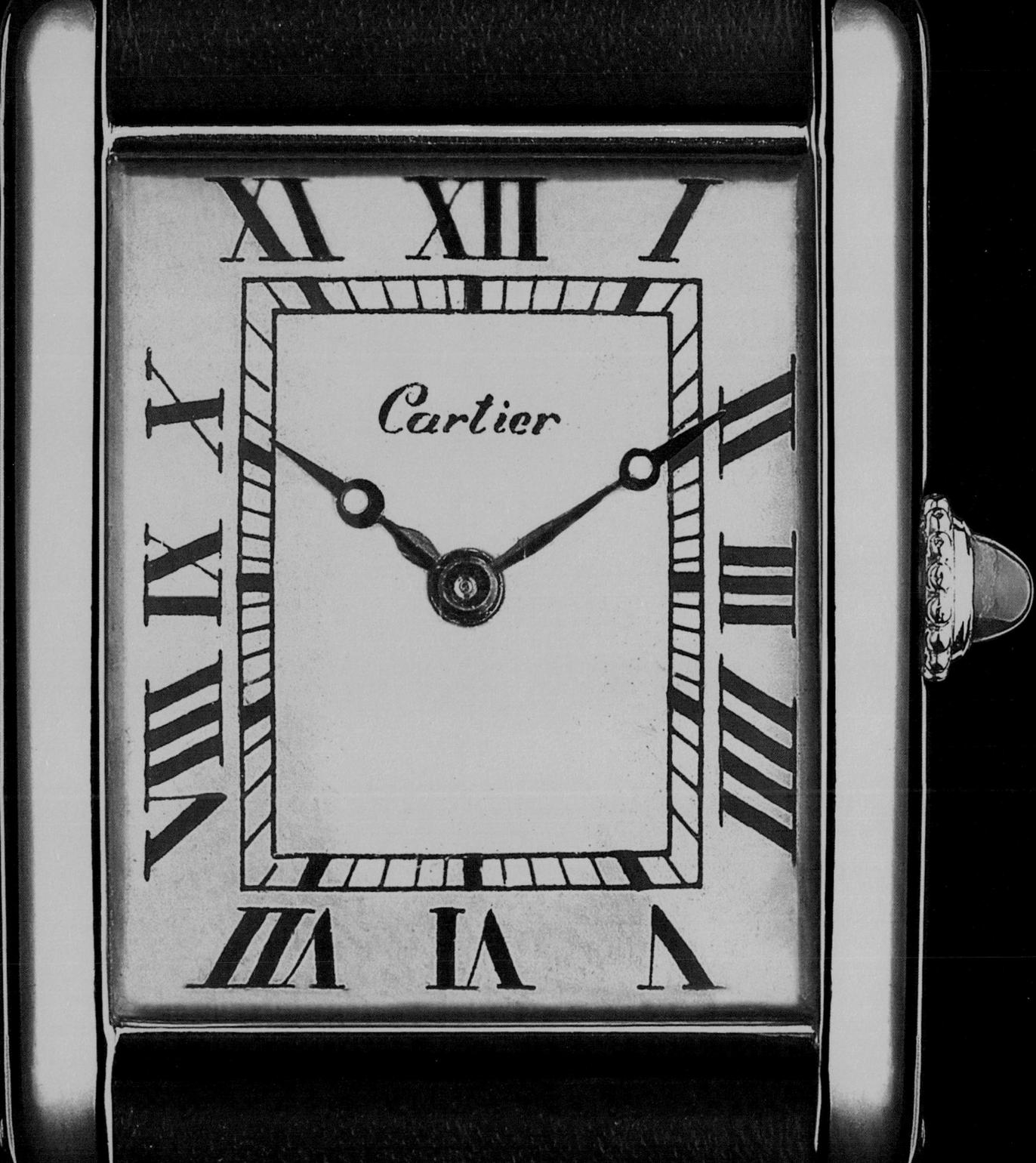

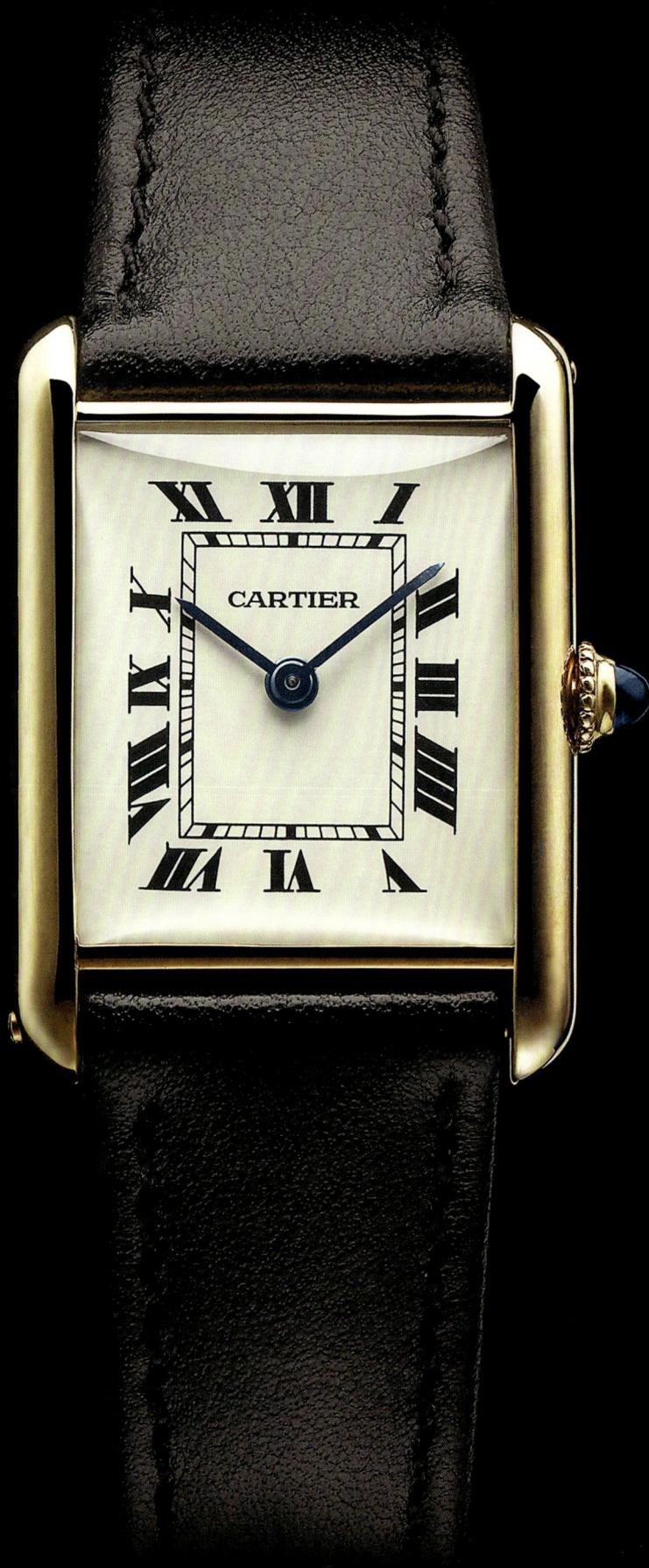

PAGE 43
Tank L.C. Wristwatch,
Cartier, 1925 (*see page 55*).

FACING PAGE
Tank *L.C.* Wristwatch
CARTIER PARIS, 1944

Marked on the dial: *Cartier*

Case of polished and satin-finish gold, *brancards* of polished gold. Beaded winding crown capped with a sapphire cabochon. Leather strap, pin buckle. Restored rectangular white dial with Roman numerals around a railroad minute track. Baton hands of blued steel.

❖ *Round LeCoultre caliber 428–2 movement, rhodium-plated, 15 jewels, Swiss lever escapement, monometallic balance, flat balance spring.*
WCL 119 A44

For the ancient Greeks, the golden age of humanity began just after Man was created. And so it was for the *Tank*—its golden age started just after the first six models were launched. As we have seen, the stock register shows they were all sold on January 17, 1920. The average time that this new Cartier wristwatch model stayed in the window was three weeks. For a distinctly avant-garde watch to be sold in this amount of time, without specific advertising, can be considered a success. The *Tank* was certainly a success, right from the start. From the 1920s onwards it was enormously popular, showing beyond doubt that the company's design developments perfectly reflected public taste. It captured the spirit of the times, and in fact, it was years ahead, since it had been conceived during the war. Although tragic, the war had accelerated history with new technology and ideas, and as peace returned, new hope emerged. While both sides counted their dead and Europe discovered its loss of ten million young men—a selective massacre unparalleled in human history—optimism returned in politics and, to some extent, in the cultural mood.

The Twenties were years of real movement. But this word no longer implied the dramatic, morbid analysis that had characterized European art, at least from 1890 until the war. The florid scrolls of Art Nouveau gave way to the undulating hallucinations of the Futurists, the dizzying colors of Les Fauves and the methodical destructuring of space by the Cubists whose agitated surfaces seemed to tear themselves open in order to create new volumes. From that point on, as history appeared to stabilize, so did forms. Previously tortuous and problematic, the modernist movement became direct and extroverted. In reality, the trend towards uniform linear form did more than the mechanics of art to drive changes in society, technology and taste. With its youthful enthusiasm and vitality, modernity built up solid support that was able to develop the movement with unhesitating confidence. Indeed, geometry is the most reassuring discipline that man has ever developed, but it needed peace to return between nations and in the minds of creative artists, followed by several years of preparation, before the Modern style finally triumphed in Paris in 1925. From April to October, spread over 20 hectares along the Seine, the International Exhibition of Modern Decorative and Industrial Arts celebrated what soon came to be called "Art Déco." The name covered a number of trends and schools but all were dedicated to pure, elegant form. There was also a keen fascination with the designs of other civilizations: Islamic and Asian, or African with "l'art nègre." With the increasing freedom of women, and the growing influence of travel and sport, the modern spirit

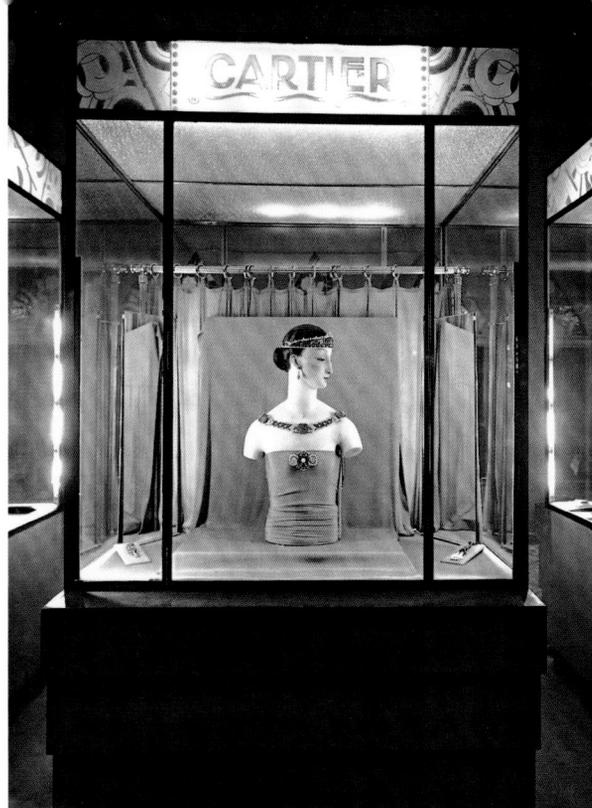

LEFT

At the International Exhibition of the Modern
Decorative and Industrial Arts in 1925, Cartier
exhibited the *Berenice* parure in the middle
of the Pavillon de l'Élégance. Cartier Archives, Paris.

FACING PAGE

For his last appearance on the silver screen,
in the *The Son of the Sheikh* in 1926, Rudolph Valentino
demanded of the director George Fitzmaurice that
he be allowed to wear his *Tank* during filming.
It is thus to be found in many scenes of this exotic
melodrama of love.

of linearity and functionalism in the arts invaded fashion. A section of the exhibition entitled "Fashion and Clothing Accessories" in the Pavilion of Elegance was directed by a client and friend of Louis Cartier, Jeanne Lanvin. It was here, rather than alongside other jewelers, that Cartier presented 150 pieces, of which only 15 were watches. Curiously, these were not the most modern, least ornamental watches, such as the Santos and the *Tank*. No doubt Cartier wanted to focus attention on his jewelry pieces that were so eagerly awaited by the public and those watches were distinctly different from his traditional style.

Unlike the ornamentation and poetry of his jewelry, the *Tank* watch perfectly met a double need: the pure line of its *brancards* gave the case a new balance that could integrate the dynamics of the movement. The form of the *brancards* and the solidity of the case exactly matched the dynamic potential of the watch, with the strap held between the two vertically projecting *brancards*, of equal length. Its brilliant case, so smooth and simple, seemed ready to swallow up the asphalt strip of the road.

In the 1920s the *Tank* was such a success that it became the iconic watch that the aristocracy, the super-rich and the stars of the golden world of entertainment were all clamoring to possess. Rudolf Valentino, in his last film, *Son of the*

Sheik in 1926, persuaded the director George Fitzmaurice to allow him to wear his *Tank* in every scene. But the great success of the model did not end Cartier's fertile development work on the shape of the wristwatch. The number of models in the *Tank* collection began to increase right from the start and in just a few years there was a whole family tree of versions and branches.

❖

The *Tank* models of 1919, except for the jewelry version, all had a 9-line caliber, a thin square case, flat *brancards* with crisp edges, a white silver dial, a "railroad minute track" minute circle and a sapphire cabochon set in the crown. Before long, this first *Tank* (later called the *Tank Normale*) was offered in different sizes, either smaller with 7- and 8-line movements, or larger with a 10-line movement. These variations reflected the development work carried out on the style of the watch and its æsthetic impact on the wrist—making it more or less powerful, more or less discreet. With these different sizes, the choice of Roman or Arabic numerals and the option of platinum or gold, the *Tank* already offered a considerable range of versions in 1920. They increased in the following years, particularly with the arrival of different woven metal bracelets. These either strengthened or

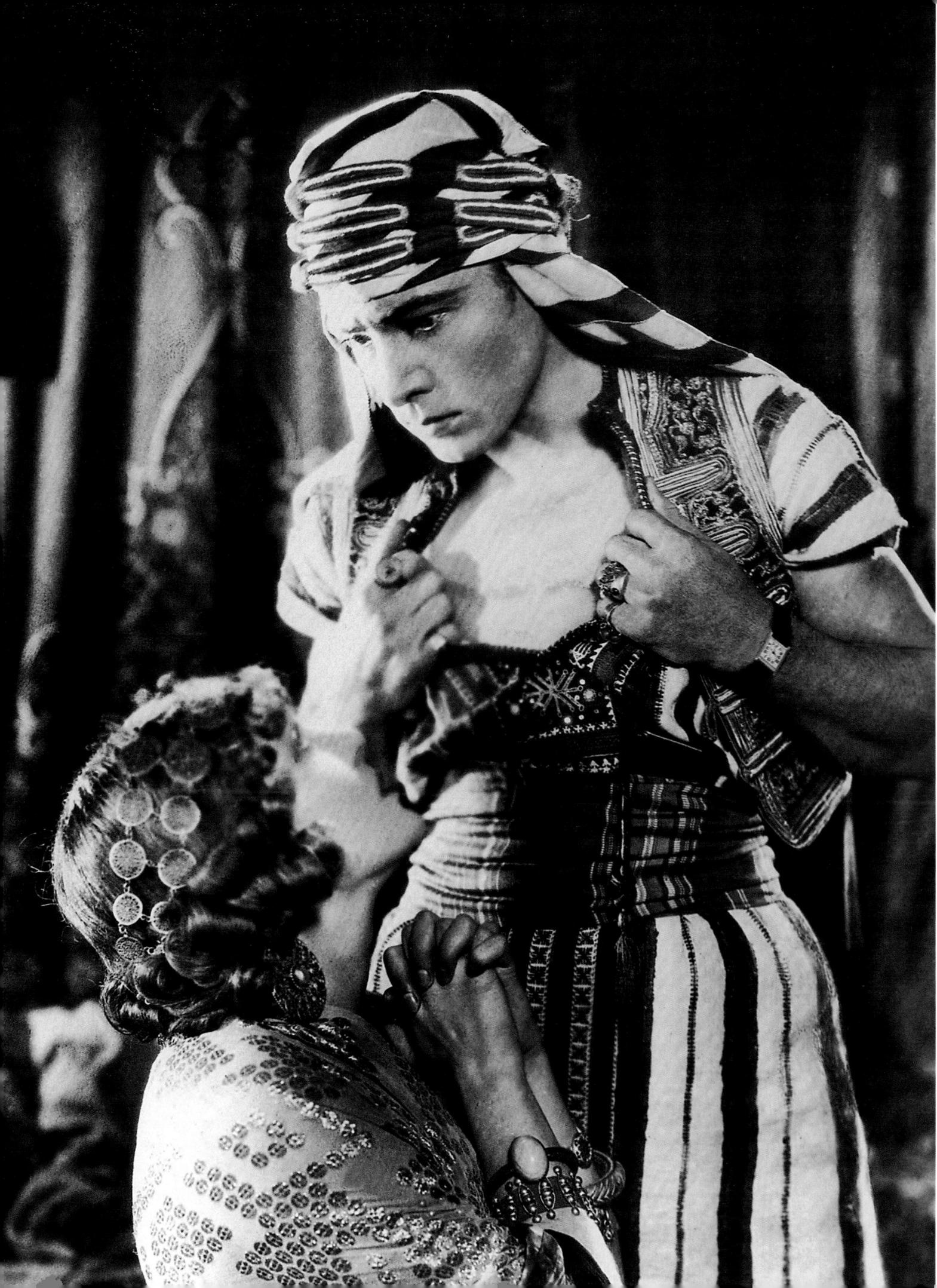

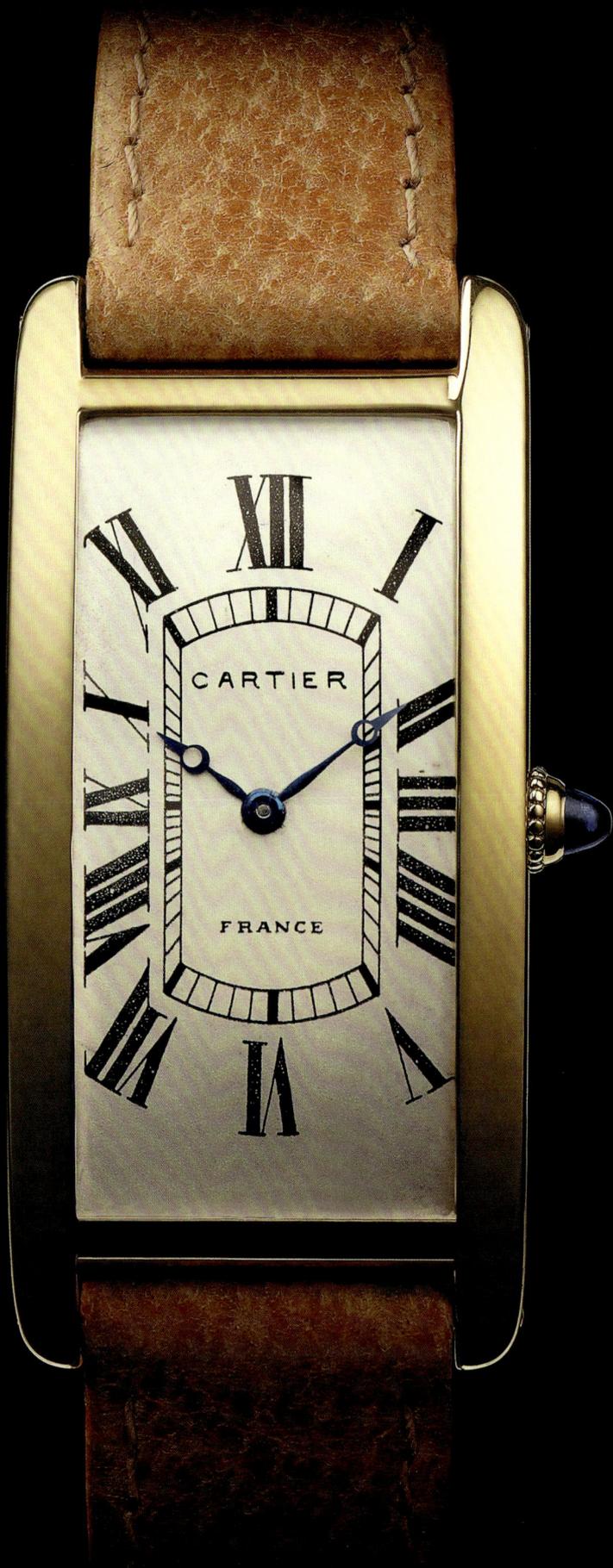

Tank Cintrée Wristwatch

CARTIER PARIS, 1936

Marked on the dial: *Cartier, France*

Curved (*cintré*) case of polished and satin-finish gold, *brancards* of polished gold. Beaded winding crown capped with a sapphire cabochon. Leather strap, deployant buckle of yellow and pink gold. Curved dial of grained silver with Roman numerals around a railroad minute track. Apple-shaped hands of blued steel.

❖ *Round LeCoultre caliber 122 movement, Côtes de Genève decoration, rhodium-plated, 2 adjustments, 18 jewels, Swiss lever escapement, bimetallic balance, flat balance spring.*
WCL 39 A36

Drawing for a *Tank Cintrée* wristwatch made for Princess Mdivani, born Louise Van Alen, 1935. Cartier Archives, New York.

reduced the impact of the geometric shape, modifying its expressive form into a feminine or a masculine object.

Over successive decades, Cartier continued to develop and refine an increasing number of families and versions of the *Tank*. But this was not simply the result of its commercial success. The *Tank* of 1919 already showed the company's interest in trying new materials and new graphics. Fifteen years of uninterrupted work since the first *Santos* had produced remarkably innovative and beautifully balanced results on the æsthetic level, but development still continued. In 1919, the wristwatch was still very new, although the war had certainly given it a boost by highlighting its modernity and its practical advantages. The tastes and habits of the wristwatch market were still not clearly defined and it was a long way from becoming a popular concept. So while the design work was almost complete as regards the shape of the case and the integration of the lugs, development still continued on materials, graphics and other details: the style, profile and shape of the lugs.

The 1919 shape was now precisely defined with variations only in its details. The first major modification, in 1921, gave birth to the second family of *Tank* Watches: the *Tank Cintrée* (The *Curved Tank*) distinguished, as its name suggests, by the curvature of its case.

Before describing this new *Tank* in detail, it may be useful to clarify a point of French grammar that had a practical effect. In French the name "Tank" takes the feminine article *la* as a watch and not the masculine *le* as an assault vehicle. Consequently, its adjectives all have a feminine ending. However, in the company's terminology the *Tank*'s gender was far from clear. In the stock registers of the time, there are mentions of "un *Tank Cintré*" and other models with masculine declensions. There was similar confusion at the start of the 1920s between "*le* bracelet-montre"—a jewelry bracelet incorporating a watch that had existed since the eighteenth century—and "*la* montre-bracelet" as the new object was tending to be called. It is quite likely that, after the war, the word for the terrible machine that gave the watch its name was still highly charged.

From the first appearance of the wristwatch at the start of the twentieth century, development work in the areas of design, technology and function was focused on the curvature of the case to follow the natural shape of the wrist. In fact, the curved *Tank* was a descendant of the *Tonneau* introduced by Cartier in 1906. The barrel-shaped design appeared in watchmaking at the start of the twentieth century, representing a radical departure from the pocket watch. Its innovative design, the fusion of a rectangle and an oval,

Tank Cintrée Wristwatch

CARTIER PARIS, 1924

Marked on the dial: *Cartier*

Curved case of polished and satin-finish platinum, *brancards* of polished platinum, back of polished gold. Beaded winding crown capped with a sapphire cabochon. Leather strap, deployant buckle of platinum and pink gold. Curved dial of grained silver with Roman numerals around a railroad minute track. Apple-shaped hands of blued steel.

❖ *Round LeCoultre caliber 123 movement, Côtes de Genève decoration, rhodium-plated, 8 adjustments, 18 jewels, Swiss lever escapement, bimetallic balance, Breguet balance spring.*
WCL 34 A24

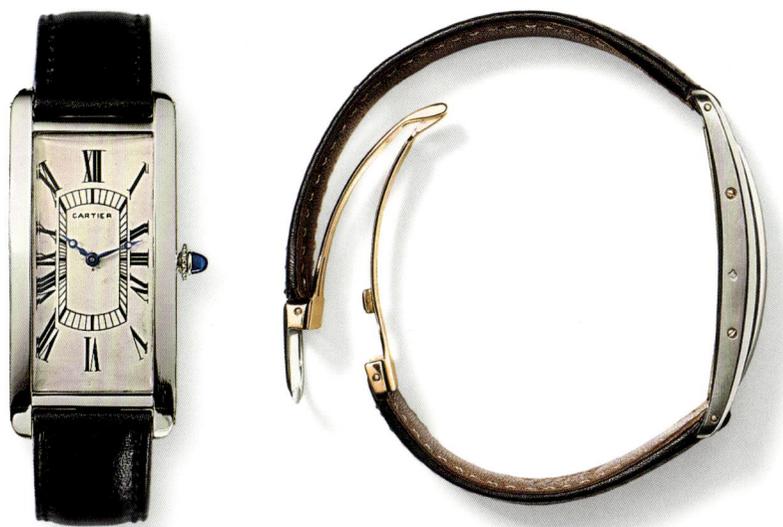

and the idea of curvature, sprang from the decision to create an unusual shape that would be reserved for the wristwatch. The curvature of the case to fit the wrist was the first important structural modification. This model, described in Cartier texts as "hugging the camber of the arm," was probably perfected in collaboration with Edmond Jaeger.

Later, the evolution of the wristwatch showed that a thin case could hug the wrist with no problem, to the point where this became the predominant shape. Customers' eventual preference for the curved case was, in fact, a style choice. Taking this step at a time when the wristwatch was still thought to be eccentric, Louis Cartier reconfirmed his interest in watchmaking and demonstrated his vision. The Tonneau of 1906 launched the era in which a host of versions of well-established Cartier watches were developed. It first existed in platinum and gold versions, then regularly reappeared, always the same but always different.

The curve of the *Tank Cintrée* meant the case had to be elongated so that, exceptionally in the *Tank* family, this model was not square but rectangular. The rectangle, of course, finally broke any connection with the circle. Like any regular polygon, the square is very close to the circle and a circumference can fit perfectly inside it. Since this is impossible with a rectangle there is no direct connection between the shape of the dial and the hour chapter it presents. Now the only circle was the side view of the closed bracelet. Moving from one shape to another did not mean abandoning a preference that had been developed at Cartier since 1906, but rather deepening it. And as the *Tank Cintrée* showed, the devotion to the square, or even the rectangle, had its own logic quite independent of fashion or cultural and artistic trends. The challenge of attaching the strap was not just to find an æsthetic solution for the *brancards* but to create a fluid, harmonious line for the entire watch. From this point of view, the curvature of the case opened up an interesting avenue for development at Cartier. The case had to curve, not so much to be in tune with the wrist anatomically and functionally, but to perfectly adapt to it physically and visually. So the *Tank Cintrée*, following the dynamics of the strap it had to bond with, naturally meant elongating the case, changing it from square to rectangular. Its substantially extended dial was also visually enlarged and softened by the curves of the "railroad minute track" minute circle. Only its large, projecting *brancards* with square edges and, to a lesser extent, its white silver dial and the cabochon on its crown, immediately recalled the 1919 model. They definitely identified the watch as a *Tank* , but a rectangular *Tank*, even more daringly modern. It was later produced in 9, 8 and 7 lines.

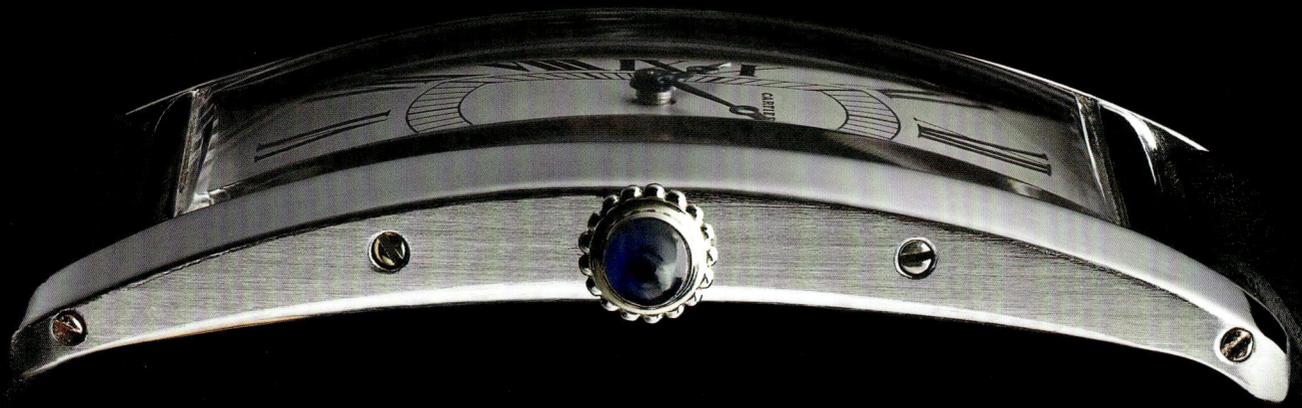

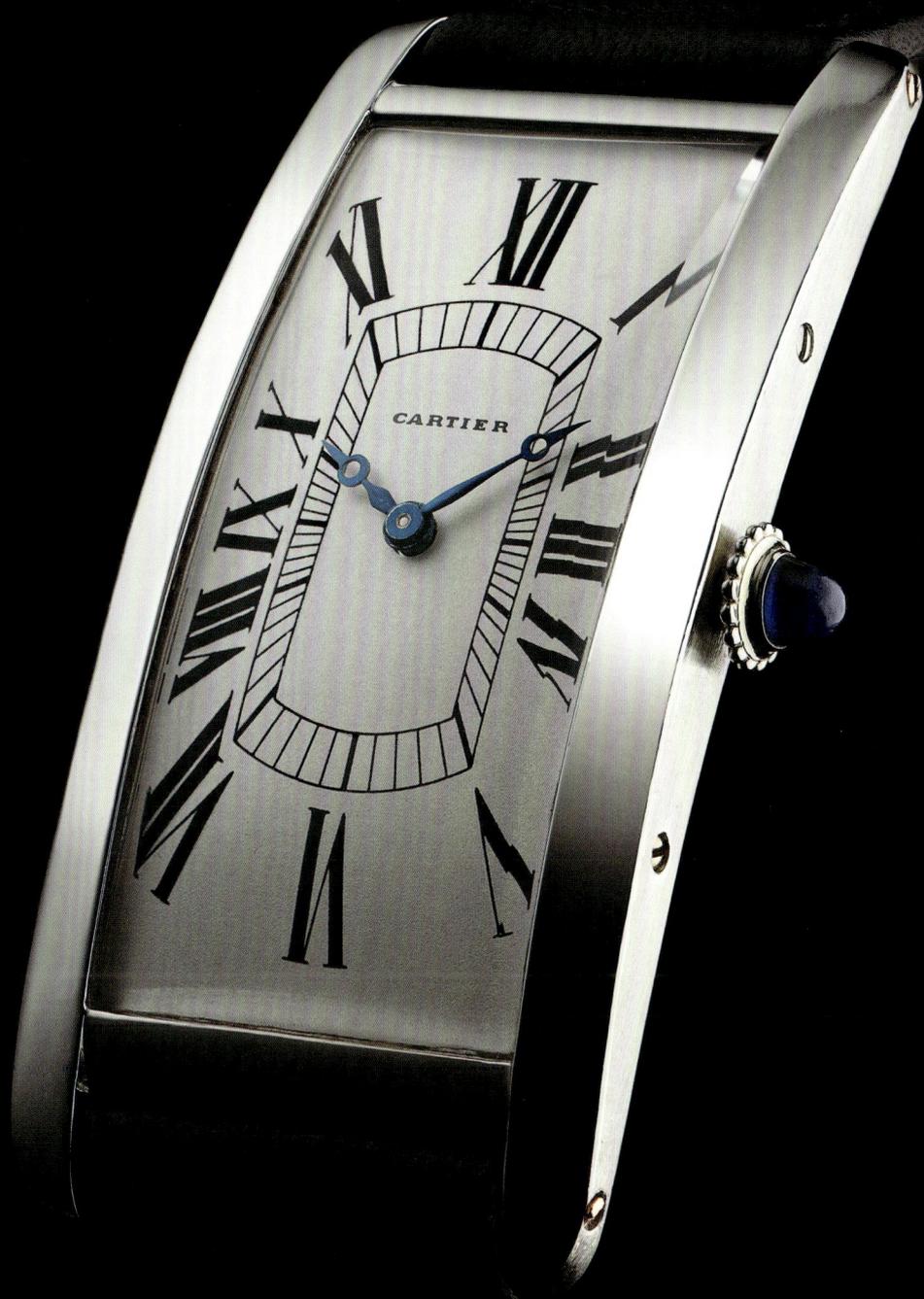

Tank L.C. Wristwatch

CARTIER, 1925

Marked on the dial: *Cartier*

Case of polished and satin-finish platinum, *brancards* of polished platinum. Beaded winding crown capped with a sapphire cabochon. Leather strap, deployant buckle of white gold. White rectangular dial with Roman numerals around a railroad minute track. Apple-shaped hands of blued steel.

This particularly rare timepiece is one of the very first *Tank L.C.* model, a version of the *Tank* wristwatch and created in 1922.

❖ *Round movement, rhodium-plated, 8 adjustments, 19 jewels, Swiss lever escapement, bimetallic balance, flat balance spring.*
WCL 125 A25

A rectangular dial was an almost unavoidable variant in the *Tank Cintrée*, since arching the case meant extending it and giving it a more enveloping shape. But the rectangular dial was purely a style choice in the other two families of *Tank* that were introduced in 1922: the *Tank L.C.* (for Louis Cartier) and the *Tank Allongée*.

The *Tank L.C.*, produced with a 9-line caliber and later with an 8-line caliber, was first described by the company as "*Tank* bords arrondis," or "*Tank* with rounded edges." The reason for naming it after Louis Cartier is unknown. Nevertheless, it is stylistically interesting. The initial name of "*Tank* with rounded edges" focuses on specific organic details that differentiate this family of *Tank* from all the others: its softened edges and the rounded tips of its *brancards*. Even more than the square case, the rectangular *Tank L.C.* removed any echo of the traditional round watch. But at the same time it seems there was an attempt to reduce the potential negative impact of breaking the rules. After the extreme modernity of the *Tank Cintrée*, it is quite likely that Louis Cartier wanted to introduce a less radical watch, partly for commercial reasons.

It would satisfy his clients' insistence on diversity, and it was almost certainly his personal inclination. In a sense, this model was a rigorous symbol of his ideas, representing his vision of the Art Deco style. In fact there is no doubt that Louis Cartier played a key role in defining the geometric codes of the period, with invaluable help from one of his most talented designers, Charles Jacqueau. But perhaps because they were the pioneers, these two men were never among the fiercely determined, dogmatic supporters of the straight line in jewelry. Records of jewelry production at that time show that there was a growing tendency to temper the almost disdainful beauty of rectangular and square forms. It seems that, once the clarity and æsthetic nobility of geometric lines and angles had been established, there was no need to constantly emphasize them. On the contrary, they could be gently softened without betraying the concept.

At the start of the 1920s, circles and ellipses began to appear alongside rectangles and triangles in Cartier jewelry. Square and curved forms alternated in the same brooch, creating a striking effect with their perfect proportions. The straight line, a standard element in the æsthetic codes of the time, almost seemed to enjoy appearing and disappearing, only to emerge as strongly as ever in the overall linear development of the piece. In a figure such as a triangle, the boldness of the angular shape was compensated by the voluptuous roundness of pearls or cabochon-cut stones whose volume emphasized the controlled softness of their surface.

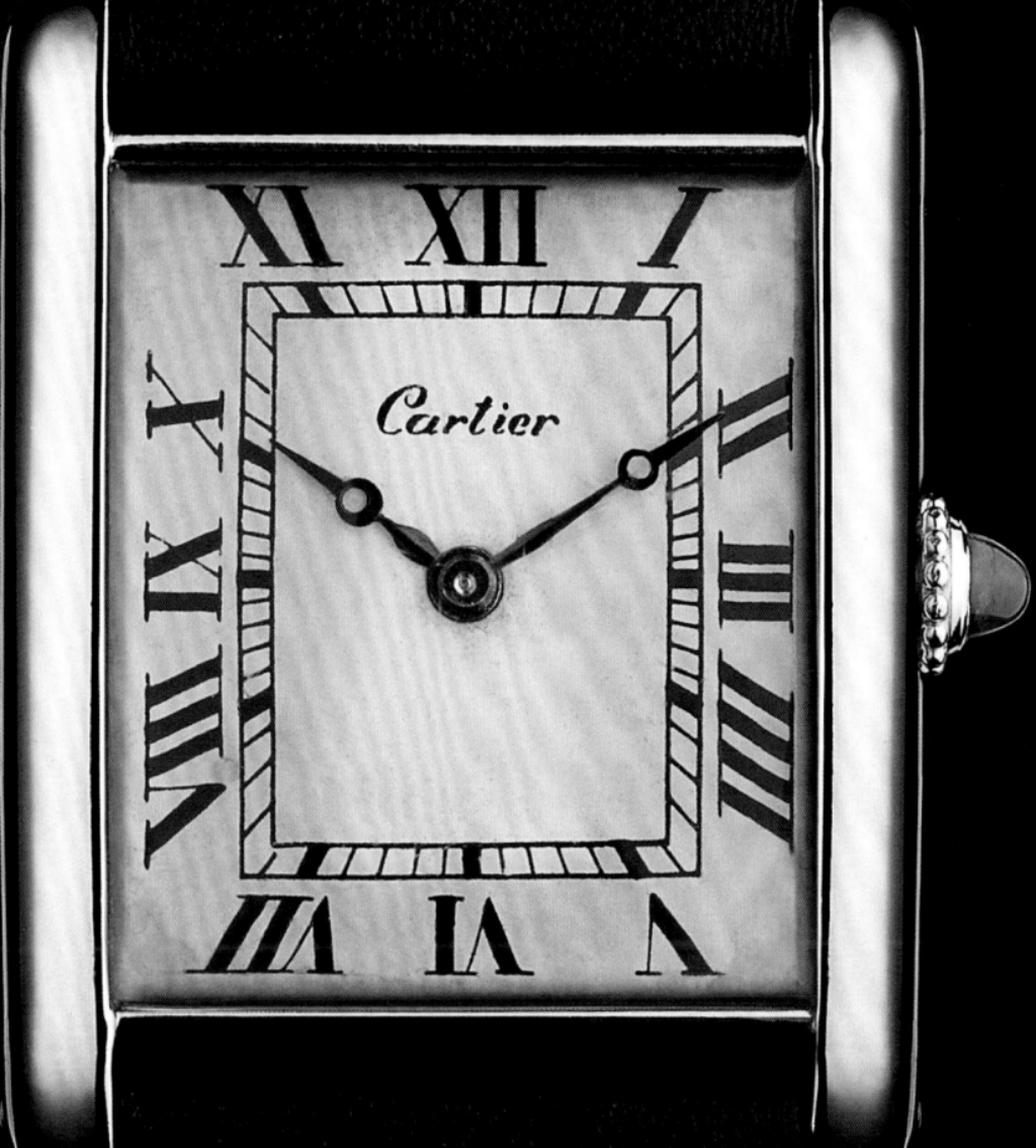

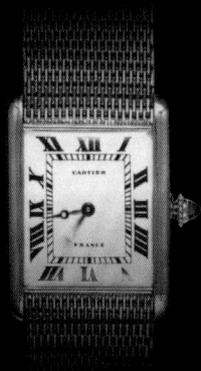

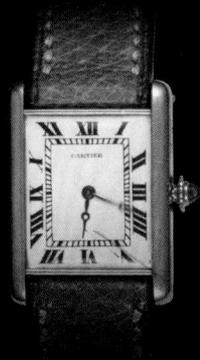

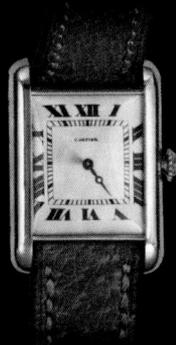

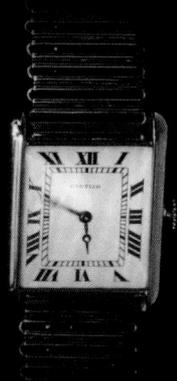

The *Tank L.C.* 9 lines and 8 lines model is characterized by a very open rectangular dial and by its sides with borders and its elegant rounded corners. Known at its creation in 1922 as the *Tank à bords arrondis* ("with rounded edges"), it was dubbed the *Tank L.C.* or *Tank Louis Cartier* from 1924. The 9-line caliber model was followed by an 8-line caliber version.

FACING PAGE (CLOCKWISE FROM TOP LEFT)
Tank L.C. 9 lines, 1928. Polished gold on fine figaro mesh; *Tank L.C.* 9 lines, 1928. Polished gold on leather; *Tank L.C.* 8 lines, 1925. Polished gold on transverse bars; *Tank L.C.* 8 lines, 1926. Polished gold on leather.

In a sense, the smoothed geometry of the *Tank L.C.* was the watchmaking equivalent to the mix of straight lines and curves that contributed so much to the extraordinary distinctiveness of Cartier's Art Deco jewelry. In this determined search for balance between formality and softness, the element that created the biggest difference from the original *Tank* was the thinning of the two vertical *brancards* and the borders of the case at 6 and 12 o'clock. Since the aim was to soften the edges, it would be logical to expect the two longest sides of the rectangle to be widened. Yet the exact opposite took place, confirming that the *Tank L.C.* was an example of the subtlety of Cartier's style. Softening the sharpest geometrical features was an attempt to ensure that the watch would never become outdated, and make it easier to wear.

By extending the shape longitudinally, the *Tank L.C.* led to the *Tank Allongée*, forerunner of the "Baguette" watch introduced by Cartier in 1926. For watchmakers, the *Tank Allongée* remains the definitive use of the rectangle as a symbol for time. Interestingly, the *Tank Allongée* family was given various other names in the stock registers, such as *Petite Tank* and *Tank Rectangle*, but its chief characteristics were the change from square to rectangular and its miniaturization.

While the 9-line caliber of the first *Tank* still features among the various versions of all the other models, the *Tank Allongée* immediately adopted a smaller size and only offered two calibers of 7 and 8 lines. Four years later an important new version, the *Petite Tank Rectangle*, was introduced with a 7-line movement. It retained the sharp-edge *brancards* of the first *Tank*. Meanwhile the *Tank Allongée*, in principle a feminine watch, shifted towards to the mens' sports area more naturally than any other Cartier model at that time. A paradox in all this is that although the wristwatch was derived from bracelet-watches, which were typically feminine jewelry pieces, it was a functional concept that started life with a firmly masculine image. In the first decade of the twentieth century, wristwatches production, particularly at Cartier, was focused on a female clientele that was clearly the jeweler's priority. But feminising a wristwatch, at least soon after the war, meant losing the essentially metallic character that made it a symbol of modernity, decorating it instead with stones, pearls and enamel, and giving it a precious bracelet.

Furthermore, the *Tank*, rather like a racing car, had been created as the ultimate masculine watch. Its first models were only produced with 9-line calibers which, at that time, were movements for men's models. Yet it became the first

Petite Tank Rectangle
Wristwatch
CARTIER, 1929

Marked on the dial: *Cartier*

Engraved on back of case: a crown and monogram.
Case of polished and satin-finish gold, *brancards*
of polished gold. Flat, beaded winding crown.
Leather strap, deployant buckle of yellow and pink gold.
Rectangular cream dial with Roman numerals.
Apple-shaped hands of blued steel.

❖ *Oval LeCoultre movement, Côtes de Genève*
decoration, rhodium-plated, 2 adjustments,
17 jewels, Swisslever escapement, bimetallic balance,
Breguet balance spring.
WCL 93 A29

wristwatch to offer adaptations and versions of even the simplest shapes, designed to meet the demands of a female clientele that had been deeply changed by the war. Indeed, the increasing liberation of women had its roots in the terrible damage that the war had inflicted on men, demographically and psychologically. Women's emancipation was helped by the absence of so many men, removed from their families and their occupations by mass mobilization. All the countries involved in the war had gradually conscripted a large percentage of their male population, from 17-year-olds to fathers of families. The gap they left thrust women into the workplace and allowed them to show how active they could be in the town and the country, in the office and the factory. And when peace returned those women were not about to give up their new status. They had not only proved themselves at work but in leisure activities, art, sport and, above all, in a bolder relationship with men, becoming more confrontational yet also more seductive.

One of the signs of this evolution was their adoption of the wristwatch in steel or a noble metal, without any expensive decoration, for the sole purpose of showing the time. And if their watch was smaller than the masculine version it was purely to fit on a smaller wrist. The predominant fashion at the time was androgynous, slender and straight, and the popular hairstyle was the "garçonne," a term borrowed from the novel by Victor Margueritte that created a scandal in 1922. This new boyish woman was animated, thin, curious about the world and excited by the new freedom of body and mind that had opened up for her. Then gradually another kind of woman appeared, equally hungry for emancipation and greater rights. She, however, was inclined to be dynamic yet introverted, intelligent yet tormented. The first kind of woman was likely to identify with the novels of the French writer, Colette who was torn apart by the unreliable happiness of living life to the full. The second would have felt closer to Virginia Woolf, author of some of the most beautiful novels of the twentieth century. Virginia Woolf's female characters gave impeccably graceful accounts of the painful search that a woman had to undertake when affected by two phenomena simultaneously; continuity (the persistence of her femininity), and rupture (the crumbling of the protective wall she had been accustomed to). Suddenly exposed to the same experiences as men but naturally disinclined to aggressiveness and the "struggle for life," the woman developed a wounded sensitivity that was quite new, both from a literary and a historical point of view. A different consciousness launched her into the world, but her destiny kept her firmly in the centre

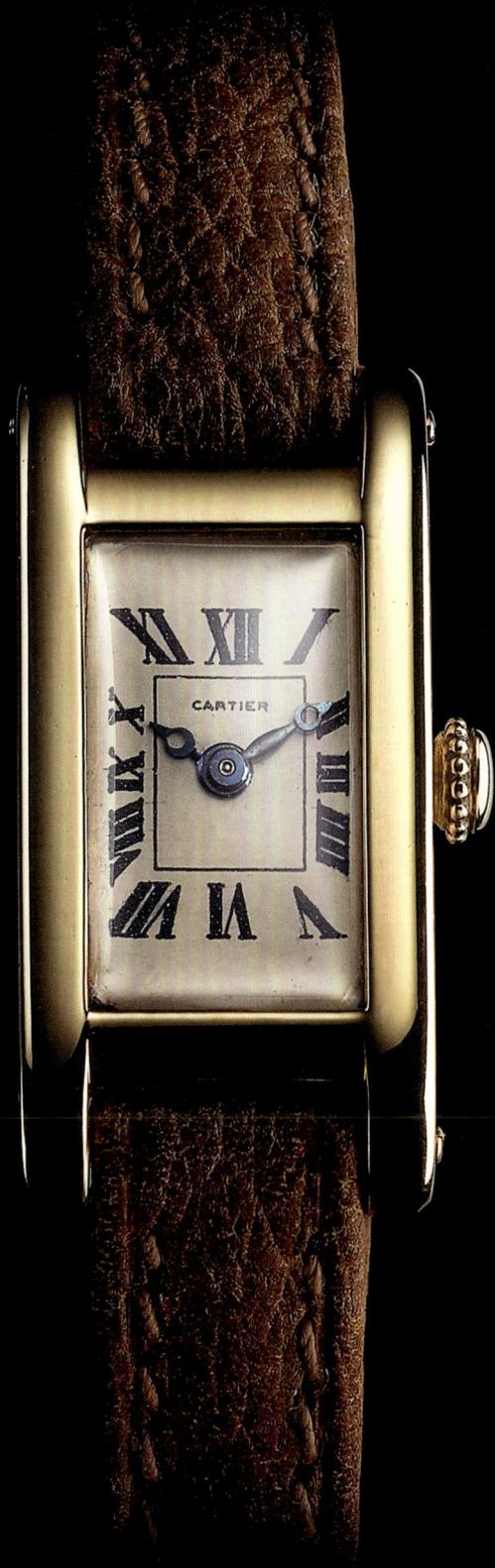

LEFT
Chinese dragon vanity case,
Cartier Paris, 1927.
Gold, enamel, emeralds and diamonds.
VC 69 A27

FACING PAGE
Chimera Mystery Clock,
Cartier New York, 1926.
Enamel, onyx, nephrite, agate,
citrine, pearls and emeralds.
CM 23 A26

of a universe dominated by men. She was forced, for the first time, to share its obligations but still had to play her role as comforter and peacemaker.

These books suggest that the Roaring Twenties were not really as carefree as we like to believe. In the perfect geometry of Art Deco or the paintings of Mondrian, anxiety is only temporarily allayed. It soon returns to bloom and to express itself in new twists and turns. In the artistic sphere, along with the grand rationalization of the Bauhaus and its founder, Walter Gropius, the surrealist movement was coming rebelliously into bloom, leaning fearlessly over the abyss of the unconscious, impatient to open up the world of art to dreams, hallucinations and even to madness.

The *Tank Allongée*, after its initial masculine, sporting version, finally became the most feminine *Tank* of all. The most masculine seems to have been the *Tank Chinoise* that appeared in 1922, the last of the five families from the early days of the *Tank*. It was produced only with a 9-line caliber. Structurally, it was a derivation of the 1919 *Tank* : its square case was identical to the first model with two crossbars at 6 and 12 o'clock extending onto the lateral *brancards*. While the rectangular *Allongée* was the most refined version of the original *Tank* design, the square case of the Chinese model was its clearest, strongest version.

The brilliant creative idea behind it was, as is often the case, strikingly simple: symmetry. To make the *Tank Normale* symmetrical, both axially and diagonally, there were only two possibilities: either to cut the four extensions of the vertical *brancards* (which would have been absurd since they served as essential strap attachments), or to similarly extend the two horizontal borders that formed the square dial opening. That was the concept of the *Tank Chinoise*. Four corbels projected from the four corners of the square with the *Tank* spread out happily between them. Unlike their vertical counterparts, these projections had no structural role. Their purpose was purely æsthetic and graphic, adding volume in order to balance the weight and remove any affinity with a rectangle by forcibly reducing the watch to a square.

It cannot have been a coincidence that this watch, which was so concerned about its balance and its permanence, was the only watch in history to be inspired by an architectural feature: the doorway of Chinese temples. This resemblance gave the watch its name. Its Chinese theme is as evocative as its geometry. Its final form, that dates from 1924, is clear and simple: it is a doorway that reveals both the interior of the temple and the time, framed by solid beams that intersect like a grill. In the model designed in 1922, the horizontal crossbeams were less robust and the framing effect was less pronounced.

FOLLOWING DOUBLE PAGE, LEFT

Large *Portique* Mystery Clock,
Cartier Paris, 1923.
Gold, rock crystal, enamel and onyx.
CM 09 A23

FOLLOWING DOUBLE PAGE, RIGHT

Tank Chinoise Wristwatch
CARTIER, 1930

Marked on the dial: *Cartier, Paris*

Case of polished and satin-finish gold, *brancards* and
transversal bars of polished gold. Beaded winding
crown capped with a sapphire cabochon. Leather strap,
pin buckle. Square white dial with Roman numerals
around a railroad minute track. Apple-shaped
hands of blued steel.

❖ *Round movement, fausses Côtes de Genève
decoration, rhodium-plated, 8 adjustments, 18 jewels,
Swiss lever escapement, bimetallic balance,
Breguet balance spring.*
WCL 66 A30

Chinese objects were highly fashionable in the 1920s. Cartier created some exceptional examples in both watchmaking and jewelry, particularly on a theme that had become a fetish: the chimera. They included the famous *Chimera* bracelets and in 1922 Louis Cartier presented the first of them to Countess Jacqueline Almassy, his future second wife. The first Chimera mystery clock went on sale in 1924. One year later, the company introduced the first *Portique* mystery clock, its most important three-dimensional tribute to the magic of the orient. This large contemporary echo of the *Tank Chinoise* was a perfect illustration of Asia's influence on Louis Cartier. Much of this inspiration came from his frequent visits to Paris antique dealers. Among them were C.T. Loo on Rue de Courcelles, Michon on Boulevard Haussmann, and la Compagnie de la Chine et des Indes, Rue de Londres. These antiquarians, and the Japanese dealer Yamanaka, who had a branch in New York, supplied Cartier with the engraved jade screens and the inlaid lacquerware that decorated many of the large and small clocks he created in the Art Moderne style. Cartier's fascination with the Far East was also fuelled by a number of books, particularly *L'Ornement chinois* by Owen Jones, and by the collections of the Guimet and Cernuschi museums in Paris.

In a cultural exchange that was typical of this time when long-distance travel was becoming more common, his admiration for Chinese taste was matched by a growing interest in his creations among Eastern princes. They were now becoming important clients at Cartier. The *Tank*, in particular, attracted a number of Indian Maharajahs, confirming its status as an iconic watch. For example, in just two years (1923–25) the Princes of Kapurthala acquired no fewer than twelve *Tank*'s in various versions from Cartier in Paris. The Aga Khan and the Maharajah of Patiala were also its clients, while other Indian princes patronized Cartier in London. When so many Europeans were travelling East, the fabulous Indian aristocracy were coming to the West, eager to adapt its tastes to the fashions of Europe.

The Indian princes may have been the most spectacular admirers of the *Tank*, but they were not alone. In just a few years, wearing this masterpiece of contemporary design and sophistication on the wrist had become a distinctive sign of wealth and social prestige. Above all, it was a cultural statement. The most devoted "Tankistes" among the clients of Cartier Paris included the entire royal families of Yugoslavia and Serbia, Princess Bibesco (the hostess of a social and literary salon often attended by Marcel Proust), and the Rothschilds.

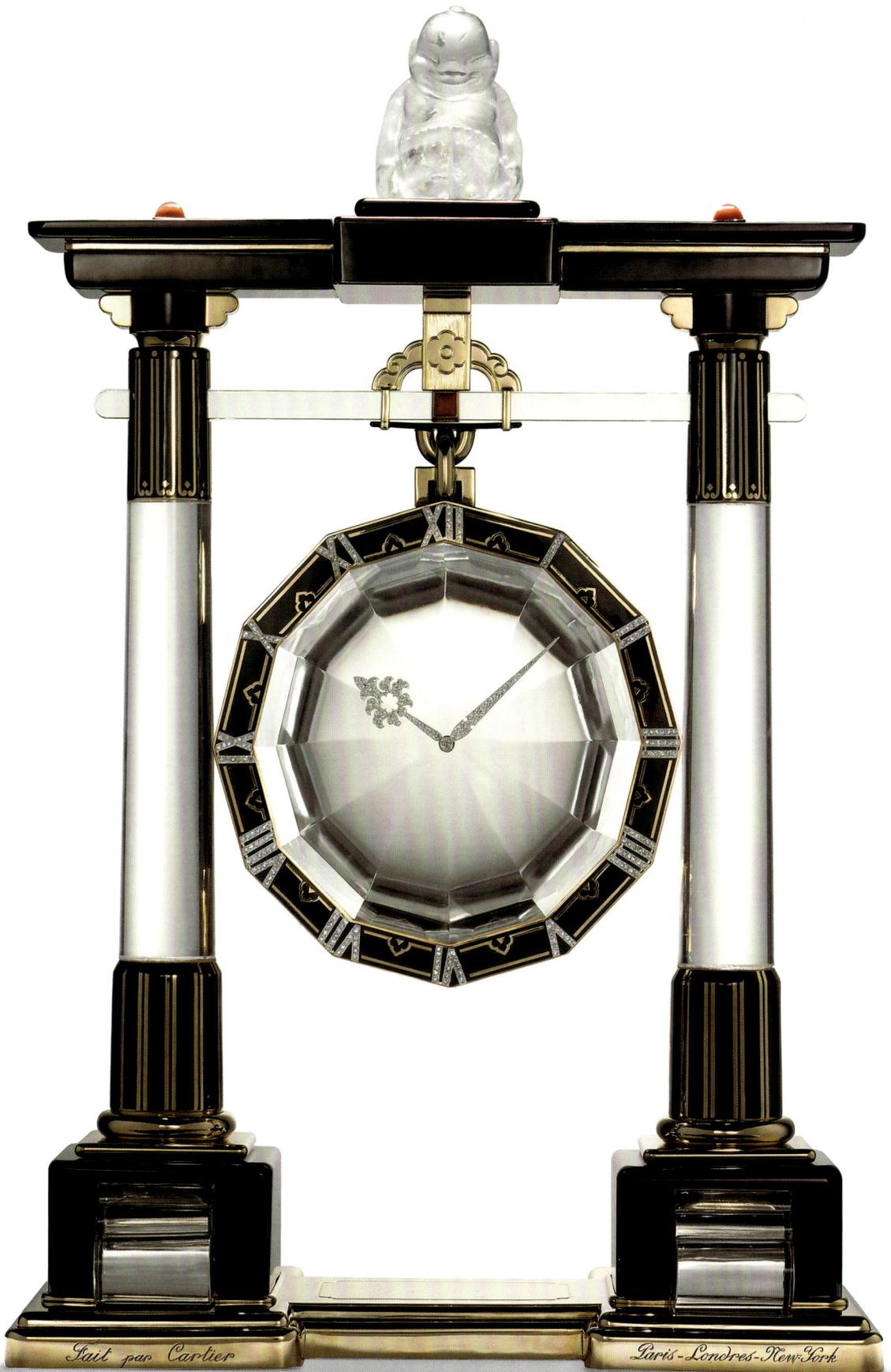

IN JUST A FEW YEARS, WEARING THIS MASTERPIECE OF CONTEMPORARY DESIGN AND SOPHISTICATION ON THE WRIST HAD BECOME A SIGN OF DISTINCTION AND SOCIAL PRESTIGE. ABOVE ALL, IT WAS A CULTURAL STATEMENT.

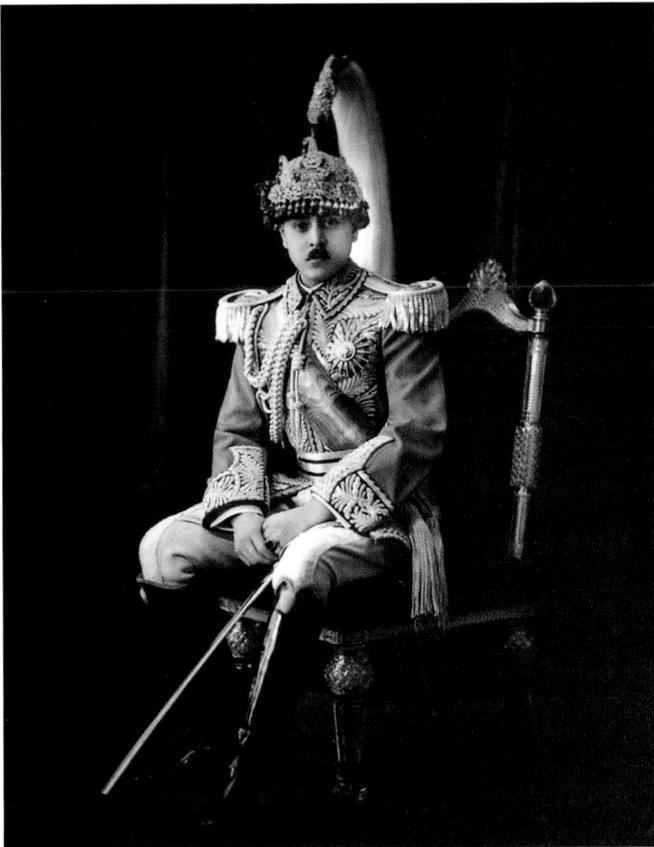

FACING PAGE

Tank Wristwatch

CARTIER PARIS, 1934

Marked on the dial: *Cartier, France*
Sold to the Prince of Nepal

Case and *brancards* of polished and satin-finish
platinum. Beaded winding crown capped with
a sapphire cabochon. Bracelet a 7-strand mesh
of platinum links, deployant buckle of pink gold.
Square cream dial with Roman numerals around
a railroad minute track. Apple-shaped hands
of blued steel.

❖ *Round LeCoultre caliber 168 movement, fausses
Côtes de Genève decoration, rhodium-plated,
8 adjustments, 19 jewels, Swiss lever escapement,
bimetallic balance, flat balance spring.*
WCL 30 A34

LEFT

Tribhuvan Bir Bikram Shah Dev (1911–55),
prince of Nepal, circa 1930.

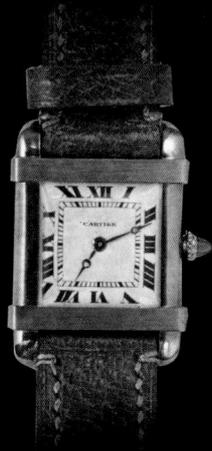

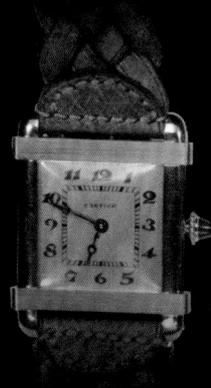

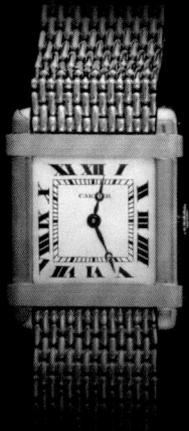

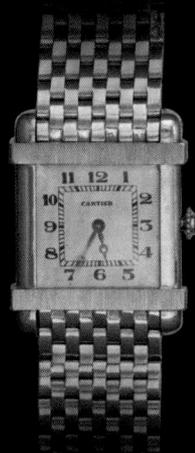

The *Tank Chinoise*, created in 1922 and given its "Chinese" soubriquet in 1923, immediately established itself as a leader in the æsthetic field. Its structure was derived from the *Tank* of 1919, the square case, identical to that of the original model, displaying at 12 and 6 o'clock the two horizontal bars overlapping the vertical *brancards*. The *Tank Chinoise* was produced solely in a 9-line caliber.

FACING PAGE (CLOCKWISE FROM TOP LEFT)
Tank Chinoise 9 lines, 1922. Gold on leather; *Tank Chinoise* 9 lines, 1926. Satined gold on plaited leather; *Tank Chinoise* 9 lines, 1928. Gold on 9-row flexible tile in polished gold; *Tank Chinoise* 9 lines, 1927. Gold on figaro mesh.

FOLLOWING DOUBLE PAGE

Tank Cintrée Wristwatch

CARTIER LONDON, 1929

Marked on the dial: *Cartier*

Curved case of satin-finish gold, *brancards* of polished and satin-finish gold. Beaded winding crown capped with a sapphire cabochon. Leather strap, deployant buckle of yellow and pink gold. Curved white dial with luminescent Arabic numerals around railroad minute track. Luminescent skeleton hands.

❖ *Round LeCoultre caliber 122 movement, fausses Côtes de Genève decoration, rhodium-plated, 8 adjustments, 19 jewels, Swiss lever escapement, bimetallic balance, flat balance spring.*
WCL 113 A29

After the first five families of *Tank* watches were launched between 1919 and 1922, no significantly different new models appeared until the turn of the decade. Nevertheless, some watchmaking improvements were made to the *Tank* and two complications were added, which was highly unusual before the 1970s.

In 1925 Cartier introduced luminescent dials or "radium dials" with thicker numerals and open-work hands coated with radium salts. This technique, which had been developed around 1912, enabled soldiers to read the time at night. It remained popular, especially on technical or sports watches, until the end of the 1960s. After this date only certain chronographs had luminescent numerals, then produced with tritium. In 1928 another technical feature was added to certain 10-line *Tanks*: a small seconds counter at 6 o'clock. In the same year, the company introduced its first complication *Tank*, the *Tank à Guichets*. Then, as we will see, a second followed in 1931: the *Tank Allongée* which had a new movement with an 8-day power reserve.

Three new *Tank* families were born during this period. The *Tank à Guichets* of 8 or 10 lines, first appeared in the stock register in 1928 in response to a growing interest in watches with a numerical rather than an analogue display. The glass, dial and hands were replaced by a plate with two windows (*guichets*) cut into it. Each showed a number on a turning disc, one indicating the hours, the other the minutes. The hour disc "jumped" from one number to the next while the minute disc "dragged" continuously. This numerical display was a forerunner of the system adopted in the 1970s when quartz movements were introduced. The simple, functional appearance of these watches was certainly influenced by fashion as well as the refined but "industrial" spirit of Art Deco in which technology was ennobled by design. At the same time it also reflected the economic impact of the 1929 crash and the austerity that followed. This fashionable object shows Cartier doing what it had done for many years with clocks and pocket watches: creating a very simple version that was still in harmony with the style of the company.

Visually, the *Tank à Guichets* with its large expanse of naked metal and its tiny windows, was the fulfillment of the *Tank*'s vocation—to act as the meeting point between the two worlds of machinery and jewelry. In doing this, Cartier avoided the risk of monotony in the various versions by altering the arrangement and shape of the windows, the crown's position (at 12 or 3 o'clock) and its design: set with a cabochon or faceted sapphire—the only concession to the art of jewelry—beaded, or flat and ribbed. A few special models combined a dial (minutes and seconds) with a

Felix from Fred '29

21335 MADE IN FRANCE 27667

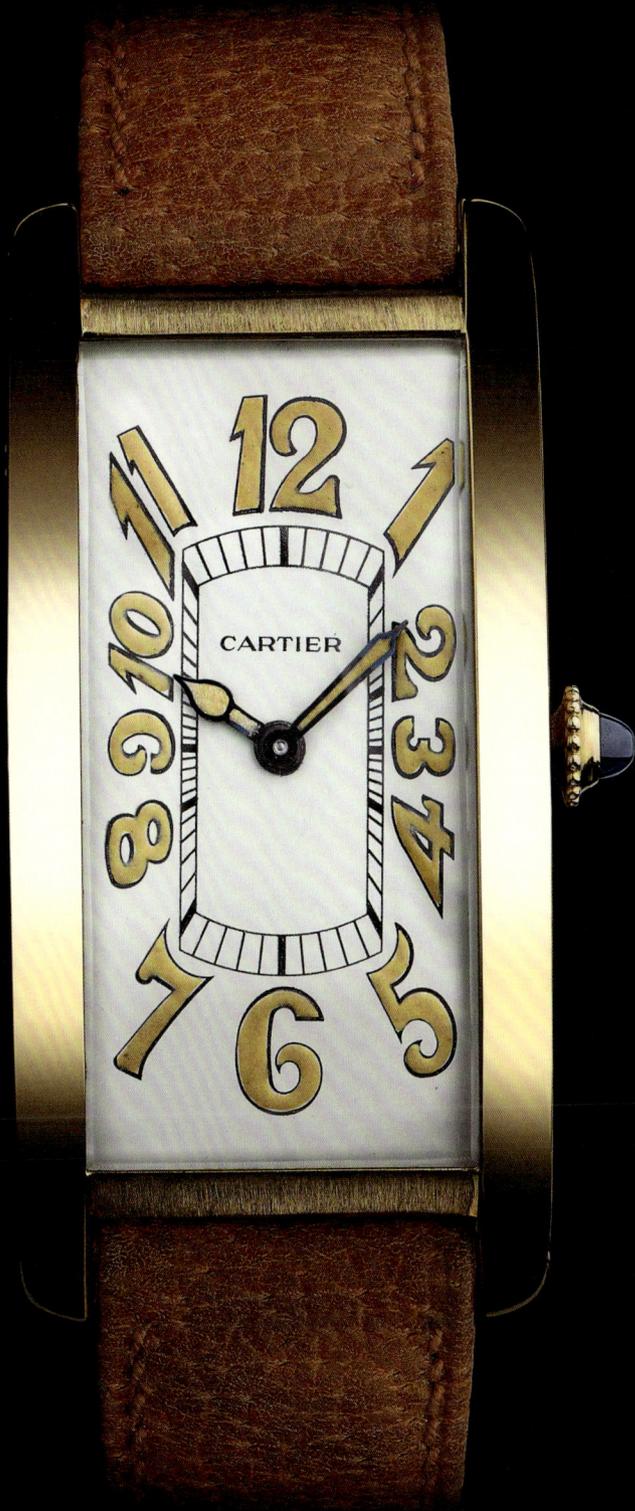

window (hours). The concern for simplicity and modernity led either to the choice of platinum or the voluntary reduction of the sparkle of gold by brushing the metal to create a matte finish. This concern reached its limit in 1930 with a model in which the profile of the *brancards* disappeared completely in a flat treatment of the bezel. With this abrasion of the surface that favored the plan view over the profile, Cartier was being very bold at a time in which multiple layers were preferred to a flat surface.

From a technical and functional point of view, the brief story of the "window watch" casts an interesting light on the history of all "numerical" revolutions in watchmaking. Window watches had already enjoyed some success in pocket watches in the middle of the nineteenth century, when the expansion of the railways and public transport in general led to the widespread adoption of a system for indicating times that was different in the written form than the traditional spoken form. A watch with the shorter hand between 10 and 11 o'clock and the longer hand at 9 o'clock clearly indicated quarter to 11. But a train scheduled to leave at the time when the hands were in that position would not, according to the official timetable, leave at a quarter to eleven but at 10.45. To make matters worse, 10.45 could mean the morning or the evening, and in the second case

it could also be written 22.45. While this is perfectly clear today it was far from obvious 150 years ago. To address this difficulty and get the public used to thinking of time in a different way, numerical watches began to appear in the second half of the nineteenth century (as well as some rare pocket watches with 24-hour dials).

Watch fashion in the late 1920s was certainly not driven by these issues but partly by something more recent: the fascination for numerical display, which many people considered "more modern." In reality, the short-lived interest in numerical display in the 1920s, 1930s and even the 1970s proved that hands were a more effective and instant means of displaying the time. Apart from their æsthetic beauty and symbolic elegance, hands offered instant time-reading and were therefore, paradoxically, more up-to-date.

The *Tank Étanche* born in 1931 was a joint effort, combining the creativity of Cartier and the expertise of Cartier-Jaeger. It introduced the first major technical innovation in watchmaking since the appearance of the wristwatch: the water-resistant case. Its presentation caught the public's imagination—it showed the watch submerged in a glass of water. The structure of the watch was based on the *Tank à Guichets* of 1929, but with one important difference. The dial flange extended onto the *brancards*, which interrupted the straight-line theme

FACING PAGE, LEFT
Drawing for a *Tank à Guichets* watch, 1930.
Cartier Archives, London.

FACING PAGE, RIGHT
The Maharajah of Patiala—fascinated,
like all Indian princes, by the latest developments
in watchmaking—ordered a *Tank à Guichets*
in 1928.

BELOW
Photographs illustrating tests for water-resistance
of the *Tank Étanche* ("waterproof"), 1931.
This model was equipped with a system for
locking the winding crown in order to render
the case impervious to water and dust.
Cartier Archives, Paris.

and altered the proportions of the case. For this reason, it was listed in the Cartier archives as a "*Tank* shape" version.

A water-resistant patent already had been filed on October 18, 1926 by Hans Wilsdorf, and is owned by Rolex, the company he founded. However, this patent was designed for a round case and the *Tank* required a much more complex and detailed system. In fact, making a square or rectangular case water-resistant was thought to be impossible due the problem of sealing the corners. So for Cartier to offer this fundamental advance in technology in a shaped watch obviously involved more than simply acquiring the rights to an existing solution from a competitor. Even if Cartier had been the owner of the Wilsdorf patent it wouldn't have known what to do with it since all its wristwatches at that time were shaped models. So instead, it searched for a new way to apply this technology to its geometrical, firmly Art Deco watches, particularly the *Tank*, the uncontested champion of modernity in watchmaking.

There is a story at Cartier that in the mid 1930s the Pasha of Marrakech commissioned a watch he could wear in his pool so that he could swim without losing track of time, and the only water-resistant model available was the *Tank Étanche*. Today's *Pasha* takes its name from this story and the watch that inspired it was produced in 1943:

ABOVE

Duke Ellington, American pianist,
composer, and band-leader wearing
a *Tank à Guichets*, circa 1940.

FACING PAGE

Tank à Guichets Wristwatch

CARTIER PARIS, 1928

Case of polished and satin-finish gold.
Flat, notched winding crown at 12 o'clock.
Leather strap, deployant buckle of yellow and pink
gold. Time displayed through 2 windows, Arabic
numerals for the hour, minute track with Arabic
numerals at 5-minute intervals for the minutes.

❖ *Round LeCoultre caliber 126 movement,
jumping-hour disk and continuous minute disk,
fausses Côtes de Genève decoration, rhodium-plated,
8 adjustments, 18 jewels, Swiss lever escapement,
bimetallic balance, Breguet balance spring.*
WCL 31 A28

VISUALLY, THE *TANK À GUICHETS* WITH ITS LARGE EXPANSE OF NAKED METAL AND ITS TINY WINDOWS, WAS THE FULFILLMENT OF THE *TANK*'S VOCATION — TO ACT AS THE MEETING POINT BETWEEN THE TWO WORLDS OF MACHINERY AND JEWELRY.

Reversible *Basculante*
Wristwatch
CARTIER PARIS, 1936

Marked on the dial: *Cartier, France*

Rectangular case of polished and satin-finish
gold that pivots around the 12-o'clock–
6-o'clock axis within a frame of polished
and satin-finish gold. Flat, notched winding
crown at 12 o'clock. Curved (*bec d'aigle*) lugs,
leather strap, deployant buckle of yellow
and pink gold. Rectangular dial of grained
silver with Roman numerals around a railroad
minute track. Pear hands of blued steel.

❖ *Rectangular LeCoultre caliber 111
movement with cut corners, rhodium-plated,
2 adjustments, 18 jewels, Swiss lever
escapement, bimetallic balance,
flat balance spring.*
WCL 96 A36

Drawing for a *Tank Savonnette*
watch on a leather strap, circa 1930.
Cartier Archives, London.

Images from the scrapbooks of Cartier
designers. Cartier Archives, Paris.

a watch with a water-resistant round case in line with pop-
ular taste during the war, and fitted with a grill to protect
the glass.

When the *Tank Réversible* appeared in 1932 it intro-
duced a radical innovation. In fact, it was actually launched
with the name "Réversible Basculante" (Reversible Pivoting
watch). It was constructed with a series of layers that cre-
ated a play of nested shapes, quite different from the
original *Tank*. And the lateral bars that held the strap had
been refined to a maximum. But it was later accorded the
name "*Tank*" since the iconic watch had clearly inspired
the linear design of its case, its dial with Roman numer-
als, its railroad minute track minute circle and, above all,
its unmistakeable *brancards*. As with the *Tank à Guichets*,
the *Tank Réversible* was created to meet a specific demand
from the market. Or, rather, from the small, but high-
quality section of the market that admired a type of watch
in which the bezel and dial were well protected against
shocks. Since unbreakable sapphire glass had already
arrived in watchmaking the year before, it seems that the
Tank Réversible had a more æsthetic and social purpose. It
allowed the dial to be easily hidden by pivoting the watch
by 180 degrees which revealed a case back in gold, person-
alized with engraved initials.

In fact, these two æsthetic and protective functions
had already been introduced in a simpler ancestor of the
Réversible, the 9-line *Tank Savonnette*, in 1926. The original
meaning of the term "savonnette" was a watch with covers
on the front and the back. In the *Tank Savonnette*, the watch
itself acted as the cover, pivoting vertically from 6 o'clock
and held shut by a latch at 12 o'clock.

The new reversible watch offered by Cartier was equipped
with an ingenious system. This allowed the case to rotate
360 degrees on its horizontal axis and fit inside a second
case, so that the dial could be either displayed or hidden at
will. With this freedom to turn on its horizontal axis, it was
renamed *Tank Basculante* in 1992.

From 1910 onwards, many reversible models were
patented. On July 6, 1926, Cartier filed his patent for the
Savonnette, "a wristwatch in which the glass is turned
towards the wrist. A point of the case, or one of its sides, is
fixed on the bracelet in such a way as to allow the watch to
pivot around this side…." Working along the same lines, Le
Coultre, César de Trey and Jaeger Paris created the famous
Reverso, invented by René-Alfred Chauvot (patent filed
March 4, 1931). On July 1, 1932 the distribution company for
watches made by LeCoultre (Spécialités Horlogères S.A. de
Lausanne, founded by César de Trey) patented a watch that

1075

Hinge of cover must
be at 12 %.

Croquis Désignation

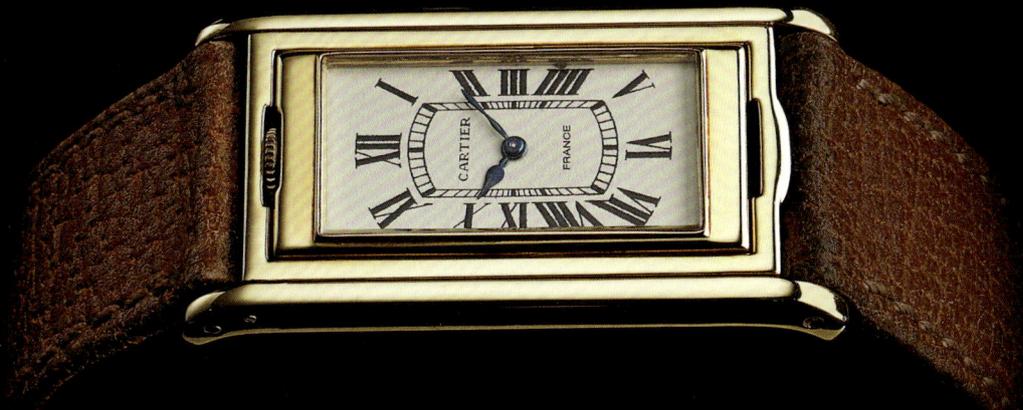

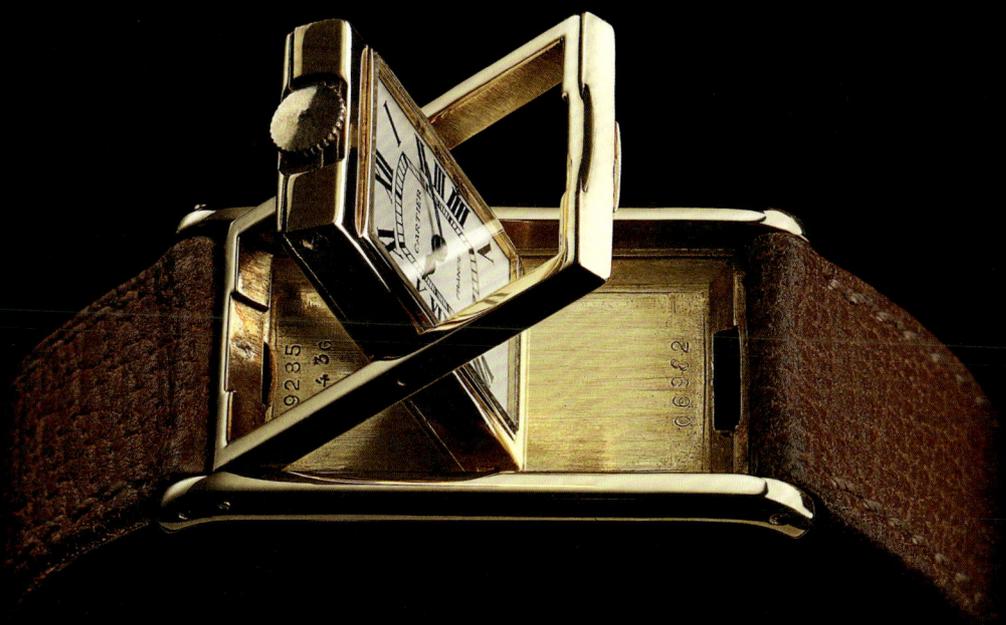

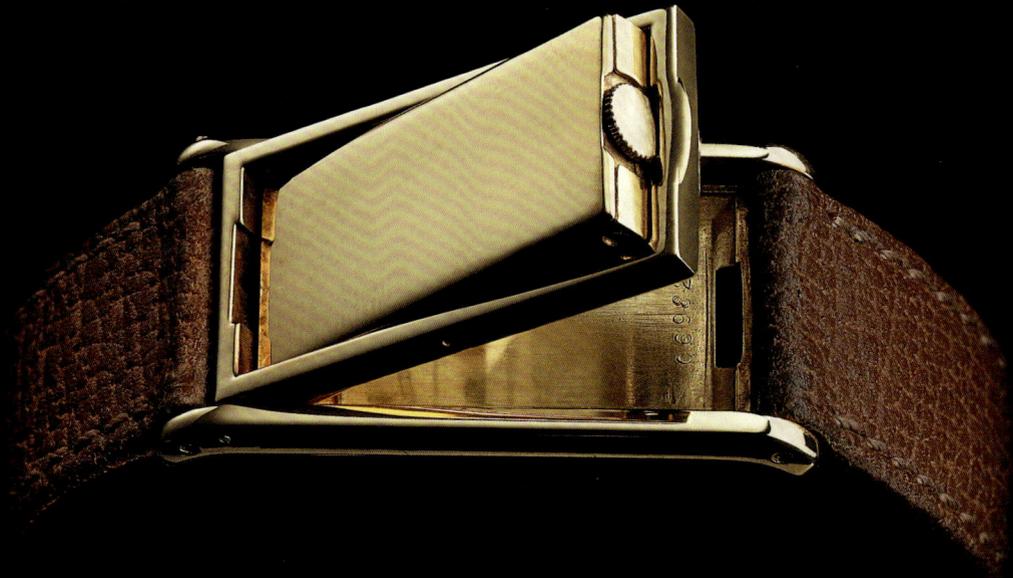

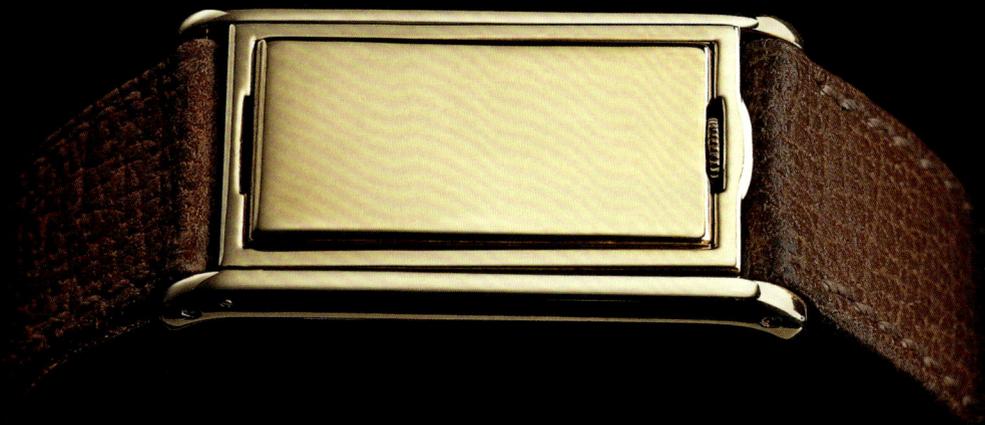

The Matthews "46" Sport Cruis
capable of engine installation
speeds exceeding 30 miles per

The combination of the *Tank* and enamel, essential ingredient of Art Deco, was always carefully considered. Now opaque, rather than translucent as at the beginning of the century, enamel fulfilled an important decorative function, accentuating the geometrical rigor of the watch. Between 1924 and 1926, with a later version in 1931, it was used only on the 9- and 8-line caliber models of the original *Tank* and the 8-line *Tank Allongée*. Used in flat bands, it lent the *brancards* more substance, in lines it lightened them and in geometrical patterns it enlivened them.

Tank 9 lines, 1924–25. Gold, with broad flat strips of black enamel; *Tank* 9 lines, 1924–25. Gold, with *brancards* bearing geometrical motifs in black enamel; *Tank* 9 lines, 1925. Gold, with enamel strips with a line of royal blue; horizontal bars in fluted gold; *Tank* 8 lines, 1931. Polished gold, with two strips of black enamel; *Tank* 8 lines, 1926. Gold, with *brancards* bearing geometrical motifs in cream enamel; *Tank* 8 lines, 1926. Polished gold, with flat bands of black enamel on the *brancards*.

it reserved for Cartier. It was the *Tank Réversible*. After its launch in 1932, other versions were produced in very small quantities, including in 1942 the highly elongated model that, unusually, did not display a minute circle.

❖

Although the very first *Tank* (without this name) was a jewelry watch that appeared three days before the triplets born on November 15, 1919, the *Tank* was a new model designed by Louis Cartier in a modern style with not intended to be decorated precious ornamentation, except for the cabochon on the crown. In fact there were very few jewelry *Tank* models until the early 1970s when a genuine range of feminine versions started to be produced. As already mentioned, the 8-line model set with rose-cut diamonds arrived in May 1920, followed in 1922 by a 7-line *Petite Tank Rectangle* in platinum with round-cut diamonds on the *brancards* and calibrated sapphires on the horizontal borders. Later stock records list precious watches in platinum set with baguette-cut diamonds. This cut, attributed to Louis Cartier, became one of the major components of a renewed Art Deco after 1925. For example, in 1929 a 7-line *Petite Tank Rectangle* set with rose-cut diamonds was also enhanced by four baguette-cut diamonds at 3, 6,

9 and 12 o'clock. In 1930, this style of diamond was set on a 5-line *Petite Tank Allongée* at 3 and 9 o'clock, amid rose-cut diamonds. All these precious watches were mounted on a strap of black watered silk. Even more exceptional were two 1925 creations that owed more to fine jewelry than watchmaking: 7-line *Petite Tank Rectangle* models in platinum with enamel and diamonds, including the strap. These sumptuous watches were examples of an oriental style inspired by Persian art that Louis Cartier particularly admired at this time and which he developed in a large number of jewelry pieces, accessories and watches.

In the 1920s when Cartier agreed to decorate the *Tank*, at the request of certain clients, it did so mostly with enamel, a fundamental component of Art Deco. However, enamel never appeared regularly on the *Tank*. Art Deco enamel was opaque, unlike the translucent material used at the start of the century. It was most effective in large flat areas or in fine monochrome lines where it emphasized the rigorous geometry. From 1924 to 1926, with one version in 1931, only the 8- and 9-line versions of the original *Tank* and the 8-line *Tank Allongée* had *brancards* decorated with the new geometric patterns of enamel: their flat surfaces added body, their fine lines reduced weight, their angular designs brought energy.

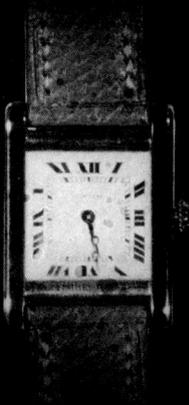
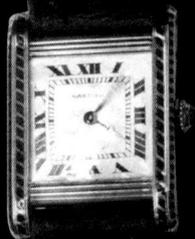
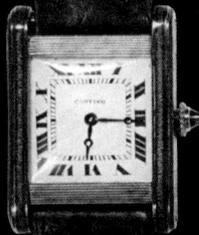
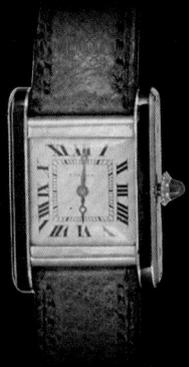
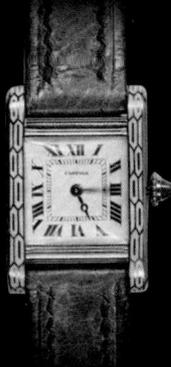
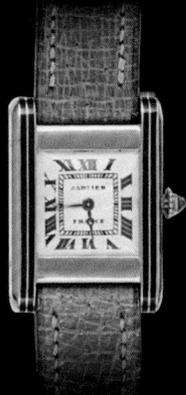

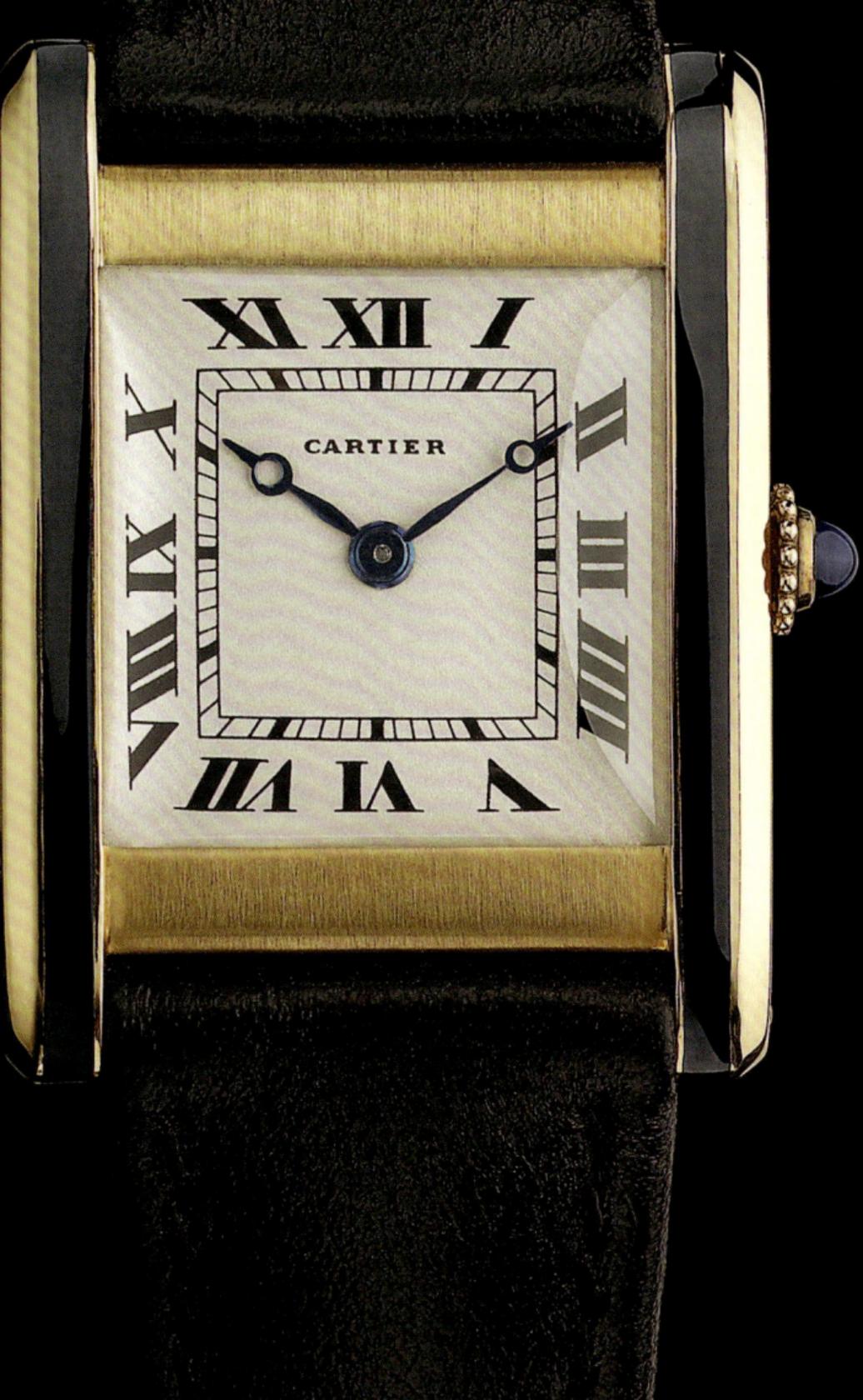

WHEN CARTIER AGREED TO DECORATE THE *TANK*, AT THE REQUEST OF CERTAIN CLIENTS, IT DID SO MOSTLY WITH ENAMEL, A FUNDAMENTAL COMPONENT OF ART DECO.

FACING PAGE

Tank L.C. Wristwatch

CARTIER PARIS, 1921

Marked on the dial: *Cartier*
Sold to the Maharajah de Rajpipla

Case of polished and satin-finish gold, *brancards* of polished gold and black enamel. Beaded winding crown capped with a sapphire cabochon. Leather strap, pin buckle. Square grained-silver dial with Roman numerals around a railroad minute track. Apple-shaped hands of blued steel.

❖ *Round LeCoultre caliber 123 movement, fausses Côtes de Genève decoration, rhodium-plated, 8 adjustments, 19 jewels, Swiss lever escapement, bimetallic balance, Breguet balance spring.*

WCL 117 A21

ABOVE

Maharana Shri Sir Vijayasinhji Chhatrasinhji, Maharajah of Rajpipla (1890–1951) at his home The Manor, Old Windsor, Berkshire, in 1927.

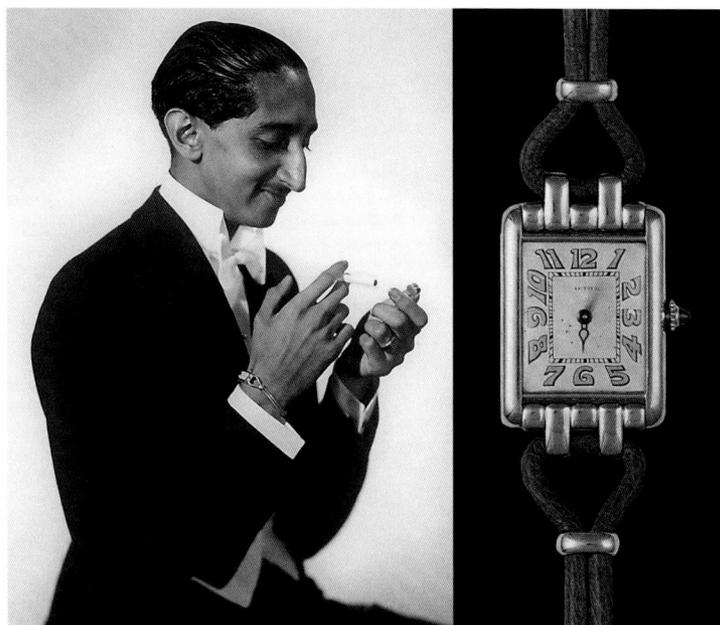

At this time, too, another decoration occasionally enlivened the rigorous purity of the *Tank* case by rejecting its vertical linearity. These were special decorative metal strap attachments, similar to more traditional watches of the period.

In fact, it was more often the straps themselves that gave Cartier an opportunity to increase the ornamental aspect of the new watch. At the time the *Tank* was introduced, there was a vast choice of straps in fabric or leather, and bracelets in platinum, gold, silver, and plated metal. Straps of watered silk or fabric were reserved for ladies' models, with leather straps mostly fitted on men's. In the 1920s, braided bracelets of cords that formed a system of loops were favored for many women's watches. It was quite similar to the narrow, articulated and extendible metal bracelet that was popular at the start of the century. The cord bracelet was fixed to the *Tank* with *brancards* in the form of loops, quite different from the *Tank brancards*.

The watch was available with a very large range of metal bracelets. It is a common misconception that the Art Deco movement abandoned gold. The links favored in Art Deco, with parallel intersections and transversal pins, were assembled in vertical and horizontal lines. They could almost have been made for the *Tank*. In the 1920s and 1930s, as endless combinations of cases, bracelets and dial graphics were tried, the main trends emerged: large patterns of strong, flat surfaces were preferred for use with the sharp-edged cases of the original *Tanks* or the *Cintrée* and *Allongée* models. Finer patterns of Figaro or Milanese links that curved easily, or large links with rolled loops often appeared with the *Tank L.C.* and the *Tank Allongée*. For small models, a concern for personalization led to stricter choices: the 8-line caliber of the first *L.C* and *Allongée Tanks* never adopted the classic large basket weave mesh. This, however, was the obligatory metal bracelet for the 7-line *Petite Tank Rectangle*.

There was a fundamental distinction between a strap in leather or fabric, and a metal bracelet. The difference between them was probably most apparent, and most definitive, in the *Tank* watch. A leather or fabric strap emphasized the striking geometry of the case that perfectly fitted the modern notion of time-measurement. A metal bracelet completed the seamless integration of the three elements: case, *brancards* and bracelet. Leather made the *Tank* a wristwatch. Metal made it a bracelet-watch.

Naturally, this difference produced different effects depending on the family of *Tank*. Applied rigorously, it meant that a leather strap would be preferred for square cases such as the *Tank L.C.* and the *Tank Chinoise*, and a

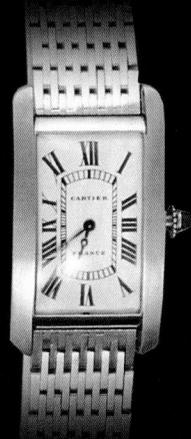
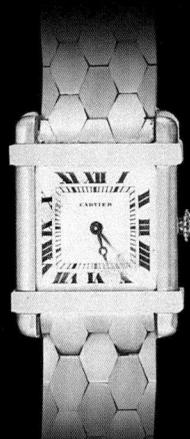

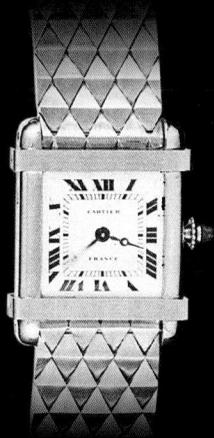
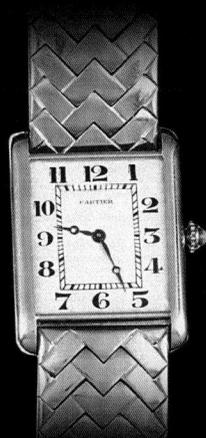
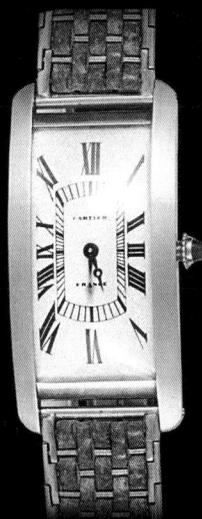

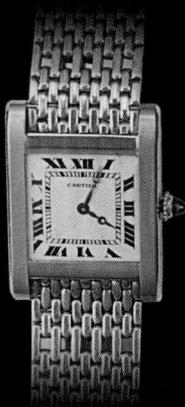
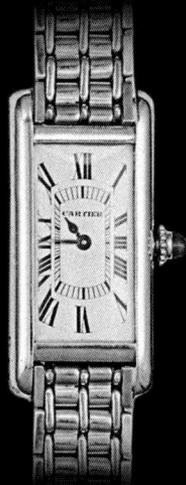
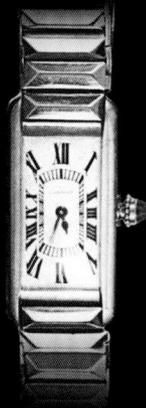
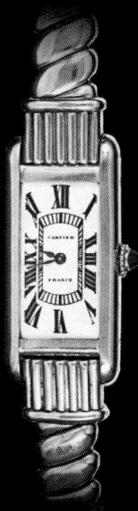
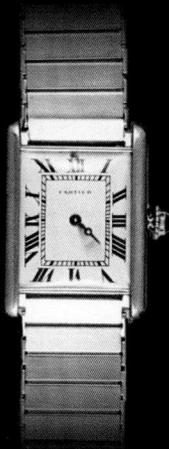
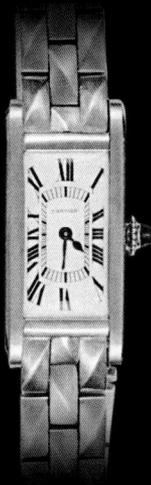

The more personal touch desired for smaller models dictated a more restricted choice: the 8-line caliber versions of the *Tank Carrée*, the *Tank L.C.* and the *Tank Allongée* were never associated with classic broad basketweave mesh, which was by contrast obligatory for the *Petite Tank Rectangle* 7 lines.

FACING PAGE (CLOCKWISE FROM TOP LEFT)
Tank 9 lines, 1927. Gold on special figaro mesh; *Tank Rectangle* 8 lines, 1928. Gold on basketweave mesh in two gold; *Tank Rectangle Allongée* 8 lines, 1929. gold on mesh with ribbed bars; *Tank Rectangle Allongée* 8 lines, 1929. Gold on 3-row gold pavillon mesh; *Tank L.C.* 8 lines, 1929. Gold on polished gold fluted bars; *Tank Rectangle Allongée* 8 lines, 1929. Case and rope-design bracelet of platinum, fluted tube-shaped lugs.

metal bracelet for rectangular cases such as the *Allongée* and, in particular, the curved case of the *Cintrée*. This case could complete the unity of the circle that seemed to have been broken. But the *Tank* could accept both solutions and, in practice, all models were equally harmonious with simple straps of watered silk or leather as with expensive bracelets of gold or platinum.

The subtle play of alternate straight and curved lines or sharp and rounded edges was echoed in matching the case with a bracelet or strap: beauty can flow just as freely from emphasis as from understatement. It is fascinating to note how well the "assault vehicle" in platinum stood out on a crocodile strap, emphasising its modernity that is still so striking today. But it is surprising that, on the same model, the gold bracelet blended perfectly with the gold case, and the *brancards* were less aggressive and less obvious without losing their strong character as rigid, dynamic, firmly vertical elements.

In looking at the range of metal bracelets, it becomes clear how many possibilities were offered by the different types of links, large and small, articulated and interwoven, creating the effect of horizontal or vertical movement. Similarly with the plays of light created by alternating horizontal and vertical orientation, or brushed and polished surfaces. Lastly, the same type of bracelet produced a distinct result on each family of *Tank*. Mounted on a bracelet of Milanese links, a watch with Arabic numerals could create a surprisingly different effect than one with Roman numerals. Anyone wanting to calculate all the different possibilities would certainly need to use a computer.

We might imagine that at the end of the 1920s Louis Cartier thought the æsthetic and functional development phase was now complete. His stature in watchmaking was confirmed: he was one of the pioneers of the revolution that had almost finished, and the creator of several "cult" models. Louis Cartier had showed great prescience in anticipating trends and in grasping the importance of style innovations in jewelry and watches. He would not have been surprised to know that, all the technical advances aside, today's high-class wristwatches still have the same Art Deco cases that he and his designers created from 1904 to 1922. He would have already guessed that what had been achieved in two decades of development work on wristwatch design was more than just a provisional stage in a process of evolution.

Development work stopped at that point, abandoning the great structural and formal themes in favor of exploring the details. This was not so much a sign of exhausted inspiration but rather a result of the new harmony that had been

achieved between function and form. This harmony was so satisfactory that the only way forward was to create various derivatives. In the 1930s two innovative versions of the *Tank* shape were introduced. The first was a short-lived development of the baguette watches that Cartier made its speciality from 1926, using the Duoplan system invented by Jaeger and LeCoultre. As its name suggests, the Duoplan was a mechanism on two levels: one for the gear train and the other for the escapement. The precision of a movement is a function of its balance size and this design enabled the balance to have a diameter almost as large as the entire caliber. It was the extension of a patent registered by the company in 1922 which included positioning the crown at the bottom of the case. In 1931, attempts to integrate these movements into the *Tank* were not successful. Then several "*Tank* form" models appeared with variously modified designs. They were rapidly abandoned.

The second version of the *Tank* shape was the *Parallélogramme* of 1936. Originally its design was unconnected to the *Tank* and had only been moved closer to it shortly before when it was given its current name, *Tank Asymétrique*. It symbolized and adopted all the contradictions of the decade. Its large dial and flat ribbed crown showed its derivation from a new 11-line *Tank* family that we will discuss later. Its lines

were not rigidly straight and it seemed to fit more naturally into an ellipse than an angular shape. Even more radical was the "décalage" of the bezel and the rotation of the markers to put 6 and 12 o'clock in the corners, almost creating a feeling of vertigo, while the disappearance of the railroad minute track made the watch seem even more unreal.

In addition to these original variations, in the mid-1930s the *Tank* design evolved even more. The case saw the development of the 11-line models (their interchangeable calibers enabled the watch to continue functioning during repairs) and the bracelets were enriched by the introduction of new link patterns. The 11-line model was identifiable by its thicker lateral bars, its new graphics with boldface Roman numerals and a right-angular railroad minute track. The crown was flat and ribbed as in the *Tank à Guichets*. The blued-steel hands were either apple-shaped or thick sword-shaped. Both of these types of hand remained in use from that time onwards. In 1935, the shape was developed for curved cases. The result was a curved rectangle that was massive yet soft. Its slightly relaxed proportions and the special dial graphics marked a clear departure from the classic *Tank Cintrée*—and from the company style. The *Grande Tank Allongée* was very much a 1930s creation showing the masculine and feminine traits that had been present since the start. The 11-line *Tank*

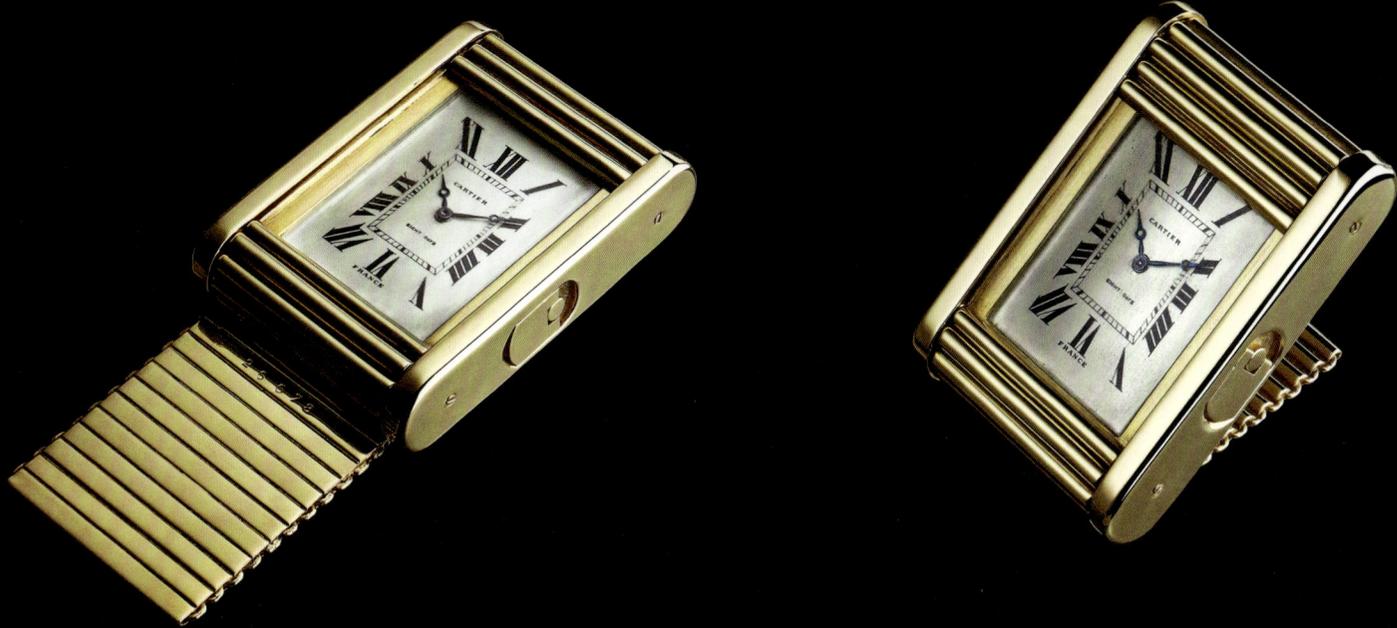

Rectangle celebrated its mass and rigidity by adopting a flat ribbed crown, thick graphics and a right-angular rail-rack, while the *Tank Rectangle Spéciale*, was described as "opening the way" for the *L.C.* In fact, the sharp edges of its *brancards* were softened, and the graphics of its dial went back to Roman numerals that were short and lighter. In 1942, the model in pink gold borrowed the rounded *brancards* of the *L.C.* that had been given a new look.

The metal bracelets followed the same idea, bringing back strong links with large hinges that added to the solid impact of the *Tank Rectangle*, and classic or flexible basketweave mesh for the *Tank Spéciale*. After 1935, as part of the design changes that began with the return to the use of gold, the classic *Tanks* started to accept new bracelet patterns: a play of vertical lines among alternating wide and narrow bands, juxtaposition of little moulded rollers between links, shapes made by braided, contrary lines (creating a chevron motif with the coils of the chain) or parallel lines with a flexibility and orientation that moved the linear case away from its Art Deco inclinations. The unusual relationship between a case and a bracelet can renew, or even recreate, a model: the initial 10-line *Tank* which had never been mounted on a metal bracelet during the 1920s was given a a flat, interlocking 7-row bracelet in

ABOVE
Eight-day watch with sliding strut-cover.
Cartier Paris, 1931. Rectangular case of polished
and satin-finish gold. WO 02 A31

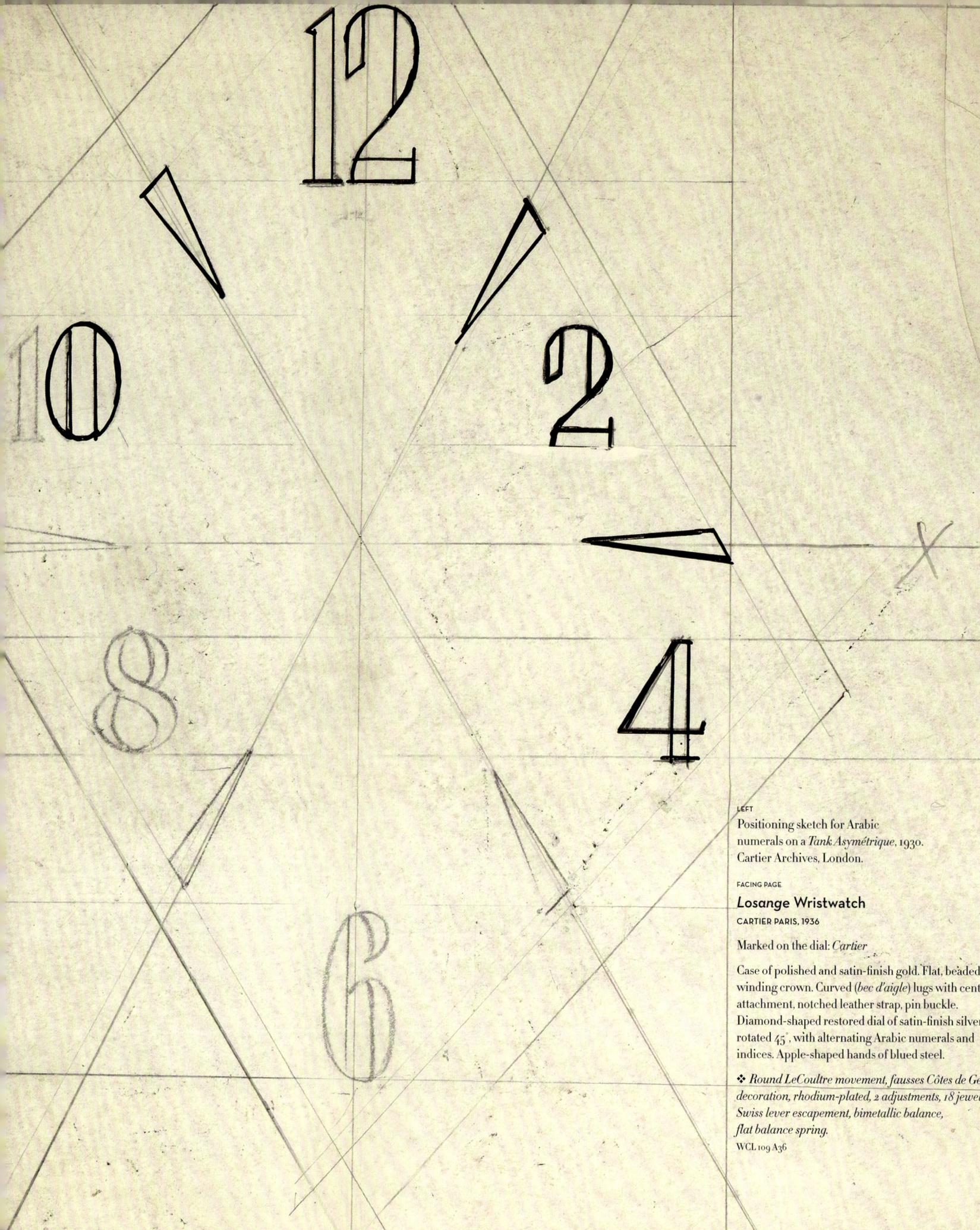

Positioning sketch for Arabic
numerals on a *Tank Asymétrique*, 1930.
Cartier Archives, London.

Losange Wristwatch
CARTIER PARIS, 1936

Marked on the dial: *Cartier*

Case of polished and satin-finish gold. Flat, beaded
winding crown. Curved (*bec d'aigle*) lugs with central
attachment, notched leather strap, pin buckle.
Diamond-shaped restored dial of satin-finish silver,
rotated 45°, with alternating Arabic numerals and
indices. Apple-shaped hands of blued steel.

❖ *Round LeCoultre movement, fausses Côtes de Genève
decoration, rhodium-plated, 2 adjustments, 18 jewels,
Swiss lever escapement, bimetallic balance,
flat balance spring.*
WCL 109 A36

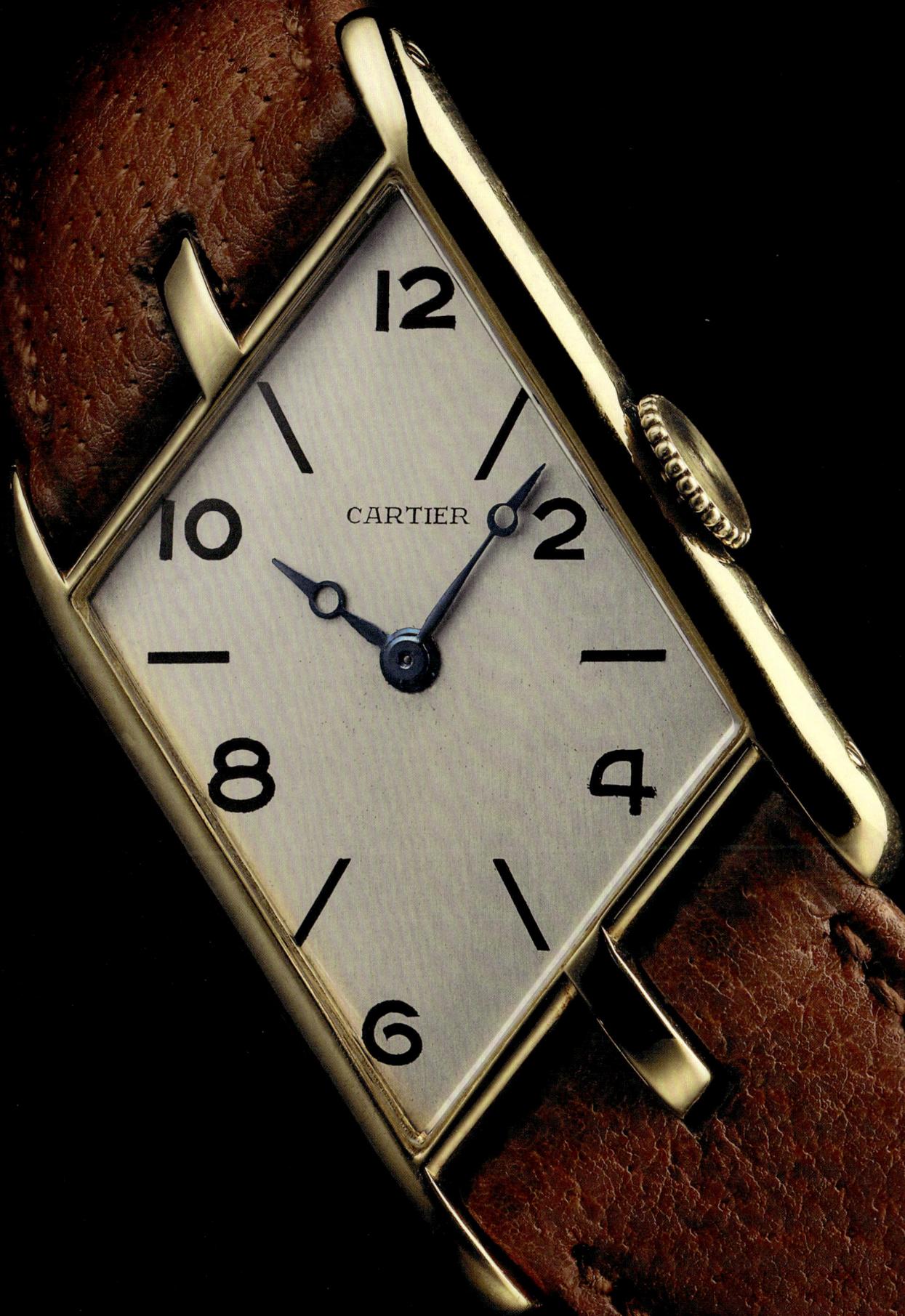

CARTIER: THE TANK WATCH

1931. It adapted perfectly to a model that set out to attract attention.

In the late 1930s, the development of radical shapes led the first *Tanks* and the *L.C.* to significantly enlarge their *brancards*. The sapphire cabochon on the crown and the blued-steel, apple-shaped hands continued to be the *Tank*'s identifying elements. Only the *Tank L.C.* was given "pen" hands in 1938 and 1941.

The Wall Street Crash of 1929, followed by the historic depression, and the accession to power of the Nazis in Germany in 1933 raising the spectre of another war, were events tragic enough to create the climate of pessimism that rapidly pervaded the West during the 1930s. Yet these years were also the period in which all forms of art developed a more direct, though complex, connection to happiness. The introduction of talking films in 1927 accelerated the evolution of cinema, tearing it away from the silent world of mine to create the most realistic fiction that art had ever produced. The gap disappeared between the screen and the audience who became involved in the story as if it were one of their own dreams. Unlike books or the theatre, the cinema fostered total identification and, with it, the self-abandon and irresponsibility that encouraged people to live in a fantasy world.

The talkies revolutionized the art of acting, forcing actors to behave as they would in real life with much more natural accents and attitudes. In just a few years, a generation of highly talented writers had set the rules of the new art and created narrative masterpieces in which the tempo of the performance maintained the constant emotional involvement of the audience.

The cinema was a great comfort at a time that had lived with so much tragedy and, in Europe at least, it helped to spread the notion of modernity. Cinema remained a speciality of America which was technically way ahead of Europe. Through the cinema, iconic objects, such as the car or the telephone, became part of the collective imagination. Stars such as Greta Garbo, Joan Crawford, Clark Gable and Cary Grant directly helped fashion to become a major industry. The world continued to grow smaller, although it was not until the arrival of television that it could be described as a village.

Fashion trends were shaped by the rapid, almost constant, diffusion of stories and photographs, creating a climate that indirectly contributed to the success of the *Tank*. It was a long way from being a popular product: it was a luxury watch intended for a privileged few. But its elegant, almost aggressive simplicity symbolized a modernity that

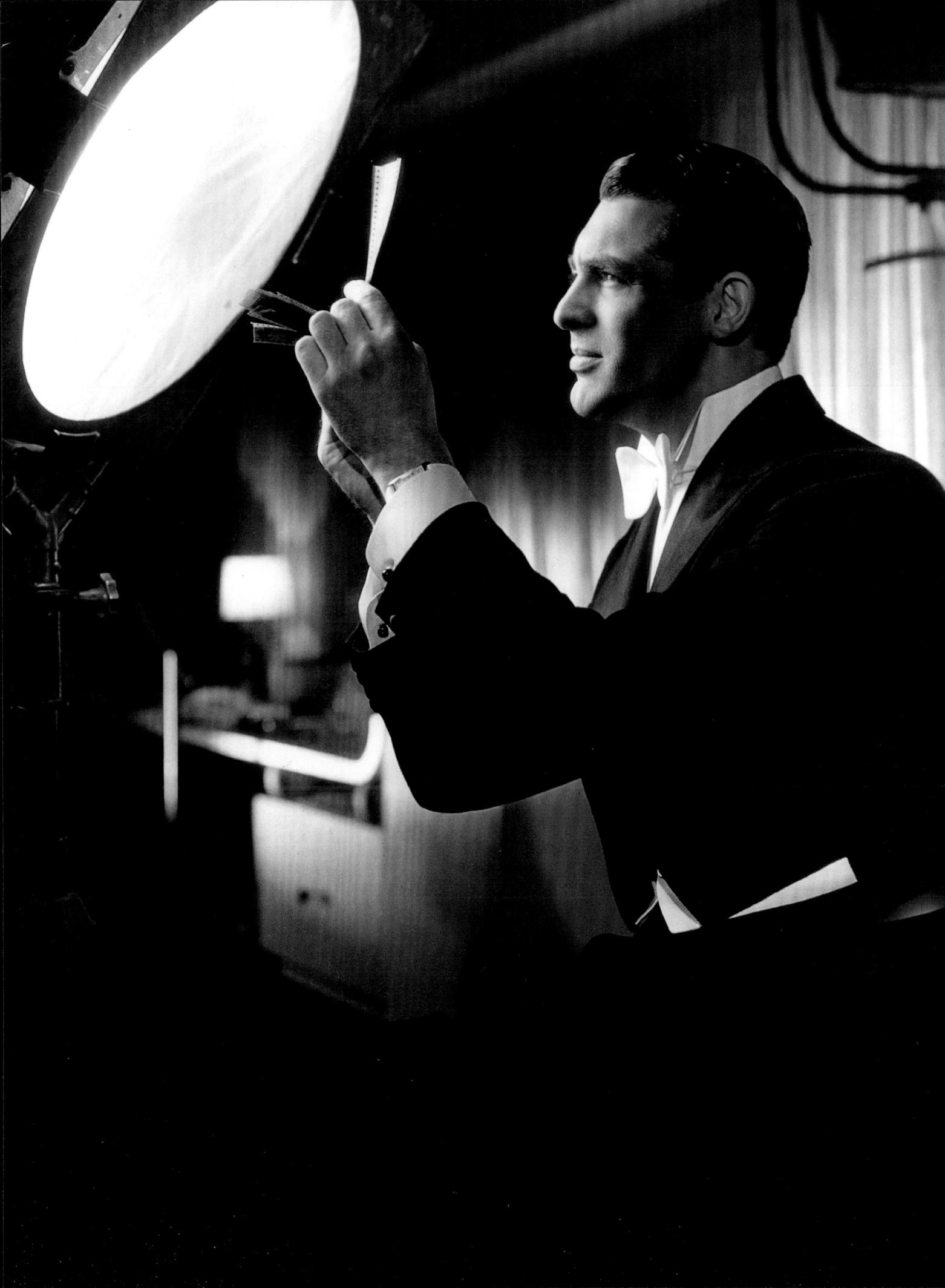

Lighter with watch
CARTIER PARIS, 1929

Gold, black enamel, striped pattern of
gold and black enamel, friezes of black
enamel chevrons and dots. Square
grained silver dial, inner railroad minute
track, apple-shaped hands of blued
steel, square bezel of black enamel with
reserved gold Roman numerals. At top
left, a system for adjusting the flint.

❖ *Round movement, Côtes de Genève
decoration, rhodium plated,
3 adjustments, 15 jewels, Swiss lever
escapement, bimetallic balance wheel,
Breguet balance spring.*
LR 03 A29

most people recognized and which helped them to identify
with their times.

Yet the 1930s marked a serious crisis for the *Tank*, and for
watchmaking in general. Throughout the decade, the level
of demand declined severely right across the economy but
particularly at the top end of the market. And this was just at
the time when, after thirty years of development, the wrist-
watch had managed to replace the pocket watch as the pre-
ferred personal timepiece.

In the mid-twenties, Cartier Paris had regularly sold
around 500 wristwatches a year, a remarkable figure, but
by 1932 this number had fallen to 130. The only year in the
entire decade when annual sales reached 300 pieces was
1937. The orders placed by the three Cartier branches with
Jaeger Paris, a good indicator of turnover in previous years,
show a very strong downward trend during this period.
Paris fell from FF 6,100 000 in 1929 to FF 800,000 in 1932,
New York fell from FF 6,500,000 in 1929 to FF 100,000 in
1932, while London fell from FF 3,500, 000 francs in 1928
to FF 300,000 in 1932. This indicates that in watchmaking,
as in other sectors, the decline was more severe in the USA
than elsewhere. Unlike Paris, which began to recover in
1937, Cartier New York saw its watch sales remain depressed
all through the decade. This long period of depression par-

ticularly affected the evolution of the *Tank* because, just as
creativity had moved its focus from the case to the bracelet,
it had also moved from Paris to New York, as we will see.

Since the minimum value of purchases agreed with
Jaeger could no longer be fulfilled, notice of termination of
the contract was given on July 7, 1933 and came into effect
on July 16, 1934. However, this separation was merely con-
tractual and Jaeger Paris continued to supply Cartier at least
until 1938 and the new entity, Jaeger-LeCoultre, remained
its preferred partner until the end of the 1970s.

In practice, the *Tank*'s solid reputation and the lasting
appeal of its modern design enabled it to retain its almost
hand-picked clientele throughout the 1930s and on to the
end of the war. This clientele included some of the finest
members of the British aristocracy, film stars, and American
millionaires who had survived the depression, such as
Florence Gould, a very important client of Cartier Paris.
Others were Maharajahs and Oriental princes who were not
little affected by the decline of their Western investments.

For Cartier, the crisis proved to be less serious for the
jewelry department than for watches. The 1930s was still a
period of extraordinary creativity for the company. It con-
tinued to develop fantasies in colors and materials, such
as the Tutti Frutti style, but also won over its more refined,

Cartier advertisement made in 1931.
Published in the December issue
of *L'Illustration* featuring a variety of
Cartier creations, including the famous
triple ring and three form watches.
At the bottom is the facade of the Rue
de la Paix premises, with not only
the Paris address but also the addresses
of the New York and London branches.

traditional clients with the formal splendor and simplicity of white Art Deco. As often happens during periods of economic turbulence, the medium- and high-priced models suffered the most while truly exclusive jewelry pieces continued to sell, thanks to their very specific clientele. Around 1925, Cartier Paris sold some 500 watches a year. But while this figure included multiple orders from the Prince of Kapurthala and the royal family of Yugoslavia, most of the sales came from a few hundred other clients, three quarters of whom were in severe financial difficulties after 1929. The most important pieces of jewelry went to that small group of privileged people who survive all market crashes and financial crises, or to those whose careers were flourishing despite the hard times, notably film stars. These few clients were enough to support the jewelry department at Cartier and finance the style development work that continued relentlessly until the war and the death of Louis Cartier in 1942. But in the watch department, creativity declined from the early 1930s, partly attributable to an internal loss of energy and initial curiosity, but mainly to the market conditions that severely cut the volume of sales.

At this time, the leading Swiss manufacturers vigorously reinforced their reputation by introducing the concept of "Fine Watchmaking" that confirmed both the technical perfection of their watches and their image as a status symbol. Within this elite group, which included such names as Patek Philippe, Audemars Piguet, Vacheron Constantin, Rolex, Jaeger LeCoultre and Piaget, Cartier was the exception that proves the rule: it was not Swiss but French, not a watchmaker but a jeweler. But Cartier had made a fundamental contribution to the development of the wristwatch, and legendary models such as the *Tank* had forged its credentials in the Swiss world of watchmaking, while still preserving its French identity. Although it did not manufacture movements it had certainly found suitable partners in the Swiss market to supply them. Most of all, its twenty-five years of design work in wristwatches had been of such a high standard that the competition had been forced to follow its lead unless they wanted to copy it. Cartier thus became synonymous with absolute excellence even in the sophisticated field of watchmaking, combining Swiss reliability with refined French design. The uncontested King of Jewelers became a prince in the highly exclusive realm of watchmakers.

The war had had had three tangible effects on watchmaking: it revived the round case, it emphasized technical-functional features, and it demanded reduced production costs and sales prices. In fact, the war had helped to ease

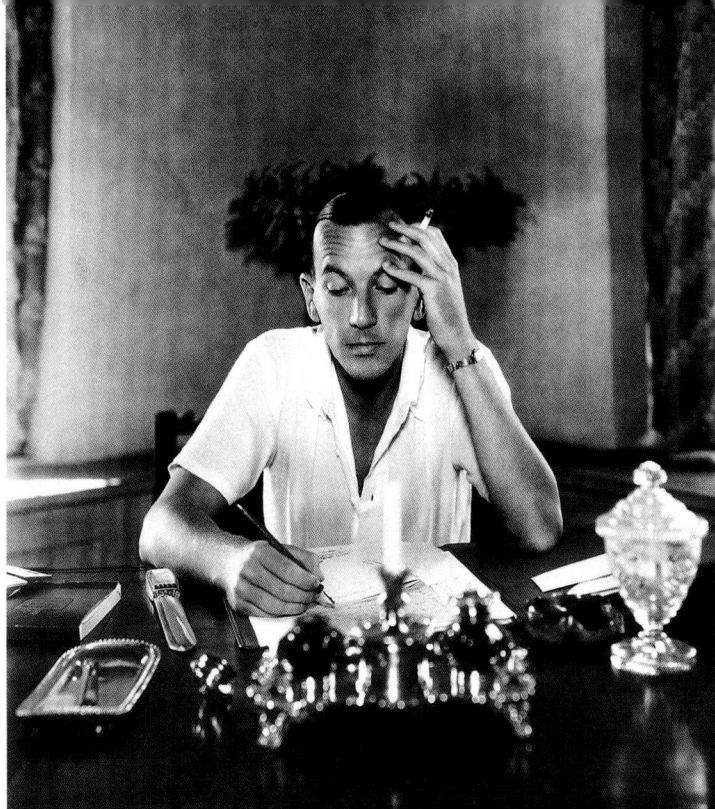

LEFT

Actor and playwright Noël Coward
(1899–1973) at his writing desk at
Gouldenhurst Farm in 1935,
a *Tank* watch around his wrist.

the crisis in the sector thanks to significant orders from both sides for watches that met specific military needs. For armies, of course, function was more important than form. Their key requirements were: readability at night as well as by day, precision and reliability, protection for the glass, a water-resistant case, and chronograph functions. The possibility of reading in the dark led to the development of a whole range of luminescent dials and hands which soon found their way into non-military models.

After World War II, these features became more common, aided by the final domination of the wristwatch and the growth in mass consumption. In 1949 the Timex revolution began. Under this brand name, the American company Waterbury marketed a wristwatch with good technical quality and acceptable design at a price that had no competition. It introduced a concept that was new to watchmaking: the throw-away product. It was highly practical, quite attractive watch, yet it cost so little that it was not worth repairing: it made more sense to throw it away and buy a new one. The figures on their own tell the story of what happened: in the mid-1960s thirty million Timex watches were sold around the world and accounted for half the entire American market. Then of course it became the most famous victim of another revolution in the 1970s and 1980s: the arrival of the quartz watch.

From 1944 to 1946, just as had happened after the 1929 crash, the *Tank* classics suffered an identity crisis, this time in their secondary design features. For example, in the original *Tanks* and the *Tank L.C.*, the railroad minute track disappeared or was reduced to a single line. Numerals with new graphics, semi-markers, and small, ribbed, gently curved crowns began to appear. While fashion still dictated miniaturized cases of jewelry-watch type, the post-war years were devoted to appearance: shapes grew heavier and denser. The 11-line models were at the forefront. The *Tank Rectangle* was reworked in a more compact structure with less enveloping *brancards* and was given a new "thick" model in 1946. In the same year, gold dials appeared on the *Tank Spéciale* and the *Tank Allongée*. The gold in the dials and the heavy cases was everywhere, setting the tone.

From 1948 a more unified *Tank* line became established for almost two decades, concentrating on three models: the original *Tank* (labelled "ordinaire" in the stock registers from 1956), the *Tank L.C.* and the *Tank Cintrée* that returned in 1950. It was the end of a period in the *Tank*'s history. The 1940s seemed to echo the 1930s with seemingly no real rupture caused by the war years. The two decades were years of diversity and openness: the classic models developed on two levels, tradition on one hand, adaptation to fashion on the

Portrait of a woman in 1938 by
the painter Eduardo Malta (1900–67).
She is wearing a *Tank à Guichets*
wristwatch.

other. The 11-line models became a separate group, leading
a parallel life to the classics. Improvements in watchmaking
enhanced the line. But this period also saw a break-up of the
original family: the derivative versions were not systemati-
cally followed-up and certain classics were not developed,
even abandoned. The world of the *Tank* came to resem-
ble a tree with a single root but several trunks, numerous
branches and many off-shoots, some of which flourished
and divided again while others wilted and died. Just like a
family. Just like life. ∎

New Territories

Chapter III

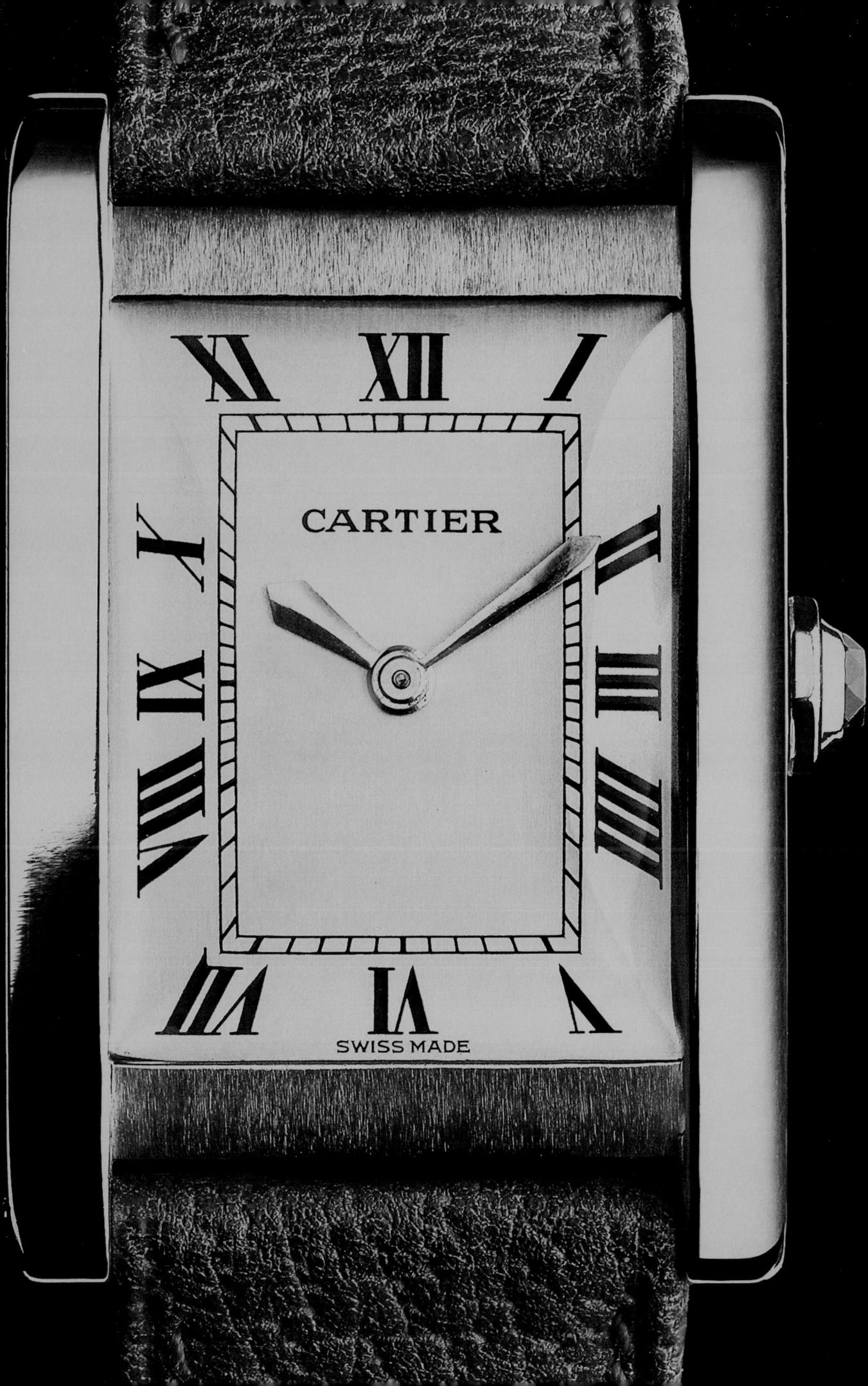

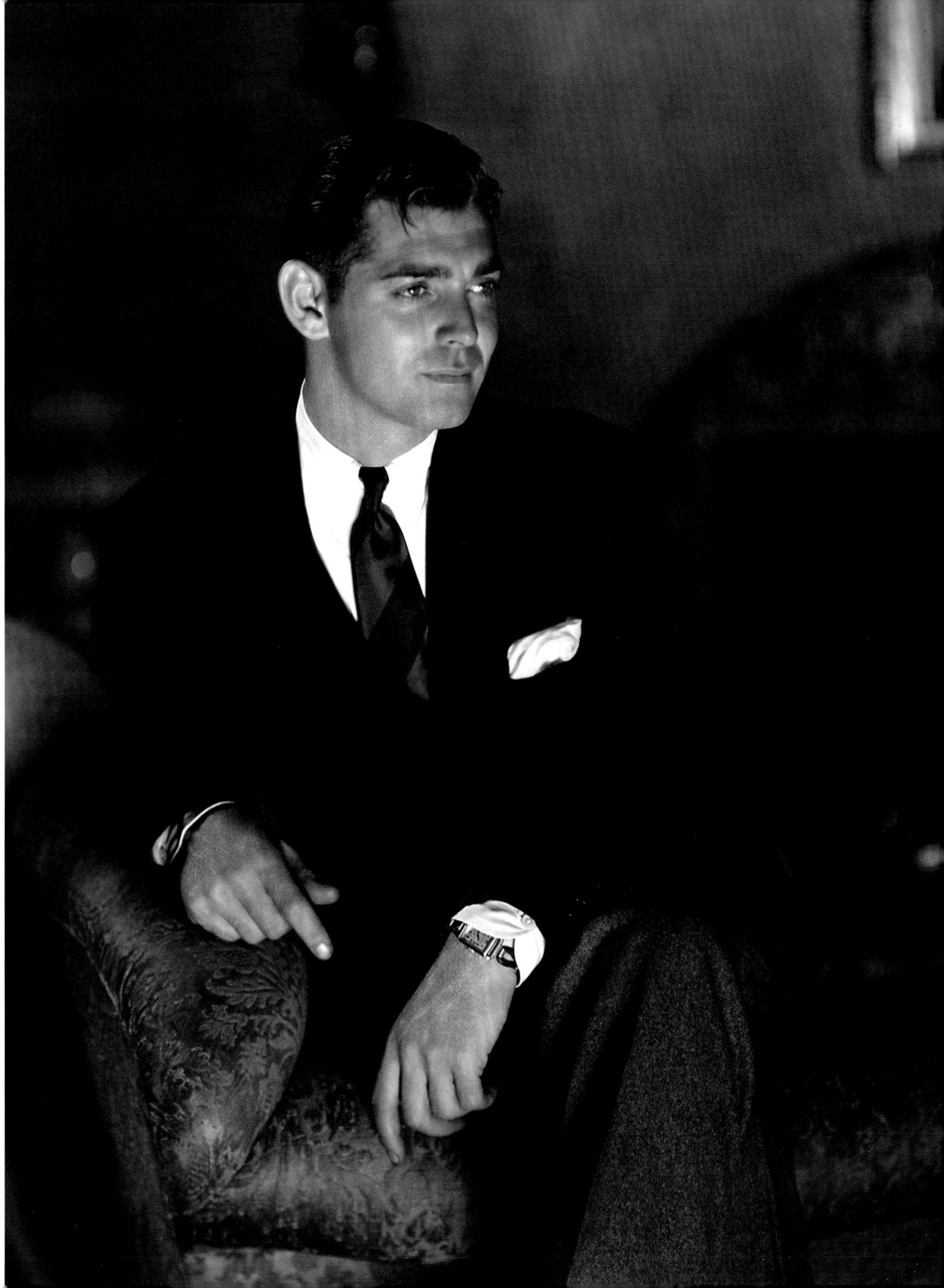

PAGE 99
Tank Rectangle Wristwatch,
Cartier Paris, 1952 (*see page 116*).

FACING PAGE
Clark Gable wearing a *Tank* in 1933.

FOLLOWING DOUBLE PAGE
Paris watchmaking workshops where
jewelry watches were set, circa 1927.

One of the keys to the survival of life on Earth has been its ability to disperse. Plants, animal, humans—none of them would have lasted very long if they had not left their original habitat and taken over new territories. The dispersion of species promoted genetic diversity, increased adaptability and favored natural selection. The *Tank* family tree certainly dispersed. It spread into new areas, producing the same fruit but adding new varieties better adapted to different latitudes and abandoning those that did not flourish. Dispersion made it a survivor in the world of watchmaking and proved that the *Tank* concept had a natural vigor that could happily travel the world and prosper in all climates. Its seeds were carried abroad by the strong wind of enterprise, first to the other side of the Atlantic.

In 1909, Cartier opened a boutique in New York. It was important to be present there because almost one third of the great fortunes accumulated in the Gilded Age were located in that city. So Cartier's first branch was established on the second floor of a building at 712 Fifth Avenue, New York. It was headed by Pierre Cartier who had recently married an American, Elma Rumsey, the daughter of a St Louis businessman and associate of the railway financier, John Pierpoint Morgan. In 1917 he found a more suitable address, a beautiful building just twelve years old at 653 Fifth Avenue on the corner of 52nd Street. It was owned by the banker Morton Plant whose wife Maisie adored pearls. Cartier invited him to exchange the building for two fabulous strings of pearls estimated to be worth one million dollars. Plant accepted and the sale took place for just one hundred dollars more. Cartier then had the interior redesigned by Welles Bosworth the architect for the Rockefellers and divided it up, like the Paris shop, into small rooms: the *salon Bleu*, the *salon des perles*, the *salon de l'argenterie*.

Shortly afterwards, he brought over craftsmen and designers from Paris and set up a workshop to produce his own jewelry and accessories. It was located on the fifth floor of the building and named American Art Works. It eventually employed up to 70 people. A second workshop was added in 1925 specialising in working with gold.

With regards to watchmaking, in its early years, Cartier New York was almost exclusively supplied with watches from Paris, produced by Edmond Jaeger. Repairs were carried out by the New York watchmaker, Braun. But Braun soon started to create new models specifically for the New York branch: in 1910 he designed an extra-thin pocket watch in rock crystal set with diamonds and with a hidden winding crown. It was such a success that Braun went on to create other similar watches, starting in 1912 with models in

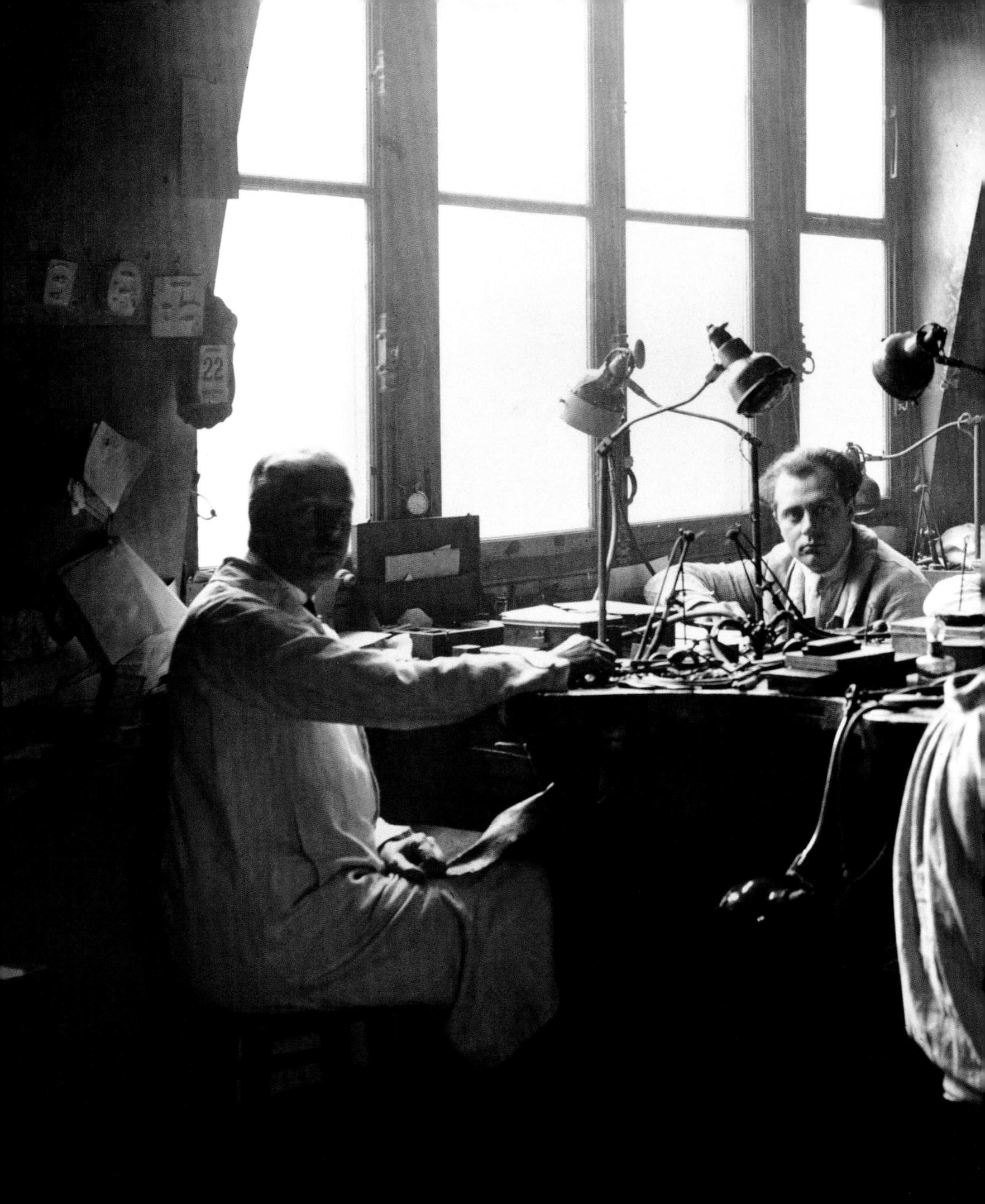

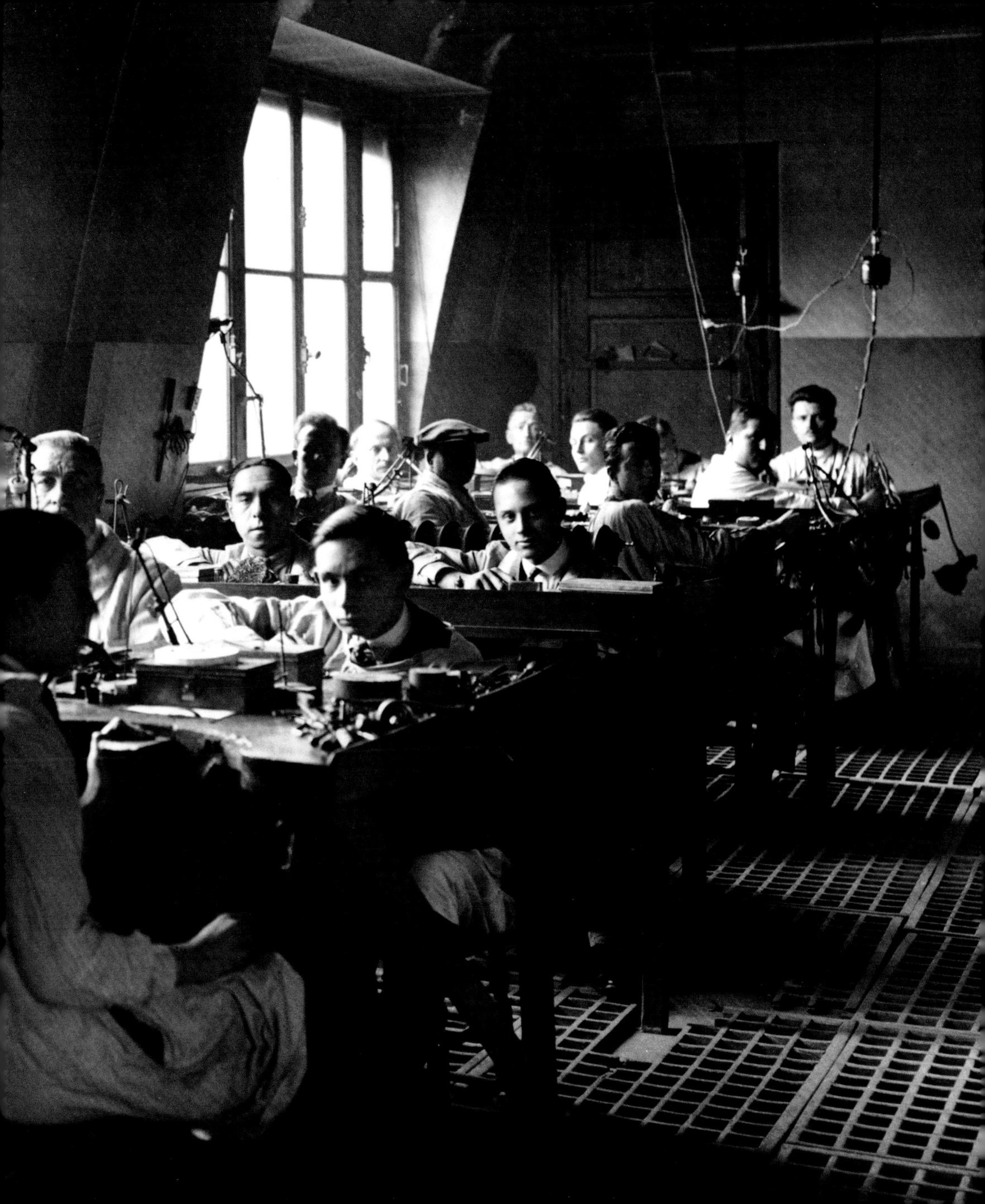

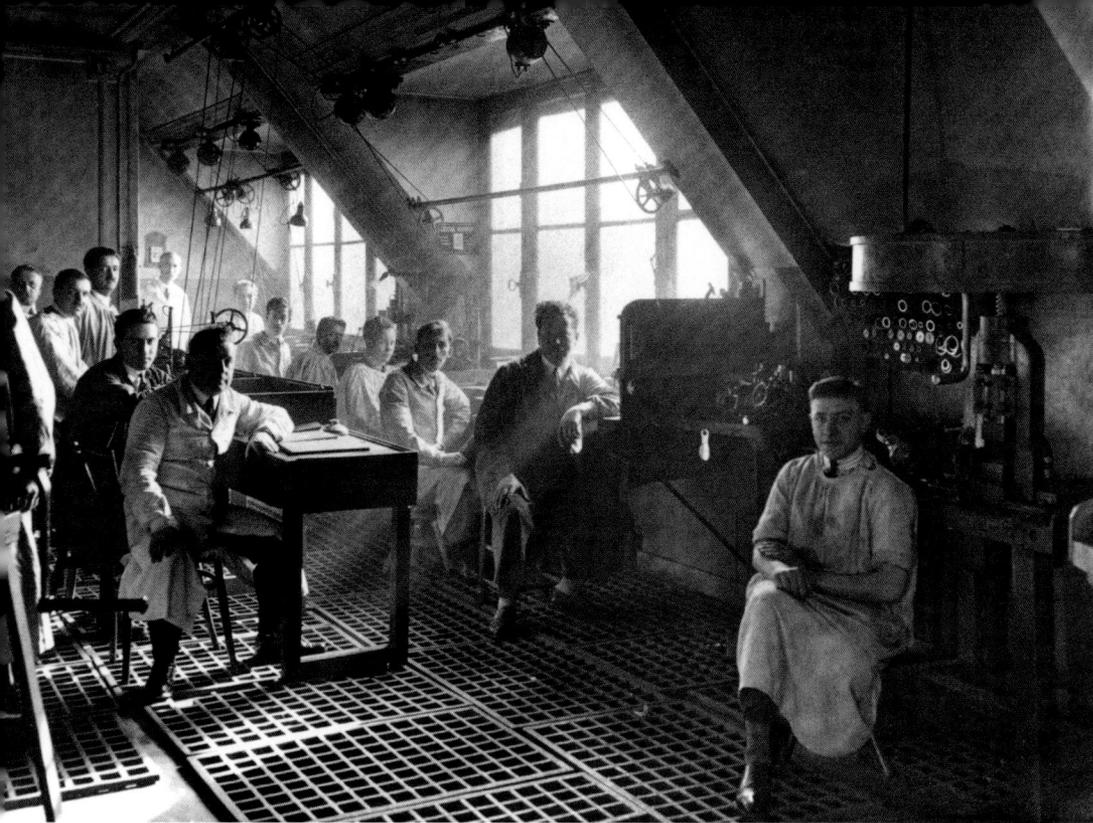

LEFT
Paris watchmaking workshops where
the *Santos* and *Tank* models were
produced, circa 1927.

FACING PAGE
Movement of the *Tank* Wristwatch,
Cartier Paris, 1920 (*see page 30*).
Round LeCoultre caliber 119 movement,
Côtes de Genève decoration, rhodium-
plated, 8 adjustments, 19 jewels, Swiss
lever escapement, bimetallic balance,
Breguet balance spring.

geometric shapes. One of them was a single-hand design of such elegance that Pierre Cartier adopted it as his personal watch. However the Braun watches remained an exception. The volume of stock sent from Paris was now so significant that Edmond Jaeger set up his own small office in New York.

This situation changed significantly in 1919. In that year, while the *Tank* was being launched, the New York branch became a full subsidiary, Cartier Inc., with Pierre Cartier as its President. The new entity soon took control of the European Watch and Clock Co. Inc., better known as EWC, that concentrated on manufacturing and importing watchmaking products and optical instruments. From 1920, Cartier Inc. sourced the movements to be used in its watches through EWC, all stamped "European Watch and Clock Co Inc." They were ordered from the Société Anonyme des Établissements Edmond Jaeger, and manufactured by LeCoultre in Switzerland. (Note: from that time until the mid-1950s, in order to simplify the export process, all the movements supplied by Jaeger and LeCoultre to any Cartier company were stamped "European Watch and Clock Co Inc.") By providing this direct link between Cartier New York and Jaeger and LeCoultre, EWC made it feasible for Cartier watches, particularly the *Tank*, to conquer the United States. In the country where "time is money," the

wristwatch soon became a popular consumer product, selling much more widely than in Europe.

Cartier New York started to devote a large part of its creative energy and financial resources to its watchmaking department. During the next few decades, the New York company set up design and assembly workshops that produced a whole series of versions of the basic *Tank* models and, particularly, a wide range of bracelets.

By the end of the 1920s, creative development for the *Tank* seems to have moved from Paris to New York. While Paris focused on a few technical improvements, derivations and the effects of changing fashions, New York independently started to create new lines that respected the original concept, specifically aimed at the American public. In 1929, New York marketed a *Tank Shape* with a flat case, developed from the 8-line Paris model, but it was bolder, less feminine, with the radiating Arabic numerals that Paris kept for the *Tank Cintrée*. At that time, the Paris *Tank Cintrée* had flat *brancards*. The New York *Tank* echoed this model, while still remaining distinctive, and opened the way for the 9-line *Tank Allongée* of 1930 which was itself derived from the 1929 *Tank à Guichets*. So far from diverging, the two worlds actually came together in the thrust of their evolution.

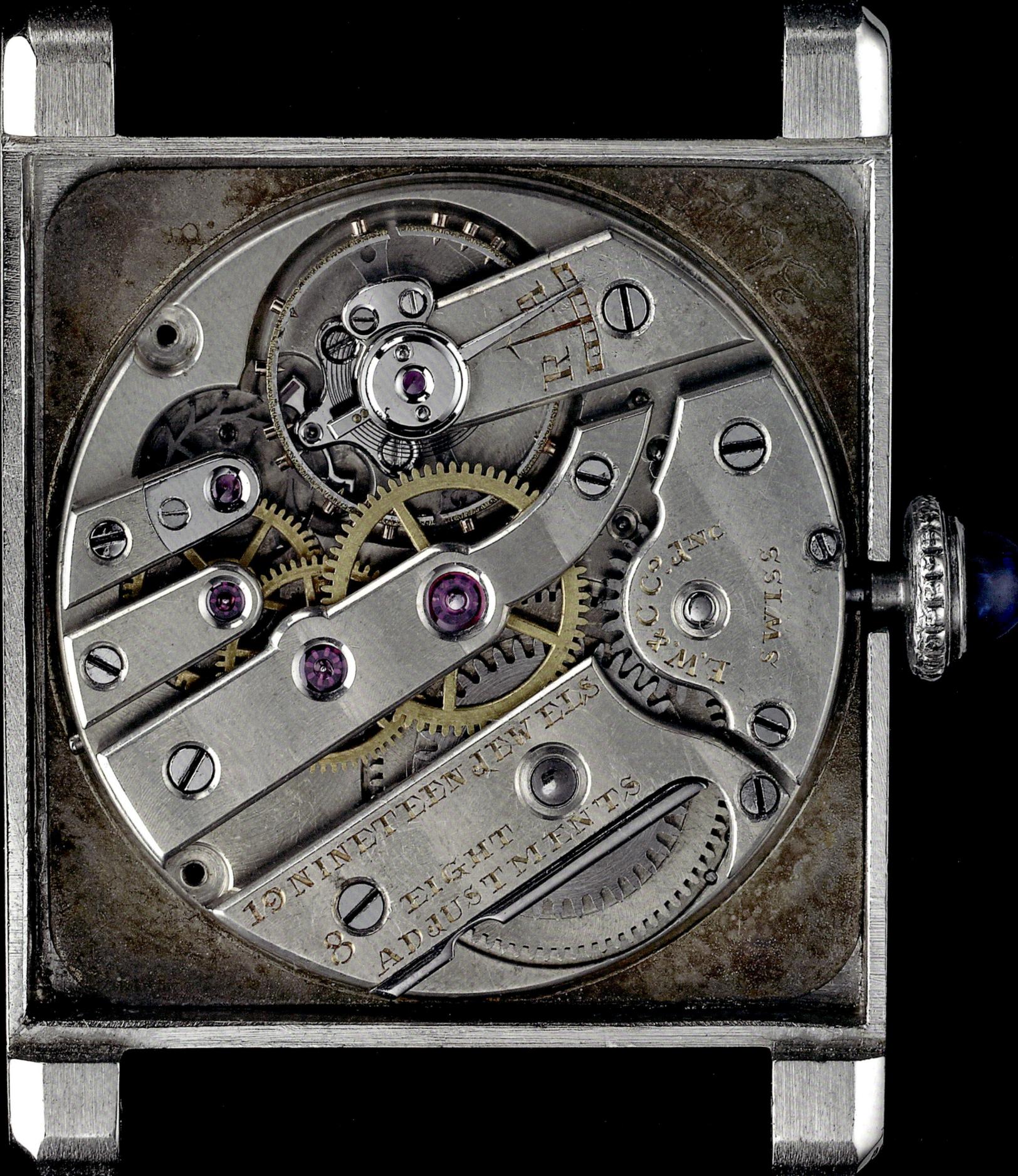

In 1909, Cartier New York opened at 712 Fifth Avenue, moving to 653 Fifth Avenue in 1917. On December 1, 1919, Cartier Inc. was established in New York. It very quickly took over the European Watch and Clock Company Inc. (E.W.C. Co. Inc.), which was principally concerned with the manufacture and import of clocks and watches, jewelry and optical instruments. From 1921, Cartier Inc. acquired through EWC movements to be used in their watches, many of them stamped "EWC." Commissioned from the Société Anonyme des Établissements Edmond Jaeger, they were manufactured in Switzerland by the firm of LeCoultre.

FACING PAGE (CLOCKWISE FROM TOP LEFT)
Square Gold Chinese Tank, 1935;
Gold Chinese Tank, 1942;
Gold Chinese Tank, case of satined gold with polished *brancards,* 1952;
Square Gold L.C. Tank, 1944.

RIGHT
Curved Tank Wristwatch
CARTIER NEW YORK, 1937

Marked on the dial: *Cartier*
Engraved on back of case: a name and a date

Curved case of polished and satin-finish gold, *brancards* of polished gold. Flat, notched winding crown. Leather strap, pin buckle. Curved dial of grained silver with satin-finish center; 8 Arabic numerals set vertically around radial indices for hours and minutes. Apple-shaped hands of blued steel.

❖ *Round LeCoultre caliber 9JN movement, fausses Côtes de Genève decoration, rhodium-plated, 8 adjustments, 2 positions, 19 jewels, Swiss lever escapement, bimetallic balance, Breguet balance spring.*
WWG 15 A37

However, at certain times they did make different choices in promoting particular models. From 1933 to 1935, two neglected classic models, the *Tank Cintrée* and the *Tank Chinoise,* which had been dropped at the Rue de la Paix boutique because they were considered "too 1925," were used by Cartier New York to firmly establish both the brand and the line. The *Curved Tank* of 1933 had the same proportions as the 8-line *Tank Cintrée* but seemed to slightly accentuate the sharpness of the *brancards,* while the *Curved Grand Tank* of 1934 had less volume than the Paris 9-line *Cintrée.*

Arabic numerals predominated in dial graphics. In 1934, the *Curved Grand Tank* adopted a "semi-index" dial: between the white Arabic numerals outlined in black at 3, 6, 9 and 12 o'clock, bold black markers disrupted the previously classic hour circle. From 1934, cursive lettering progressively replaced the baton-shaped characters and became one of the distinctive features of Cartier New York.

At the end of the decade, the New York line of *Tanks* clearly differentiated itself by reviving the classic shapes: the new *Curved Tank* of 1937 was narrower than the *Cintrée* with the dial squeezed between very flat *brancards.* It ushered in a highly original series of more elongated curved cases. Two years later, the first *Square Tank* reduced the overshoot of the *brancards* and created a solid connection

between them and the horizontal bars, firmly re-establishing the square shape of the original *Tanks.* At the same time, the *Square Tank L.C.,* a derivative model, was introduced. This was an unusual *Tank* because its squareness was an illusion: the horizontal bars were refined to such a point that the bezel was, in fact, rectangular. It differed radically from the original L.C.: the fine curved *brancards* of the Paris watch had turned into flat, right-angled bars which, although less sharp than on the *Curved Tank,* made it a more imposing model with a new, greater density. Nevertheless, these models had some of the classic features of the *Tank* with their Roman numerals, their apple-shaped hands and their sapphire cabochon on the crown—which was sometimes sunken—another New York touch. At this time, too, New York was imposing its taste in metal bracelets, preferring fine links such as in the 17-row basketweave design mounted on a platinum *Curved Tank* in 1942.

At the start of the 1950s, as Paris was bringing back the original *Square Tank,* together with an 8-line *Petite Tank,* Cartier New York was developing its own *Square Tank* in a *Small Tank* version with very short *brancards* that emphasized the simplicity of the square. But New York took a different direction in 1952, adopting "index and semi-index" dials with Arabic numerals and studs, and abandoning the

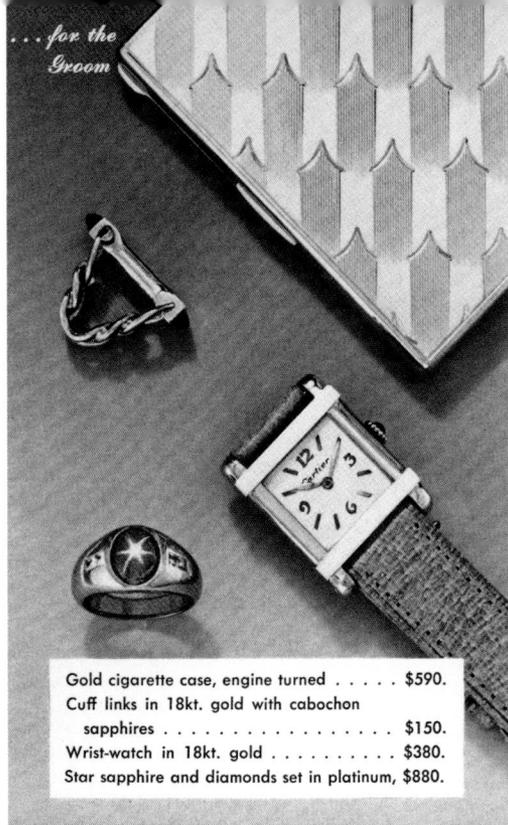

Gold cigarette case, engine turned $590.
Cuff links in 18kt. gold with cabochon
 sapphires $150.
Wrist-watch in 18kt. gold $380.
Star sapphire and diamonds set in platinum, $880.

LEFT
Page from a catalog of men's accessories
showing a model of the *Tank Chinoise*.
New York 1951. Cartier Archives, New York.

In the mid-1930s, Cartier New York designers
created a *Tank* line which developed and enriched
the *Tank*'s original æsthetic principles of 1919.
Two classics, the *Curved Tank* and the *Chinese
Tank*, established the name and production
of Cartier New York.

FACING PAGE (CLOCKWISE FROM TOP LEFT)
Gold Curved Tank, *1934*; Gold Curved Tank, *1935*;
Gold Curved Tank, *1942*; Gold Curved Tank, *1934*.

railroad minute track more often. And, unlike Paris and London, it also abandoned the *Tank L.C.*

The *Grand Tank* that then appeared resumed the structure of the late 1930s with a narrower case and *brancards* with cut ends: it also altered the model's linearity to an oblique design. The curved shape was completely renewed by the applied hour markers in gold, by the flat winding crown and by moving the delicate railroad—when it existed at all—out to the edge of the dial. The contemporary model to the *Grand Tank*, the *Rectangular Tank* had a dial that was the most to the *Tank* structure with its circular minute scale, large radiating markers and Arabic numerals at 6 and 12 o'clock. Like the *Grand Tank* it distanced itself from the very French, classical shape of the Paris model.

But the *Square Tank*, which was also reborn in the New York workshops in the early 1950s, was firmly classical. It stood alongside the *Chinese Tank* that retained the proportions of the *Tank Chinoise*. Yet, it clearly deviated from its original influences with a "semi-index dial," Arabic numerals, an exterior railroad minute track and a bracelet of contrary coils.

The metalwork of a bracelet was a clear sign of when and where it was created. In both Paris and New York the choice varied between two designs. The vertical arrangement of the links that were traditionally assigned to *Tank* models: a flexible mesh of flat and half-ring basketweave; or the style of the 1950s that favored oblique lines and contrary coils forming chevron or *pailasson* motifs. In New York they happily created chevrons in fine, loose links, cutting the metal into small flat-rolled or rounded surfaces, as in the bracelets mounted on a *Gold Grand Tank* and a *Gold Square Tank* in 1952 and 1954.

The Cartier family sold the New York company in 1962 and in the early 1970s its new owners focused on the large-volume production of gold-plated *Tanks*. Pricing them at around 150 dollars substantially increased sales but dented the prestige of the brand. However, the fact is that, while this commercial decision had a negative impact on the company's image, it led to extraordinary sales across America and made the *Tank* the most famous watch in the world. The "real" *Tank*, the precious *Tank*, then became a cult object. But operations that risked eroding *Tank*'s worldwide image would not happen again: in the second half of the 1970s, Cartier New York, like Cartier London, was brought together with Cartier Paris under the leadership of Robert Hocq as President.

Although it had been developed along specifically American lines, the *Tank* had always been admired in America

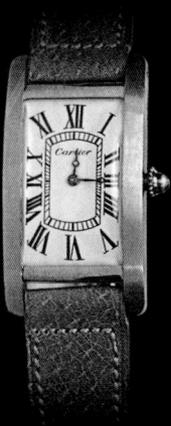

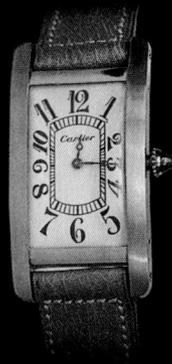

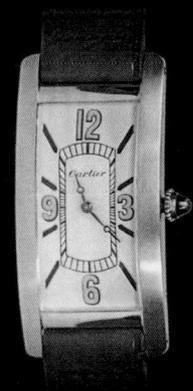

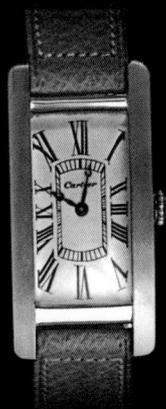

FACING PAGE
Gary Cooper, a legend of Hollywood's golden age and a symbol of masculinity and elegance, was a *Tank* lover. Here he is wearing his *Tank Basculante*. Circa 1940.

RIGHT
Stewart Granger, posing for posterity with his gold *Curved Tank* on a 7-row flexible tile bracelet, circa 1954.

ALTHOUGH IT HAD BEEN DEVELOPED ALONG SPECIFICALLY AMERICAN LINES, THE *TANK* HAD ALWAYS BEEN ADMIRED IN AMERICA FOR ITS "FRENCH TOUCH" OF ELEGANCE AND REFINEMENT, AS WELL AS FOR THE HIGH QUALITY OF ITS MOVEMENTS.

"Take that terrible watch off your wrist
and wear this!" When the embarrassed
journalist tried to refuse, Truman Capote
insisted: "No, please take it. I've got
at least seven of them at home!"

for its "French touch" of elegance and refinement, as well as for the high quality of its movements. This made the *Tank*, whether bought at Cartier New York or elsewhere, a real success story on the other side of the Atlantic, and it remains so today.

The first Americans to own a *Tank* may have been General Pershing and some of his officers. According to a company story, Louis Cartier offered them a prototype just after the victory in 1918. What is more certain is that from the 1920s celebrities began to wear the watch in America. The first was an Italian who had emigrated to New York at the age of 18, the star of the silent films, Rudolph Valentino. In the 1930s, personalities such as the newspaper magnate, William Hearst, Lady Mountbatten, the billionaire Barbara Hutton, and the eccentric actress Tallulah Bankhead acquired a *Tank* from Cartier New York. Others were giants of business and finance, as well as a good number of artists and film stars. Clark Gable bought an original *Tank* then an *L.C.*, Duke Ellington chose a *Tank à Guichets*, Gary Cooper a *Tank Basculante*, and Steward Granger a *Curved Tank*. Another famous admirer was the Francophile composer Cole Porter whose musical comedies were a huge success on Broadway. He may have seen real tanks in action when he served in France in the Great War. The list grew to include Elizabeth Taylor, Rex Harrison, Cary Grant, Yul Brynner, Bob Hope, Peter Sellers and Henry Fonda.

Over the years, many others joined them in wearing the iconic watch. In the 1960s and 1970s, the most famous were Jackie Kennedy, who was often seen wearing the *Tank L.C.* This model was very much in vogue and was the choice of Warren Beatty and the artist Andy Warhol. It was also the favorite watch of the boxer Mohamed Ali. A famous writer shared his preference: Truman Capote, the author of *Breakfast at Tiffany's* had a large collection, but declared that he never wound the watch because he didn't wear it to tell the time. On one occasion, Capote was being interviewed for *Esquire* and learned that it was the interviewer's birthday. He took off his *Tank* and said to him: "Take that terrible watch off your wrist and and wear this!" When the journalist tried to refuse, he insisted: "No, please take it. I've got at least seven of them at home!" In the 1980s and 1990s one of the most famous English actresses who loved the *Tank* was Jacqueline Bisset whose particular favorite was the *Tank Allongée*. More recently, other stars have happily displayed their *Tanks* such as Angelina Jolie and Jennifer Garner. Lastly, for her 2009 official portrait as First Lady, Michelle Obama wore a *Tank Française* on her wrist. Cartier could never have hoped for a more beautiful tribute to its iconic watch.

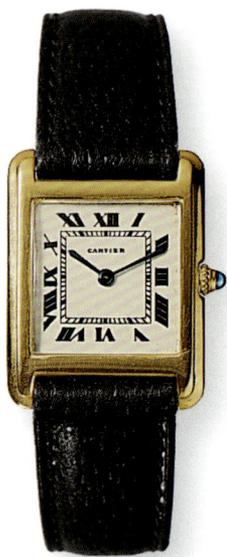

Extra-thin Wristwatch
CARTIER PARIS, 1955
Marked on the dial: *Cartier*
Sold to Françoise Sagan

Square extra-thin case of polished gold. Beaded winding crown capped with a sapphire cabochon. Rounded lugs, leather strap, pin buckle. Square white dial with Roman numerals around a railroad minute track. Sword-shaped hands of blued steel.

❖ *Round LeCoultre caliber 169 movement, Côtes de Genève decoration, rhodium-plated, 2 adjustments, 18 jewels, Swiss lever escapement, bimetallic balance, flat balance spring.*

Until it was altered in 1956, this watch had a dial with narrow indices and a flat, notched winding crown flush with the case.
WWG 42 A55

Mohamed Ali bought a *Tank* on February 14, 1976 when in Puerto Rico to train for his fight with Jean-Pierre Coopman. A few months later, the World heavyweight champion posed for his official photographer, Howard L. Bingham.

During this time, the *Tank* family tree continued to flourish in Paris. But at the end of the Second World War, the Paris *Tanks* began to return to their roots and followed a different evolutionary path from those of New York. It was a period of reconstruction all across Europe with strong economic development and an impressive expansion in sales of consumer goods. In just 20 years, the car, which had been a luxury product, became more accessible. Poorer families started acquiring refrigerators, washing machines and TVs, changing the quality of life as well as social relationships. The late 1940s to the early 1960s was the time of the Baby Boom, a demographic explosion that reflected the public's more optimistic outlook.

But this material prosperity masked a cultural emptiness that could almost be described as the real phenomenon of the times. The twentieth century, that had started with such a burst of creative vitality, seemed to have run out of energy for innovation. After the First World War, the strong movement for change produced an unexpected formal order but now now the opposite was happening: the lack of dynamism was resulting in formal disorder. It was most obvious in what was justifiably called "informal art," since all attempts to turn this disorder into a trend or a style ended in failure.

At Cartier Paris, the lack of new ideas coincided with an internal crisis of succession: the death of Louis Cartier in 1942 threatened to turn off all creative energy in the family company. But the dynamism and intelligence of Jeanne Toussaint, who directed the jewelry department, made the following decade a highly imaginative period, bringing back the naturalist style and strongly developing the animal theme. These ideas ushered in a prestigious period of originality in Cartier jewelry but they were nonetheless difficult to adapt to the world of the wristwatch. One jewelry trend that was reflected in watchmaking was the return to gold at the expense of platinum, and this produced the only significant design modification to the *Tank*: the launch of gold models with a gold dial.

Nevertheless, the *Tank* was met with success once again in the 1950s and 1960s. In fact, it was helped by two factors: the widespread growth of the wristwatch in general and the resurgence of the round case as opposed to the shaped. The *Tank*'s success was still based on its originality, together with its beauty, its persistent modernity and its refinement that attracted a clientele who wanted to stand apart.

The unprecedented spread of semi-industrial manufacturing in the 1950s meant that products and tools had to be created with mass production in mind. This fostered the

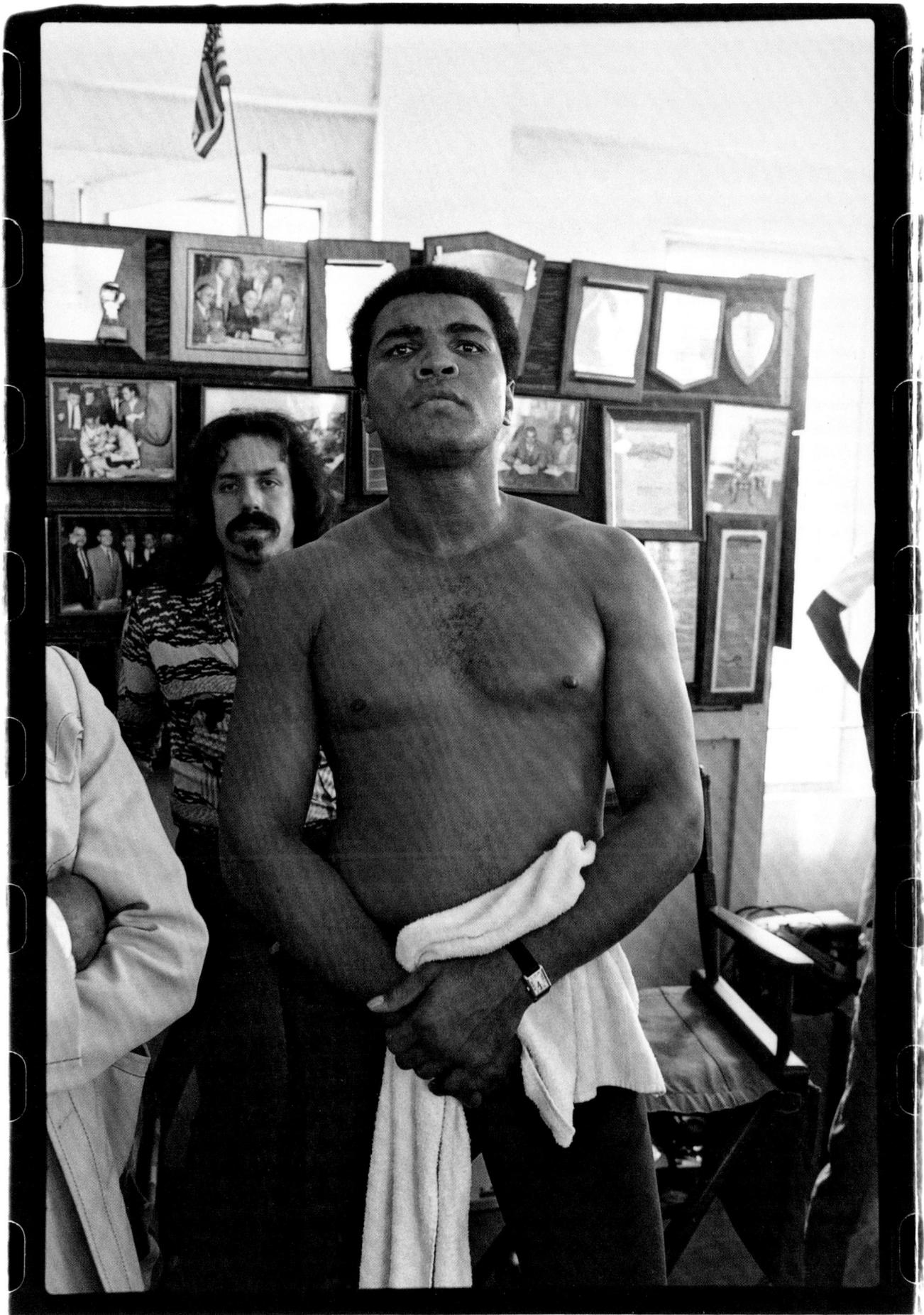

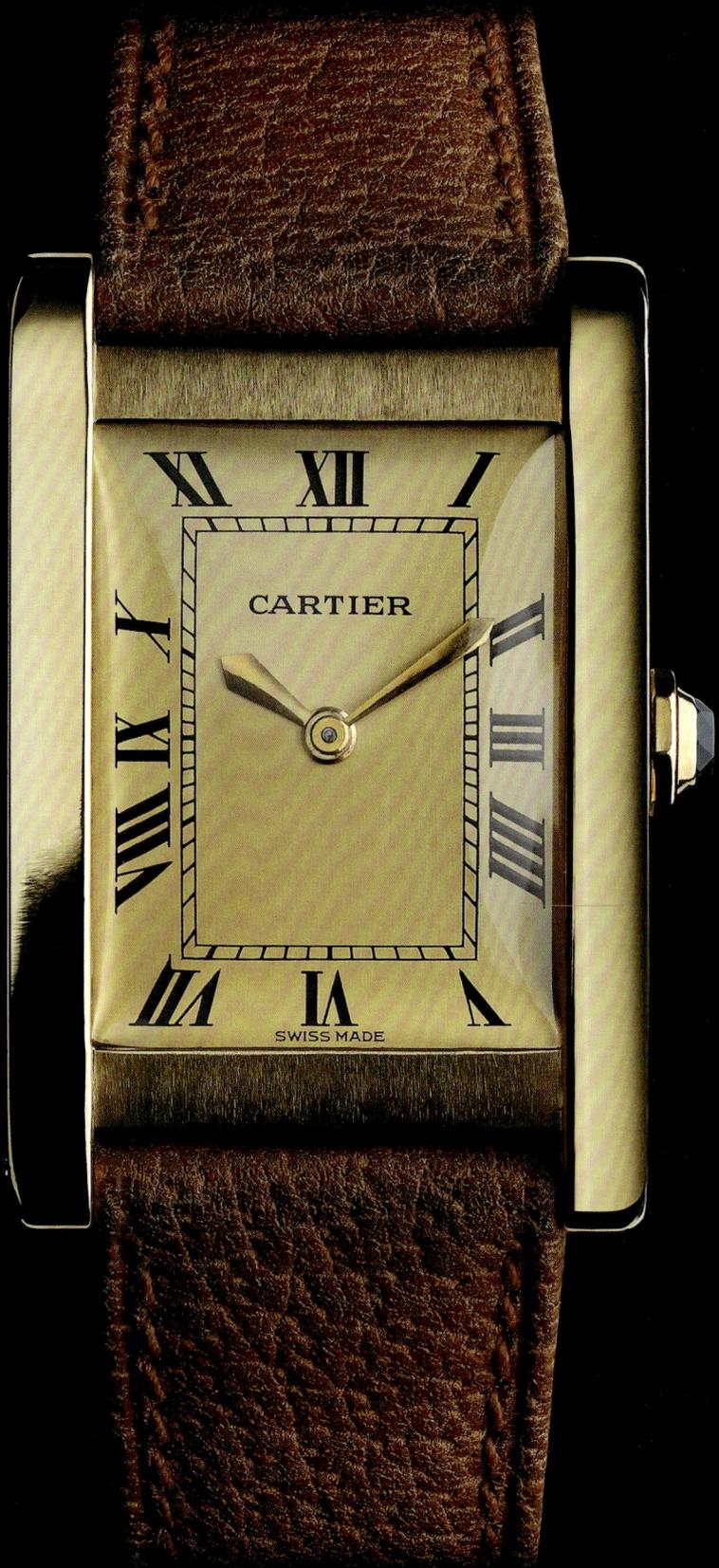

Tank Rectangle Wristwatch

CARTIER PARIS, 1952

Marked on the dial: *Cartier, Swiss Made*

Case of polished and satin-finish gold, *brancards* of polished gold. Eight-sided winding crown capped with a faceted sapphire. Leather strap, deployant buckle of yellow and pink gold. Satin-finish gilded dial with Roman numerals around a railroad minute track. Gilded sword-shaped hands.

❖ *Rectangular LeCoultre caliber 424 movement with cut corners, fausses Côtes de Genève decoration, rhodium-plated, 15 jewels, Swiss lever escapement, monometallic balance, flat balance spring.*

WCL 71 A52

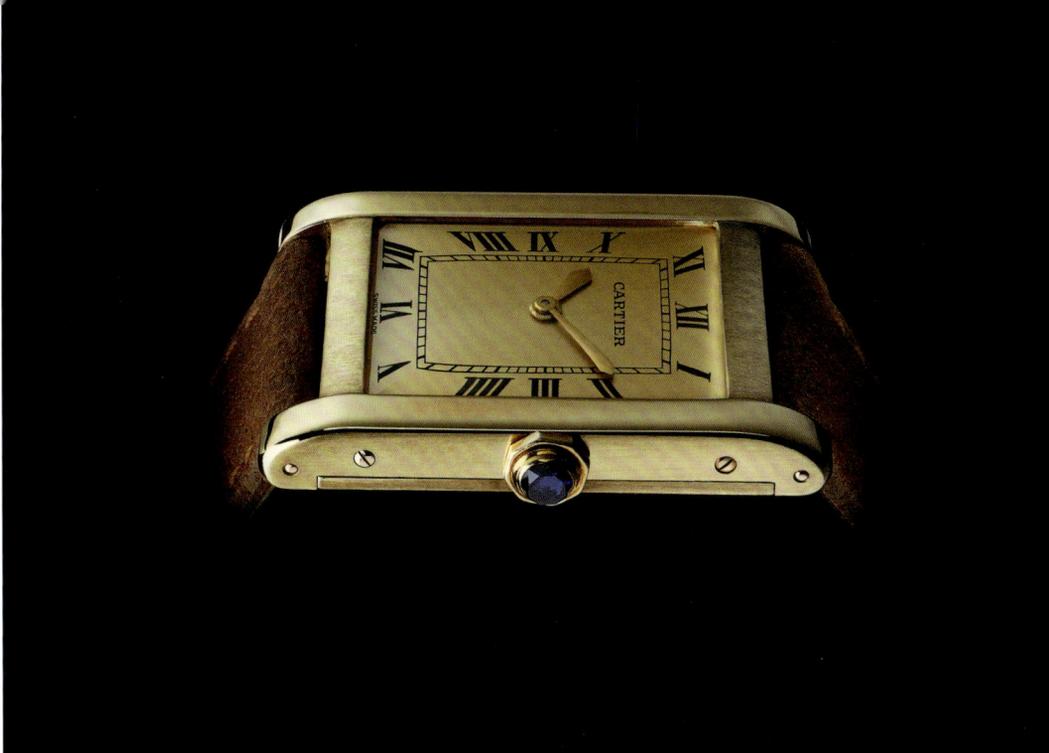

development of a specialized form of applied art: industrial design. It had actually been introduced after the First World War, creating huge interest with the productive and dramatic experiments of the Bauhaus and functional architecture. However, these were pioneering, elitist efforts accompanied by lively theoretical debate and the general public found them strange and unappealing. But in the 1950s, masterpieces and everyday examples of this design approach were there for all to see: the cars and scooters in the street, the refrigerators in the kitchen, the typewriters in the office. Modernity started to become a precise idea of fine lines, light weight, and uncluttered shapes with a mysterious beauty.

The *Tank* represented exactly that, even though it had been conceived and produced more than thirty years earlier. The facts would show just how much more "modern" it was than the watches designed after 1950. These did not even ask the question that had been brilliantly answered by Cartier and his team with the structural elegance of the *brancards*. Ironically, the steady move of watch brands towards mass production simply confirmed the timeless character of the *Tank*.

As we have seen, in Paris the *Tank* focused on three models: the 1919 original (the only one to be listed simply *Tank*

in the company records until it became *Tank "Ordinaire"* in 1956, the name then being used everywhere from 1963), the *Tank L.C.* which was then enjoying a real resurgence, and the *Tank Cintrée* that reappeared in 1950. The range of calibers was reduced: The *Tank L.C.* and the *Cintrée* went back to their previous sizes (9, 8 and 7 lines). The original *Tank* only developed two calibers, the 9-line and the 8-line version that became the *Petite Tank*.

But the range was not stuck in time, simply producing a series of re-editions. Its exquisite touch of jewelry, the cabochon on the crown, was redesigned. When the postwar *Tank* opted for a faceted crown with a flat cabochon it lost some of its expensive allure and became a more rational object. The faceted crown and the sword-shaped hands made the watch look more functional although the sapphire, albeit less evident, was a discreet reminder of its jewelry lineage. Another sign of a return to its roots was the traditional dial with Roman numerals, often referred to as the "Cartier dial" in the records of 1955 at the Rue de la Paix boutique. The metal bracelets retained the same structure: classic mesh, flat or half-ring basketweave.

The hierarchy of the three flagship models now changed. The *Tank Cintrée* and the *Tank L.C.* were now the established models and there was no thought of updating them.

THE *TANK* REPRESENTED EXACTLY THAT, A MODERNITY CORRESPONDING TO A PRECISE IDEA OF FINE LINES, LIGHT WEIGHT, AND PURE SHAPES WITH A MYSTERIOUS BEAUTY.

ABOVE

On her visits to Cannes, Monte-Carlo, London or New York, Elizabeth Taylor indulged her passion for jewelry and watches, and forged a special link with Cartier.

FACING PAGE

Tank Wristwatch

CARTIER PARIS, 1959

Marked on the dial: *Cartier*
Sold to Miss Elizabeth Taylor

Case of polished and satin-finish gold, *brancards* of polished gold. Eight-sided winding crown capped with a faceted sapphire. Bracelet a 9-strand mesh of polished gold links, hidden deployant buckle of pink gold. Square white dial with Roman numerals around a railroad minute track. Sword-shaped hands of blued steel.

❖ *Round LeCoultre caliber 821 movement,*
Côtes de Genève decoration, rhodium-plated,
2 adjustments, 18 jewels, Swiss lever escapement,
monometallic balance, flat balance spring.
WCL 37 A59

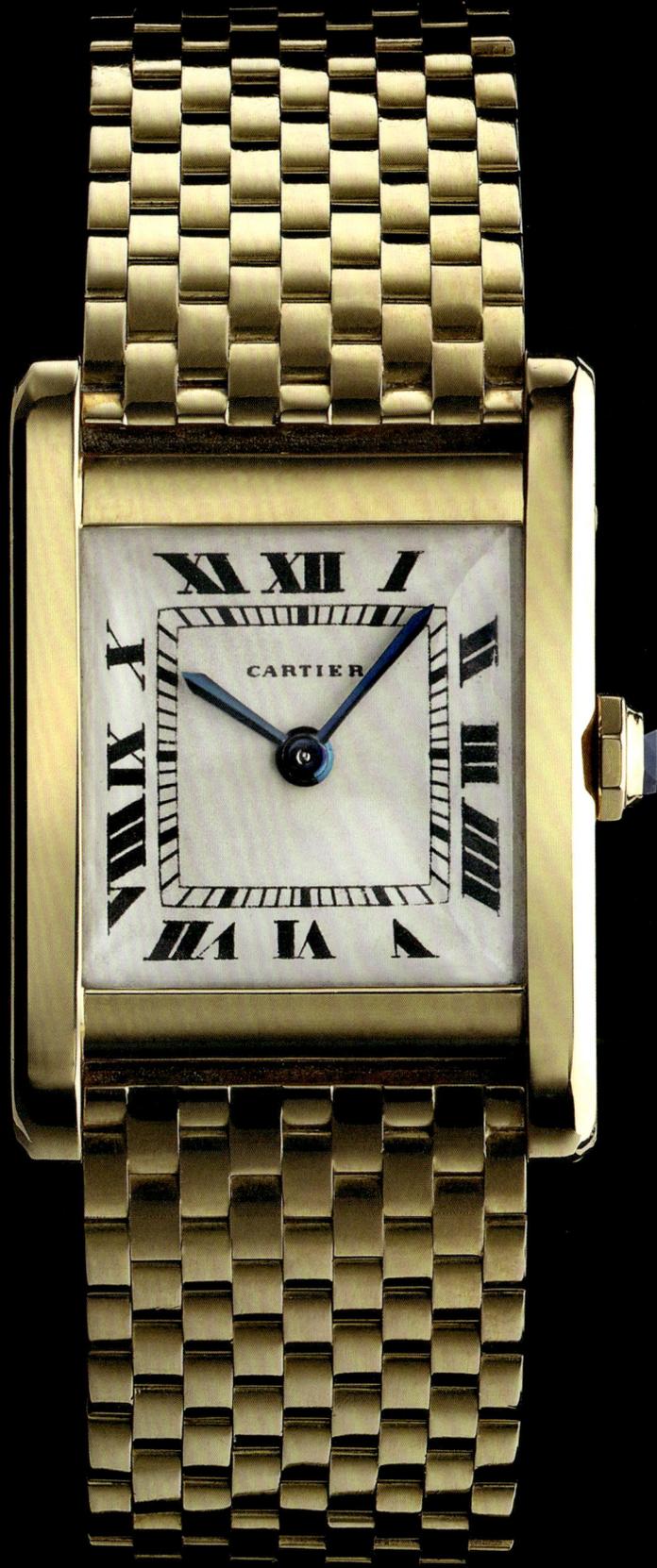

During the 1950s, the *Tank L.C.* appeared
to outstrip the original *Tank* of 1919: from 1956
the latter—until that time the only model
to be described simply as the "*Tank*" in the Cartier
Archives—became known as the "*Tank Ordinaire*,"
a qualification which became general in 1963.
Since the 1940s, the faceted winding crown set
with a flat cabochon and the sword-shaped hands
had combined to give the watch a more functional
appearance, while the sapphire remained as
a discreet reminder of its essential nature as a piece
of jewelry. The traditional dials with Roman
numerals were frequently described as "Cartier dials"
in ledger entries from 1955 onwards. The structure
of the bracelets remained unchanged, consisting
of classic meshes and flat or demi-jonc basketweave.

FACING PAGE (CLOCKWISE FROM TOP LEFT)
Petite Tank 8 lines, *1953*. Platinum, 7-row bracelet; *Tank
Chinoise* 9 lines, 1956. Gold; *Tank* 9 lines, 1951. Gold,
flexible bracelet of opposing spirals; *Petite Tank*, new
model, Gold; *Tank L.C.* 9 lines, 1956. Gold;
Tank L.C. 9 lines, 1955. Gold, 9-row demi-jonc bracelet.

The only significant support was given to the *Tank L.C.*
The 9-line *Tank* was the first to receive a flat case, paving
the way towards the extra-thin models of the 1960s. The
Tank L.C. also seemed to take precedence over the so-called
"*Ordinaire*." In the early 1920s, the *L.C.* had been a slightly
nostalgic "folly" of Louis Cartier, a man in love with classi-
cism and who had developed highly sophisticated variations
on the curve in his "garland" style jewelry. The curves of the
L.C. had softened the rigorous geometry of the line, making
it rather more feminine. But production of the model was
limited and it was overshadowed by the square cases with
clean-cut edges that were more in tune with the times. On
the other hand, the *Tank L.C.* was favored by many clients at
the start of the 1950s and for years afterwards, because the
shape of its *brancards* made it fit into a curve, in harmony
with the mood of the times: dominating femininity. Then
Christian Dior triumphantly introduced his "New Look."
This was a dazzling tribute to bold femininity with a pro-
fusion of fabrics and colors, generous volumes and curves.
As the wartime shortages eased, Cartier jewelry and acces-
sories changed too, introducing more fluid, rounder shapes
and bringing back colored precious stones.

However, it was the *Tank* "*Ordinaire*" that showed the
future evolution of the line most clearly. In 1955 this 9-line

Tank was joined by a new model with a flat bezel. The *bran-
cards* and horizontal bars were levelled off in a version with-
out a flange that echoed the flat 1930 *Tank à Guichets*. This gave
the square cases an unusual structure, in which the traditional
æsthetic function of the *brancards* was done away with in
favor of matte and polished gold. In 1958, one of these models
was given a dial with fine hour markers and no railroad min-
ute track, which made the watch even more contemporary.

Hour markers were very much in fashion at that time
and some took unusual forms. In a "new model" *Petite Tank*
in 1960, the *brancards* and horizontal bars were thinned to
a minimum, renewing the "interplay of lines." In 1959, the
slender hour markers and horizontal bars made a very sim-
plified dial on a version that attempted to follow the fash-
ions that have appeared throughout the *Tank*'s history.

These short-lived versions that ended the decade were try-
ing to rework the fundamental structures of the *Tank*, in par-
ticular the square cases, and in doing so they lost the essence
of the original watches. This approach reached the point of
no return in 1963 with a large-opening *Tank*, a new model
with a square dial that overflowed onto *brancards* reduced to
the point where they could only be seen in profile. Although
this wide dial opening matched the taste of the time, it had
none of the æsthetics that distinguished the original square

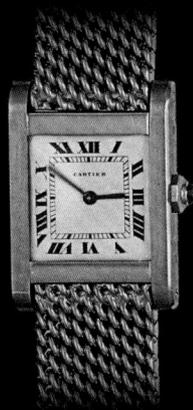

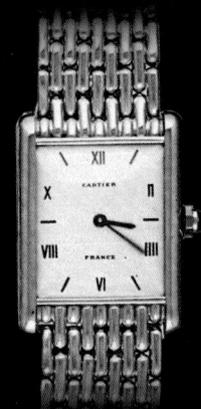

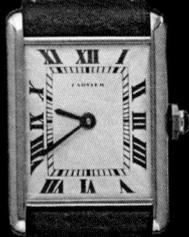

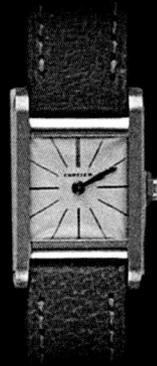

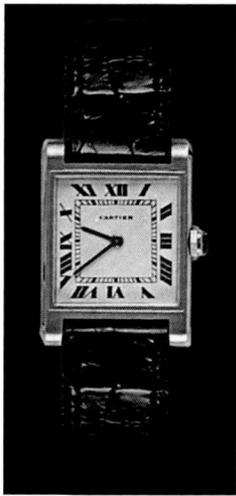

LEFT
Tank Wristwatch, 9 lines, gold, 1963.
Cartier Archives, Paris.

FACING PAGE
The French fashion designer Jacques Fath
(1912–54) posing in 1951, a *Tank* watch
around his wrist.

models—demonstrating how easily the *Tank* identity could be lost by adopting shapes that were foreign to it.

Yet, as often happens after a period of uncertainty or looser standards, the *Tank* soon returned to rigorous formality. Also in 1963, just 15 years after the "refocusing" of 1948, the classic versions came back into favor. Their simplified design suited the accelerating pace of production that was needed to meet growing demand: in 1963, annual sales of *Tanks* at Cartier Paris had doubled in just three years (to 223 from 101) and continued to steadily increase throughout the decade, reaching almost 800 in 1969.

It was the comeback of the three great classics. The original *Tank*, the *L.C.* and the *Cintrée* were each produced in three versions with more commercial labels: "Large Model", "Medium Model" and "Small Model" that is to say the original 9-, 8- and 7-line calibers. The *Tank L.C.* was simultaneously offered in a specific version: the *Petite Tank L.C.* which existed alongside the *L.C.* This opened the way for the miniaturization of the entire line at the end of the decade. The *Tank L.C.* was now the most popular model by a wider margin than ever. And the return of the traditional cabochon on the crown confirmed it as one of the great classics. The *Tank Cintrée*, meanwhile, carefully preserved all the traditional design details that defined it. An important technical

development also took place in 1964 with the arrival of the extra-thin models: the *Tank "Ordinaire"* and the *Tank L.C.* were both fitted with 9-line movements. It was thanks to the art of the watchmaker, particularly in the trend for miniaturization of the 1960s, that enabled the structure to evolve, this time without affecting the æsthetics of the line.

In 1968 that æsthetic was refreshed with smaller cases and by jeweled models. The long-neglected *Petite Tank Allongée* was now back in the spotlight. And in the same year, the *Mini Tank L.C.* was added to the line. The jewelry versions that Louis Cartier had deliberately avoided in the 1920s appeared in 1969 when the *brancards* of the *Petite Tank Allongée* and the *Mini Tank L.C.* were set with diamonds (jonquil diamonds on yellow gold and brilliant-cut diamonds on platinum.) By introducing the jewelry theme at the start of the 1970s, it seemed that the *Tank* line had finally broken away from the heritage of its creator.

Throughout the 1950s and 1960s it had continued to attract an exclusive clientele ranging from the few aristocratic families that had survived the two World Wars to the new celebrities of entertainment, culture and politics. The long list included personalities ranging from Georges Pompidou to Juliette Gréco who bought no fewer than four *Tanks* between 1952 and 1960, from the Queen of Greece to

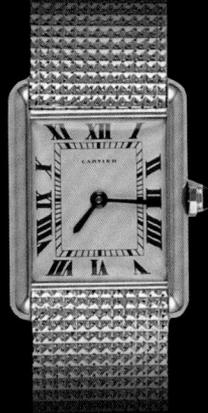

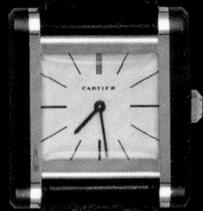

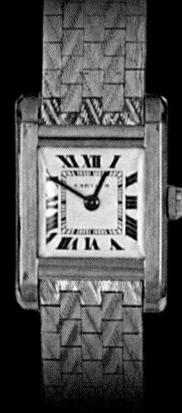

ABOVE

Design for the dial of the *Elongated Curved Tank*,
circa 1965. Cartier Archives, London.

In 1963, a simplification of the line ensures that the classic models
once more came to the fore. This meant a return to the three
great classics: the original *Tank*, the *Tank L.C.* and the *Tank Cintrée*,
each produced in large, medium and small models.

TOP AND FACING PAGE (LEFT TO RIGHT)

Tank L.C. 9 lines large model, 1961. Gold, *guilloché*
diamond-tipped bracelet; *Tank* 8 lines, 1962. Gold, lapis lazuli;
Tank Normale 8 lines medium model, 1963. Gold, *guilloché*
5-row mesh, moire chevrons; *Tank* 9 lines extra-thin, 1964.
Gold; *Tank L.C.* 9 lines, 1964. Gold; *Tank* 9 lines, 1966.
Gold, blue enamel.

Brigitte Bardot, and from the King of Morocco to Marcello
Mastroianni who bought four in 1961, as well as King Farouk
of Egypt who only ordered *Tanks* in platinum. A leading fig-
ure in male fashion was "Avvocato", Gianni Agnelli, head of
the FIAT family, who wore his *Tank* not directly on the wrist
but on the cuff of his shirt. In addition to these names, the
Tank became highly popular in the world of cinema. Taking
just the example of French cinema, in addition to the names
already mentioned, its admirers included Louis Malle, Jean-
Pierre Melville, Annie Girardot, Simone Signoret, Jeanne
Moreau, Philippe Noiret, Jean Seberg, Jean-Paul Belmondo,
Catherine Deneuve and Alain Delon.

During a turbulent period in the 1960s when the student
movement spread across America before reaching Europe
in 1968, the *Tank* remained a wonderful, totally contempo-
rary object. The new spirit in the air was profoundly chang-
ing the lifestyle of a whole generation and the *Tank* was
preparing for a new chapter in its history.

❖

In the postwar years, a growing wave of creativity took over
the *Tank* in London where Cartier had been present since
the start of the century. At the end of the nineteenth cen-
tury, and particularly since the move to the Rue de la Paix

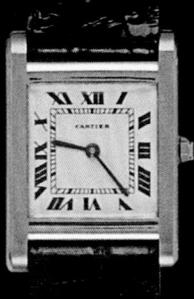

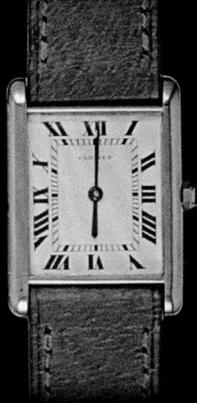

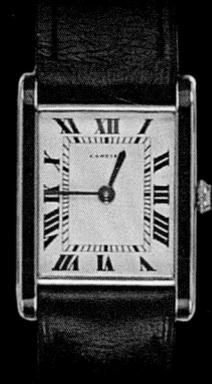

in Paris, the English and the Russian aristocracy had made up the principal part of Cartier's international clientele. There was a healthy market in England and the coronation of Edward VII in 1902 produced an extra flood of orders for jewelry. In order to respond as rapidly as possible, the Cartiers travelled to London. Encouraged by the future King himself, they looked for a suitable location. They chose a boutique at 4 New Burlington Street. Two years later, after producing an extraordinary necklace for Queen Alexandra, Cartier was appointed Official Supplier to King Edward VII. In 1906 Jacques Cartier, Louis' youngest brother took control of the branch. Three years later Cartier moved to 175-176 New Bond Street. This neo-classical Victorian building was soon full of the English nobility placing orders for the tiaras required for the Coronation of George V, in 1911. All the articles sold in the London branch were imported from Paris, until 1922. In that year it opened its own workshop, the English Art Works, in order to better meet its clients' expectations. It was headed by a Frenchman but all the craftsmen, who numbered about sixty in the 1930s, were English.

The watch department in Cartier London developed in a particular way. Apart from the very first models imported from Paris at the start of the 1920s, all the *Tanks* sold until 1929, and sometimes until 1937, were produced by Jaeger and LeCoultre and, as in New York and Paris, their movements were stamped EWC. From 1929, Jaeger LeCoultre was always listed as the principal supplier of movements, through its London subsidiary De Trevars Ltd. A very small number of *Tank* cases were produced by English Art Works, but most of them came from a London manufacturer Wright and Davies, who also made other items for the Cartier branch: cigarette cases, vanity cases and clock cases. Until 1950 there was no difference between the *Tank* watches sold in London and those produced and sold in Rue de la Paix before the War. In New Bond Street, Jacques Cartier was used to dealing with English gentry and many of the Princes of the British Empire. *Tanks* were bought there by the aristocracy, including HRH Prince Albert, Duke of York, and future King George VI following the abdication of his brother Edward VIII, as well as the Maharajahs of Jamnagar, Kashmir and Rajpipla who were enthusiastic *Tank* collectors.

When war broke out in September 1939, Jacques Cartier was caught by surprise in France. He decided to stay, leaving the direction of Cartier London to his Sales Director Etienne Bellenger, and settled in the Basque country. He died in September 1941 less than a year before his brother Louis. In London, the management offered support to General de Gaulle but nevertheless removed the stock for

THE NEW SPIRIT IN THE AIR WAS PROFOUNDLY CHANGING THE LIFESTYLE OF MEN AND WOMEN AND THE *TANK* WAS PREPARING FOR A NEW CHAPTER IN ITS HISTORY.

ABOVE

Simone Signoret and Yves Montand in Los Angeles, April 1960. The French star won an Oscar for Best Actress of the Year, with her role in *Room at the Top*. Yves Montand wore the *Tank* watch that she had given him the year before.

FACING PAGE

Simone Signoret and Yves Montand on the beach at La Baule in 1959.

On the set of the film *Un flic* in 1972, Alain Delon
notes with amusement that his favorite watch,
the *Tank Arrondie*, is also the one chosen by the director
he most enjoyed working with, Jean-Pierre Melville.

FOLLOWING DOULE PAGE

***Petite Tank Allongée* Wristwatch**

CARTIER PARIS, 1969

Marked on the dial: *Cartier, Paris*

Case of polished and satin-finish gold, *brancards* of
gold and translucent lapis lazuli blue enamel. Beaded
winding crown capped with a sapphire cabochon.
Leather strap, deployant buckle of yellow and pink gold.
Rectangular cream dial with Roman numerals. Baton
hands of blued steel.

❖ *Oval LeCoultre caliber 845 movement, rhodium-
plated, 18 jewels, shock-resistant, Swiss lever
escapement, monometallic balance, flat balance spring.*
WCL 102 A69

128

fear of losing it in The Blitz. In 1945, Jacques Cartier's son,
Jean-Jacques, took over management of the branch. Five
years later, he made his mark in the company's history by
launching an original line that carried his initials: JJC.

In reality, the first model in this line was not called *JJC*,
nor even *Tank*, in the stock register of August 9, 1950. Yet
it clearly was a *Tank*, judging by its description in the reg-
ister: a gold wristwatch, rectangular, with enamelled dial,
sapphire cabochon on the winding crown, and folding
buckle in gold. It was a new *Tank*, a tribute to the *Tank L.C.*
that it resembled with its fine, very rounded *brancards* and
the sword-shaped hands that the Paris model had recently
adopted. But it differed from the *L.C.* in its proportions
and unusual Roman graphics. The first example was sold
on December 20. The following year, a very similar model
appeared in the stock register and was described as a "rect-
angular *Tank* (*JJC* model)."

Another version was also introduced that year but with
apple-shaped hands, just like the first *L.C.* from Paris.
And like the preceding model it was fitted with the origi-
nal crown, unlike the contemporary *L.C.* which had a fac-
eted crown. This time, though, it clearly belonged to the
Tank family as right from the start it was given the name,
Rectangular Tank, JJC model. However, as often happens

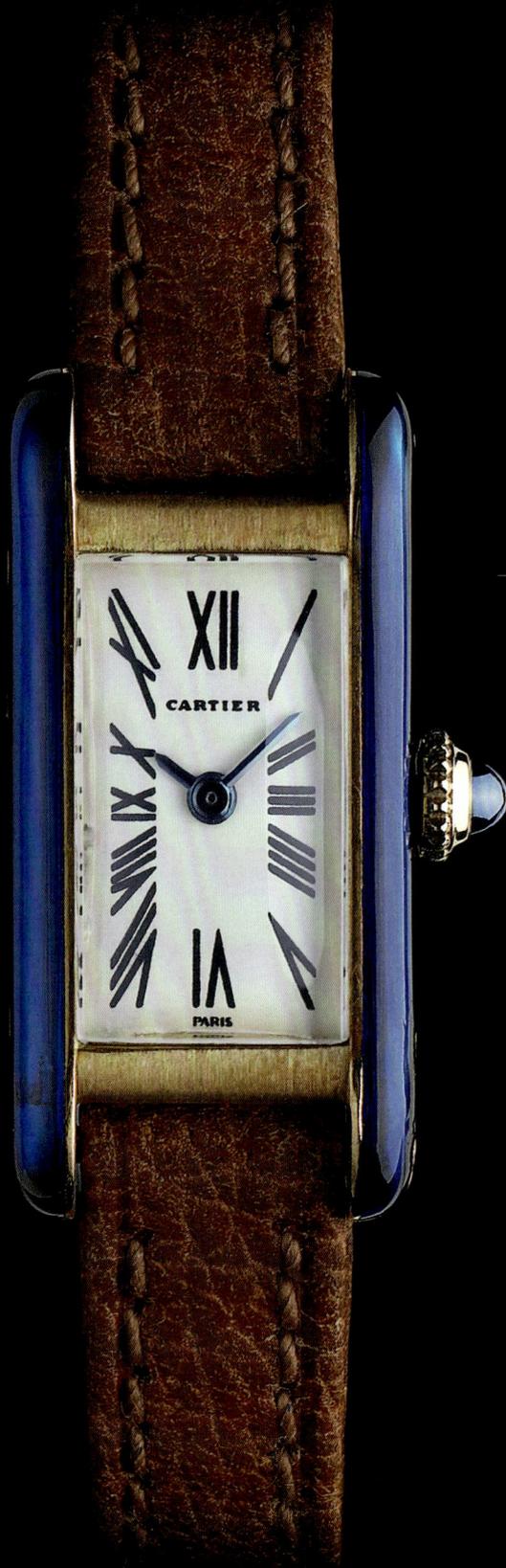

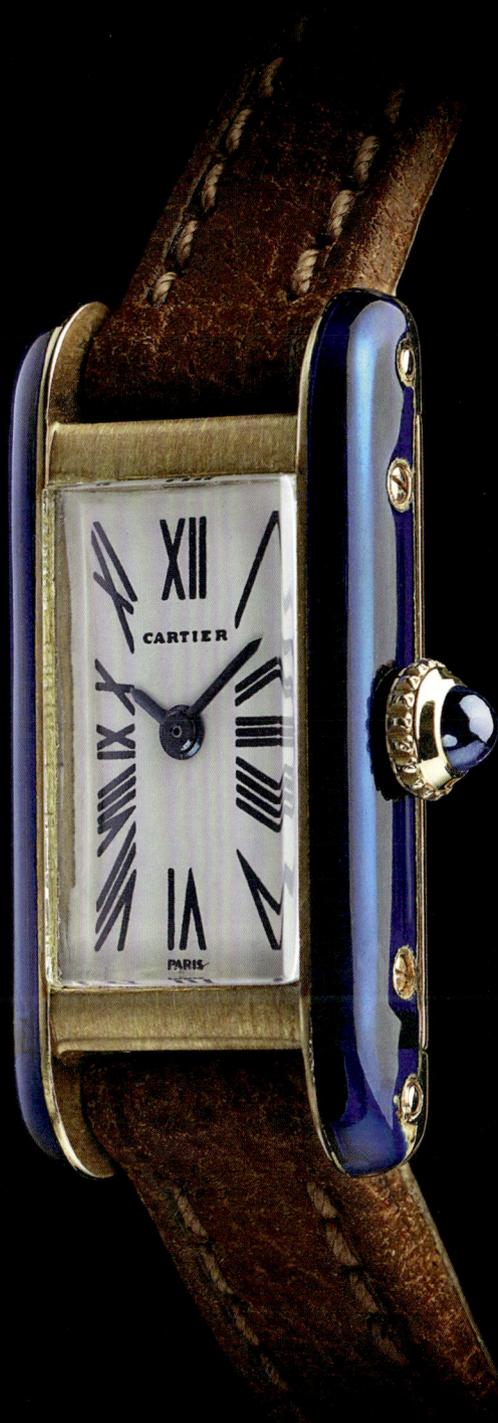

THE FIRST LONDON *TANK*, A WATCH THAT MARKED THE HISTORY OF THE FAMILY, WOULD BE CALLED SIMPLY THE *JJC*.

LEFT
British actress Jacqueline Bisset
wears a *Tank Allongée*. June 1993.

FACING PAGE

**Elongated JJC Tank
Wristwatch**
CARTIER LONDON, 1974

Marked on the dial: *Cartier, London*

Case of polished and satin-finish gold, *brancards*
of polished gold. Beaded winding crown
capped with a sapphire cabochon. Leather strap,
pin buckle. Rectangular cream dial with Roman
numerals. Sword-shaped hands of blued steel.

❖ *Barrel-shaped LeCoultre caliber
841 movement, rhodium-plated, 17 jewels,
shock-resistant, Swiss lever escapement,
monometallic balance, flat balance spring.*
WCL 12 A74

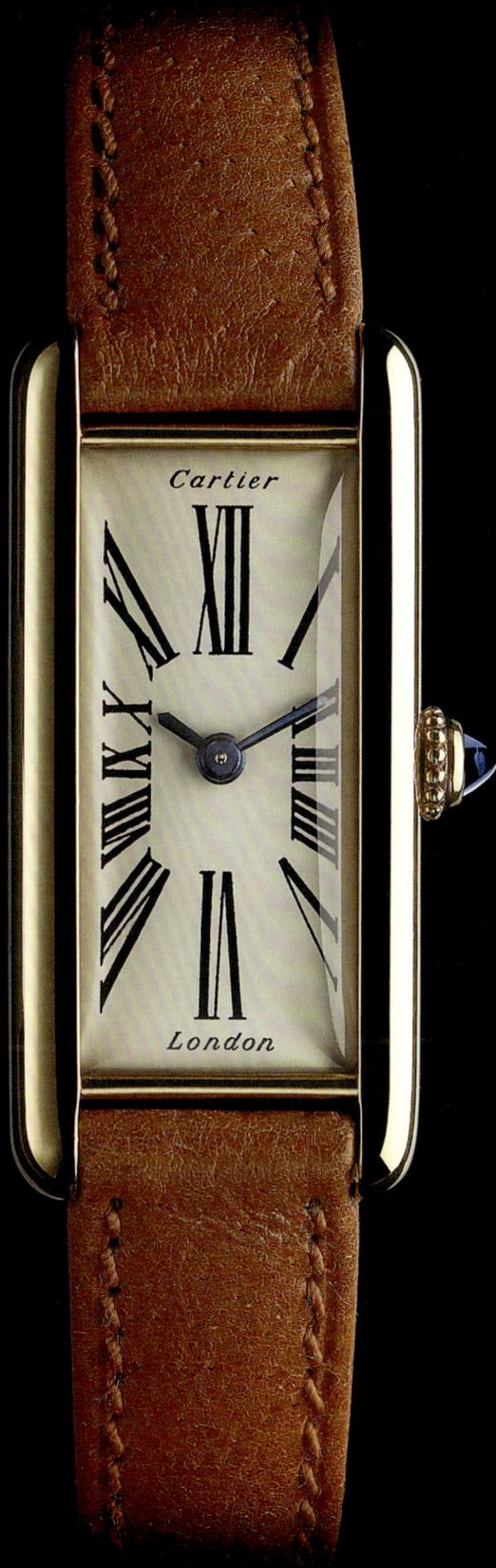

Crash Wristwatch

CARTIER LONDON, 1967

Marked on the dial: *Cartier, London*

Case of satin-finish gold, bezel of polished gold; winding crown capped with a sapphire cabochon. Leather strap, deployant buckle of yellow and pink gold. White dial with Roman numerals. Baton hands of blued steel.

❖ *Barrel-shaped LeCoultre caliber 840 movement, Côtes de Genève decoration, rhodium-plated, 17 jewels, Swiss lever escapement, monometallic balance, flat balance spring.*

Tradition holds that this model represents an interpretation of a watch damaged in a crash.
WCL 53 A67

Double Strap Wristwatch

CARTIER LONDON, 1970

Marked on the dial: *Cartier, London*

Transversal, rectangular case of satin-finished gold, corners rounded on top and squared at the base. Winding crown capped with a sapphire cabochon. Case slides along the double leather strap; 2 pin-buckles. Matt white rectangular dial, rotated 90°, with Roman numerals at 6 and 12 o'clock, intermediate hours marked by indices. Baton hands of blued steel

❖ *Barrel-shaped LeCoultre caliber 845 movement, 17 jewels, shock-resistant, Swiss lever escapement, monometallic balance, flat balance spring.*

WWL 74 A70

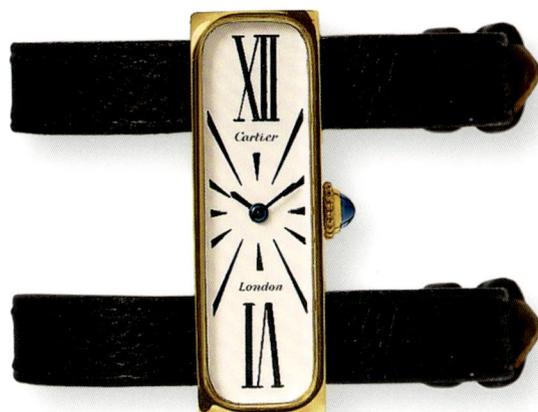

before a new model finds its final identity, none of the many future variants of the *JJC* would ever be called a *Tank*. They included small, extra small, medium, large, slim case, thin case, thick case, square, and wide versions all derived from the *L.C.* with its fine *brancards*. The first London *Tank*, a watch that marked the history of the family, would be called simply the *JJC*.

Also in 1951, Cartier London launched a 9-line *Square Tank*. It was quite similar to the model that Paris would soon call the *Tank "Ordinaire"* but differed from it by retaining the traditional pointed cabochon on a beaded crown. It was offered under the same name by Cartier New York in the following year, but with a flat, ribbed crown. In a surprising exchange of design influences, this type of crown then reappeared on the 7-line "Medium" version of the London Square in 1953.

Cartier London benefitted from the exceptional wave of creativity that marked England in the 1960s and 1970s. It was "Swinging London", as an American journalist living in the city described the extraordinary artistic energy that reigned in the British capital. A real revolution was taking place in all the arts, triggered by the Mods—young middle-class people whose carefully studied appearance masked a deeply rebellious attitude—and fanned by the music of the Beatles, the

Who and the Rolling Stones. It came to be known as *pop* culture. It made itself felt in areas other than music, too: in the cinema—*Blow up*, directed by Michelangelo Antonioni, appeared that year—in art and photography produced by names like David Hockney, Peter Blake, Patrick Caulfield, Allen Jones, Derek Boshier or David Bailey—and, above all, in fashion. It was a time for breaking the rules, for enjoying the pleasure of living and the power of derision. Mary Quant showed the mini-skirt, the most striking symbol of liberation, while a large part of Western youth flooded to London's 2000 fashion boutiques to ridicule the army with military jackets and brighten up the streets with multi-colored outfits, satin shirts, frock coats and cloche hats.

In this atmosphere of celebration, Cartier London created some spectacular watches, such as the psychedelic *Crash*, the giant *Maxi Oval* and the *Double Strap* with two bracelets. With an already long history behind it, the *Tank* now moved forward in three directions. First of all the original *Tank* appeared in large, medium and small versions: square cases with bold *brancards* on the large models and much finer on the smaller ones; Cabochons were flat or, sometimes, conical but substantially lowered; the railroad minute track was removed from dials with Roman numerals that were more delicate than in the Paris models. These very simplified dials

THE TASTE FOR FANTASY
AMONG LONDON DESIGNERS
LED THEM TO USE DARING
GRAPHICS OR DIALS IN
COLORED ENAMEL, THAT
GAVE THE CURVED SHAPES
AN UNEXPECTED
REBELLIOUS VITALITY.

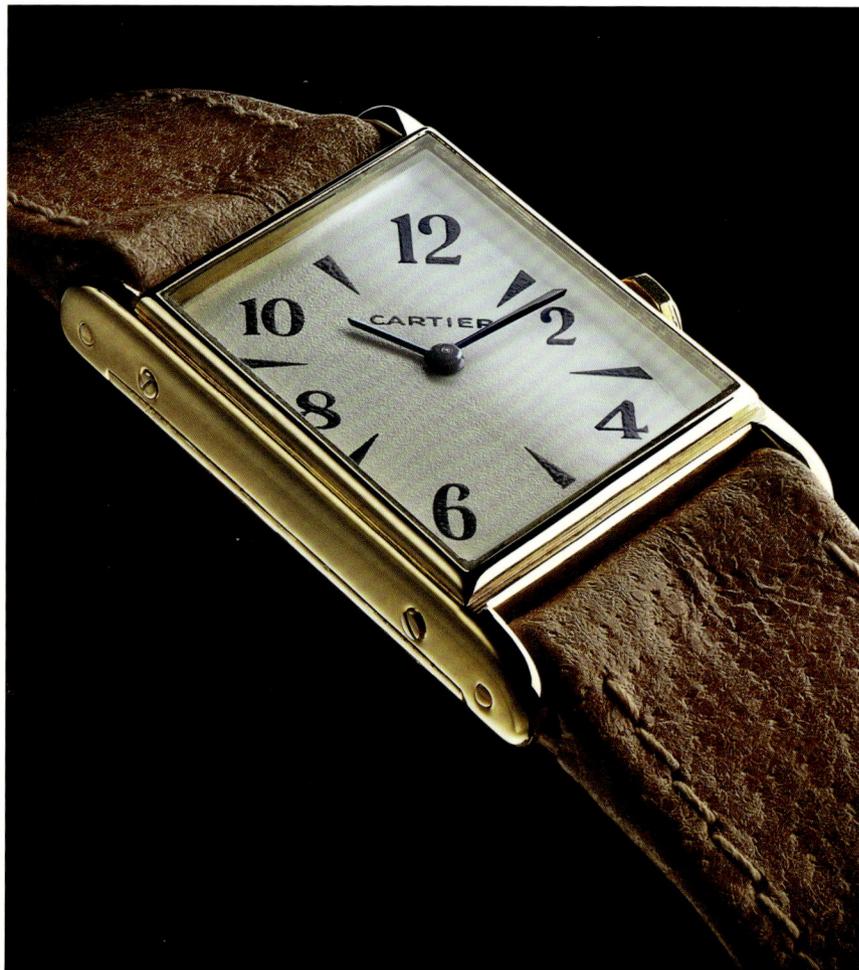

LEFT AND FACING PAGE

Oblique Wristwatch

CARTIER LONDON, 1963

Marked on the dial: *Cartier*

Case of polished and satin-finish gold. Eight-sided winding crown capped with a faceted sapphire. Leather strap, deployant buckle of yellow and pink gold. Cream, diamond-shaped dial, rotated 45°, with alternating Arabic numerals and indices. Sword-shaped of blued steel.

❖ *Round LeCoultre caliber 169 movement, fausses Côtes de Genève decoration, rhodium-plated, 2 adjustments, 18 jewels, Swiss lever escapement, bimetallic balance, flat balance spring.*
WCL 52 A63

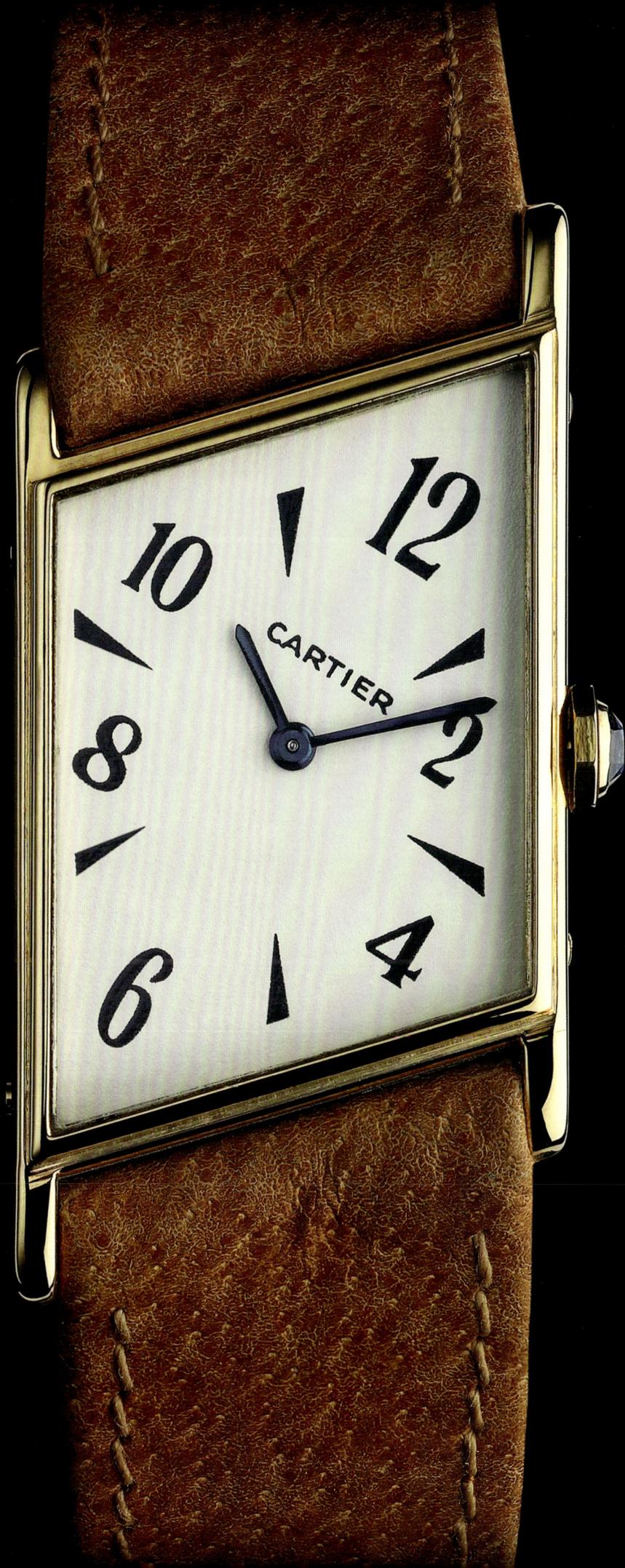

Small Elongated Curved Tank
Wristwatch

CARTIER LONDON, 1967

Marked on the dial: *Cartier*

Curved case and *brancards* of polished gold.
Beaded winding crown capped with a sapphire
cabochon. Leather strap, deployant buckle of
gold. Curved white dial with Roman numerals
around a railroad minute track.
Baton hands of blued steel.

❖ *Barrel-shaped LeCoultre caliber
840 movement, Côtes de Genève decoration,
rhodium-plated, 17 jewels, Swiss lever
escapement, monometallic balance,
flat balance spring.*
WCL 95 A67

emphasized the rigor of the square form, and the signature varied between small capitals and cursive text. Then versions of the curved models arrived: the *Off Centre Tank Case* in 1963, the *Elongated Curved Tank* of 1966 and 1969, available in large and medium sizes, and the *Standard Curved Tank* in 1967. They diversified the curved cases by playing with the dial openings, the width of the *brancards* and the degree of curvature. The taste for fantasy among London designers led them to use daring graphics or dials in colored enamel, that gave the curved shapes an unexpected rebellious vitality. In 1962 the *Half Tank*, a typically London model, displayed a form that was slightly hybrid: a rectangular case, close to square, with thinned edges at 6 and 12 o'clock. It was also available in a first jewelry version, mounted on a bracelet of fine-link chevrons, with *brancards* set with brilliant-cut diamonds and a diamond on the crown. Three years later, a more daring jewelry version was introduced in a typical 1960s style with very fine markers covering the entire dial like a spider's web, and the signature down at 6 o'clock. A distinctly marginal version appeared in 1966, curiously named the *Paris Model*. Made in platinum, it had an elongated rectangular shape similar to the 11-line *Tank* that Paris no longer produced.

London fantasy created some even more original models, such as the 1962 versions of the *JJC* with large Arabic numerals, moving away from the *Tank* tradition with a touch of extravagance. Examples included an *Extra Thin Tank* that was square, but with an an oval dial supplied by Piaget in 1962, and in 1971 the *Enamelled Tank* with Roman numerals on its square bezel. The strap connections were graphically separated from the bezel, rejecting the *brancard* idea—and the initial concept. Its dial with no numerals and no railroad minute track was a pure white square only interrupted by the signature and the sword-shaped hands. Another of the watches that continued this concept with a daring touch of fantasy appeared at the very end of 1988 and enjoyed a longer life: the *JJC Wide* with a horizontally extended case was reborn in Paris in 2002, significantly modified but still in the same spirit, under the name of *Tank Divan*.

And so the different branches of the *Tank* family kept in touch, across the seas and through all weathers, by exchanging their fruits that were carried by the wind. Until the day at the end of the 1970s when, as we will see, they came together again in a time when distances were abolished and diversity erased in the crucible of a common creation delivering a universal message. ■

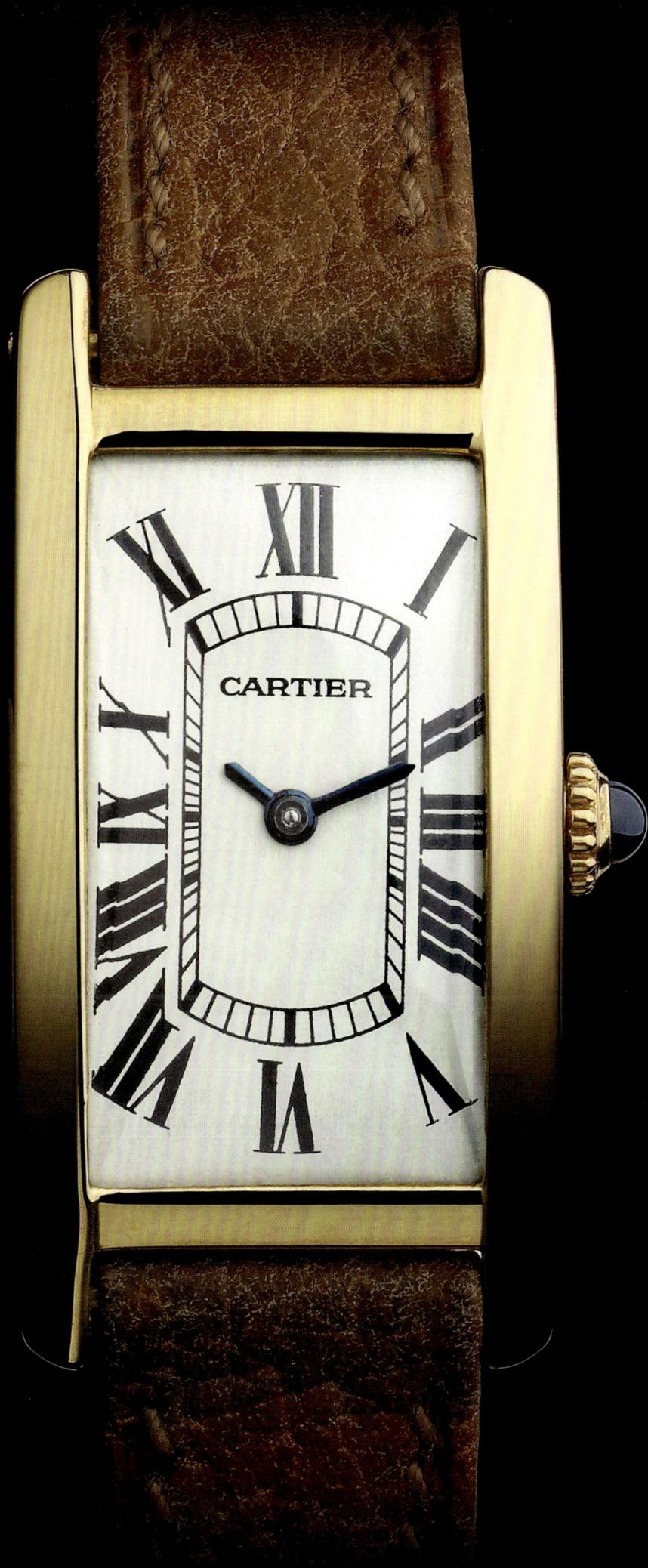

The Tank Changes the World

the

Chapter IV

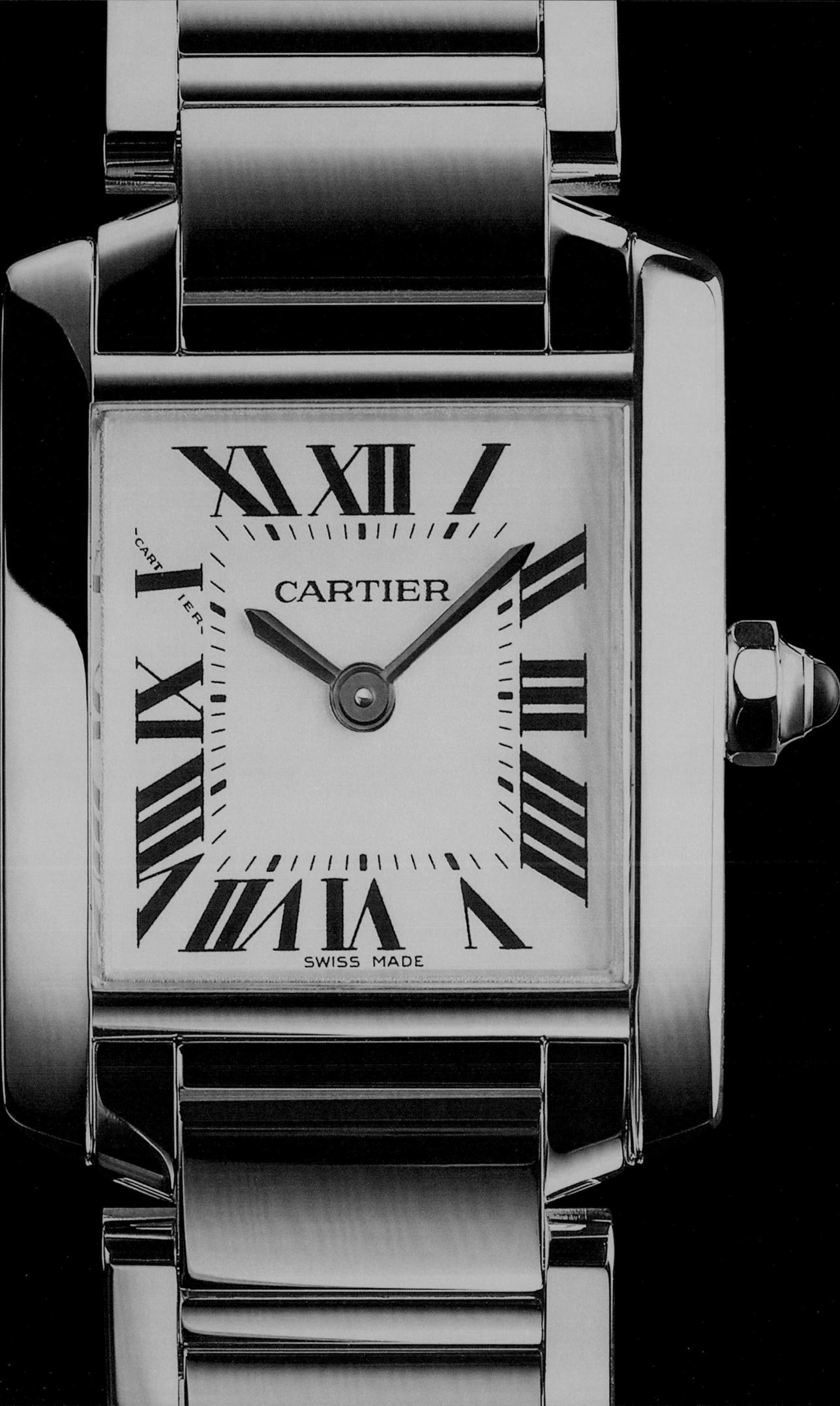

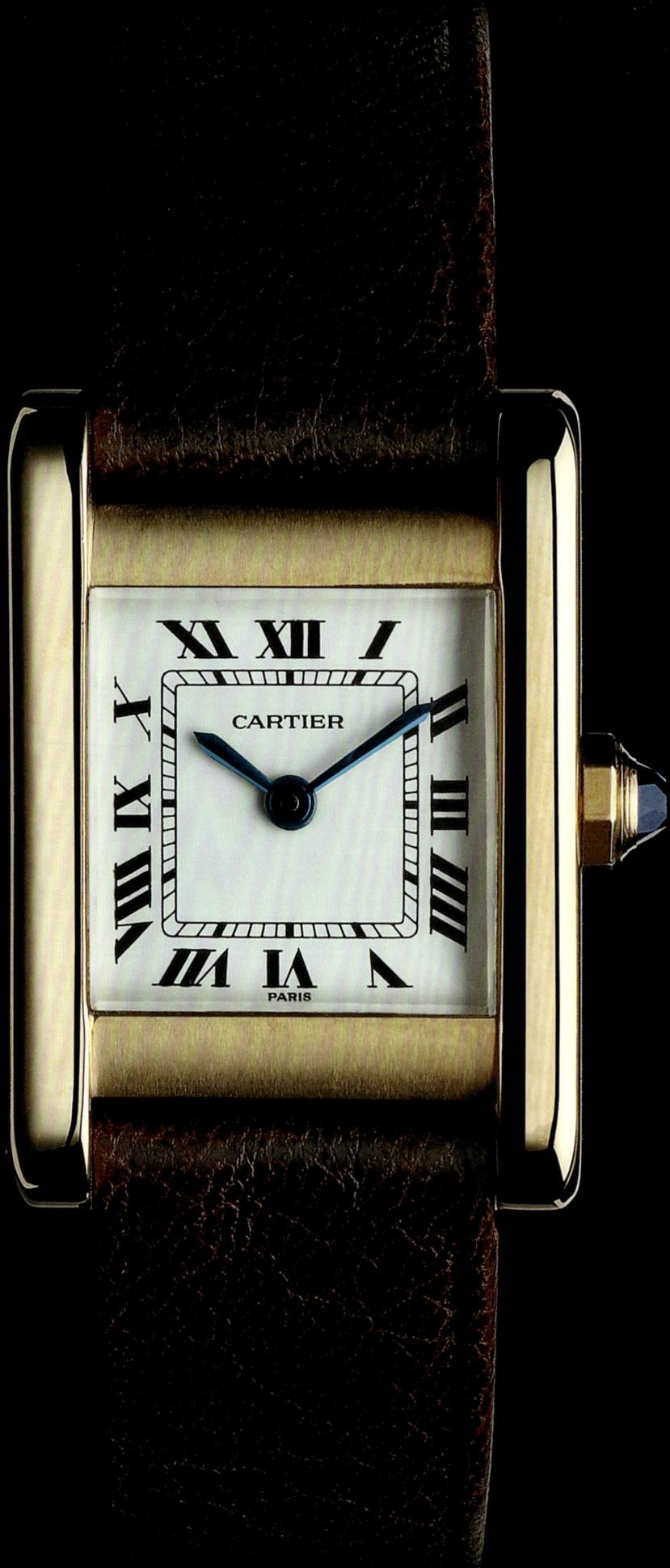

PAGE 141

Tank Française Wristwatch, small model,
Cartier Paris, 1995 (*see page 172*).

FACING PAGE

Tank Normale Wristwatch, small model

CARTIER, CIRCA 1978

Marked on the dial: *Cartier, Paris*

Case and *brancards* of satin-finish and polished gold.
Eight-sided winding crown capped with a faceted
sapphire. Leather strap, deployant buckle of yellow
and pink gold. Square white dial with Roman numerals
around a railroad minute track. Sword-shaped hands
of blued steel.

❖ *Round movement, Côtes de Genève decoration,
rhodium-plated, 17 jewels, shock-resistant, Swiss lever
escapement, monometallic balance, flat balance spring.*
ST-WCL 33 C78

*I*n the quarter of a century before the mid-1960s, Western civilization had shown extraordinary dynamism, yet it had failed to produce a new idea that really fired the imagination and enthusiasm of its young people. So it was no accident that discontent with "the system" began to emerge in the universities. The feeling was that they had become centres of administrative power rather than institutions of learning and culture, and that their teaching had not fundamentally changed for at least 50 years. The academic world, particularly in the field of humanities, seemed to have closed itself off, not only from the few new trends that had emerged since the Second World War, but from all the changes produced by the extraordinarily turbulent and transgressive period at the start of the century. At a time when the West was living at space-age speed, official culture had not progressed beyond the nineteenth century.

The wave of discontent in the 1960s started in the universities but very rapidly turned into something much wider and more important than a student movement. It became a confrontation between generations with young people questioning all the values of the preceding era. They denounced the very roots of middle-class society: its acceptance of authority, its faith in the market economy to deliver progress, its hypocritical moralising about freedom and sexual behavior and the fundamental immorality of its acceptance of social injustice. The violence of the confrontation clearly confirmed that these were the truly fundamental values of Western civilization. In France, once the storm had passed, it became clear that the only important results achieved by the young in 1968 were in the areas of social mores and relationships with authority. But these changes were so far-reaching that they were irreversible.

They also had a significant effect on deep changes taking place in the visual arts as seen in the "psychedelic" folklore movement, the ephemeral expression of "performance art" or "installation art," the optical experiments of "Op Art" and the demystifying influence of Pop Art. As we have seen, it was in London that Cartier was most willing to reflect these trends in watch design. It was also in London that fashion designers were inspiring young people all over the Western world to dress in a new way, encouraging fantasy as a deliberate break with the careful style of the previous generation.

In this same crucial year, 1968, Cartier Paris introduced a little revolution of its own whose effects lasted much longer. It was the launch of the Cartier oval lighter. Its great success led directly to the *Must de Cartier* programme five years later. The three key figures in this revolution were:

In the "Swinging London" of the 1960s and 1970s, fashion designers were inspiring young people all over the Western world to dress in a new way, encouraging fantasy as a deliberate break with the careful style of the previous generation.

LEFT
English fashion model and sixties icon Twiggy in the King's Road, London, June 12, 1966.

FACING PAGE
The Rolling Stones group leaving London Airport in March 1967.

Robert Hocq, a visionary genius and creator of the Cartier lighter, who became president of the company in 1973; Joseph Kanoui, an outstanding organizer and financier who led an international group of investors to take control of Cartier Paris in 1972 (the Paris, London, and New York companies were reunited at the end of the decade, creating a single management structure and long-term strategy); and Alain Dominique Perrin, a highly successful manager and strategist who, together with Robert Hocq, launched the new brand and the marketing concept of the *Must de Cartier.*

This concept was based on three important insights, displaying detailed observation of how the world had changed in the previous twenty-five to thirty years.

The first was that the ideas of beauty and luxury had significantly changed. With the acceleration in technical progress on the one hand and the deep social changes that followed the war on the other, the notion of beauty no longer concerned simply luxurious objects such as jewelry—"this so necessary thing" according to Voltaire. Now it enlarged its horizons and was applied also to functional objects, particularly the watch, where its design and its practical purpose were seen as inseparable. The great architects of the Bauhaus had dreamed that industrial pro-

duction would adopt the constraints of design but now the reverse started to happen. It was design that adopted the discipline of industrial production, all the while using its great creativity to shape the major trends in style. This evolution had a marked impact on the 1945–70 period. Design turned its attention firmly towards "consumer durables," especially the car and domestic appliances which became genuine cult objects in the 1950s and 1960s. It led to the emergence of a new style that not only met precise taste criteria but also satisfied the requirements of large-volume production.

Their second insight was that Cartier's splendid isolation in its three historical companies had become suffocating and that progressive market globalization would force it to open up to the wider world. A critical element in this re-orientation was to set up an exclusive but worldwide distribution network. Striking the right balance between exclusivity and broad coverage would be one of the keys to its success from 1973 onwards.

The third insight concerned the distribution of wealth in Western societies after the war. The pyramid of wealth had broadened its base and shrunk in height. This meant that an intelligent marketing strategy would be aimed at a potentially larger target with products such as the *Must*

de Cartier, which still offered superior style and quality but at more affordable prices. The attractiveness of a product destined to become a cult object could no longer be found simple in sumptuous luxury. Instead, it needed a sensuality in its form and materials that made it desirable on an everyday level.

These three insights were the basis of a strategy in which watchmaking would play a vital role right from the start. As objects that were both valuable and functional, they perfectly embodied the new idea of beauty. Cartier watches, especially the *Tank*, represented many people's idea of modern design. Of course, it was not particularly flattering to our era that a watch designed more than 50 years before should at the start of the 1970s be considered as a symbol of modernity, absolute æsthetics and and purity of style. But once again it is important to remember that the development of design in the first 20 years of the century had been extraordinarily productive in the field of watchmaking. Then, once a successful balance of forms had been found, watch manufacturers tuned their attention to technical and functional progress. They were particularly interested in miniaturising movements, introducing complications that had already been tried out in pocket watches, making watch cases and dials resistant to water, dust and shocks.

Above all, they wanted to change the watch from a relatively exclusive object into something that many more people could afford.

In the post-war period, watchmaking came to represent a natural fusion of function and form, and the industry showed exceptional creativity and dynamism. After the change in habits brought about by Timex in the 1950s, a new technical revolution began in 1960 with the new tuning-fork electromagnetic movement. It made a fortune for Bulova Accutron in just a few years, but another revolution was already on the horizon: quartz.

Interestingly, the tuning-fork concept had been developed by a Swiss engineer, Max Hetzel. Disappointed by the chilly reception his idea received from Swiss watchmaking companies, he took it to the Bulova Watch Company of New York. That story is revealing in several respects. The Swiss were still at the forefront of technical research and were at the same time suspicious of any invention that threatened to make traditional mechanical movements obsolete. But in America, the idea of precision was starting to fascinate a lot of people who, as part of a highly technical and practical-minded society, could not help but be attracted by it.

At the end of the 1960s the quartz movement, which would soon become the most revolutionary symbol of this

LEFT
The hands of the *Tank Must de Cartier*
Wristwatch, 1977 (*see p. 153*).

new passion for technology, was still facing major difficulties which made industrial-scale production complex and slow. But its potential was well understood and several Japanese and American companies were concentrating all their research efforts on quartz. Two Swiss companies were also among the pioneers in this area: Omega and Piaget were the only companies at the high end of the market to bet on quartz. In 1969, Piaget introduced two men's models with a quartz movement, the Beta 21, that it had designed and produced in Geneva. It is interesting to note that Piaget, synonymous with miniaturization thanks to its famous extra-thin movements, was so ready to try quartz. The most obvious disadvantage of quartz at the start was that its large movements made watches look cumbersome and even unattractive. Other problems, apart from its high cost, were energy consumption, unreliable batteries, and difficult-to-read time displays. But research work continued throughout the 1970s, and it made extraordinary progress. In 1976 Piaget presented the thinnest quartz movement ever made at that time: the 7P measuring only 3.1 millimeters (⅛ inch) in depth.

The fast-evolving watch market was strongly influenced by two factors at this time: uncertain technical progress and significant social change that was altering popular taste and, therefore customers' choices. Nevertheless, in 1973 Cartier appeared to put its faith in its classic watches. In reality, it was revising them by adding inimitable design details that reflected the spirit of the times, without altering their style. Twelve models were introduced that year, forming the basis of what was soon called the Louis Cartier Collection: *Vendôme, Ceinture, Fabergé, Baignoire, Gondole, Ellipse, Santos, Cristallor, Coussin, Square, Tank Normale* and *Tank Louis Cartier.* Apart from the *Baignoire*, the archetypal feminine watch, each of these models were available in a man's and a woman's version. A total of 23 new watches were launched, each in 18-karat gold and mounted on a leather strap with a folding buckle, and all inspired by the models that best represented Cartier's history.

The *Tank Normale* of 1973 was available in a man's and a woman's version with the choice of yellow or white gold. It included all the basic characteristics of the 1919 *Tank*: a square case framed by two *brancards* projecting to form the paw-like strap attachments, simple geometry and clean-cut edges, a silver dial, Roman numerals, and railroad minute track minute markers. But two changes visibly updated this iconic model: the classic apple-shaped hands were replaced by the straighter sword-shaped design and

RIGHT

Extra-thin *Tank L.C.* Wristwatch

CARTIER PARIS, 1970

Marked on the dial: *Cartier, Paris*

Case of polished and satin-finish gold,
brancards of polished gold. Beaded winding
crown capped with a sapphire cabochon. Leather
strap, deployant buckle of yellow and pink gold.
Rectangular white dial with Roman numerals
around a railroad minute track.
Baton hands of blued steel.

❖ *Round LeCoultre caliber P838 movement,
fausses Côtes de Genève decoration, rhodium-
plated, 3 adjustments, 18 jewels, Swiss lever
escapement, monometallic balance,
flat balance spring.*
WCL 33 A70

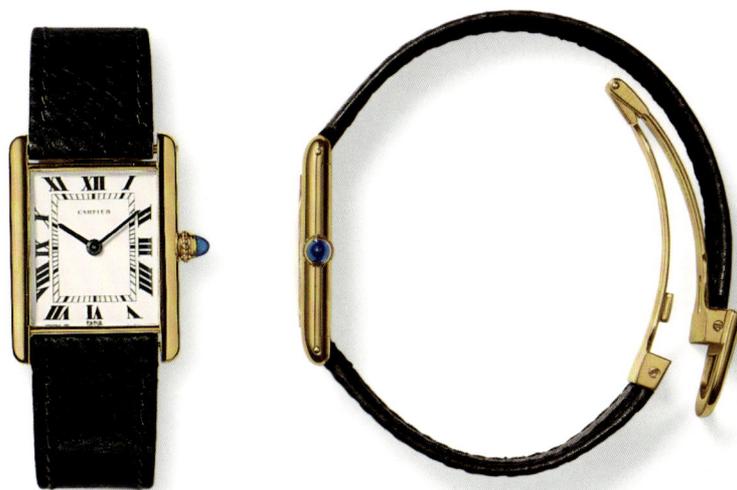

the traditional, round, beaded crown by an octagonal ver-
sion, still set with a sapphire cabochon. Lastly, the strap in
crocodile skin for day or evening wear was again fitted with
a typical Cartier-style folding buckle. This buckle, patented
in 1909, gave the watch a subtle touch of elegance that was
entirely contemporary. At the time, it famously symbolized
the elegance of Cartier watches with leather straps, and
was one of the most important reasons for their success.

The *Tank Louis Cartier* drew its inspiration from the
Tank L.C. of 1922. The largest model in the line had adapted
most visibly to the taste of the time with a new extra-thin
mechanical movement just 1.8 millimeters (1/16 inch) in
depth. Piaget was the first manufacturer to achieve this
technical feat that was the clearest demonstration of the
modernity of watches in the 1970s. Cartier immediately fit-
ted it into its different models of extra-thin *Tanks*.

In the 1970s the timeless beauty of the *Tank*, with its
rigorous Art Deco elegance and its perfect angular or soft
geometry, began to take on a new life. It showed no sign of
its real age. On the contrary, as tastes changed, the *Tank*
was seen as a perfectly balanced object that was both tradi-
tional and innovative. Its superb classic simplicity counted
for as much as its performance based on the latest technol-
ogy. The *Tanks* of 1919 and 1922 were carefully updated in

their designs, and fitted with the technical improvements
regularly created by progress in watchmaking. There was
no doubt that Cartier was dedicated to constant renewal of
tradition in its watches as much as in its jewelry.

In 1973, the *Tank L.C.* was fitted with an extra-thin
movement before, one year later, being given an automatic
movement with a thickness of 4.80 mm (3/16 inch). The
complexity of automatic movements means they have to
be housed in a larger case. It was a considerable achieve-
ment to modify the *L.C.* case to accept the movement
without affecting its balance or proportions. As always in
the Cartier tradition, although the technical requirements
were rigorously respected, style and design considerations
came first.

The company continued to revisit its famous models
over the next few years. In 1976, a *Mini Tank* was intro-
duced, echoing the *Petite Tank Rectangle* of 50 years earlier
but with rounded edges as in the *Tank L.C.* The following
year, a new *Tank Allongée* and a new *Tank Cintrée* appeared
and, in 1978, a new *Tank Chinoise*. While these contem-
porary watches included most of the traditional features,
a few important details gave them a new modern appear-
ance: they each had sword-shaped hands and finer Roman
numerals than the originals, the *Mini* and the *Allongée* had

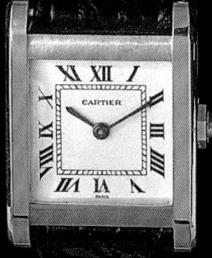

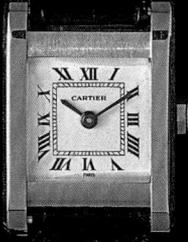

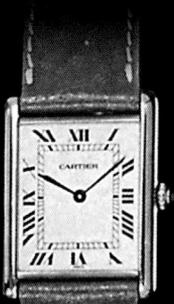

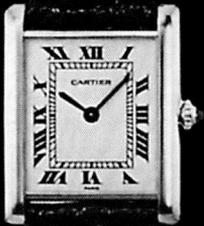

The *Tank Normale* and *Tank L. C.*, part of the *Louis Cartier Collection* of 1973, were a projection into the future of the prestige of the past. In 18-karat yellow gold and with mechanical movements. Under the name *Tank Normale* the 1973 model returned in two variations (yellow gold and white gold) to the fundamental characteristics of the *Tank* of 1919.

FACING PAGE (CLOCKWISE FROM TOP LEFT)
Tank Normale, 1973. Yellow gold on leather; *Tank Normale*, 1973. Yellow gold on leather. Ladies' model; Extra-thin *Tank L.C.*, 1974. Yellow gold on leather; *Tank L.C.*, 1973. Yellow gold on leather.

RIGHT
Actress Ingrid Bergman wearing her *Tank* watch, circa 1967.

abandoned the railroad minute track, simplifying the graphics of their dials, and the *Cintrée* had adopted the octagonal crown. Among these carefully modified versions was one that stood apart. In 1977 a new *Tank* appeared that seemed to be a radical break from the past: the *Tank Arrondie*, which inevitably was also called the *Tank Ellipse* as it was a fusion of two Cartier watches, the *Tank* and the *Ellipse*. It had a completely original shape with a pronounced curvature of the two vertical sides (they could no longer be called *brancards*), creating a geometric form somewhere between the rectangle and the ellipse. This gentle softening of the angular Art Deco concept was a new step in exploring the graphic potential of the *Tank*. Since the beginning, the *Tank* had easily adapted to all the experiments with its form: elongating the square into a rectangle, thinning and thickening the sides, rounding and sharpening the edges. Comparing the *Tank Arrondie* with the similar shape of the classic *Tortue* model underlines the uniqueness of the *Tank* style: the two shapes are similar, but in the former its two vertical sides, although inclined, do not bend at all to form the strap attachments. This is the feature of the *Tank* that made it easy to distinguish from other watches, even from its "cousins" in the Cartier family: no element of the case altered its shape to form the *brancards*.

This series of watches from 1976 to 1978 also marked a momentous turning point in the *Tank*'s long history: these models, with mechanical movements from Jaeger and LeCoultre, were assembled in limited series in a new workshop on the Place Vendôme called "Cartier Paris" devoted to the assembly and gem-setting of exceptional watches. This workshop was the start of a real Cartier watchmaking operation that developed steadily from that moment on.

The non-conformist spirit of the early 1970s came to characterize the entire decade, largely as a result of the oil crisis of 1793 and the lasting recession that followed. The economic environment fostered the spread of a new fashion that was more active and sporty, impertinent, young, colorful and carefree. It was best described in the phrase "elegant casual."

Of course, there was some ideology behind all this "casualness" in clothing and behavior. The universal jeans and anoraks, the tennis shoes, the long colored scarves thrown over coats and jackets or wrapped around the face like a balaclava were all a way of showing support for the values of a new generation that wanted to be different in form and content, and to look and think differently. But one of the characteristics of fashion is that it quickly forgets its roots and becomes just a way of dressing, a way of expressing an

FACING PAGE
The French fashion designer and stylist
Yves Saint Laurent wore his extra-thin *Tank L.C.*
at the exhibition devoted to him at the New York
Metropolitan Museum of Art in 1893.
With Pierre Bergé, posing for the famous
Australian photographer Alice Springs.

instinct rather than a concept, and reflecting the spirit of the time. And so, in the shadow of the recession, young people's fashion became everybody's fashion. The tie was temporarily banned from menswear in favor of check shirts and round-, V-, or polo-neck pullovers. In women's fashions, two items of clothing made a powerful impact. Interestingly, they were symbolically opposed, but driven by the same desire for emancipation. The mini-skirt emphasized femininity through a display of sexual difference, while jeans, identical to the men's versions, glorify women by demonstrating equality, at least for the 1968 generation.

In 50 years, the Cartier *Tank* had graced so many different wrists and adapted to so many changes in customs and in the cultural climate that it was no surprise to see it adjust easily to the casual elegance of fashion. In the 1970s the ideological distaste for luxury was reinforced by the economic crisis. So was the *Tank* necessarily a luxury item? It was certainly intended to be so, but it represented an idea of luxury that was so refined, so controlled, so effortless that it was never ostentatious. Its classic shape, its geometric lines and its elementary beauty made it a watch that could be worn at any time or with any kind of clothes—or even with no clothes at all in those days when anything was permissible. The famous Russian dancer, Rudolph Nureyev

appeared virtually naked in Ken Russel's Film *Valentino* but still had his *Tank* on his wrist. Shortly before the film was released, the producers removed it from the poster photograph, afraid that it gave too much publicity to the world's most famous watch.

In any case, everyone was free to interpret the *Tank* in their own way: as a symbol of wealth or a mark of refinement, as a touch of modernity or a piece of retro nostalgia. In the 1970s it represented both the newness of the *Must de Cartier* and the renewal of Art Deco. Nobody was surprised at that time to see the watch adopted by a highly controversial celebrity, the actress Jane Fonda. She had caused a scandal in America with her firmly left-wing views and her fiery opposition to the war in Viet Nam. It seemed that the *Tank*, that had been born as part of an avant-garde movement, was still appealing to those who wanted to change the world. This was a magnificently ironic achievement for a watch which was then more than half a century old.

❖

The three traditional branches, Paris, London, and New York, had been given considerable autonomy but still remained part of the same, single brand. They shared a common

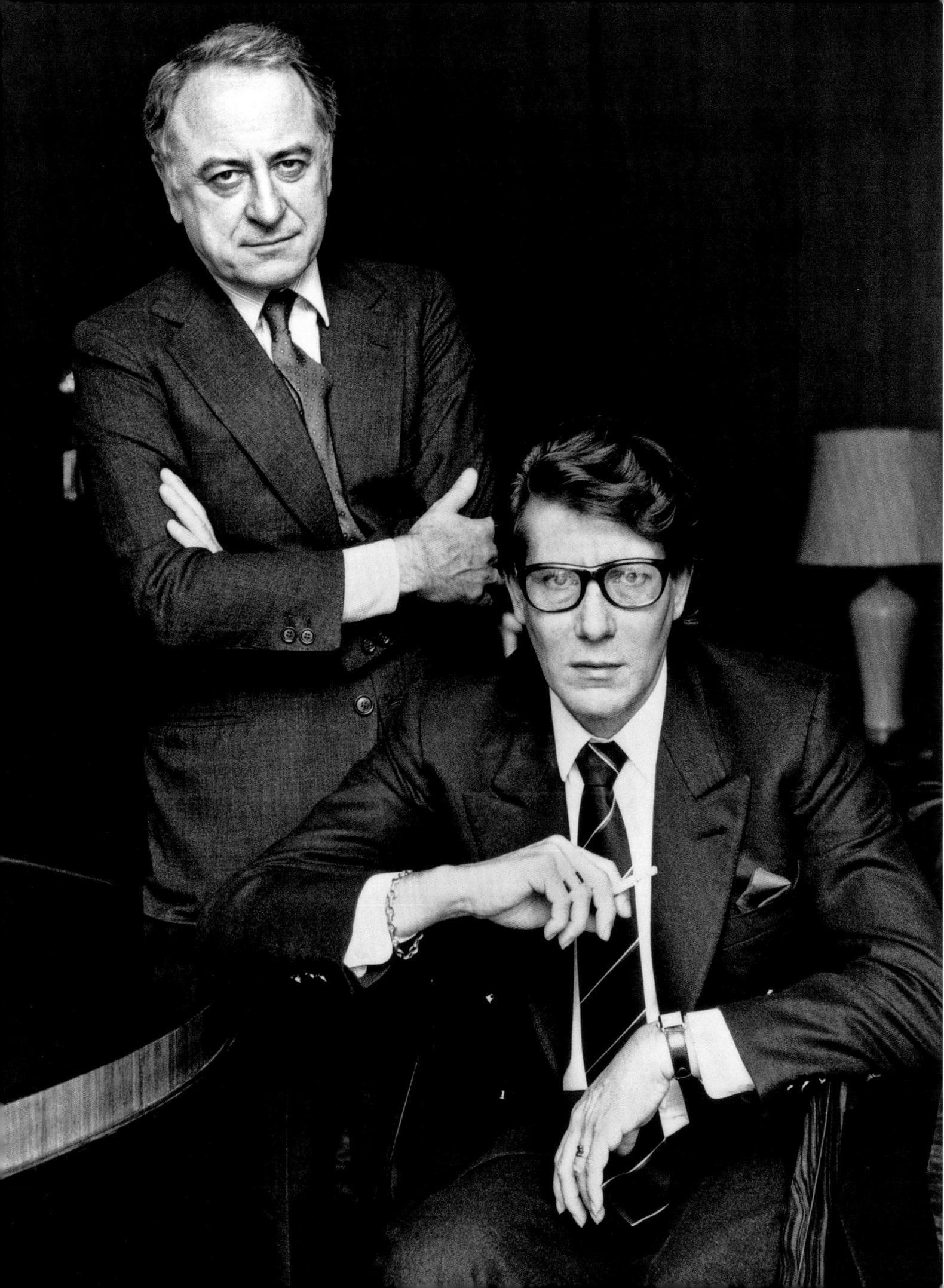

Tank Must de Cartier
Wristwatch
CARTIER, 1977

Marked on the dial: *Must de Cartier*,
an entwined double *C*, and *Swiss*

Case of polished and satin-finish silver gilt, *brancards*
of polished silver gilt. Beaded winding crown capped
by a blue spinel cabochon. Leather strap, pin buckle.
Rectangular onyx lacquer dial. Gilded sword-shaped
hands.

❖ *Round movement, Côtes de Genève decoration,*
rhodium-plated, 17 jewels, shock-resistant, Swiss lever
escapement, monometallic balance, flat balance spring.
ST-WCL 238 A77

spirit and style. Their Cartier design and production unit ceased to exist in the 1960s when the Cartier family was faced with growing difficulties and gave up the Paris and New York branches. They were transferred to two separate companies that sold Paris to a group of investors led by Joseph Kanoui in 1972. New York followed in 1979. Cartier London was retained by Jean-Jacques Cartier until 1974 when it joined the same group.

In 1977, Alain Dominique Perrin had prepared for the re-acquisition of the New York branch by putting together a marketing strategy involving the launch of Cartier's "*Must*" collection of watches. The 150-dollar *Tank* was replaced by the *Tank Must* in silver gilt. This model retained all the style details that were associated with the tradition and spirit of the company. It also proved to be an effective tool in combating the counterfeiting that was spreading fast in North America. It took the form of the *Tank L.C.*, including the beaded crown set with a sapphire cabochon. Fourteen models, in two sizes, were soon available with only one difference between them: the appearance of the dial. The first model, with its railroad minute track minute circle and traditional Roman numerals on the dial, was immortalized in Irving Penn's photograph of Yves Saint Laurent in which the shy fashion designer hid behind his hand, clearly show-

ing his *Tank Must*. However this model was almost immediately replaced by a series of naked dials in a vivid lacquer of onyx, coral, ivory, lapis-lazuli or tortoiseshell. Garnet was added in 1979.

The novelty of these models with colored lacquered dials, selling at 500 dollars, and the introduction of quartz movements as of 1980, made this collection a worldwide success. It sold particularly well in the USA and Japan, where the market was very demanding when it came to precision, and was very popular among young people.

Also in 1980, the silver gilt *Must* was given a series of dials with new variations. They were first inspired by one of the company's favorite themes, Cartier's famous blend of three golds: pink, yellow, and white. The dial without numerals was decorated with alternate fine and broad bands of the three golds, or a motif of three overlapping squares. In 1986, the theme was taken up again with the addition of gray enamel. The three golds helped to give these watches the aura of jewelry. The original concept allowed for other touches of fantasy to be added: dials with Roman numerals and markers in gold cloisonné on an ivory or burgundy background, or combinations of metals that had rarely been used in the history of the *Tank*, such as rhodium-plated silver.

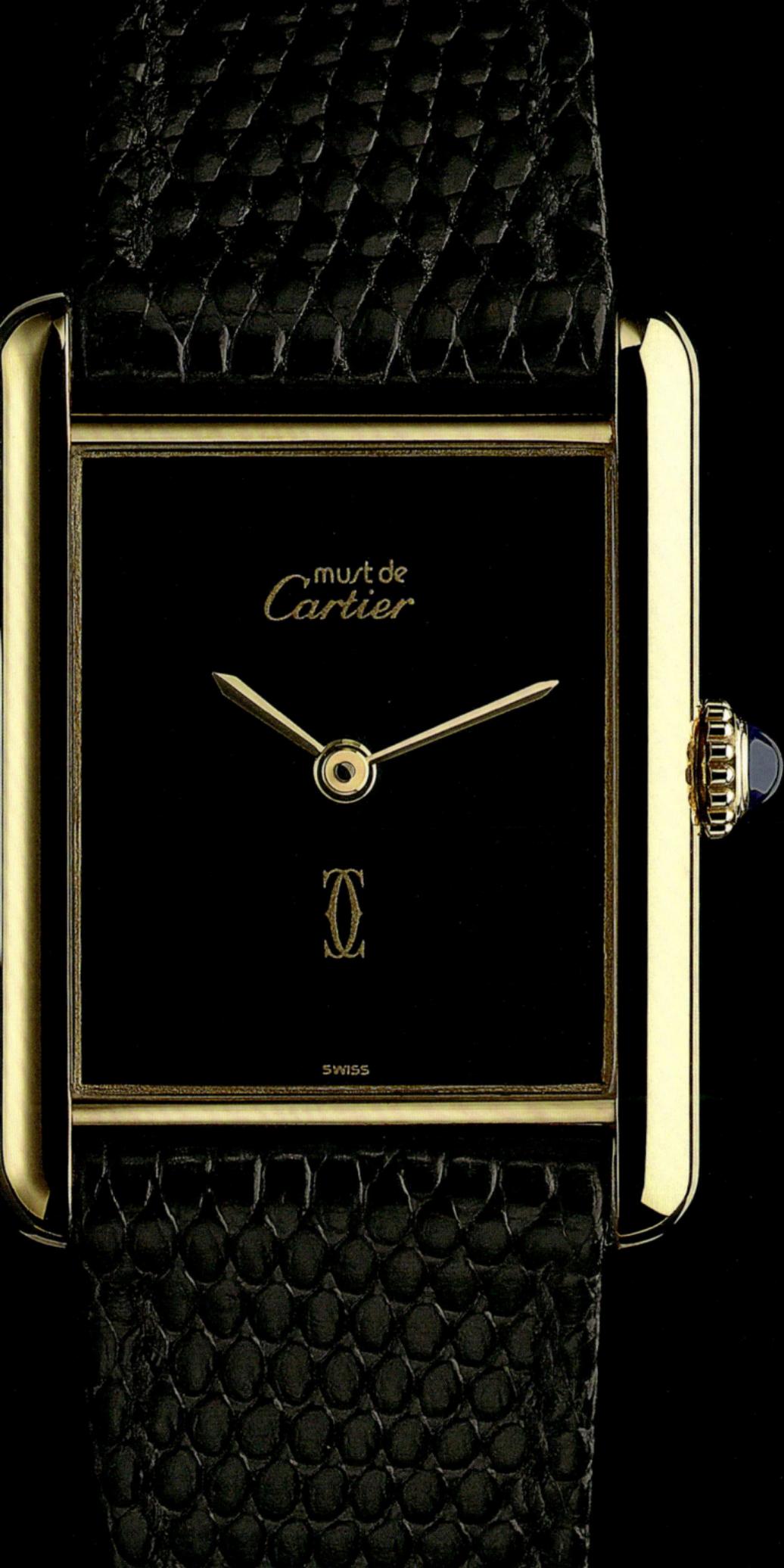

IT SEEMED THAT
THE *TANK*, WHICH
HAD BEEN BORN
AS PART OF
AN AVANT-GARDE
MOVEMENT, WAS STILL
APPEALING TO THOSE
WHO WANTED TO
CHANGE THE WORLD.

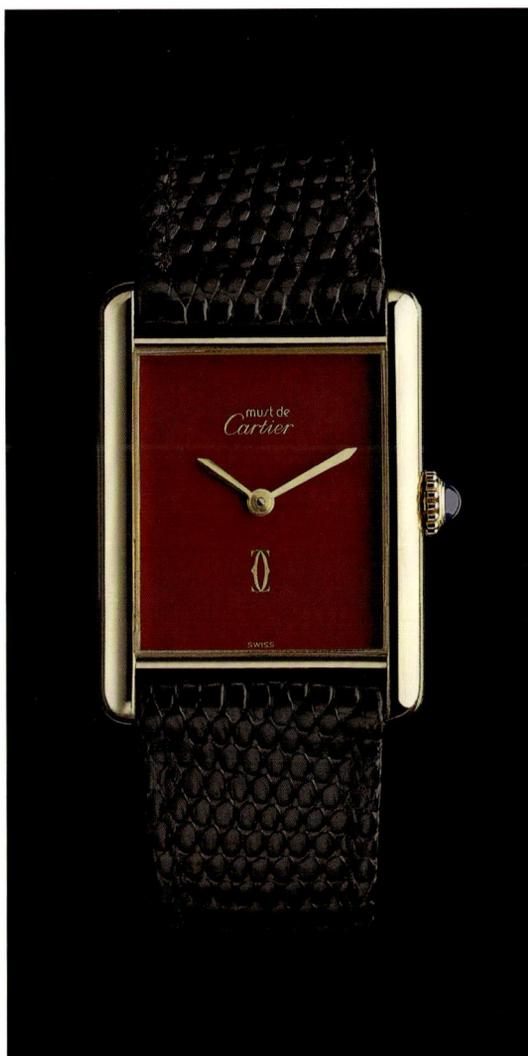

FACING PAGE

American artist Andy Warhol, king of Pop Art, was a great collector of *Tank* watches. 1973.

LEFT

***Tank Must de Cartier*
Wristwatch**

CARTIER, 1977

Marked on the dial: *Must de Cartier*, an entwined double *C*, and *Swiss*

Case of polished and satin-finish silver gilt, *brancards* of polished silver gilt. Beaded winding crown capped by a blue spinel cabochon. Leather strap, deployant buckle. Rectangular coral lacquer dial. Gilded sword-shaped hands.

❖ *Round movement, Côtes de Genève decoration, rhodium-plated, 17 jewels, shock-resistant, Swiss lever escapement, monometallic balance, flat balance spring.*

ST-WCL 245 A77

LEFT
Oval lighter, Cartier, 1973.
Solid gold, vertical reeding.
ST-LR 05 A73

FACING PAGE
American actor Warren Beatty,
inseparable from his *Tank* watch, during
the *Bonnie and Clyde* era, circa 1967.

While the *Tank Must* was enjoying international success, so was quartz. In the 1970s, the initial problems encountered by quartz were brilliantly resolved. The Americans, and even more so the Japanese, invested significant amounts of money and manpower, slowly resolving all the the technical difficulties that had delayed the introduction of quartz movements at the start of the decade. Certain advances had been particularly important: replacing the electroluminescent diodes by liquid crystals in the time display, the miniaturization of the movements to the point where quartz watches that were the same size as mechanical watches could now be produced, and improvements in the life and reliability of batteries. At the start of the 1980s, quartz was the winning strategy in watchmaking, particularly in America and Japan. Its advantages were its superior precision and the possibly more interesting fact that it could provide a range of functions at low cost, including the date, a perpetual calendar, a chronograph and an alarm. Among traditional mechanical watches, these had been exclusive features at the top of the range.

Swiss watchmakers, with a few exceptions, had refused to believe in the quartz movement. As a result, they now faced the greatest crisis in their history. Employment in the watchmaking sector fell from 90,000 in 1970 to less than 30,000 in 1982, with the number of companies falling by 75%. The darkest years were from 1978 to 1982. Then in 1983 the creation of the Swatch signalled the start of a recovery.

Cartier's attitude towards quartz was less colored by traditional, preconceived ideas than the leading Swiss watch companies. In producing wristwatches for seventy-five years, its emphasis had always been on style and design, although it had consistently offered the latest technological advances. Over the decades, Cartier watches had been home to a host of technical innovations. These had ranged from Duoplan movements to extra-thin movements, from the extreme miniaturization of the baguette watch to the much larger dimensions of the automatic movements. Cartier had been able to incorporate all kinds of technical innovations while still remaining true to itself. It was part of the company's mindset to produce watches that fitted into a tradition, but without rejecting technical progress. Cartier therefore had no objection to using quartz and benefiting from the advantages that this new technology offered.

In 1980, the first quartz movements were introduced in the "*Must*" range of watches, first of all in the *Vendôme*

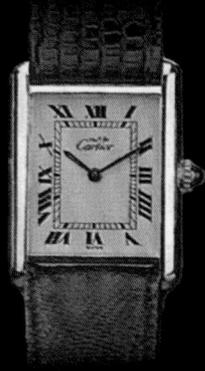

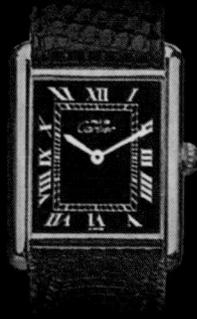

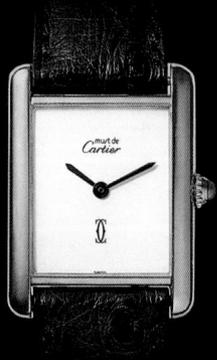

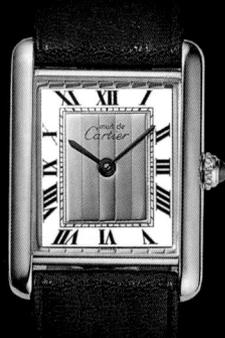

The *Must de Cartier* collection of watches
was launched in 1977. It adopted the form
of the *Tank L.C.*, with its winding crown
set with a sapphire cabochon.

FACING PAGE (CLOCKWISE FROM TOP LEFT)
Tank Must de Cartier Wristwatch, 1977.
Case of polished and satin-finish silver gilt
in two sizes. Dials of the two models with
traditional chapter ring and Roman numerals;
Tank Must de Cartier Wristwatch, 1988. Case of
polished and satin-finish silver gilt. Rectangular
white dial with central pattern of 3-gold bands,
Roman numerals, sword-shaped hands of blued
steel; *Tank Must de Cartier* Wristwatch, 1977.
Case of polished and satin-finish silver gilt.
Rectangular ivory lacquer dial.
Gilded sword-shaped hands.

RIGHT
The Canadian actress Joanna Shimkus,
in the movie *The Lost Man* in Los Angeles in
November 1968 and wearing a *Tank* watch.

Must then, two years later in the *Tank Must*. They proved so successful in the luxury watch sector that, before long, they were also introduced in the solid gold collection. In 1983, for example, electronic movements were fitted in a *Tank Louis Cartier* and a *Tank Chinoise*. The classic look of these two models was left unchanged, with only an engraving on the case back to differentiate them from those with a mechanical movement. Until the end of the 1990s, all these movements were exclusive to Cartier, designed and produced in Switzerland by Ebel, a prestigious watch company founded in 1911 in La Chaux-de-Fonds.

❖

The 1980s brought more than the quartz revolution to the small world of watchmaking. On a wider scale, the pendulum of change swung towards a different set of values and tastes in Western society. In 1979, much of the West started to emerge from the long crisis and enjoy a state of euphoria like the relief that comes at the end of a war. With Ronald Reagan's election as US President in 1980, free-market economics became the dominant school of thought and was promoted in Europe by the British Prime Minister, Margaret Thatcher. The developed world turned enthusiastically to the pleasures of consumerism, watched with growing envy by the people of Eastern Europe trapped behind the Iron Curtain.

The concept of luxury had been disdained in society for more than thirty years, but now it became one of the dynamics of the new, self-indulgent era. Together with luxury came individualism, an even more drastic rejection of the ideas and values of the 1970s. In both the public and private sectors, consumption was directly encouraged by government supply-side policies, and stimulated by a huge growth in sophisticated marketing and advertizing. The idea that making money was the key to social success had never been so widely accepted. The 1980s worshipped the entrepreneurial spirit and the aim of getting rich quick. The trend towards unselfconscious display certainly influenced fashion. As the drive for success became increasingly competitive, women adopted a more assertive, *female-executive* look with tailored suits and padded shoulders. The hyperactive urban lifestyle of the younger age group favored sportswear, tracksuits and colored basketball shoes. Behind this dynamic, uninhibited facade, two important developments were having a major influence on behavior: the birth of the Internet and the arrival of Aids.

At a time when wealth was a status symbol, when appearance was more important than substance and fiction trumped

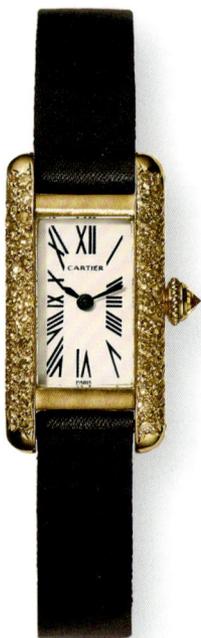

Tank Allongée Wristwatch

CARTIER, 1982
Marked on the dial: *Cartier, Paris*

Case of polished and satin-finish gold, *brancards* set with 2 rows of yellow brilliant-cut diamonds.
Beaded winding crown capped with inverted yellow diamond.
Fabric strap, deployant buckle of gold.
Rectangular white dial with Roman numerals.
Sword-shaped hands of blued steel.

❖ *Oval movement, rhodium-plated, 17 jewels, shock-resistant, Swiss lever escapement, monometallic balance, flat balance spring.*
ST-WCL 86 A82

authenticity, it would have been fatal for Cartier to meekly follow fashion and allow its creations to become just another sign of self-indulgence. Cartier had always known how to be classical yet still avant-garde. This experience helped it to update its creations without devaluing them, to reinterpret its own style without betraying it.

When the *Tank Louis Cartier* in solid gold was first given a quartz movement in 1983, the collection also offered something that seemed directly at odds with the trends of the time: a man's and a woman's version in platinum. Another platinum watch that year was the extra-thin *Tank Arrondie*. This unpretentious, yet precious, metal hardly seemed to fit the mood of the 1980s. But Cartier was a master at balancing the past and present, at alternating bold and discreet signals, or curves and angles. So it was not surprising that it reintroduced platinum, one of its favorite metals, against the tide of fashion fully ten years before it made its real comeback.

Two years earlier, Cartier had exhibited for the first time in the Basel Watchmaking Fair where the industry's new developments are introduced to the world. This was the first full presentation of its collections outside of the distribution network controlled by Paris. At Basel, a collection of jewelry watches appeared for the first time in Cartier's recent history. It was a turning point for the company: over the next few years the jewelry version of watches became very successful. The impetus was not only the increase in spending power among a large part of the population, but also the advance of women in business and in economic and cultural life overall. Women were no longer embarrassed to look at the time since they could do so on "jewelry watches" rather on "watch jewelry". Decoration of any kind had always presented a challenge for the *Tank*. The watch was a symbol of elegant, refined simplicity and adding jewelry made it difficult to preserve its basic geometrical identity. But some of the finest moments in Cartier's history were those when it expressed itself in different ways: from the garland style to Art Deco, from *Tutti Frutti* to the naturalistic flowers of the 1950s. In the 1980s it drew on its long tradition of jewelry to design an entirely new version of the *Tank*.

There are many examples of jewelry *Tanks*. They range from the simplest, such as the archetypal *Mini Tank* launched in 1976, to the most complex and daring models, assembled and set in the company's Paris workshops. The *Tank Normale* was set with a row of baguette-cut diamonds on the vertical sides and two rows of brilliant-cut diamonds on the horizontals. The interplay of rectangular and round cuts accentuated the edges of the two large sides and softened

Portrait of César by Arnaud Baumann, 1989.
The celebrated French Nouveau Réaliste sculptor
describes his *Tank* in the following terms:
"I love wearing my *Tank*. I would feel naked
without it. This watch has a physical dimension,
sensual and above all tactile. I'm always touching
it, stroking it, without even looking at it.
I look at it with my fingers."

the smaller ones. On other square and rectangular *Tanks*, the case, dial and bracelet were fully set with baguette- and emerald-cut diamonds in rigorously geometrical arrangements. The jewels emphasized the square form of the watch but also distracted from it by tempting the eye to follow the curve of the bright band of stones around the wrist. An even more fascinating contrast was created by replacing the two rows of baguette-cut diamonds on the *brancards* with two rows of baguette-cut sapphires. This recalled the DNA of the original *Tank* with the dark blue standing out against the brilliant white of the diamonds. There were also the "*Tutti Frutti*" *Tanks* offering a dial encrusted with brilliant-cut diamonds, a case set with sapphires and emeralds, and bracelets of emeralds, sapphires and rubies. However, the size and shape of the stones seemed to be carefully varied to ensure that all this ornamentation did not obscure the famous design.

The enthusiasm for jewelry *Tanks* continued to grow through the next decade when Cartier Paris gave the watch the kind of sumptuous decoration that had excited its clients back in Louis Cartier's day. Arabic-Persian geometric patterns appeared on the *Tank Kilim* (1992–93) and the *Tank Byzantine* (1994) created for the St. Petersburg exhibition, while the *Tank Patiala* (1995) recalled the Cartier

brothers' love for the vivid colors of India. But the House was also determined to associate the *Tank* with diamonds on their own, as it showed with the *Natura* (1995), a "white" version of an Indian motif. The ornamental approach continued for some years. A *Tank* mother-of-pearl dial had a motif radiating out from 6 o'clock, that seemed to extend across the waves into a "pyramid bracelet." The *Tank* was also given bracelets structured in geometric patterns such as *serpent, pastilles, gouttes perles* and *gourmette* that were an extension of the geometry of the case.

❖

Cartier continued to introduce inspired new versions of the *Tank*, often ahead of the spirit of the time. For example, in 1989, the year when the Berlin Wall came down, the Soviet Block collapsed and a new era of American dominance began, it launched the *Tank Américaine*. This model, in yellow gold, was an elegant response to the growing taste for very large watches, a trend fostered by the Cartier *Pasha* (1985). It was an immediate success. And its popularity has continued ever since. In 1998 a *Tank Américaine*, engraved with an affectionate message, was presented by King Juan Carlos and Queen Sofia of Spain to their son, Don Felipe, Prince of Asturias on his 30th birthday. The

Tank Mathilda Bracelet-watch

CARTIER, 1992

Marked on the dial: *Cartier, Swiss*

Case of polished and satin-finish gold, *brancards* set with a row of brilliant-cut diamonds. Beaded winding crown capped with inverted diamond. *Mathilda* bracelet of polished gold, deployant buckle of gold. Rectangular grained-silver dial with Roman numerals (secret Cartier mark on one bar of the numeral X). Sword-shaped hands of blued steel.

❖ *Barrel-shaped quartz movement, Côtes de Genève decoration, rhodium-plated, 4 jewels.*
ST-WCL 241 A92

Mini Tank Bracelet-watch

CARTIER, 1989

Marked on the dial: *Cartier, Swiss*

Case of polished and satin-finished gold, *brancards* of polished gold set with 3 rows of single-cut diamonds. Beaded winding crown capped with inverted diamond. Chain bracelet of polished gold, central links set with single-cut diamonds; hook clasp. Rectangular grained-silver dial with Roman numerals and indices. Sword-shaped hands of blued steel.

❖ *Rectangular cut-cornered quartz movement, gilded, 5 jewels.*
ST-WCL 113 A89

Tank Allongée Wristwatch

CARTIER, 1988

Marked on the dial: *Cartier, Swiss*

Case of polished and satin-finished gold, *brancards* of polished gold set with 3 rows of single-cut diamonds. Beaded winding crown capped with inverted diamond. "Serpent" bracelet of polished gold, deployant buckle of gold. Rectangular grained-silver dial with Roman numerals (secret Cartier mark on one bar of the numeral VII). Sword-shaped hands of blued steel.

❖ *Rectangular cut-cornered quartz movement, gilded, 5 jewels.*
ST-WCL 108 A88

FACING PAGE
Catherine Deneuve wearing her Cartier watch, 1984.

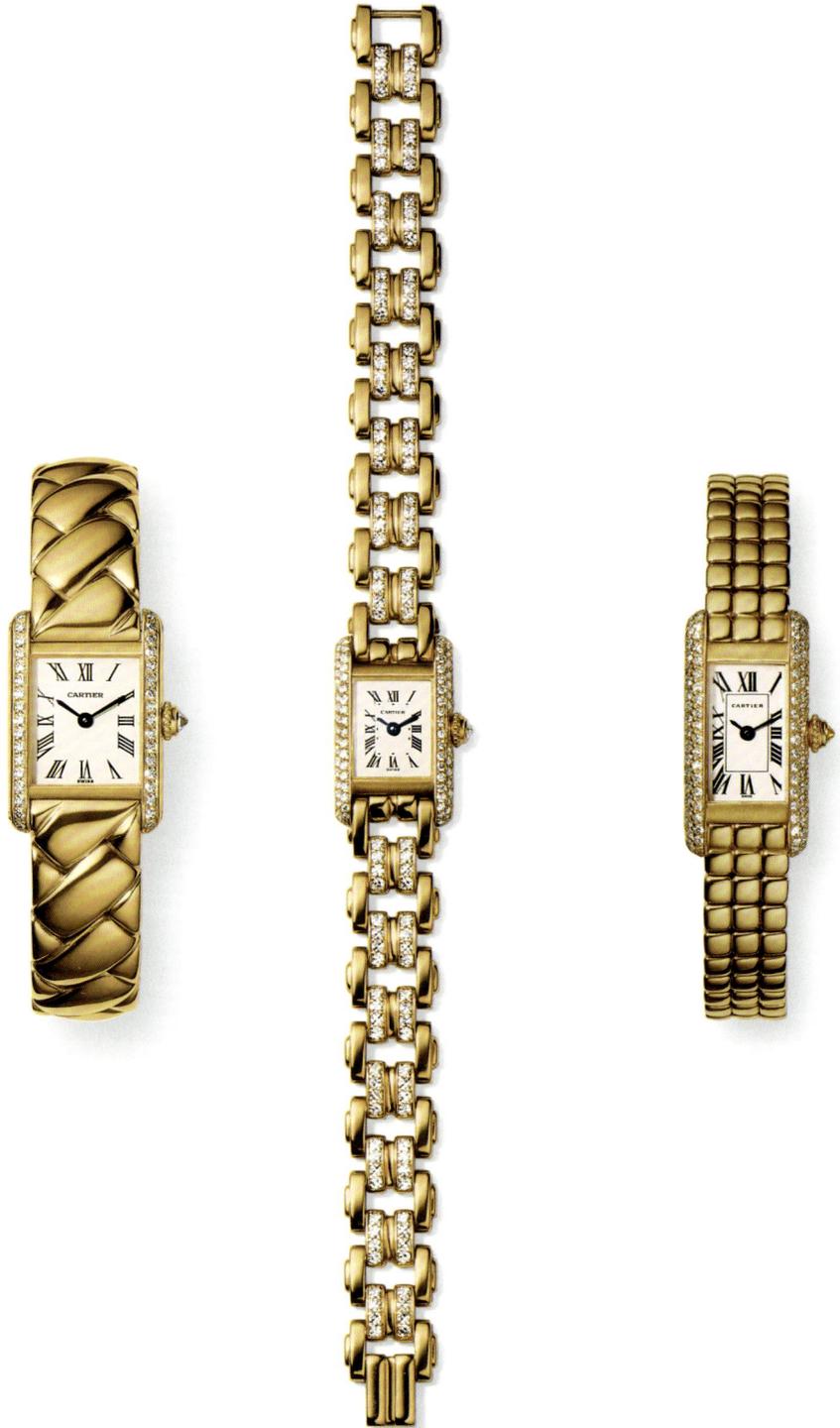

FOLLOWING DOUBLE PAGE

Tank Américaine Wristwatch

CARTIER, 1993

Marked on the dial: *Cartier, Swiss*

Curved case of satin-finish gold, *brancards* of polished and satin-finish gold. Eight-sided winding crown capped with a faceted sapphire. Leather strap, pin buckle. Curved rectangular dial with Roman numerals (secret Cartier mark on one bar of the numeral VII) around a railroad minute track. Sword hands of blued steel. Water resistant up to 30 meters (100 feet).

❖ *Round movement, Côtes de Genève decoration, rhodium-plated, 5 adjustments, 18 jewels, shock-resistant, Swiss lever escapement, monometallic balance, flat balance spring.*

WCL 131 A93

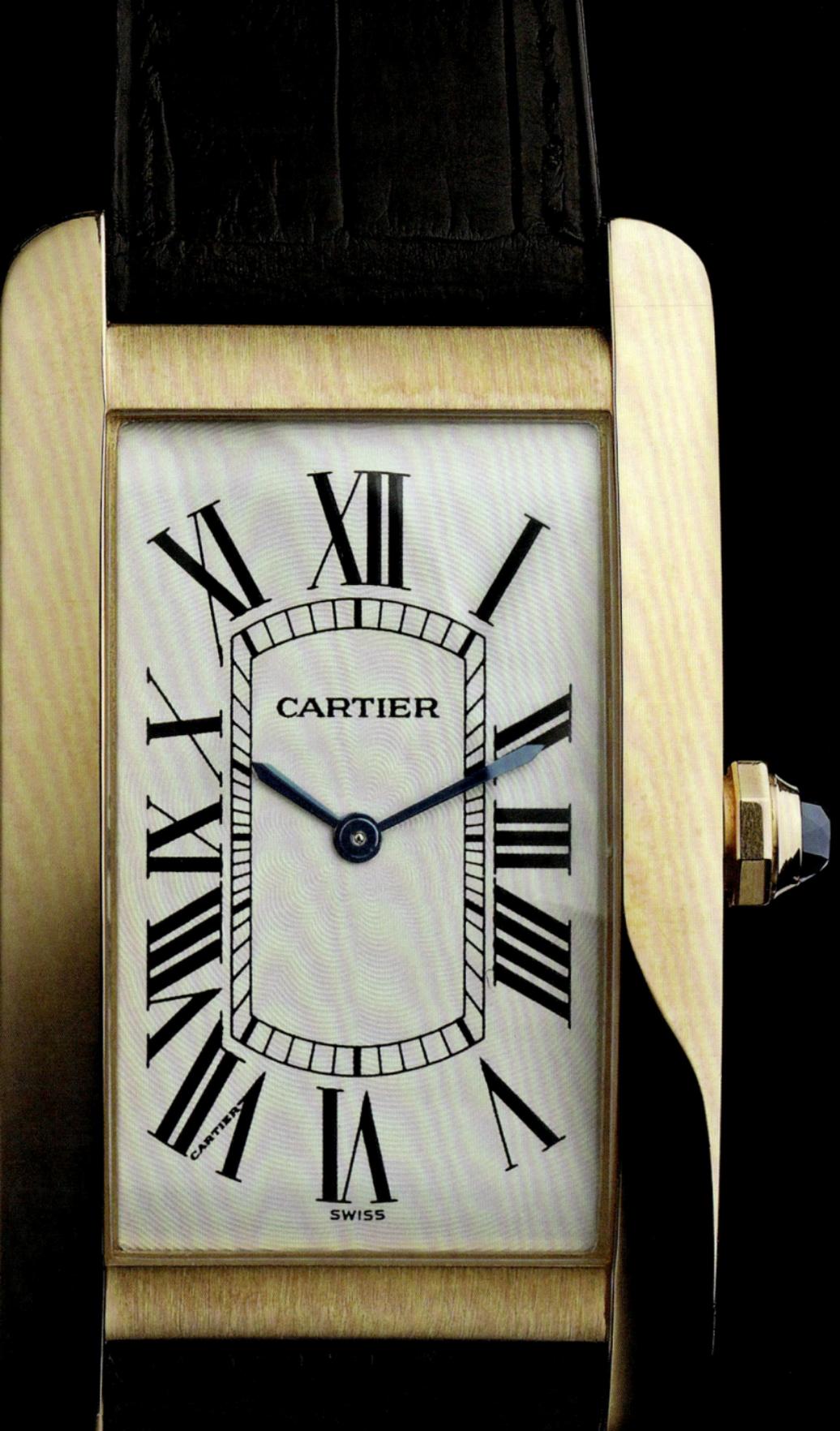

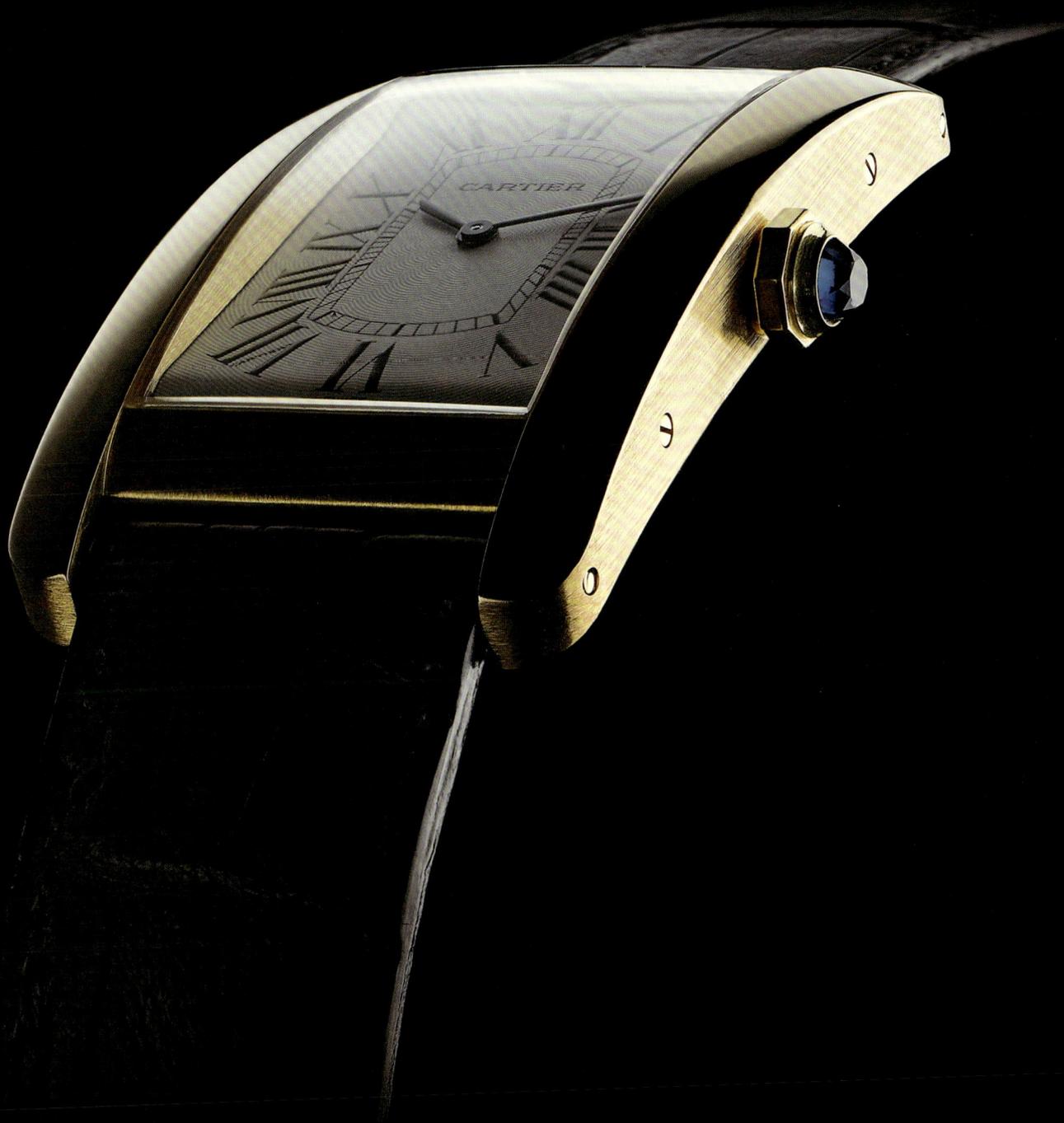

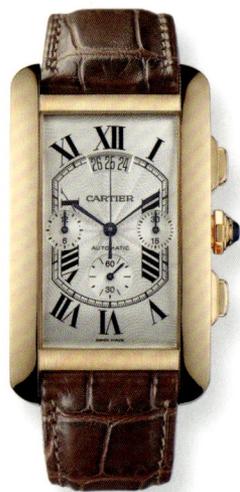

Tank Américaine Wristwatch
XL Chronographe
CARTIER, 2007

Extra-large model. Case of 18-karat pink gold. Transparent back. Octagonal crown set with a faceted sapphire. Silvered *guilloché* opaline dial. Roman numerals. Sword-shaped hands of blued steel. Semi-matt dark brown alligator leather strap. Deployant buckle of 18-karat pink gold. Functions: chronograph, hours, minutes, seconds and aperture at 12 o'clock. Water resistant up to 30 meters (100 feet).

❖ *Mechanical movement with automatic winding caliber Cartier 205.*

Tank Américaine **Chronoreflex**
Wristwatch
CARTIER, 1996

Case of 18-karat rhodiumized white gold. Bright vertical sides, satin horizontal sides. Octagonal crown set with a faceted sapphire. Bracelet of 18-karat rhodiumized white gold. *Flinqué* grained silver dial, black Roman numerals, railroad minute track. Sword-shaped hands of blued steel. Hardened mineral crystal. Functions : chronograph with fly-back hand, hours, minutes and perpetual calendar. Water resistant up to 30 meters (100 feet).

❖ *Chronoreflex quartz movement, caliber Cartier 212.*

Tank Américaine was clearly derived from the *Tank Cintrée* but with significant design and technical modifications. While it borrowed the curvature of the case, it showed a more compact rectangle with flatter *brancards* and thinner horizontal sides. Overall it was a wonderful example of the Cartier tradition of playing cleverly with the geometry, alternating sharp and gentle edges, straight lines and curves, rounded corners and angles. The *Tank Américaine* was squarer than the *Cintrée*—the sides were closer to the same length—with smaller dimensions and corners. At the same it had a more imposing, solid appearance that matched its key technical difference: it was the first Cartier watch with a curved case that was water-resistant. Other distinguishing features were its very modern octagonal crown and its folding buckle. Like all Cartier watches mounted on leather straps since 1988, the *Tank Américaine* was fitted with a new kind of buckle, not the fixed type that had been patented in 1910 but an adjustable folding buckle that enabled the length of the strap to be adapted to the size of the wrist. This development, patented in 1987, was further evidence of Cartier's devotion to improving every design element of the watch.

On the purely technical level, managing to make a curved watch water-resistant brought the company closer to being recognized as a complete watch manufacturer. The first models were given quartz movements and some had complications such as a window calendar at 3 o'clock, or a hand-display calendar. A small seconds at 6 o'clock and a moon-phase display were added to a minor version of the *Tank Américaine*—called the *Tank US* within the company—which had a different curvature and non-satin sides.

At this time though, *Tanks* with complications were still quite rare, largely because its form left little space for extra technical features and any alteration would inevitably affect the harmony of the design. They were: the extra-thin *Tank L.C.*, the *Tank L.C.* automatic (1973–74), the quartz *Tank L.C.* with moon phases and a hand-indicated calendar (1987–88) and the double time-zone *Tank Cintrée* with two independent manually-wound movements showing local time and the time in a city on a different longitude (1990). This spectacular watch was assembled in Cartier's Paris workshop. In 1991, the *Tank Américaine*, which had larger dimensions than the *L.C.*, was given an automatic movement with a central seconds hand and a window calendar. In 1994, the same watch adopted the Chronoreflex developed in 1991 and made by Piaget. This was one of the world's smallest quartz movements yet managed to incorporate a rapid time-zone change, a perpetual calendar,

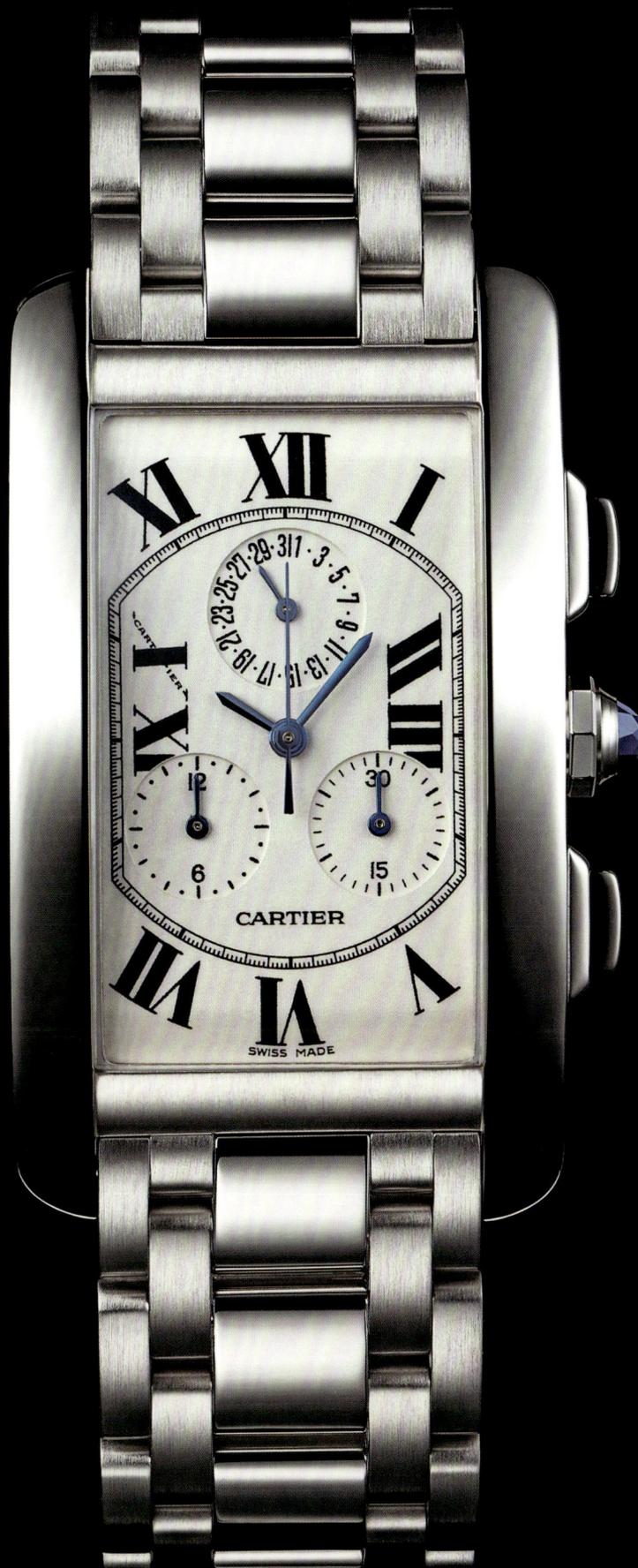

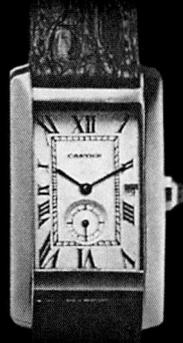

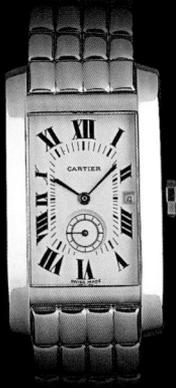

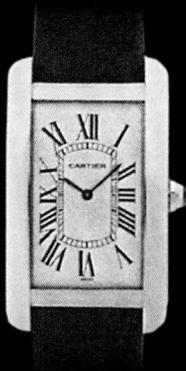

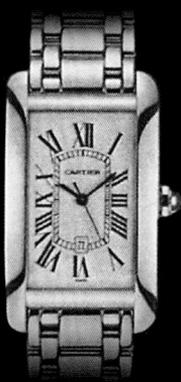

With its curved case, more compact rectangular shape, less flat *brancards*, discreet transverse bars and characteristically Art Deco dial, the *Tank Américaine* took its inspiration from the *Tank Cintrée*.

Tank Américaine, large model, 1989. Case of yellow gold, quartz movement, small second hand at 6 o'clock, window calendar display at 3 o'clock; *Tank Américaine*, large model, 1991. Case of yellow gold, automatic mechanical movement, small second hand at 6 o'clock, window calendar display at 3 o'clock, bracelet of yellow gold; *Tank Américaine Collection Louis Cartier*, large model, 1995. Case of white gold, automatic movement, central sweep second hand, window calendar display at 6 o'clock, bracelet in white gold; *Tank Américaine*, large model, 1993. Case of white gold, mechanical movement, leather strap.

Tank Américaine Wristwatch
Paved with brilliants, medium model
CARTIER, 2003

Case of 18-karat rhodiumized white gold set with 142 round diamonds. Crown set with a brilliant. Bracelet of 18-karat rhodiumized white gold set with 760 round diamonds. Silvered *guilloché* dial, Roman numerals, aperture at 6 o'clock. Sword-shaped hands of blued steel.

❖ *Automatic movement caliber Cartier 077.*

and a split-seconds chronograph, as well as 30-minute and 12-hour counters. It is still the smallest quartz movement ever to include a chronograph and a perpetual calendar.

In 1995, Cartier introduced a *Tank Américaine* with a case and bracelet in white gold, reflecting a new trend towards discretion in contrast to the exhibitionism of the years before. It had an automatic movement with a central seconds hand and a window calendar at 6 o'clock.

In parallel with all these developments in the *Tank Américaine*, in 1992 Cartier Paris unveiled another technical marvel from its workshop, the *Tank Basculante*. Its inspiration was the *Réversible* of 1932 but its extra-thin movement elegantly reduced the thickness of the case which was free to turn on its own horizontal axis. This watch was very different from Jaeger's Réverso and the technical difficulties of making it, together with the need for specific movements, ensured that the *Tank Basculante* was a genuine rarity. Only 413 pieces were made between 1991 and 1994, and it is highly coveted today by collectors and connoisseurs at the most prestigious watch auctions.

Cartier now had an efficient, highly productive watch-making organization in addition to its Paris workshop. In 1988 the company's owners acquired two famous names, Piaget and Baume & Mercier, the first for its technology

and production capacity, the second for its distribution network. The following year, Cartier became a majority owner of nine component workshops and set up the Compagnie des Technologies du Luxe (CTL). Then in 1992 it opened a pilot watch-assembly unit in Villeret in the watchmaking valley of St. Imier in Switzerland. In this building, designed by the French architect, Jean Nouvel, all Cartier's watch-making activities were gradually brought together until 2003. Its operations were then transferred to the brand new manufacture that Cartier had inaugurated in 2001 in la Chaux-de-Fonds. In parallel with all this, in the mid-1990s the company began to transform its old factory in the city of Fribourg. Instead of producing lighters, small clocks and pens, it became a modern facility, manufacturing first bracelets, then cases, and finally turning to the assembly of watches. It was entirely renovated in 2001.

In 1996, eighty-four years of development work on the design and function of the *Tank* and its variations produced a model with unmistakable features that were nevertheless completely original and innovative. It was called the *Tank Française*. It was not an obvious idea to curve a square watch case and integrate the bracelet. In fact, its simple geometrical design emerged from a style initiative intended to take Cartier back to its roots.

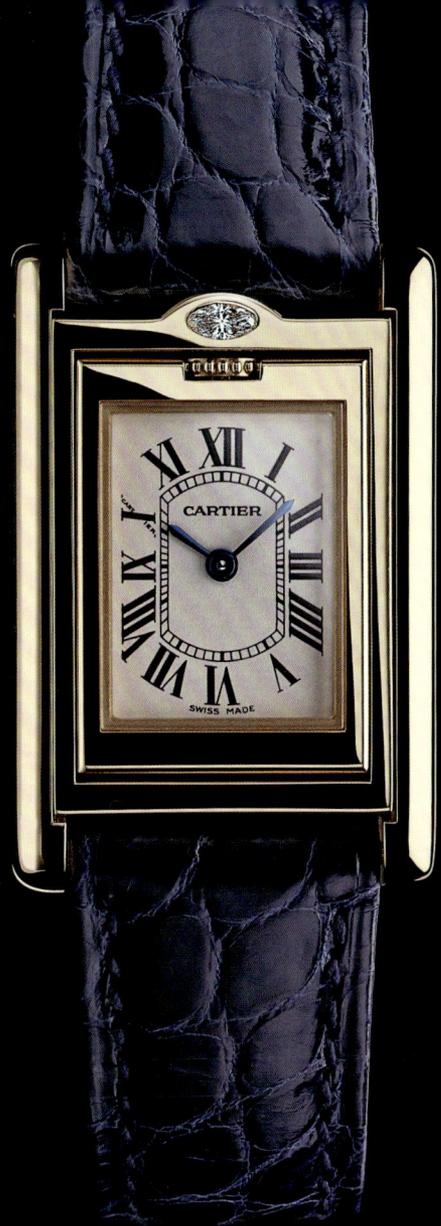

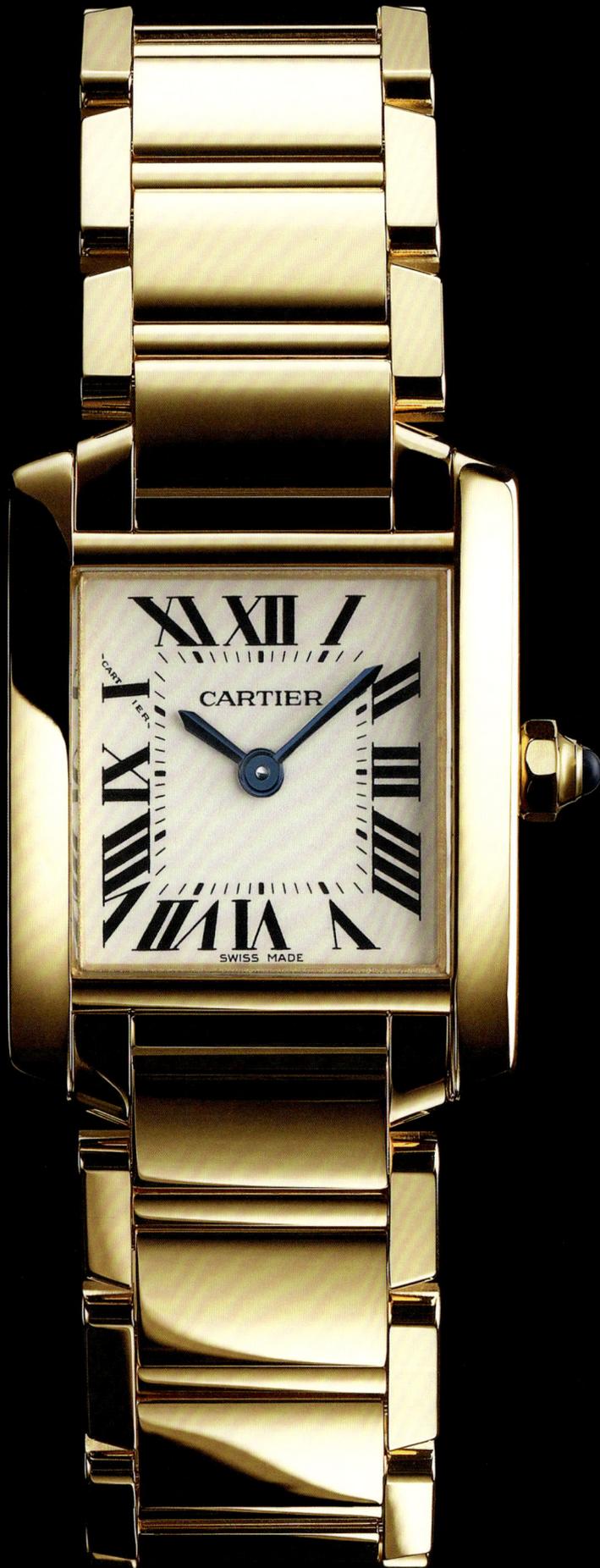

Tank Basculante Wristwatch Jewelry, small model
CARTIER, 2000

Marked on the dial: *Cartier, Swiss Made*

Case of 18-karat yellow gold, oval diamond. Case back paved with diamonds. Silver-grained dial, sapphire crystal, Roman numerals. Blue alligator leather strap. Adjustable deployant buckle of 18-karat yellow gold. Sword-shaped hands of blued steel. Sapphire crystal.

❖ *Quartz movement, caliber Cartier 059.*

Tank Française Wristwatch, small model
CARTIER, 1995

Marked on the dial: *Cartier, Swiss Made*

Curved case of polished and satin-finish gold, *brancards* of polished gold. Eight-sided winding crown capped with a sapphire cabochon. Bracelet of polished gold links, triple deployant clasp of yellow and pink gold. Square grained-silver dial with Roman numerals, secret *Cartier* mark on one bar of the numeral X, around a minute track. Sword-shaped hands of blued steel. Water resistant up to 30 meters (100 feet).

❖ *Barrel-shaped quartz movement, Côtes de Genève decoration, rhodium-plated, 4 jewels.*
ST-WCL 249 A95

Normally, a watch design starts with the case then a strap or bracelet is adapted to match, but with the *Tank Française* Cartier created a metal bracelet like a piece of jewelry then fitted a watch harmoniously into it. By replacing the modern concept of a wristwatch by the historical, but still novel idea of a bracelet-watch, Cartier was simply following its creative tradition.

The essential characteristic of a bracelet-watch is that its design takes precedence over its function of measuring the time. The bracelet and the case are inseparable elements and there is no interruption in the line, volume or material of the circle formed by the bracelet. It is as if the case were just one of the interconnected links that give form to the complete object. Of course, this "link" indicates the time, but camouflages this special function in the patterns of a common design.

The *Tank Française* certainly belongs to the *Tank* family of watches. Apart from the normal distinguishing features such as Roman numerals and the railroad minute track minute circle, it has the one common characteristic of the entire family: the parallel vertical *brancards* extending above and below the case to fully integrate the bracelet. But Cartier was almost obsessed with roundness and perfect harmony—the ultimate æsthetic refinement—and another innovation was to soften the angle of the *brancards*. They were delicately rounded, both laterally and lengthwise, and the previously square attachment to the bracelet became a gently sloping angle.

In addition, the linear geometry of the original *Tank* was relaxed even more by a third modification: the two *brancards* were no longer rigidly straight but followed a concave curve, similar to a pair of brackets.

In 1996, the *Tank Française* was presented at the Salon International de la Haute Horlogerie (SIHH), an annual event created by Cartier five years earlier, dedicated exclusively to Fine and Luxury Watchmaking. The watch was assembled in Cartier's own facilities and produced in all-gold and gold and steel versions with the choice of a quartz or an automatic mechanical movement. A chronograph version was also available, fitted with the Chronoreflex.

To match its clients' different tastes and different wrists, the *Tank Française* was offered in three sizes: small, medium and large. In practice, this simply meant proportionately increasing or reducing the case dimensions of the medium model. It was a way to make the watch look more feminine or masculine, more elegant or more casual, without changing its overall appearance. It was also an opportunity to fit quartz moments of 5 ½ lines and 11 ¾ lines in the

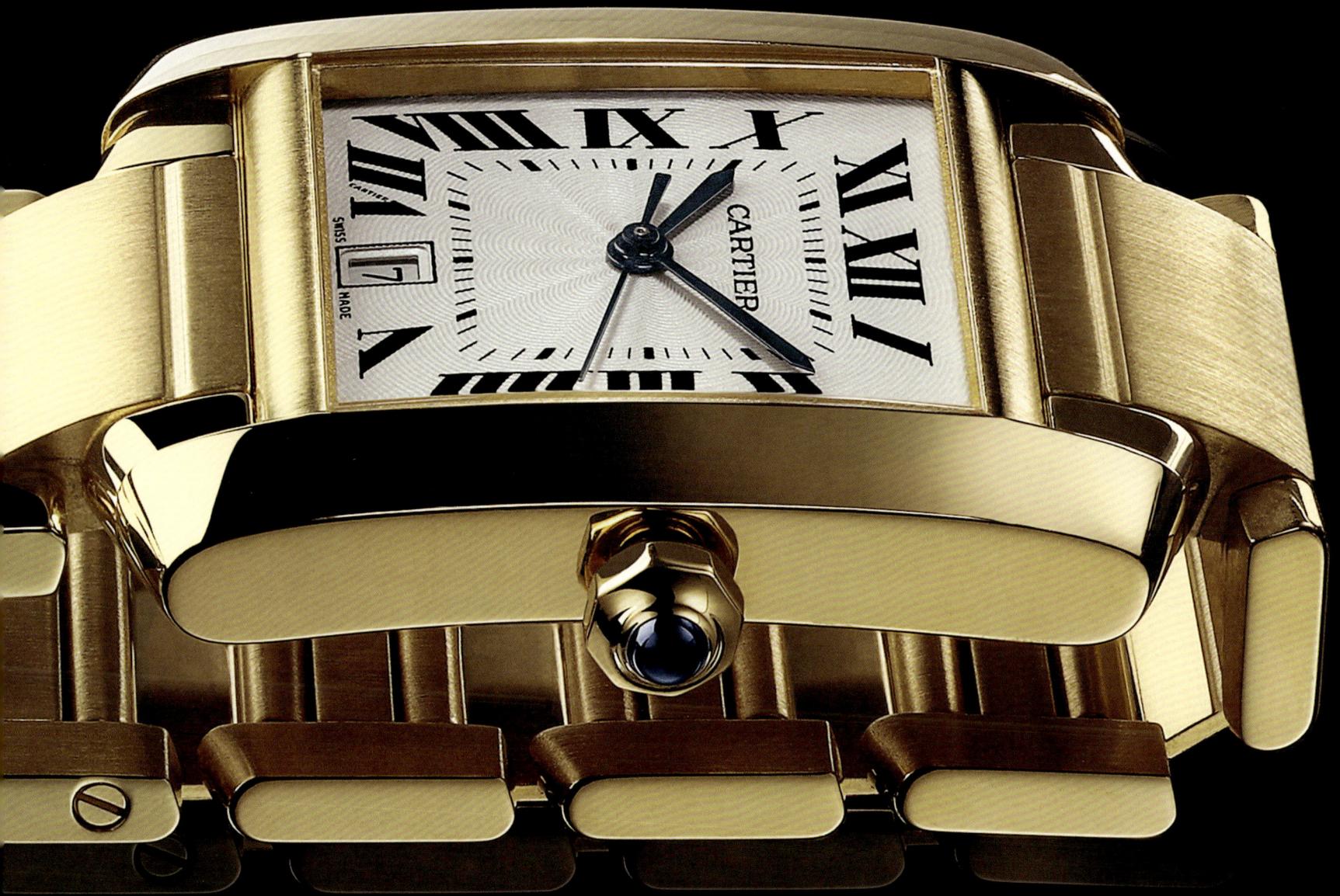

Tank Française Wristwatch
with self-winding movement
CARTIER, 1995

Marked on the dial: *Cartier, Swiss Made*

Curved case of satin-finish and polished gold, *brancards* of polished gold. Eight-sided winding crown capped with a sapphire cabochon. Bracelet of satin-finish and polished gold links, triple deployant clasp of yellow and pink gold. Square grained-silver dial with Roman numerals (secret Cartier mark on one bar of the numeral VII), around a minute track. Date displayed in a window at 6 o'clock. Sword-shaped hands of blued steel. Water resistant up to 30 meters (100 feet).

❖ *Round self-winding movement, rhodium-plated, 20 jewels, Swiss lever escapement, monometallic balance, flat balance spring.*
ST-WCL 247 A95

Tank Cintrée mechanical
Wristwatch two time zones
CARTIER, 1990

Curved case of 18-karat yellow gold. Mineral crystal made and polished by hand to fit the curve of the case. Crowns in the form of a screw nut, set with a genuine sapphire. Sword-shaped hands of blued steel. Series limited to 370 pieces.

❖ *Two mechanical movements 6 ¾''', Cartier 067. Power reserve approx. 40 hours.*

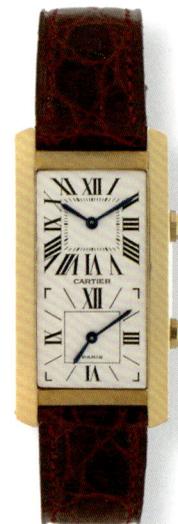

small and medium versions, and an automatic movement of 9 ½ lines in the men's model. With another change that only affected proportions, the chronograph version of the largest case was given a quartz caliber of 10 ½ lines.

The *Tank Française* was the first truly new *Tank* family to appear since the 1930s. Unlike other models that were reinterpretations or updates of older versions, or were different in certain details, it represented a new stage of technical, functional and design development in the *Tank*. This new family was naturally introduced with a metal bracelet. This gave the bracelet-case system the intended unity of style, emphasized by the curve of the case, even with mixed materials as in the gold and steel version. The "squaring the circle" in the case was now matched by the dynamic thrust of the square into the circle around the wrist. The links of the bracelet, in a horizontal pattern highlighted by its indented edges, seemed to echo the caterpillar tracks of the famous assault vehicle that gave the *Tank* its name. It was called "Française" as a reminder that this homage to the square was inspired by the French classicism so loved by Louis Cartier.

The model was hugely successful. It became the iconic watch of the 1990s, admired around the world, and its popularity showed no signs of declining 15 years later.

In 1997 Cartier marked its 150th anniversary by presenting some limited series of exceptional *Tanks*, mostly produced in its Paris workshop. They celebrated both the company's jewelry creativity in a *Tank Française* with the case, *brancards*, dial and bracelet set with diamonds, and its technical expertise in several models drawn from the *Tank* tradition: the *Asymétrique*, the *Double Fuseau*, the *Tank à Guichets* and the *Tank Basculante*. They differed from the historical models in many details or with technical features that made them truly exceptional. For example, the *Tank Basculante* was given its first engraved skeleton movement with a transparency and lightness that could be admired by swivelling the case. Cartier only produced fifteen pieces of this model which had a ruby cabochon set on the tab at 6 o'clock. And it made only one very precious example of the *Double Fuseau* in platinum.

In the following year, 1998, Cartier presented the first watches in another collection that brought together several famous models from the past: the *Collection Privée Cartier Paris*. Each of them was fitted with a mechanical movement, assembled and decorated by hand in Cartier workshops and produced in a limited series. All these valuable pieces were given an exceptional level of finishing, including hand-chamfered bridges. Their movements all carried

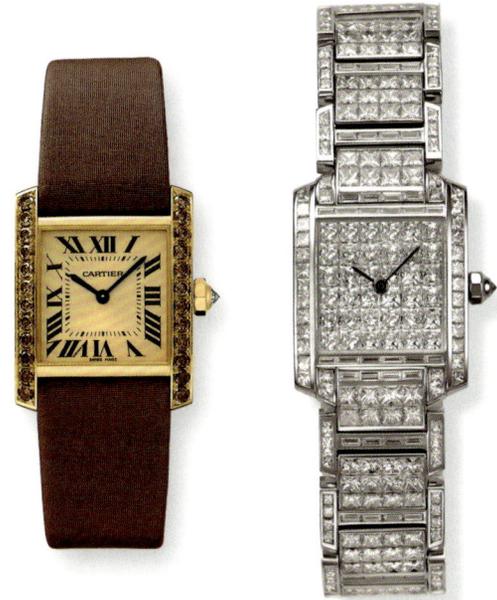

Tank Française Wristwatch
set with brilliants, medium model
CARTIER, 2003

Case of 18-karat yellow gold with a rank of wild stones.
Crown set with a diamond. Brown *toile poudré*
fabric strap. Adjustable deployant buckle of 18-karat
yellow gold. Silvered and lacquered dial
with sun-like finish, dark brown Roman numerals.
Sword-shaped hands of blued steel.

❖ *Quartz movement, caliber Cartier 157.*

FAR RIGHT

Tank Française Rivière Wristwatch
CARTIER, 1997

Case of 18-karat rhodiumized white gold.
Dial and bracelet set with princess diamonds.
Crown set with a diamonds. Sword-shaped hands.

❖ *Quartz movement Cartier.*

the Cartier intertwined double C or the classic *Côtes de Genève* decoration. Their dials in 18-karat gold were first guilloched in sectors then a fine silver coating was added to give them a glowing satin finish. The *Cartier Paris* stamp at 12 o'clock is a reminder that the jewelry company's watchmaking story began in the French capital. To start the Collection, the *Tonneau*, and the *Pasha* were joined by the *Tank Basculante*. This watch was distinguished by a sapphire case back that revealed its decorated movement, the smallest movement with manual winding, created by the watchmaker, Frédéric Piguet.

❖

With the end of the Cold War, the reunification of Germany, and a move towards nuclear disarmament, the dream of French fashion designer Jean-Charles de Castelbajac in 1994 did not seem quite so ridiculous: "If all the tanks were made by Cartier, we would have time to live in peace!" The end of conflict between the major powers encouraged belief in a better future. Developments in biotechnology seemed to promise great advances in medicine, and the spread of the Internet offered instant access to culture and information. There was a certain optimism in the air as people looked forward to the third millennium. It felt like a

blank page on which the world could rewrite itself, avoiding all its ills. This optimism fuelled the extensive preparations that began, several years in advance and all over the world, to celebrate the year 2000 in style. On the day itself, all humanity, in so far as it had access to TV, joined together to mark the great moment, even in countries like China where the calendar did not indicate anything special for January 1. Billions of people followed the progress of the date-change and the festivities that followed. It all started in Kiribati, an independent archipelago with a population of 100,000 in the middle of the Pacific, which was the first time most people had ever heard of it. But a shadow hung over the sumptuous firework displays: for several years there had been a worry that the change of the first two digits of the full date from 19 to 20 would act like a "millennium bug" disrupting the computers that operated communications networks, nuclear power stations, air-traffic-control systems etc. with apocalyptic consequences. Hundreds of billions of dollars had been spent since the early 1990s on protection against this phenomenon. So as it moved to 2000 the world was suspended between the triumph and the threat of technology, between hope and fear … but the bug failed to appear.

A watchmaker is particularly well placed to know that a date, however important, changes nothing in the eternal

"If all tanks were made by Cartier we would have time to live in peace!" Tribute to the *Tank* from fashion designer, Jean-Charles de Castelbajac. *Le Figaro Madame*, 1994.

course of time. But it also knows, better than most, how much symbolism and belief is attached to the perception and measurement of passing time. It understands that these symbols and beliefs are part of our common culture and it is unwise to disparage them. Particularly on the eve of 2000 if you are Cartier and seventy years earlier you created the turn-over *Tank* called "*Basculante*." No model could be more suitable for celebrating the turn of a millennium. In 1999 (the year when its watches were first marked *Swiss Made* on the dial), Cartier presented the watch that would mark this historic moment, a new *Tank Basculante*. It was available in three sizes, then a larger version was added. It was distinguished from the 1992 model by its spi-

nel cabochon but most of all by its steel case, the first time the metal had been used with a leather strap in this family. The case was given a contrasting satin and polished finish to create a play of light and accentuate its different volumes: the *brancards* were polished, the dial was satin and the case was polished on the dial side and satin on the back. Only 365 pieces of each size of this model were produced, with the dates of the millennium change engraved on the back: 1999, 2000, 2001. On the dial, the figure 12 was replaced by the Roman numeral MM.

As everybody now knows, the third millennium actually began in 2001. In that year, as we shall see, all Cartier watchmaking changed to start a new voyage through time. ∎

Trace d'un tank de *Cartier*

si tous les tanks étaient
fabriqués par CARTIER
nous aurions le Temps
de Vivre en paix

@dritcdecartelbape

The Tank Blooms Again in Spring

Chapter V

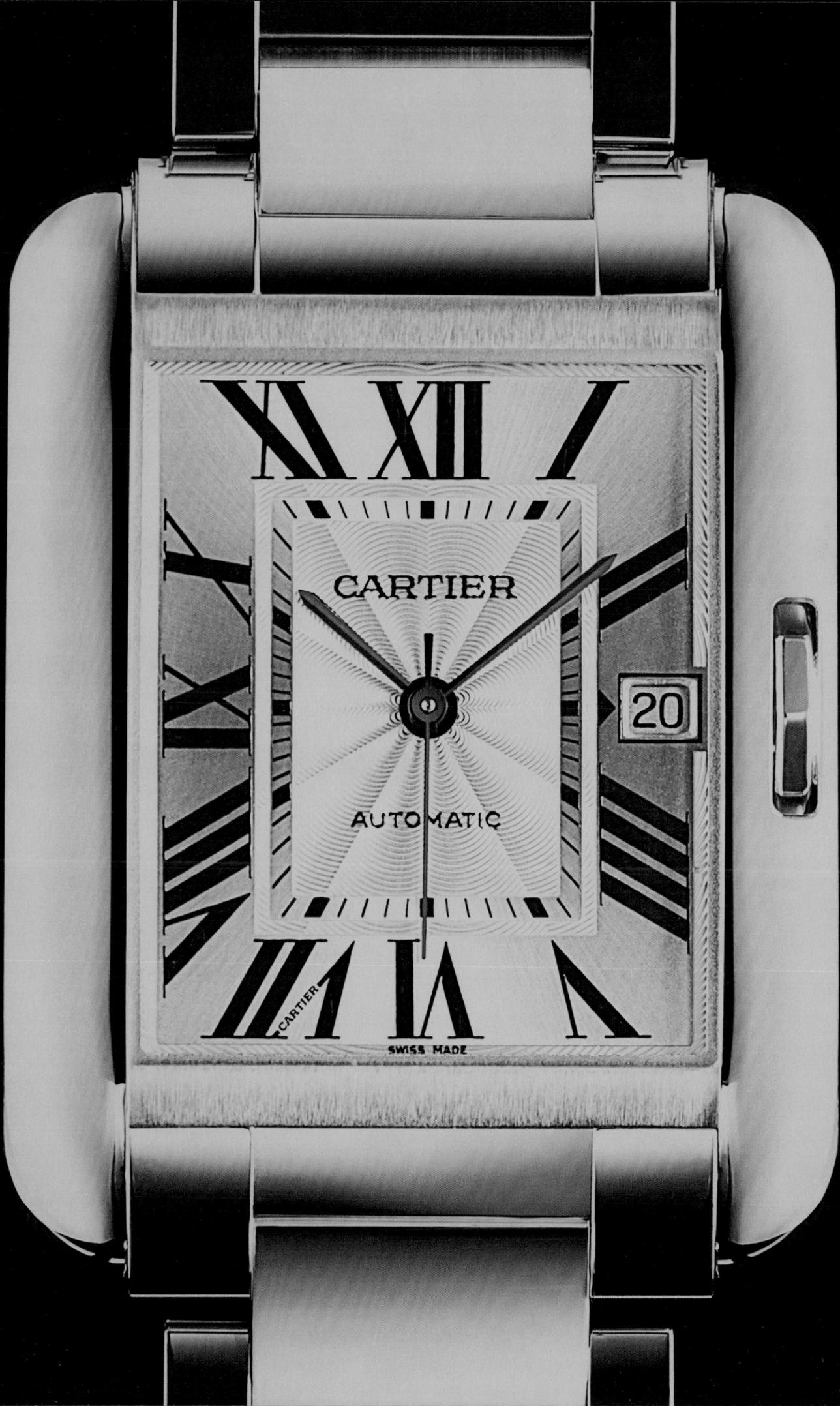

PAGE 181

Tank Anglaise Wristwatch, large model,
Cartier Paris, 2012 (*see page 204*).

FACING PAGE

Tank Divan Wristwatch, yellow gold

CARTIER PARIS, 2002

Case of yellow gold. *Brancards* of polished gold.
Octagonal crown of yellow gold.
Sapphire cabochon. Matte brown alligator strap.
Yellow gold ardillon buckle. *Guilloché* dial
with twelve Roman numerals. Sword-shaped
hands of blued steel. Scratch-resistant
sapphire crystal. Water resistant up to 30 meters
(100 feet).

❖ *Automatic movement caliber Cartier 120.*

O nce the artificial celebrations for the year 2000 were over, the new millennium started badly in several respects. The year 2001 was marked by several disasters, at least one of which would have lasting consequences. On January 1, hardly anyone outside of Greece noticed that the country was admitted into the Eurozone, and it took almost ten years for the importance of that decision to be understood. Much more immediate was the dramatic decline in the stock market when the "Internet bubble" burst in the second half of 2000. Since 1995, the rapid spread of the Internet had led many investors to believe in a technological Eldorado that would deliver endless growth. They spoke of the "new economy" and the" fourth industrial revolution" that would create an era of explosive prosperity. Share prices in numerous IT companies rose by 400% in five years, an increase that bore no relationship to their turnover and even less to their profits, which in many cases were non-existant. The bubble burst in the spring of 2000, when the market realized that most of these companies would not reach break-even for years, if ever. The stock market crash affected virtually all shares and lasted for three years. The year 2001 saw the start of a long series of bankruptcies and losses estimated at 150 billion dollars. This was followed by the discovery of a large number of illegal or highly dubious management practices. The result was a very unfavorable economic climate, particularly in the USA. Millions of small investors lost their savings and 500,000 people lost their jobs. Following this experience many investors turned towards the property market, which then became another bubble.

In 2001, the first year of the new millennium, the world received a shock of a different kind. On September 11, a series of terrorist attacks hit the United States, organized by the Islamist movement Al Qaida, killing almost 3,000 people. Apart from the psychological impact on the hundreds of millions around the world who watched events unfold live on TV, the attacks had significant long-term repercussions. They created a deep sense of insecurity and mistrust in a country that had previous always felt safe. They provoked two very bloody wars in Irak and Afghanistan. They forced most countries around the world to take drastic security measures, they led to outrageous violations of human rights in the name of antiterrorism and eventually they induced a serious slowdown in the US economy, adding to the recession caused by the bursting of the Internet bubble. In some parts of the world, this slowdown reached certain key sectors, such as transport which, in turn, had a direct effect on trade and freedom of movement.

183

The Cartier manufacture, located at the heart of the Swiss watchmaking industry in la Chaux-de-Fonds in the canton of Neuchâtel: home to an exceptional craftsmanship.

And yet…, in Switzerland, the peaceful little country that seemed sheltered from the violence of the world, the year 2001 saw the start of a phenomenon that would transform part of its economy. For the first time in thirty years, the value of all mechanical watches produced was greater than the value of quartz models. While that year saw the eighth consecutive decline in the total manufacture of *Swiss Made* watches (from 31 million in 2000 to 28.7 million in 2001), the average price of an exported watch rose from 312 to 367 francs and total sales of the watchmaking industry rose by almost 4%. From 2001 to 2008, sales of top-of-the-line mechanical watches grew at an astonishing rate—up to 18% per year.

How was it possible that, in a world gripped by an economic crisis, there could be such a large and growing demand for watches with beautiful mechanical movements that were inevitably more expensive than quartz models? Some of the answer probably lay in the crisis itself. Crises lead people to look differently at luxury items. Well-made objects are no longer seen as unnecessary extras but as pieces of lasting value that may make worthwhile investments. There is also a psychological factor at work in times of economic or political uncertainty. People are attracted by the reliability and durability of hand-made objects that are part of a long tradition, preferring them to cheaper, mass-produced, disposable products. As one leading Paris luxury manufacturer put it: "A luxury object is one that can be repaired." And something that can be repaired is always reassuring.

Another phenomenon helps to explain the trend towards more expensive watches: at the start of the third millennium the watch itself had never been so unnecessary. The exact time was always on display, at home and at work, thanks to the spread of personal computers in the previous fifteen years. But another piece of technology, that had been made available to the public in 1983, began to sell massively at the turn of the millennium: the mobile phone. New developments in 1999–2001 made it irresistible, then indispensable. WAP (Wireless Application Protocol) enabled Internet surfing, Bluetooth did away with cables between devices, MP3 brought music, a color screen and photography to the phone. Then in 2003, the arrival of third-generation (3G) versions convinced any doubters to join the revolution. At the end of the decade, an estimated 70% of the world's population owned a mobile phone. And it, too, showed the time. So why would anyone buy a watch any more, just to find out something they already knew? Or rather, why would they buy a watch any more if all it did was show the time? The watch was only interesting if it offered something that computers and phones could not provide so

RIGHT
Each caliber must be meticulously
adjusted to strive towards perfection.

easily: useful functions like a chronometer, romantic functions like the phases of the moon and, above all, the soul and beauty of an object produced with expertise steeped in tradition but always open to innovation. Beautiful mechanical watches, the last everyday tools to be made by hand, had a wonderful future ahead of them.

From the late 1990s, Cartier recognized the importance of this move towards beautiful high-end watches and decided to build a new manufacture at La Chaux-de-Fonds, the heart of watchmaking in the Swiss Jura. It had to be done quickly as the Villeret Manufacture did not have enough capacity to respond to this growth in demand. But the objective was much more ambitious than increasing capacity. It was to bring together all the stages of watch production from concept to manufacturing. This would include building quartz, mechanical and even Fine Watchmaking movements. In other words, Cartier intended to create a fully integrated watchmaking facility and join the very few brands able to carry out the entire process, from the first sketches to delivery, as well as the restoration and repair of its old watches. After completing several intermediate stages, this objective was finally achieved in 2008.

But the manufacture itself was opened in 2001. Designed by a local architect, Stéphane Horni, it provided 36,000 sq.

meters of floor space on four levels. Cartier started operations there by producing cases, metal bracelets and folding buckles, as well as assembling movements. Two years later, the Villeret Manufacture was closed and La Chaux-de-Fonds assumed responsibility for assembling and decorating the prestigious movements in the *Collection Privée Cartier Paris*. It also took over some of the new operations that had been recently started at Villeret, such as an enamelling workshop. Before long, facilities for gem-setting and for the restoration of old watches were added, as well as units for producing watch externals, such as hands and crystals. 2005 marked an important step: the creation of a development office devoted to movements. Cartier was gradually starting to design the entire watch—its case, its movement, and its bracelet. This process accelerated in 2007 when a new 3,000 sq. m. (32,000 sq. feet.) wing was opened (called the "Think *Tank*" as a nod to the company's most famous watch). It included a Reasearch & Development office, an engineering studies office, a tool design and construction workshop, a prototype production unit and a testing laboratory.

Then in 2008—an important date in Cartier watchmaking history—the first movement entirely designed, developed, produced, and assembled by the company was unveiled. Even more impressive, it was a Fine Watchmaking

FACING PAGE
A watchmaker craftsman using a
magnifying glass to work on a movement.

RIGHT
The workshops in La Chaux-de-Fonds
receive some of Cartier's oldest *Tank*
models for restoration.

complication: the 9452 MC flying tourbillon caliber with a carriage that seems to float weightless above the dial. (We will look at this movement in detail later.) It was assembled in a workshop specially set up for it in Meyrin in the Canton of Geneva, and was awarded the prestigious, highly coveted Geneva Seal, confirming that it met the most stringent production criteria. It was fitted in the *Ballon Bleu de Cartier*, the first watch in the Cartier Fine Watchmaking collection. After 2008, some fifteen complication movements, including the Astrorégulateur and the Astrotourbillon, joined this collection which was entirely designed and produced by Cartier watchmakers.

Today, all Cartier movements intended to qualify for the Geneva Seal are assembled in Meyrin. But an increasing number of both quartz and mechanical movements for Cartier watches are designed, developed, produced, assembled, tested, and regulated in the manufacture at La Chaux-de-Fonds. Naturally, these include movements for the *Tank*. This flagship of Cartier watchmaking employs a thousand people with 167 specific skills. They are organized in three areas: development, where watches are conceived and designed; production, where they are manufactured; and customer service, where watches are serviced, repaired or restored. In addition, the manufacture houses l'Institut Horlogerie Cartier, founded in 1993, which is approved to issue the Swiss Federal Certificate in Watchmaking. The future is therefore assured.

❖

The *Tank* models of the third millennium showed renewed imagination but kept the distinguishing features that had made the family famous: *brancards*, radiating Roman numerals, railroad minute track, apple-shaped or sword-shaped hands in blued steel, and a sapphire on the crown. As always with Cartier, and with the *Tank*, even the most sophisticated technology took second place to the watch's style, spirit and design codes. The first *Tank* to be unveiled in 2001 was the *Tank* à vis in yellow gold or platinum, with a manual-winding manufacture movement supplied by Piaget. It played an audacious game with the design codes: since it was water-resistant to 30 meters (98 ft.), its bezel sat proud of the *brancards* and was fixed with visible screws at semi-circular corners—a reminder of the waterproofing system used in the 1930s. The difference in the levels of the bezel and the case, and the use of visible screws, indicated a subtle shift towards the *Santos*. The dial carried all the famous Cartier codes of the original models and was decorated with guillochage, which seemed to be one of the

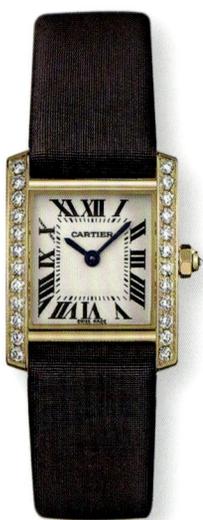

Tank Française Wristwatch
set with diamonds, small model
CARTIER, 2003

Case of 18-karat yellow gold. *Brancards* set with 24 round-cut diamonds. Crown set with a diamond. Black *toile poudrée* strap. Adjustable folding buckle of 18-karat yellow gold. Silver-grained dial, twelve black Roman numerals. Sword-shaped hands of blued steel.

❖ *Quartz movement, caliber Cartier 057.*

FACING PAGE

Madonna wearing a *Tank Française* set with diamonds, 2005.

recurring themes of the *Tank* family in this decade. Lastly, it had an octagonal crown set with a faceted sapphire, emphasising its design of structured geometry on different levels.

The *Tank à vis* was part of the prestigious *Collection Privée Cartier Paris,* composed of watches produced in a limited edition. Each one has a mechanical movement with exceptional hand-finishing and decoration revealed through a sapphire case back. As we have seen, the Collection already contained the *Tank Basculante.* The transparent case back of the *Tank à vis* watch shows its magnificent, manually wound manufacture movement. Developed by Piaget, its 153 components are chamfered, decorated, polished and assembled by Cartier at La Chaux-de-Fonds. The movement has a power reserve of around forty hours.

In 2002, Cartier raised eyebrows with the *Tank Divan* and its multiple versions. It was seen as an off-beat watch with a highly original design that no other watchmaker would dare to produce. At first sight it seemed to contradict all the traditional design codes of the *Tank* by presenting a horizontally stretched rectangle that in turn required a strikingly wide strap. The space it created, framed by large *brancards* like padded armrests rounded at the ends, evoked a feeling of comfortable opulence, an invitation to stretch out and dream. It was clearly derived from the *JJC Wide,*

designed in London thirty-four years earlier, one of the *Tanks* given the initials of Jean-Jacques Cartier who headed the London branch after the war. In fact, Cartier London produced a series of exaggerated watches that still inspire today's designers when searching for the touches of fantasy that are part of the *Tank* personality. Of course, this kind of eccentricity tends to be much more successful in purely ornamental, women's watches that are worn like a piece of jewelry intended to to create an effect. This was certainly true of the four jewelry versions of the *Tank Divan* which exploded like a bomb in the world of jewelry watches and had enormous success. These watches, paved with brilliant-cut diamonds, had a silvered dial with a laquered sunray effect, radiating Roman numerals, a rounded railroad minute track as in the *Tank Américaine,* sword-shaped hands in blued steel, and an octagonal crown set with a diamond. Two normal-size *Tank Divans,* one in yellow gold and one in white gold, were followed by two mini-size models in the same metals, each fitted with a quartz caliber. Curiously, the men's models were even more surprising. Somehow, this subversive design that flaunted all the *Tank* traditions seemed even more daring when it was plain and simple with no decoration. Cartier then produced four more versions in steel or yellow gold, with either a quartz caliber or

**Tank Américaine Wristwatch,
Pink gold Flying Tourbillon**
CARTIER, 2009

Case of 18-karat gold. Octagonal crown
of 18-karat gold set with a faceted sapphire.
Brown alligator-skin strap. Adjustable
double folding clasp of 18-karat pink gold.
Sword-shaped hands of blued steel.
Individually numbered case.
Sapphire crystal. Sapphire crystal case-back.
Water resistant up to 30 meters (100 feet).

❖ *Workshop-crafted mechanical movement
with manual winding caliber Cartier 9452 MC,
Geneva Seal certified.*

an automatic mechanical caliber with a seconds hand. The dial was identical to the jewelry versions except that it was *guilloché* in the automatic models and silver-grained in the quartz models.

The jewelry versions of the *Tank Divan* were so successful that, in 2003, a "mini" model was introduced in yellow or white gold and set with diamonds. It broke even further away from Cartier tradition by replacing the twelve radiating Roman numerals with only two, the IX and III, extravagantly enlarged. They were aligned vertically, parallel to the *brancards*, and filled two-thirds of the width of the dial. But the shocking impact of these two black elements became very elegant in the context of an almost black, brushed canvas strap, a plain matte surface, contrasting with the brilliant sparkle of the diamonds. So, far from being weakened, the Cartier identity was strengthened by this reminder of a major feature of Louis Cartier's designs. Many of his first jewelry watches incorporated the contrast of black and white, often onyx and diamonds, and were mounted on a strap of black watered silk.

The number of people interested in fine mechanical watchmaking was growing fast at that time and what could be more fascinating for them than a fully skeletonized watch? A crystal case back allowed them to peer into the heart of the movement through its openwork bridges, plates and other components, see it in action and admire its engraved decoration. In 2004, Cartier presented just such a watch as part of the *Collection Privée Cartier Paris*: an outstanding *Tank Louis Cartier* squelette in platinum, produced in a limited series of fifty pieces. It had a manual-winding movement, designed by Cartier and produced by Piaget, with a thickness of 2.15 millimeters (¹/₁₆ inch), and it introduced contemporary skeletonizing that refined all components to their absolute limit. To please lovers of the brand, a special display of craftsmanship was included: the index assembly was created in the form of a C in Cartier calligraphy. Even without the dial and its distinctive elements, the watch was easily recognizable: the case and the fine rounded *brancards* were taken from the original *Tank L.C.*, as was the beaded crown—which reappeared in this form in the new version of the *Tank*—and its traditional sapphire cabochon. Two years later, Cartier created another skeleton watch with a less famous model, the *Tank à vis*.

In the same year, another historic watch reappeared. More than 80 years old, the *Tank Chinoise* in gold or platinum had preserved all its original design features, including the beaded crown and sapphire cabochon, its apple-shaped hands and its 9-line caliber. Its only concession to the evolution of the *Tank*

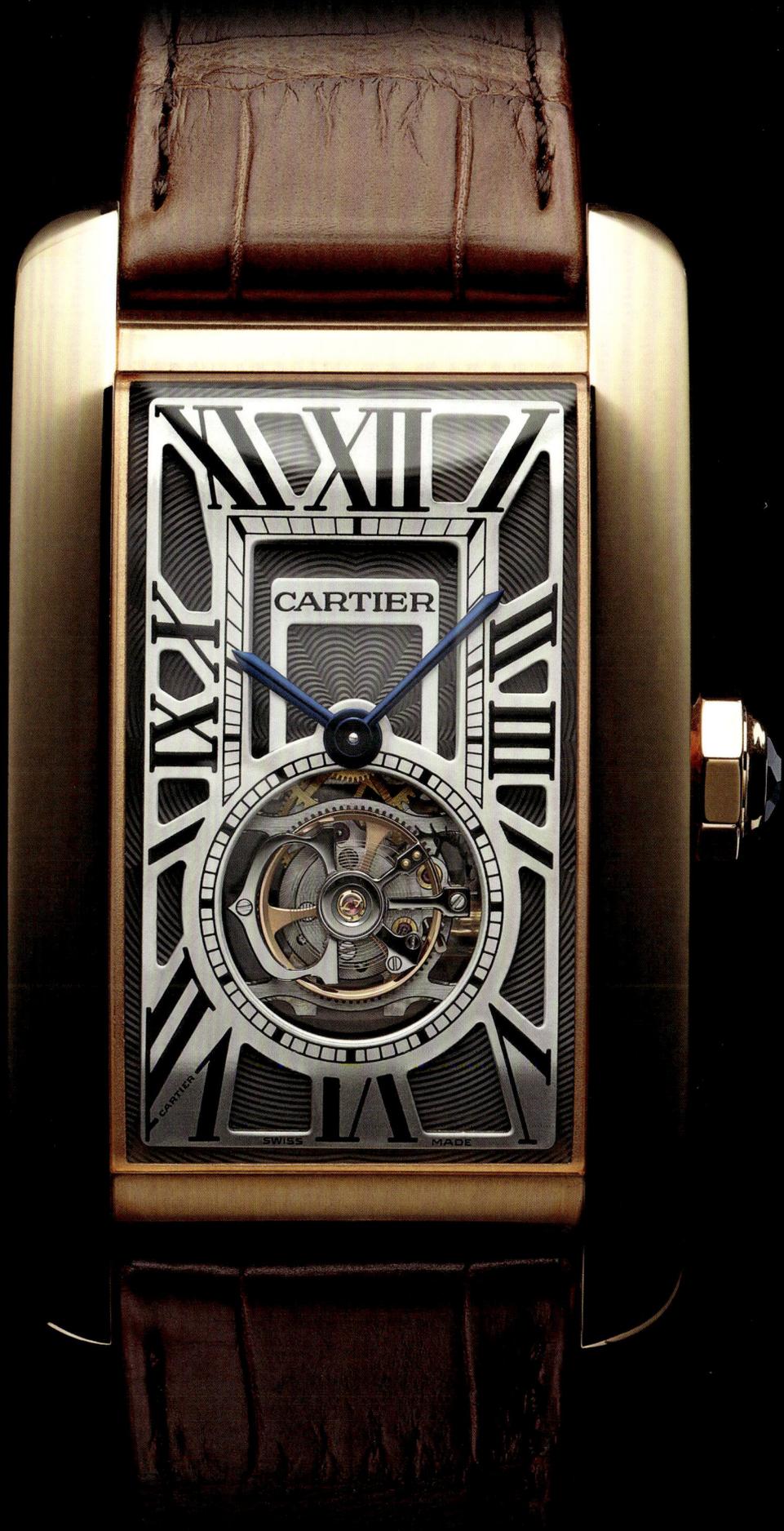

RIGHT
French designer Andrée Putman wearing
a *Tank* watch.

PAGE 194
Tank Solo Wristwatch, large model
CARTIER, 2010

Case of polished steel. Circular-grained crown
Blue synthetic spinel cabochon. Panther pattern goat
velvet strap. D-shape deployant steel buckle. Panther
pattern dial. Sapphire crystal. Sword-shaped hands
of steel. Water resistant up to 30 meters (100 feet).

❖ *Quartz movement, caliber Cartier 690.*

PAGE 195
Tank Solo Wristwatch, large model
CARTIER, 2009

Case of polished steel. Beaded crown set with a
synthetic blue spinel. Matte beige python-skin strap.
D-shape deployant steel buckle. Silvered opaline dial
polished motif python. Sword-shaped hands of blued
steel. Water resistant up to 30 meters (100 feet).

❖ *Quartz movement, caliber Cartier 690.*

in the twenty-first century was its silvered *guilloché* dial. Since it was included in the *Collection Privée Cartier Paris*, it had to have a sapphire case back to reveal the movement and the same index assembly. The manual-winding manufacture movement, supplied by Piaget but decorated and assembled at La Chaux-de-Fonds. is composed of 125 parts and has a power reserve of about forty hours.

The reappearance of the *Tank Chinoise* after an absence of 25 years came at exactly the right time to celebrate the company's sharply growing popularity in China, where its first boutique had opened seven years earlier. Cartier had already enjoyed considerable prestige among the Chinese in 2004. So it was no accident that, for the *Year of France in China,* from October 2004 to March 2005, a *Santos* watch was one of the 100 objects chosen to represent French design of the twentieth century. No doubt it was preferred to the *Tank* because it was considered to be the first wristwatch. In any case, the *Tank Chinoise* with its very Art Deco exoticism had always enjoyed plenty of admirers, such as the designer, Andrée Putman who said in 1996: "The watch I wear most often is an old *Tank Chinoise*. It is classical but still faintly Chinese. Does the gold case suggest bamboo? In fact, it is Eurasian. I almost always wear my watch on my cuff and not directly on my wrist."

Also in 2004, Cartier unveiled the *Tank Solo,* which later became a permanent reference for the family. Nearly thirty years after the launch of the silver gilt *Tank Must,* the more affordable version of the *Tank L.C.,* it probably made sense to offer this ageless model again at a price that put it within reach for all *Tank* lovers. The first version of the *Solo* was in steel and reproduced practically all the design codes of the *L.C.* (apart from the sword-shaped hands that were already replacing apple-shaped hands in the first Must): refined *brancards,* radiating Roman numerals, railroad minute track and beaded crown with spinel cabochon. One important feature nevertheless differentiated it and brought it up-to-date: while the *L.C.* was gently rounded, the surface of the *Tank Solo—brancards* and bezel—was absolutely flat. Two models were produced, small and large, both fitted with a quartz caliber. Then one year later, a new version was introduced in gold-plated steel, moving even closer to the original *L.C.* Other dial designs appeared later, breaking away completely from tradition with double-ring Roman numerals and a partial railroad minute track, designed in perspective. In 2010, a version was given a steel bracelet with large links, recalling the bracelet of the *Tank Française.*

As we have seen, 2008 was a milestone year for Cartier with the launch of the first Fine Watchmaking movement

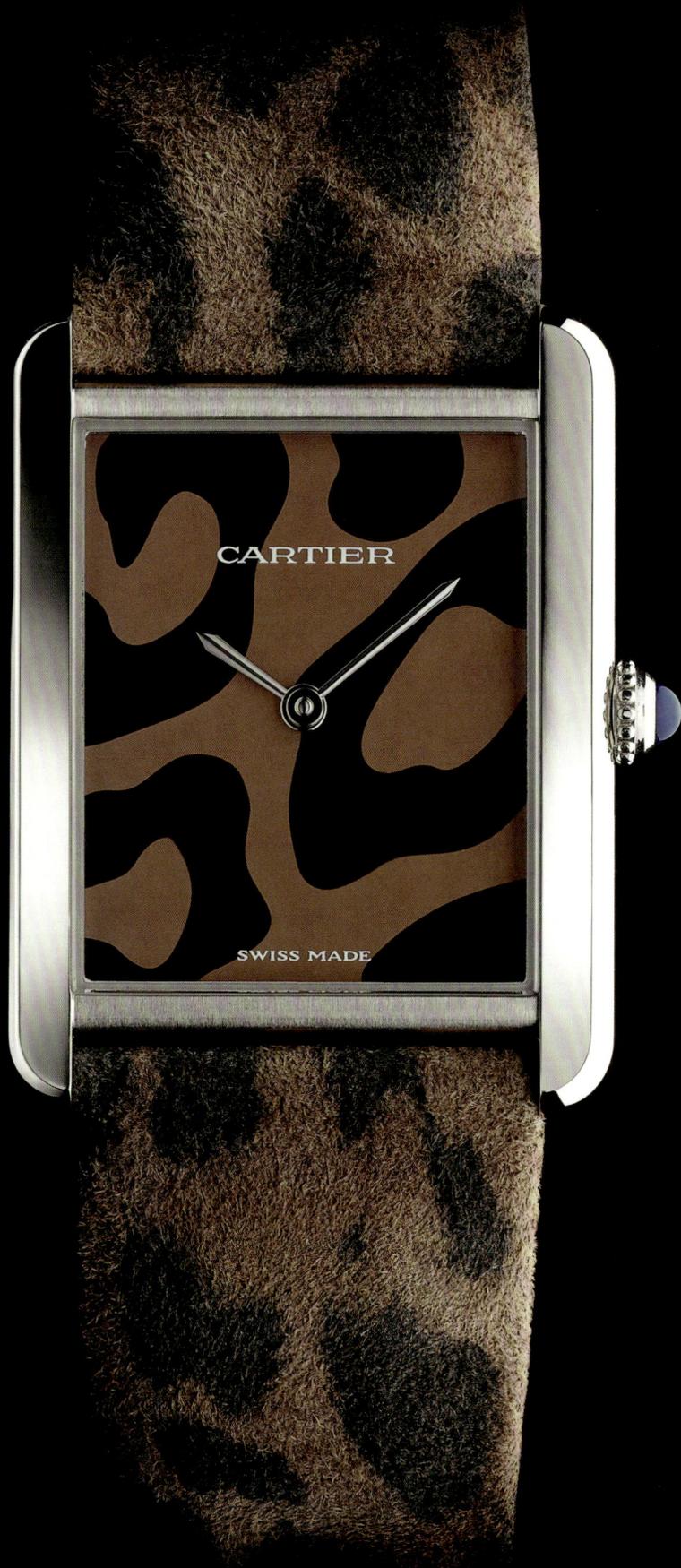

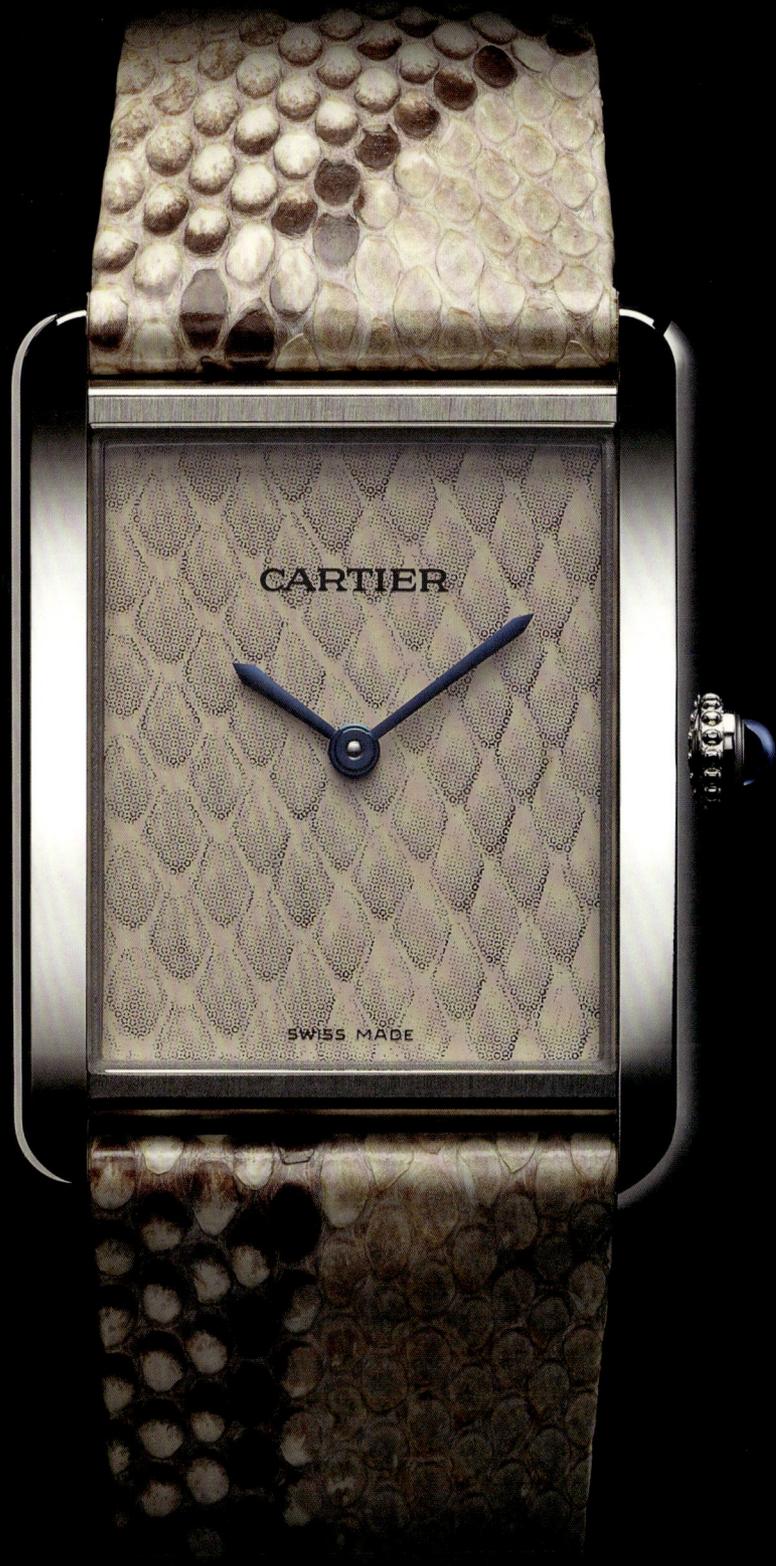

Tank Louis Cartier Extra-flat Jewelry,
rhodiumized white gold

CARTIER, 2012

Case of 18-karat rhodiumized white gold set
with 42 brilliants. Beaded crown set with a brilliant.
Black semi-matte alligator strap. Double adjustable
deployant buckle of 18-karat rhodiumized white gold.
Silvered grained dial. Mineral crystal. Sword-shaped hands
of blued steel. Water resistant up to 20 meters (65 feet).

❖ *Workshop-crafted mechanical movement with manual
winding caliber Cartier 430MC.*

entirely developed and produced by the company alone: the Caliber MC 9452 with flying tourbillon. With this new proven competence, Cartier reached the highest level of watchmaking expertise. This manual-winding movement with a thickness of 4.5 millimeters (³/₁₆ inch) and a power reserve of about 50 hours was first presented within the magical architecture of the Ballon Bleu de Cartier. Then one year later, it was fitted into a *Tank Américaine* in pink or white gold, part of the *Collection de Haute Horlogerie Cartier*. This watch was not only a demonstration of technical expertise, that we will return to later, it was also a triumph of design that would have delighted Louis Cartier. For example, the permanently turning tourbillon carriage in the form of a C also indicated the seconds, and the *guilloché* dial on two levels, framed by large satin-finished *brancards*, retained the watchmaking codes that he adopted, such as the radiating numerals and the minute railroad minute track. Here, they were positioned on a skeletonized brass grill, putting them in the forefront for the first time in the history of the *Tank*. As befitted a *Tank Américaine*, it had an octagonal crown set with a faceted sapphire. The *Tank Américaine* flying tourbillon immediately impressed as a powerful, dynamic watch in which design and technology joined in a highly contemporary object, as if Art Deco had

been revived by a love of mechanical engineering. Among the *Tanks*, it symbolized the growing passion for beautiful mechanical watches with complications that require months of meticulous work from master watchmakers with exceptional expertise.

Watch lovers found it particularly fascinating to examine the movement through the sapphire crystal case back. Assembled in Meyrin, this was the first *Cartier caliber* to carry the highly prestigious Geneva Seal, awarded by a control office of the Canton of Geneva. The Seal confirmed that the manufacture, assembly and adjustment of the movement's 142 components met the very highest standards of watchmaking, perfecting its æsthetic appeal and maximising its precision and reliability. For example, all steel components had polished edges, filed sides and smoothed visible surfaces; screw heads, pignon faces and the mounts of all nineteen jewels were polished; gear wheels were chamfered above and below; and since wire springs are forbidden in candidates for the Seal, all springs were in shaped, tempered and polished steel. Cartier watchmakers gave the movement their own creative touches by sculpting the double bridge in the form of a C and by making this brilliant mechanism a magic spectacle of continually sparkling reflections and a fascinating play of contrasting shapes and textures.

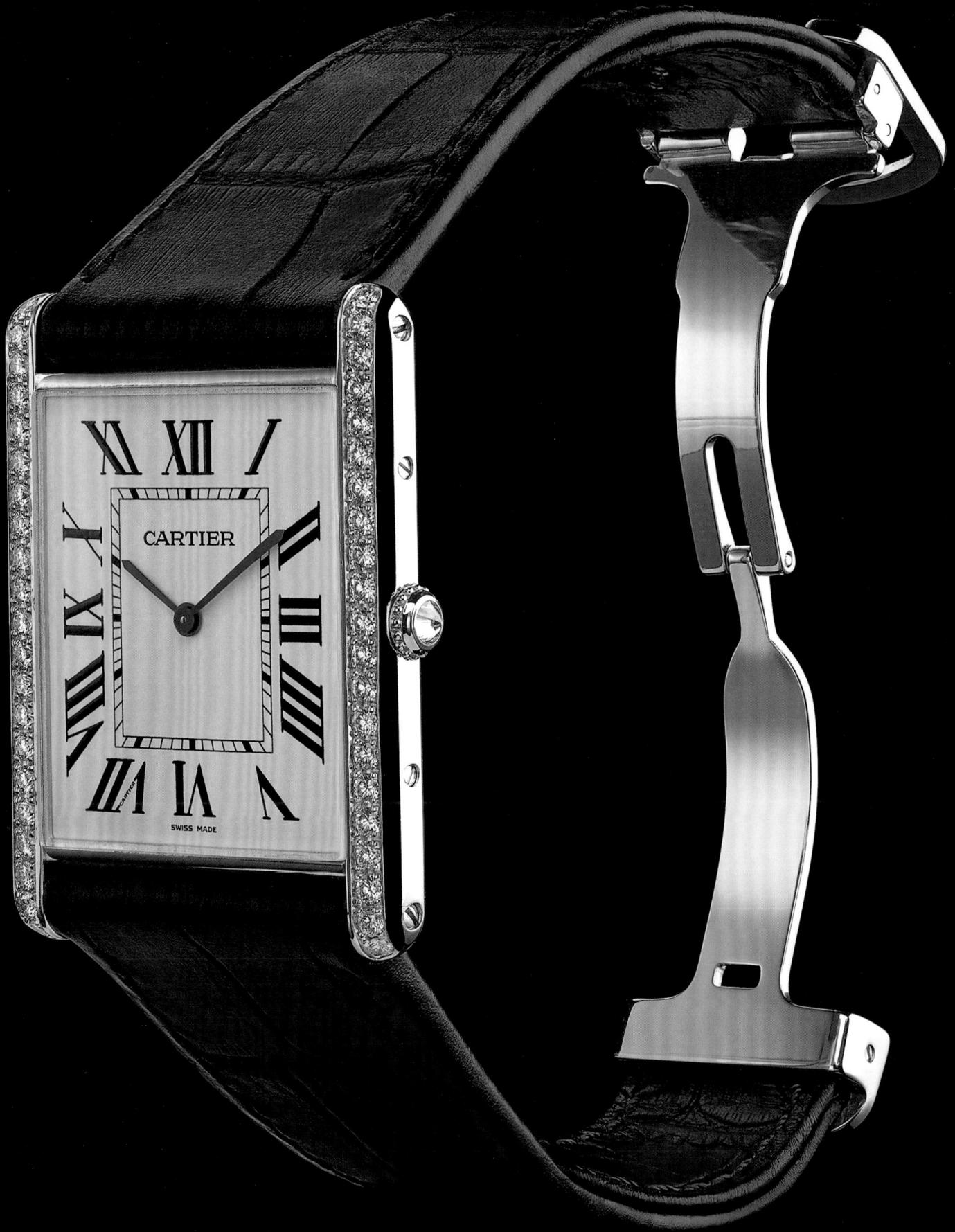

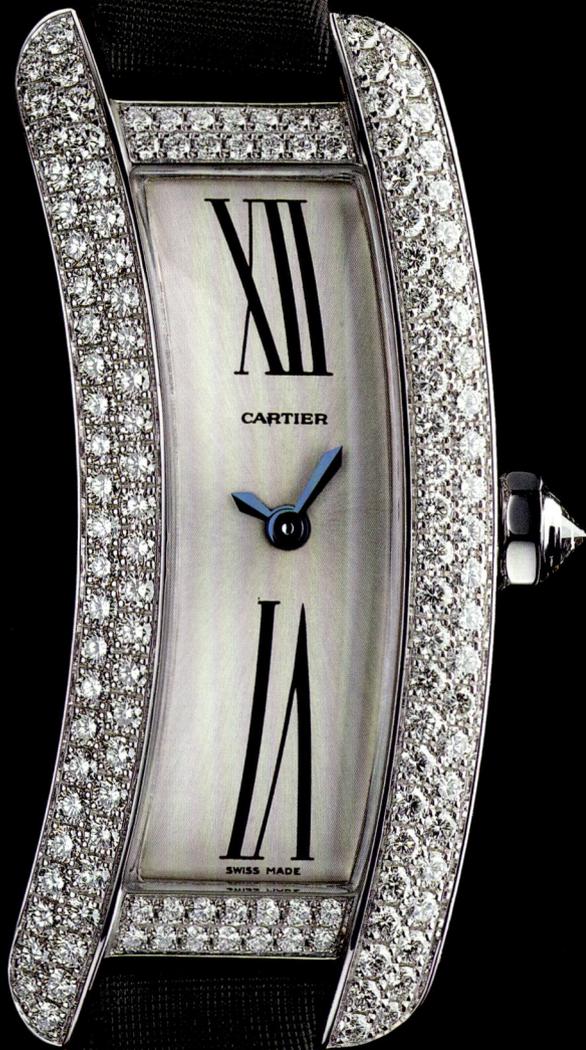

THE JEWELER HAS BECOME A MASTER WATCHMAKER AND THE MASTER WATCHMAKER A JEWELER. THE *TANK* IS AN AGELESS STYLE THAT EMBODIES THE MOVEMENT OF TIME.

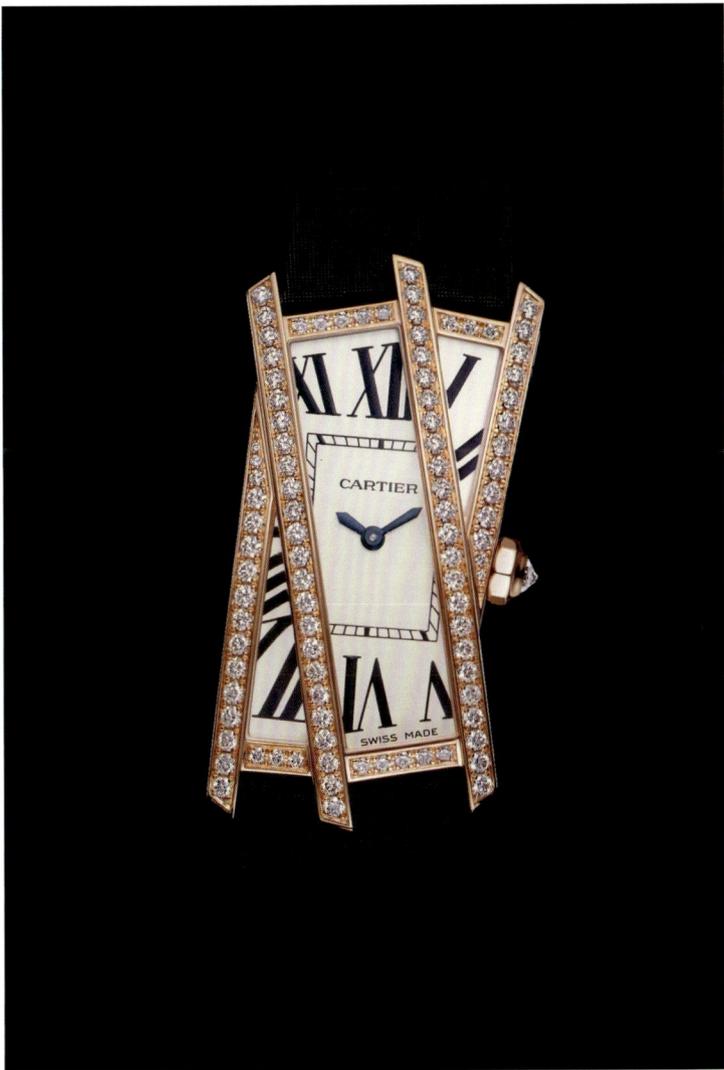

FACING PAGE

Tank S Wristwatch

CARTIER, 2003

Case of 18-karat rhodiumized white gold set with 308 round brilliants. Nonagonal crown set with a brilliant. Black *toile brossée* fabric strap. Ardillon buckle set with 17 round brilliants. Silvered *flinqué* and sun-like finish dial. Two black Roman numerals. Water resistant up to 30 meters (100 feet).

❖ *Quartz movement, calibre Cartier 059.*

LEFT

Tank Crash Wristwatch Cartier Libre Collection

CARTIER 2006

Case of 18-karat pink gold set with 94 round brilliants. Nonagonal crown set with a brilliant. Silvered grained dial. Eight roman numerals. Black *toile brossée* fabric strap. Ardillon buckle of 18-karat pink gold set with 24 round diamonds. Sword-shaped hands of blued steel. Water resistant up to 30 meters (100 feet).

❖ *Quartz movement, calibre Cartier 059.*

Extra-flat *Tank L.C.*
Wristwatch, pink gold
CARTIER, 2012

Case of 18-karat pink gold. Polished *brancards*.
Beaded crown set with a cabochon sapphire.
Alligator strap. Ardillon buckle of 18-karat pink
gold. Silvered grained dial. Mineral crystal.
Sword-shaped hands of blued steel.
Water resistant up to 20 meters (65 feet).

❖ *Workshop-crafted mechanical movement
with manual winding caliber Cartier 430 MC.*

Some other *Tanks* set out to perfect a style by using the arts of jewelry. These were generally models with a quartz movement. One example was the *Tank Enlacée*, an extravagant concept that strangled the watch with a jewelled strap criss-crossing around the *brancards*. This concept could also be interpreted as the touching tenderness of an embrace, a declaration of love. This recurrent theme in Cartier jewelry and accessories now appeared in a *Tank*. The watch was set with round-cut diamonds and has a lacquered silver dial showing only two Roman numerals, XII and VI, specially redesigned to fit harmoniously into its constricted shape. The *Tank Enlacée* was a watch for a financée or a young bride, playing on the white theme with its dial, its diamonds and its light brushed canvas strap.

Whatever the model's place in the range, whatever market it is intended for and whatever branch of the family tree it belongs to, a *Tank* is always a *Tank*, easily identifiable and eternally elegant. This iconic watch with a style established in 1916 is always a little ahead of its time and effortlessly survives in the swirling currents of history. While 2008 was a vintage year for Cartier watchmaking, it also marked the start of an economic crisis, probably the most serious since the great depresssion of the 1930s.

But against this background of worry and uncertainty, Cartier has unveiled three new *Tanks* in the Spring of 2012. They are a reaffirmation of faith in the values that no crisis can destroy, like the famous tree celebrated by Gaston Bachelard in *L'Air et les songes*: "No storm can stop the tree from turning green in Spring." These three watches are another expression of the "trinity" theme that Cartier has developed over the years in combining three golds and intertwining three rings. They represent the three pillars of creativity applied to *Tank* watches for almost a century: the simple elegance of combining gold and leather, the extravagant boldness of unusual designs and, above all, the fundamental concept of integrating the strap or bracelet with the case, which is the very essence of the wristwatch. The three *Tanks* of 2012 write the history of the famous watch.

We start with the tribute that Cartier pays once more to the man who founded the company's watchmaking: the *Tank Louis Cartier XL* in pink gold. It represents everything that Louis Cartier wanted the *Tank* to be, even to to the point of giving it his name. It is an incomparable image of masculine elegance. Its simple, light and discreetly jewelled luxury is the polar opposite of ostentation. As XL suggests, it spreads more generously over the wrist than the previous Louis Cartier model, measuring, with the crown: 40.40 × 34.92 millimeters

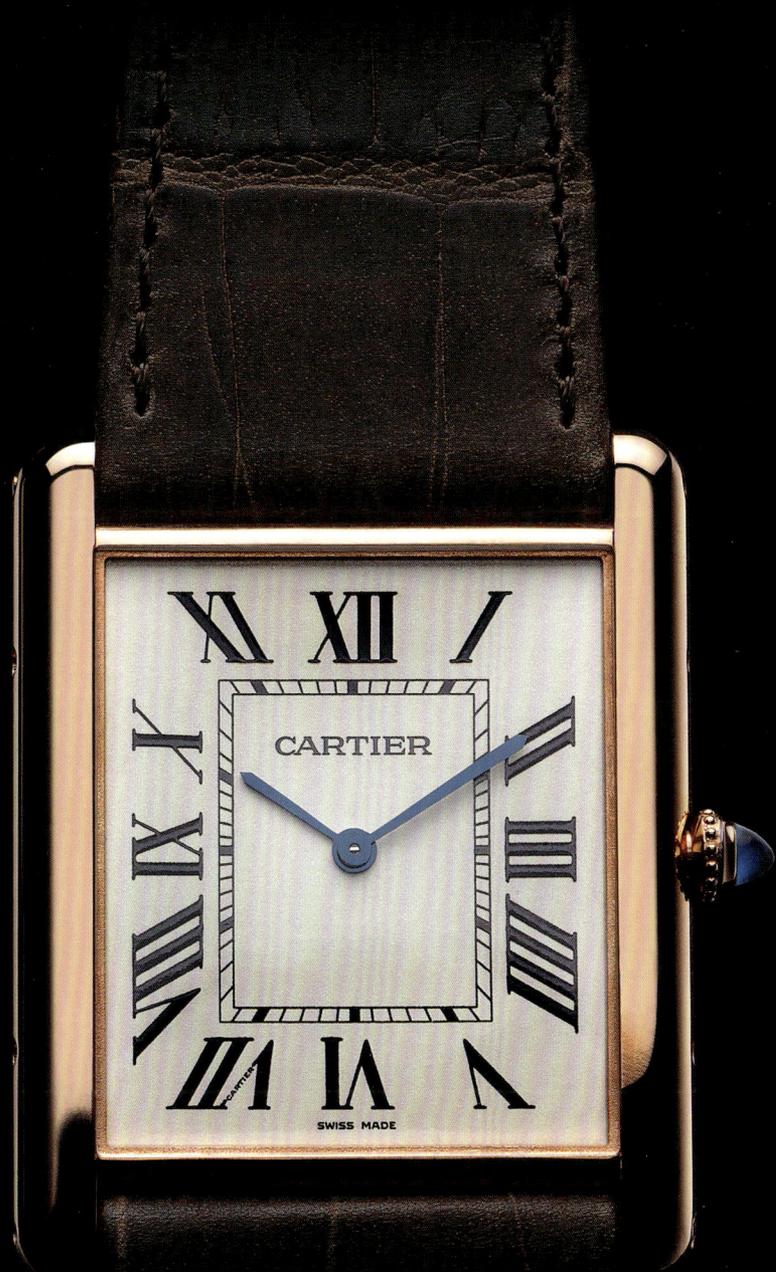

Tank Folle Wristwatch

CARTIER, 2012

Case of 18-karat rhodiumized white gold.
Bezel of 18-karat rhodiumized white gold
set with 55 brilliants.
Beaded crown set with inverted brilliant.
Dark gray *toile brossée* fabric strap.
Ardillon buckle of 18-karat rhodiumized
white gold set with 25 brilliants. Silvered dial
with sun-like finish and lacquer. Sapphire
crystal. Sword-shaped hands of blued steel.
Water resistant up to 30 meters (100 feet).

❖ *Workshop-crafted mechanical movement
with manual winding caliber Cartier 8970 MC.*

(1¼ × 1 inch). In addition, it almost perfectly reproduces the features of the 1922 *Tank L.C.* with similarly fine *brancards* and the timeless touch of the sapphire cabochon, set on a crown that is beaded as before, but this time clearly separated from the *brancard*. The result is a slightly nostalgic, vintage effect. But the principal innovation in the *Tank Louis Cartier XL* appears when it is on the wrist or, even better, when seen in profile: it is the thinnest *Tank* ever produced, with a thickness of just 5.1 millimeters (³⁄₁₆ inch).

The second *Tank* of 2012 is a jewelry model with more than a touch of madness. Cartier has produced several off-beat models in its history, starting with the *Tank Asymétrique* in 1936. They broke away from the *Tank* family codes, but without denying them completely. In fact, they proved that *Tanks* could adapt to outrageous ideas without losing their identity. These rare watches often had no antecedents and were in fashion for only a short time, but customers loved their eccentricity and collectors still search for them many years later. Apart from the *Asymétrique*, the most famous of these rebels was the *Tank Divan* and above all some of the London versions we have discussed. Cartier returned to the eccentric London designs with the *Tank Folle* of 2012 but its inspiration was not the *Tank*. It was a legendary Cartier watch with a humorous design: the *Crash*, produced in 1967

and often reinterpreted since. Its oval case appears to have been involved in a serious accident that bent it completely out of shape. It led to a number of models with original shapes that looked like survivors of a catastrophe, such as the *Baignoire Crash* in 2006, or the *Tank Crash* in the same year which showed the time on broken fragments of three displaced, overlapping dials. The *Tank Folle* is a more amusing deconstruction that looks like crumpled paper or something half-melted by sudden heat, or dropped into water. But it is still a beautiful *Tank* with its twisted *brancards* remaining *brancards*. Its harmony is intact and you feel you could restore its perfect rectangle with some careful ironing! This fresh new *Tank* in white gold, set with brilliant-cut diamonds is fitted with a manual-winding movement. A limited series of 200 pieces has been produced.

The third *Tank* of 2012 has already been recognized as one of the landmark models of the twenty-first century. After the worldwide success of the *Tank Américaine* in 1989 and the *Tank Française* in 1996, Cartier wanted to create a *Tank* that would evoke the third historical pillar in its development: England. The *Tank Anglaise* is therefore a tribute to Cartier's unity as a company, and a demonstration that operates as a perfect triad. It also echoes the extraordinary vitality of London, preparing to host the Olympic Games in

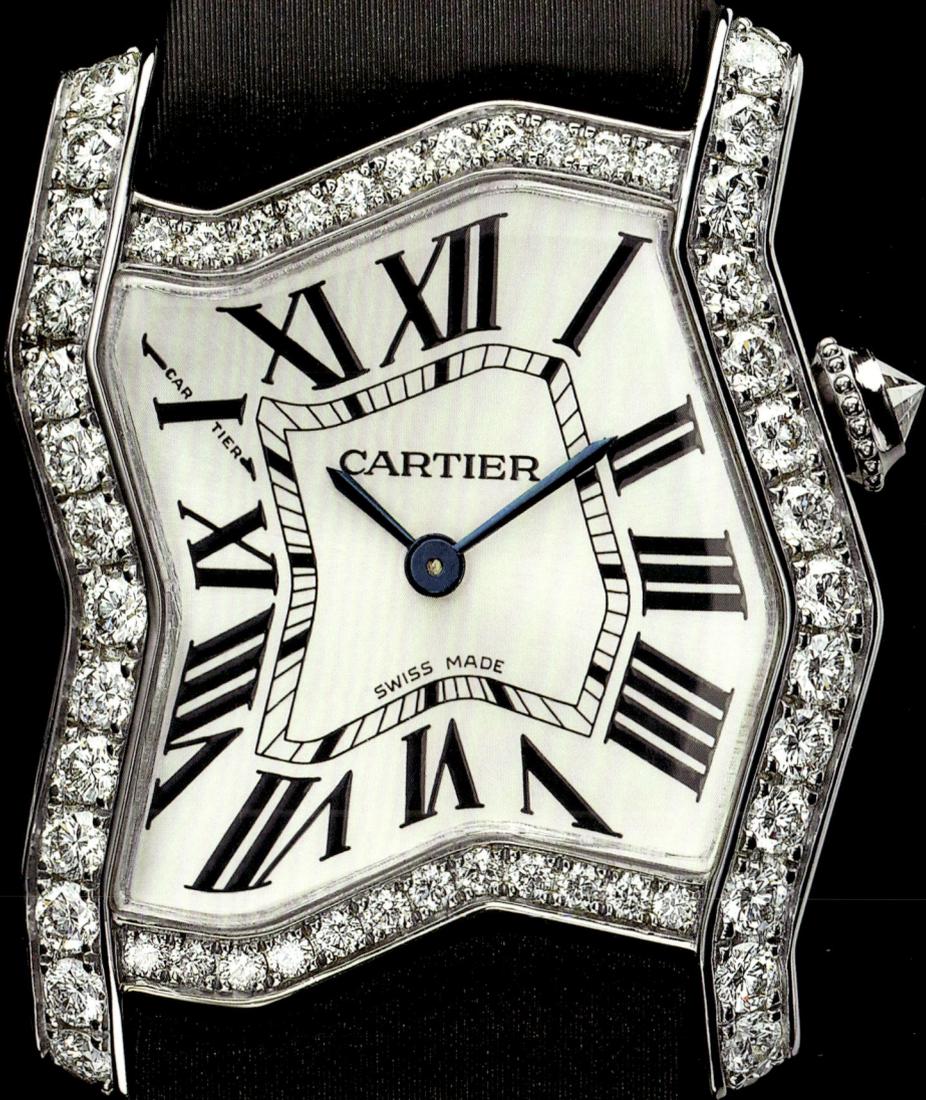

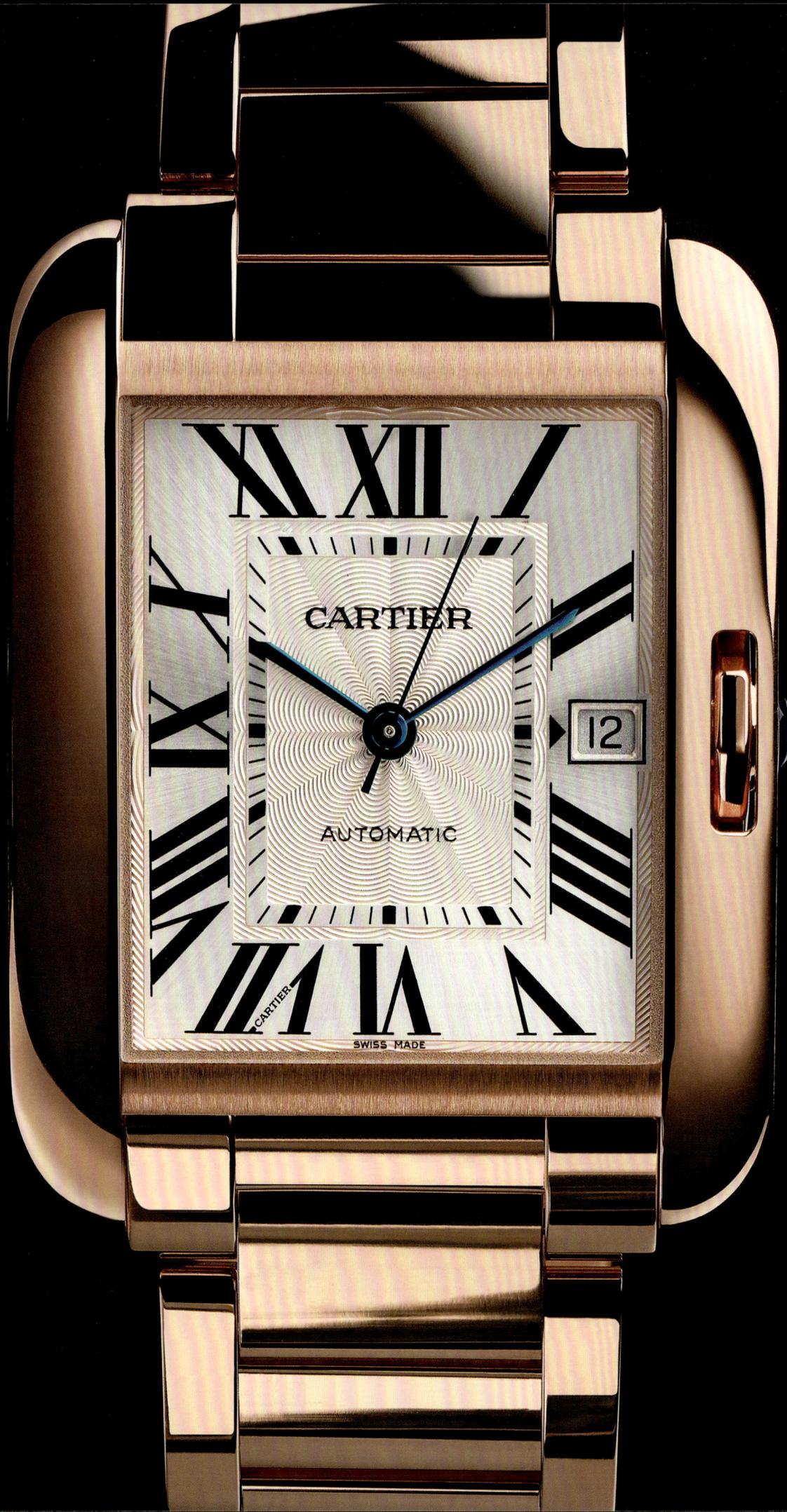

FACING PAGE

Tank Anglaise Wristwatch,
pink gold, large model

CARTIER, 2012

Case of 18-karat pink gold. Nonagonal crown
set with a sapphire integrated in the *brancard*.
Bracelet of 18-karat pink gold.
Flinqué, silvered and lacquered dial.
Sword-shaped hands of blued steel.
Sapphire crystal. Sapphire back.
Water resistant up to 30 meters (100 feet).

❖ *Workshop-crafted mechanical movement
with automatic winding caliber Cartier 1904 MC.*

RIGHT
The "Gherkin" building by Norman Foster
located at 30 St. Mary Axe in the financial district,
the City of London.

the first year of the watch's life. The city has been so influential, for so long, in fashion, design and architecture. The Central Saint Martins College of Art and Design is one of the world's most influential art schools, and has produced fashion designers that have become international stars with their "British Touch." They include Stella McCartney, Matthew Williamson, Luella Bartley, the volcanic John Galliano and the much-missed Alexander McQueen. London is also home to other influential figures in the world of fashion such as the eccentric Vivienne Westwood and the quirkily classical Paul Smith. The feverish energy of London fashion is matched its endless creativity in design. It was from here that young talents such as Neville Brody, Jasper Morrison, Tom Dixon, Lee Broom and others developed global reputations. From the windows of their studios, they almost certainly watched the extraordinary evolution in the architecture of their city, sometimes called "the Dubai of Europe." In the space of a few years, despite the economic downturn, some astonishingly daring tower blocks have been erected. It started with the "Gherkin" by Norman Forster, at 30 St. Mary Axe in 2004. In 2012, five skyscrapers are shooting up, including the Shard by Renzo Piano, the highest tower in Western Europe (310 meters [1017 ft.]) planned to open before the Olympics. The same year will also see the second highest residential building in Western Europe (288 meters [941 ft.]) inaugurated: the Pinnacle by Kohn Pedersen Fox. Shortly afterwards, it will be the "Walkie Talkie" by Rafael Viñoly (160 meters [525 ft.]) and "The Cheese Grater," the Leadenhall Building (225 meters [738 ft.]) by Richard Rogers. Other daring new constructions are eagerly awaited, including the monumental extension to a museum that attracts a great number of visitors—not only for its exhibitions of contemporary art but for its impressive location in a giant disused power station—the Tate Modern.

Now that Cartier has firmly established the *Tank*'s understated masculine elegance and cautious extravagance, the 2012 *Tank Anglaise* recalls the third facet of its identity with the theme that had always been fundamental: the seamless integration of the case with the strap or bracelet. While the *Tank Française* seemed to be a bracelet designed to receive a watch, rather than the other way around, in the *Tank Anglaise* it is the harmony between the bracelet and the *brancards*, and the form of the links themselves, that seems to have designed the watch. The integration benefits even more from an important detail: to preserve an unbroken line between the case and bracelet, the crown is embedded into the *brancard* with only its jewel protruding—a

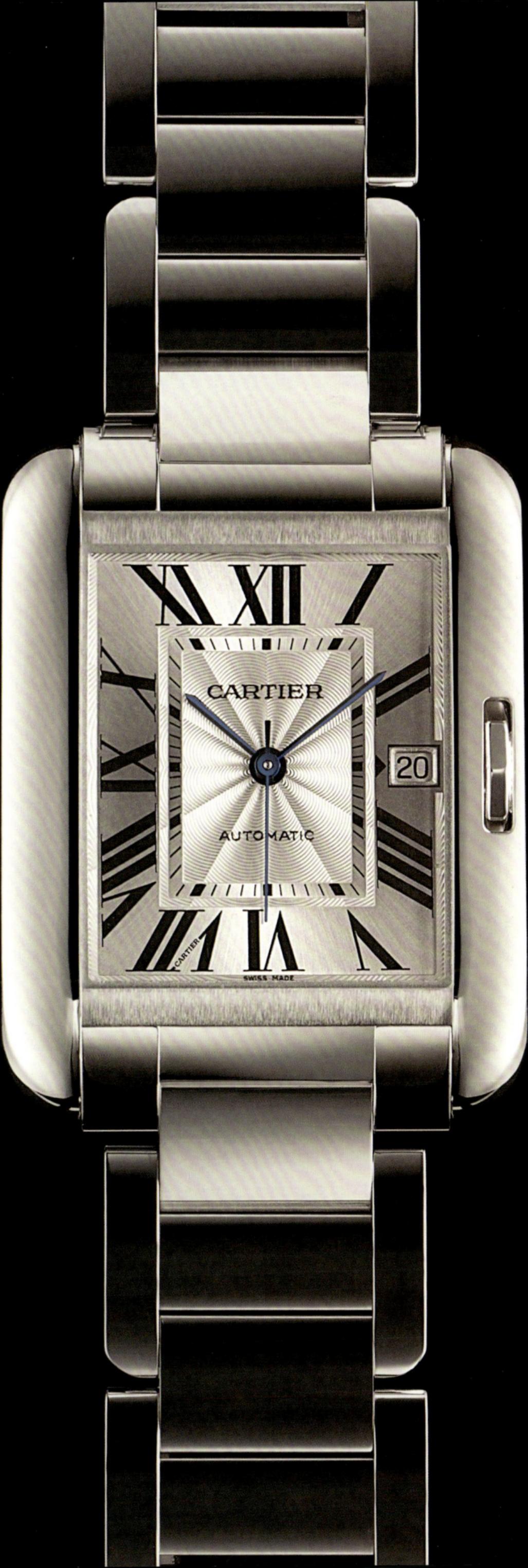

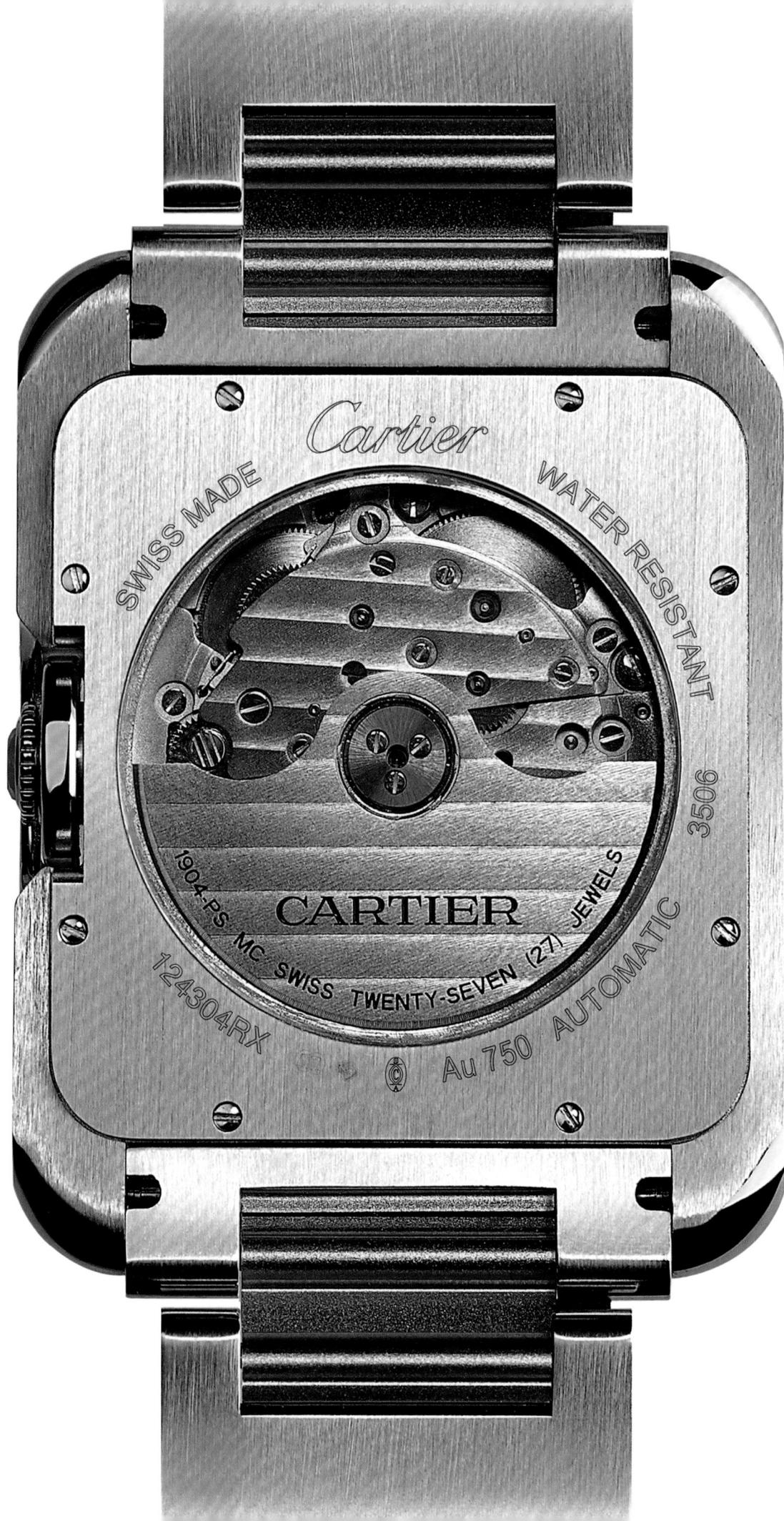

PAGE 206
Side views of the *Tank Anglaise*
in yellow gold and white gold.

PAGE 207

Tank Anglaise Wristwatch, white gold, large model
CARTIER, 2012

Case of 18-karat rhodiumized white gold.
Nonagonal crown set with a sapphire integrated
in the *brancard*. Bracelet of 18-karat rhodiumized
white gold. *Flinqué*, silvered and lacquered dial.
Sword-shaped hands of blued steel.
Sapphire crystal. Transparent sapphire back.
Water resistant up to 30 meters (100 feet).

❖ *Workshop-crafted mechanical movement
with automatic winding caliber Cartier 1904 MC.*

FACING PAGE
The workshop-crafted mechanical movement
with automatic winding caliber Cartier 1904 MC
of the *Tank Anglaise.*

sapphire in the gold version, a diamond in the jewelry version. This idea comes from Cartier's watchmaking heritage: the *Louis Cartier Collection* of 1973 included the octagonal *Ceinture* with a crown incorporated into the bezel, and the same device was brilliantly repeated in the 2007 *Ballon Bleu.* In this watch, it is even more effective. Like Columbus's egg, "It's obvious, once somebody has thought of it." Seen from the side, the crown and the *brancard* represent the wheel and the caterpillar track of a tank. The spirit of Louis Cartier appears to be very much alive among designers at La Chaux-de-Fonds.

The *Tank Anglaise* is produced in the three colors of gold and in three sizes for men and women, as well as two jewelry models, one of which is fully set with brilliant-cut diamonds. Apart from this last model, they have a classic dial that is refreshed by the contrast of the flinqué central rectangle within the railroad minute track and the silvered lacquer surround, which carries the radiating Roman numerals and a calendar window. The contrasting structured sections of this dial, which is swept by a central seconds hand, mark an elegant return to Art Deco. Nevertheless, the polished surfaces and rounded angles of the case and bracelet give the watch a very gentle character. Perhaps because it has been created at a difficult time, the smooth, rounded, softness of the *Tank Anglaise* is comforting and reassuring.

It will certainly have an important place in the history of the *Tank*, not only for its distinctive appearance but because the large version is the very first *Tank* to have a movement designed, produced and assembled entirely within the company. And, unlike Fine Watchmaking movements with complications, it can be used in a large number of models. The caliber 1904 MC (the number is a tribute to the first *Santos*) can be admired in action through the sapphire case back. It is an automatic $11\frac{1}{2}$-line movement that was first fitted in the *Cartier Caliber*, introduced in 2010. Among other innovative features, this caliber delivers stable, high-precision timekeeping, a stop-second system for accurate setting by simply pulling out the crown, and a higher automatic winding speed. Naturally, being a Cartier, it has to be beautiful. The sapphire case back reveals the traditional *Côtes de Genève* decoration on the upper bridges and the oscillating weight. What it cannot reveal is the circular-grained bottom plate which is masked by the movement's components. On the dial of the large model of the *Tank Anglaise*, as on the very rare *Tank Américaine* with flying tourbillon, is the Cartier name. It now refers to a full-capability watchmaker that maintains the highest traditions of the craft yet is committed to innovation.

And that is why the *Tank Anglaise* shows the way ahead for the *Tank* family. Soon all its movements will be bursting

FACING PAGE

Tank Anglaise Jewelry, white gold, medium model
CARTIER, 2012

Case of 18-karat rhodiumized white gold set with 89 brilliants. Nonagonal crown set with a sapphire integrated in the *brancard*. Bracelet of 18-karat rhodiumized white gold. *Flinqué*, silvered and lacquered dial. Sword-shaped hands of blued steel. Sapphire crystal. Water resistant up to 30 meters (100 feet).

❖ *Workshop-crafted mechanical movement with automatic winding caliber Cartier 077.*

with the same energy as its designs. The iconic watch of the twentieth century grew from a fundamental design principle into a cult object and a symbol of supreme elegance. Now in the twenty-first century it has been given an equally beautiful heart. Cartier has always been chiefly interested in its visible surfaces, volumes and shapes. The *Tank* was a style, the *Tank* was the *Tank*. It still is and always will be. But in a world where so many things are mass-produced to meet a passing fashion and their value is always changing, the *Tank* now has a new role. It meets a need for expertise that is slowly acquired and patiently matured, for functional objects made with a love of artistic and technical excellence at the highest level. Delighting not only the eyes but the spirit of those who love it, the *Tank* has had its own revolution, its most beautiful Spring: suddenly the *Tank* is a watch. The gold of the icon starts to shimmer, its beating heart can be heard and its wonderful, sparkling mechanisms that were invisible can be seen. The jeweler has become a master watchmaker and the master watchmaker a jeweler, to glorify its internal beauty. The *Tank* is an ageless style that embodies the movement of time. ∎

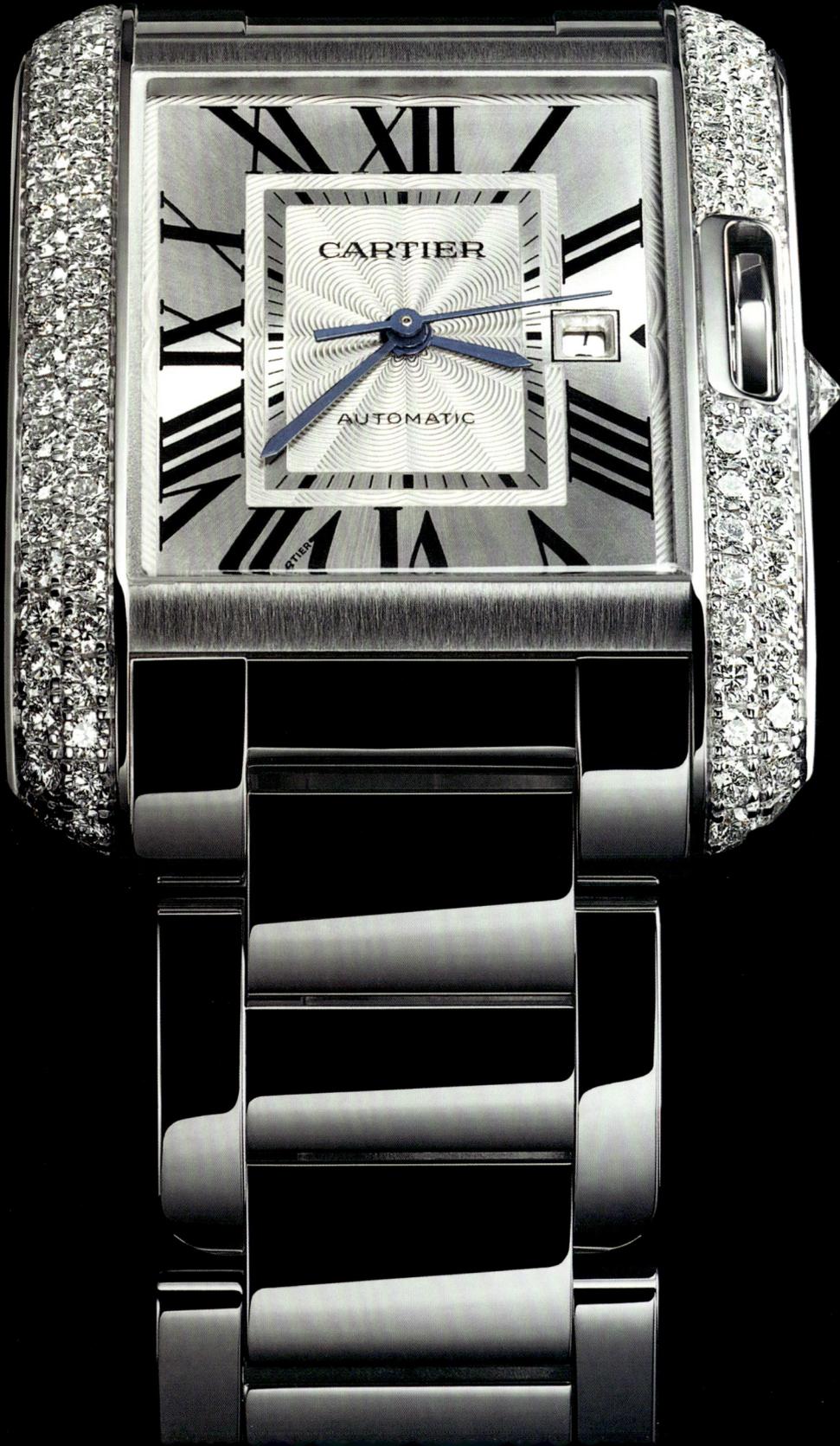

Glossary

Aperture

Small window in the dial in which is displayed, for example, the date. Certain watches such as the *Tank à Guichets* have no dial, replacing it with a flat plaque pierced with small windows showing the hours and minutes. A third may indicate the seconds. These indications are carried on concealed discs, "jumping" (moving on only once an hour) for the hours, and turning continuously ("sweeping") for the minutes and seconds.

Bezel

Ring adjusted to fit the watch case and which holds the glass. When the rim of the latter is encased in a type of frame, the bezel is said to be raised.

Brancards

On the *Tank*, the top and bottom sides incorporating the lugs without any physical or visual interruption. On other watches, these may also be known as loops or horns.

Caliber

Term used to define the dimensions of a watch movement (mechanical or quartz). In a mechanical movement, the energy produced by the mainspring is transmitted to the regulating mechanism (balance and spiral), from where it is distributed periodically by the escapement. The spring may be rewound manually or automatically by means of the turning of a rotor freely seeking the vertical position in response to the movement of the arms. *Tanks* with automatic rewinding may, for example, be wound manually in order to restart the mechanism after a long period out of use. In quartz movements with analogue displays, the quartz is supplied with electrical energy to make it resonate. The integrated circuit reduces the frequency of the resonance, transmitting an impulse each second to the motor which turns the hands. Like the watch case, the caliber may take various forms.

During its history, the *Tank* has used numerous types:

- mechanical: round, form, extra-flat, baguette, skeleton, water-resistant, automatic, or manual-rewinding;
- a quartz: simple or multifunctional.

The *Tank* has also been endowed, among other watches, with the baguette movement, generally constructed with proportions in a length-to width ratio of three to one. Used in miniaturized form on the *Tank*, this permitted a system (patented by Edmond Jaeger in 1921) of rewinding and setting in which the winding crown was positioned on the case back. In extreme cases, a mechanism on two levels was used, one section for the works and the other for the escapement. This arrangement ensured maximum accuracy, as the balance became almost equal in diameter to the overall diameter of the movement.

In the skeleton movement, the cocks are pierced to the limits of the metal's tolerance, thus allowing a view of all the watch components, frequently including the mainspring, visible through the pierced barrel wheel. Chased, gilded and polished to a matt or burnished finish, these movements are veritable works of moving sculpture.

Modern versions of the *Tank Américaine* and the *Tank Française* are water resistant to a depth of 30 meters, conforming to modern standards by virtue of high-technology seals. *Tank Étanche* models of 1931 responded to the more modest needs of the times with movements protected by a hermetically sealed shell set inside the case.

Case back

Cover on the opposite side from the dial, either hinged, screwed on by means of a thread around its circumference, attached with screws or pushed on.

Caseband

Central part of the case in which the movement is placed.

Chemin-de-fer

Name given by Cartier to the signs indicating the minutes, inspired by their resemblance to a railway track (*chemin-de-fer*) motif, also known as the chapter ring.

Chronograph (chronoscope) à rattrapante

Chronograph with one (or two) second hands serving to time events of different duration but starting at the same moment.

Dial

Surface bearing the indications provided by the watch. The *Tank* dial is in matt silver, sometimes *guilloché* (engine-turned), enamelled, gilded, lacquered, or studded. It may be without numerals or with Roman or Arabic numerals, indexes (strokes) or semi-indexes (strokes alternating with numerals), and these may be stretched, inlaid, or painted.

Certain *Tank* dials bear a secret signature, consisting of a diminutive Cartier signature in place of one of the strokes of the Roman numerals. Radium or luminous dials have numerals, indexes, or points coated with luminous salts.

Display

Manner in which the hours, minutes and seconds are indicated, whether numerical (by means figures turned on revolving discs and appearing in windows, liquid crystal figures or electro-luminescent diodes) or analogue (by means of hands). The *Tank* essentially uses displays with hands, with the exception of a few numerical models (the *Tank à Guichets*).

Double time-zone watch

Watch with two dials, one displaying local time, the other that of a different longitude (i.e. to east or west of the prime meridian).

Extra-flat movement 430 MC

The workshop-crafted mechanical movement with manual winding caliber Cartier 430 MC, assembled in the manufacture Cartier, is one of the thinnest movement of the watchmaking market (2.10 millimeters [¹/₁₆ inch] thickness).

Glass

Sheet of natural or synthetic glass, adjusted to fit the bezel and protecting the dial and hands. The extremely fragile natural glass of early wristwatches has today been replaced by extremely tough reinforced mineral glasses or virtually scratch-resistant sapphire glasses. In many valuable watches, the case back is replaced by a sapphire glass revealing the mechanism.

Hands

Components serving essentially to indicate the hours, minutes and seconds. The *Tank* uses principally:
- Apple-shaped hands, have a hollow circle design, are of blued steel and have straight shafts; also known as Breguet hands because they were designed by Abraham-Louis Breguet.
- bâton hands;
- old-style bâton hands.

A few very rare *Tank L.C.* have feather hands. The straight second hand may turn on the same axis as the hour and minute hands, or it may be placed in a small dial at 6 o'clock.

In mechanical movements, the second hand generally makes five jumps per second, in quartz movements only one.

Chronographs are equipped with three complementary hands: a central second hand, moving only during timing operations, and the hands of the minute and hour counters, calculating the total time measured. Openwork skeleton hands are known as radium, luminescent or luminous hands when the hollow areas are replaced with a luminous paste (formerly of radium salts, nowadays of tritium).

Line

The "line" or "Paris line," is a measure in traditional watchmaking used prior to the metric system, derived directly from the French "foot" used under the *Ancien régime*. One line was equivalent to 2.2558 millimeters, rounded to 2.26 millimeters (¹/₁₆ inch). One foot (') used to contain 12 inches (") each of 12 lines ("'). This measure is usually written as a triple apostrophe after the figure: thus a movement may be of 11"', i.e. 11 lines, or 24.8 mm (1 inch) in diameter.

Perpetual calendar

Watch which takes account automatically of the varying length of the months and of leap years. Some models include correction for all the non-leap years of a century. They may indicate only the month or also the date, day of the week, name of the month, and possibly the phases and age of the moon (time since the new moon).

Pushbutton

Control button for the chronographic function of a chronoscope: start, stop, return to zero. The first chronographs had a single pushbutton incorporating the winding crown. On modern versions, the winding crown is flanked by two pushbuttons, one for starting and stopping and the other for returning to zero.

Savonnette

Savonnette watches are equipped with cover in order to protect the glass. In the case of the *Tank Savonnette*, the watch itself acts as the cover.

Watches with complications

Watch with a mechanical movement providing indications other than the hours, minutes and seconds. The term "function" is reserved for watches with quartz movements.

The principal complications are:

- extra-flat movement;
- phases and age of the moon;
- ordinary calendar;
- perpetual calendar, sometimes self-correcting for all the non-leap years in a century;
- chronograph *à rattrapante*;
- tourbillon regulator;
- minute-repeating.

Watch case

Case containing the mechanism and serving to protect it against dust, damp and shocks. All researches in æsthetic matters concern the case. A watch described as a form watch (de forme) may be oval, square, rectangular, triangular, or polygonal, but not round. In profile it may be flat, or curved to follow the shape of the wrist.

Winding crown

Fluted knob of varying shape serving to wind the watch or set the hands. On the earliest wristwatches, the hands were set by pressing a pushbutton and turning the winding crown.

Tank winding crowns may be:

- fluted ;
- fluted and decorated with a sapphire cabochon ;
- set with pearls in place of fluting;
- set with pearls and decorated with an unfaceted cabochon-cut sapphire;
- set with pearls and decorated with a rose-cut diamond;
- faceted and set with a flat or cabochon-cut stone.

Certain models are notched and flat or notched and convex.

213

Index of Proper Names

Page numbers in italics correspond to captions.

Index of Timepieces and Objects

Selected Bibliography

AFUHS, Eva, FORSTER, Jack, *Cartier Time Art, Mechanics of Passion*. Musée Bellerive, Zurich, Milan: Skira, 2011 (English, German and French editions).

BARRACA, Jader, NEGRETTI, Giampiero, NENCINI, Franco, *Le Temps de Cartier*. Paris: Wrist International S.r.l, 1989; Milan: Publi Prom, 1993 (2e ed.).

COLOGNI, Franco, *The Tank Watch*. Paris, Flammarion, 1998.

COLOGNI, Franco, CHAILLE, François, *The Cartier Collection, Volume 2: Timepieces*. Paris: Flammarion, 2006.

COLOGNI, Franco, *Jaeger LeCoultre: The Story of the Grande Maison*. Paris: Flammarion, 2006.

FLÉCHON, Dominique, *The Mastery of Time*. Paris: Flammarion, 2011.

ZALLER, Tom, FORSTER, Jack, *Cartier Time Art, Mechanics of Passion*. Art Science Museum, Singapore, Milan: Skira, 2011 (Simplified Chinese and English editions).

For an exhaustive bibliography, readers can find information on the website of the Fondation de la Haute Horlogerie:
www.hautehorlogerie.org

Photographic Credits